T0256406

TAKING PLACE

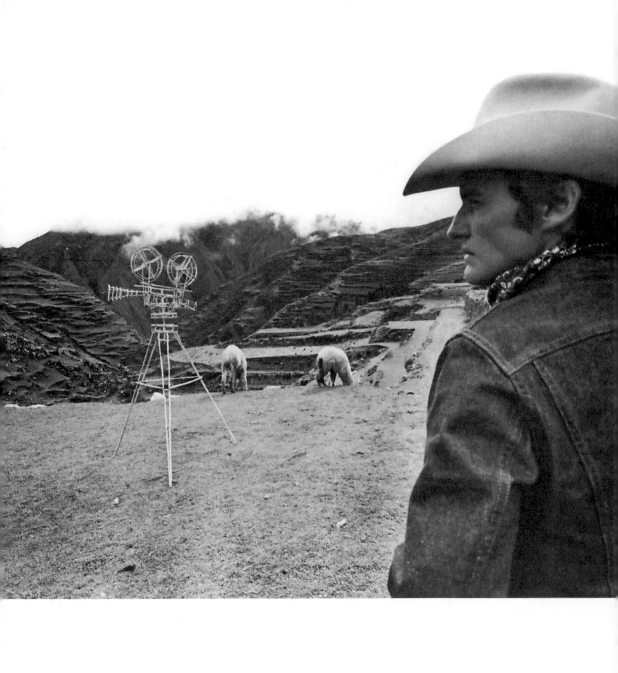

Taking Place

LOCATION AND THE MOVING IMAGE

JOHN DAVID RHODES
AND ELENA GORFINKEL
EDITORS

University of Minnesota Press
MINNEAPOLIS · LONDON

A version of chapter 5 was previously published in *October* 128 (Spring 2009). An Italian version was published in two parts in *Bianco e nero* 560 (November 2008) and 561–562 (May 2009).

Published by the University of Minnesota Press
111 Third Avenue South, Suite 290
Minneapolis, MN 55401-2520
http://www.upress.umn.edu

Library of Congress Cataloging-in-Publication Data

Taking place : location and the moving image / John David Rhodes and Elena Gorfinkel [editors].
 p. cm.
 Includes bibliographical references and index.
 ISBN 978-0-8166-6516-7 (hc : alk. paper)
 ISBN 978-0-8166-6517-4 (pb : alk. paper)
1. Motion pictures—Setting and scenery. 2. Place (Philosophy) in motion pictures. 3. Space in motion pictures. 4. Cities and towns in motion pictures. 5. Motion picture locations. I. Rhodes, John David. II. Gorfinkel, Elena.
 PN1995.9.S4T35 2011
 791.430'25—dc22
 2010048759

Printed in the United States of America on acid-free paper

The University of Minnesota is an equal-opportunity educator and employer.

17 16 15 14 13 12 11 10 9 8 7 6 5 4 3 2 1

Contents

Introduction: The Matter of Places

ELENA GORFINKEL AND JOHN DAVID RHODES

Toward the end of his *Theory of Film*, Siegfried Kracauer writes some of the most explicitly humanist passages to be found in the book, a book whose subtitle is, we should remember, *The Redemption of Physical Reality*. In the final chapter, under the subheading "Moments of Everyday Life," Kracauer wonders if the "small units" of contingent, material existence captured on and by film have a power over and above their service and enchainment to a film's plot-driven, narrative project. Such a small unit, Kracauer contends,

> no doubt . . . is intended to advance the story to which it belongs, but it also affects us strongly, or even primarily, as just a fragmentary moment of visible reality, surrounded, as it were, by a fringe of indeterminate visible meanings. And in this capacity the moment disengages itself from the conflict, the belief, the adventure, toward which the whole of the story converges. A face on the screen may attract us as a singular manifestation of fear or happiness regardless of the events which motivate its expression. A street serving as the background to some quarrel or love affair may rush to the fore and produce an intoxicating effect. Street and face, then, open up a dimension much wider than that of the plots which they sustain.[1]

This is an account of a spectatorship that is both distracted and overcathected. A concentration on what might be the "wrong" or unimportant part of the image threatens (or promises) to usurp the stately or hurried progress of the narrative, and a world of meaning that the image does not mean to impart seems to pour down on us from the screen. Feminist film theory would take up the challenge of the face's ability to arrest narrative, while semioticians have elaborated an understanding of what happens when we find other meanings in images than the ones we presume were intended.[2] But the street's ability to enthrall us has not been as well understood. When the background suddenly becomes foreground

and we wonder, "What is that place?" or else we murmur, "I know that place!" we register something—an experience of place through the moving image—about which surprisingly little has been said.[3]

Our experience of the moving image is intimately connected to our experience of place. That "movies take place" (pace Michael Snow) is a cliché of both realist location shooting and avant-garde film practice. Nevertheless, the phrase continues to resonate richly. Films are shot either on location or in the studio. In the first case, films take actual places—take images of places, record impressions of the world's surfaces—and archive them on celluloid. This seemingly natural ability of the cinema to record place enthralled early filmmakers, who devoted endless reels of film to panoramas (urban, rural, familiar, foreign) or to urban traveling shots often made by standing a camera on a streetcar and letting it capture the life of a city as seen by an unblinking, one-eyed commuter. Even in studio shooting, film continues to exert its natural affinity to act as archiving agent. Whether or not we know it, we are being given information about the nature of Paramount's two main shooting stages when we look at the closing scenes of *White Christmas*, while similarly, Fellini's *La dolce vita* is an object lesson in the spatial capacities of Stage 5 at Cinecittà.

But beyond what they record, document, and archive, films also take place in another way: they have to be seen somewhere. The space of the theater, while it has been under threat by "home entertainment" for the last half century, has been and continues to be a powerful social and psychic space—a space, in fact, where the social and the psychic seem most to lose their distinctness and bleed, in darkness and in light, into one another. Very often, an experience of a film may be memorable less for the film itself and more for the theater in which one has seen it. Films and other moving image artifacts (video installations, site-specific projections) may also be produced to be seen in one specific place alone. In this case, film's apparent affinities to be reproduced and shown *anywhere* are refused. Instead, it is forced to work with and against its nature: it must take place and perhaps represent place, *but only in this place and nowhere else*.

Cinema must, by its very nature, exhibit places to its spectators and lure its spectators to places of exhibition. Despite the chiasmic logic of this statement, which may at first appear as nothing more than a truism, its rich implications have been rarely considered in detail by moving image historians. This lacuna in film studies is all the more surprising given the recent attention devoted to the study of place by scholars working in, across, and between the disciplines of geography, philosophy, history, art history, and literary studies. Our intention in this collection is to put this growing body of work on place in conversation

with cutting-edge historical and theoretical scholarship on moving image media.

Edward S. Casey—one of the leading contributors to place studies in the field of philosophy—has claimed that our "immediate placement" as subjects "counts for much more than is usually imagined. More, for instance, than serving as a mere backdrop for concrete actions or thoughts. Place itself is concrete and at one with action and thought."[4] Casey's emphasis on the centrality of place to the constitution of subjectivity needs to be adopted and adapted for the study of moving image media. The metaphor of the "backdrop," in fact, resonates with the typical figure–ground relations that obtain in the construction and consumption of moving images: very often, the place of the image is registered as mere "backdrop"—the necessary material support for the human action that will transpire before it. This "ground," however, does more than support the action; the essays we have collected here demonstrate that the place or location of the moving image is, like the place of human subjectivity, "at one with action and thought."

In a sense, all these essays seek to particularize our understanding of the emplacement, the location, of the moving image, and in that sense, they embrace Casey's understanding of place as "the phenomenal particularization of 'being in the world.'"[5] These essays tend to look at what has been overlooked, taken for granted, or ignored. Thus the emphasis—even overemphasis—on place as a heuristic, practiced in concert with a diverse array of theories and methodologies, produces not only new readings of individual moving image artifacts but, more important, a new understanding of how the moving image works, how it constitutes itself in and through emplacement, how we may understand it anew and afresh through the particularizing lens of place.

Place, however necessary it is as the precondition of human subjectivity, is not only a constitutive force but a *constructive* one as well. As J. Nicholas Entrikin suggests, "our relations to place and culture become elements in the construction of our individual and collective identities."[6] Identity is constructed in and through place, whether by our embrace of a place, our inhabitation of a particular point in space, or by our rejection of and departure from a given place and our movement toward, adoption and inhabitation of, another. The notion that place inflects and informs the construction of human identity (which is only one aspect of human subjectivity) might seem to operate under the assumption that place itself is a natural category: it is the land, the sea, the sky above. Recent scholarship in human geography has sought rigorously to demonstrate, however, that place itself is constructed and is something that has already been acted on prior to its acting on the human subject.[7] Place, after all, is a subset of that larger category, space, and as Henri Lefebvre has famously taught us, "*(social) space is a (social) product.*"[8]

Cinema, one of the primary moving image technologies studied in this collection, is, as we know, a social product as well: it is produced collectively and consumed collectively. The places and spaces of its production and consumption are also, moreover, vital to any understanding of its aesthetic, political, or cultural agency. To take only the most obvious and convenient example, one cannot understand the textual construction of classical Hollywood filmmaking without understanding the spatial practices of the Hollywood studios, as well as the place of those studios in Southern California. We know, for instance, that the American film industry transported itself from its first home on the East Coast to Hollywood for a nexus of reasons, all of them having to do with the nature of Hollywood as a specific geographical place: its year-long availability of natural sunlight, the diversity of landscapes (mountain, coastal, urban, desert, etc.) within close range of the studios, the lax labor laws in Los Angeles, and so on. Similarly, we cannot understand the operations of the classical Hollywood film without understanding the places of its consumption, a claim whose interest has been demonstrated forcefully by recent work on exhibition sites situated at the crossroads of film studies and geography.[9]

What is implicit in all of the preceding is that place and cinema share an intriguing and morphologically consonant doubleness: both are felt and have been understood to be simultaneously natural *and* constructed, to be the effects of both ontology and the articulations of a code or codes. Cinema as photographic medium has been notoriously and controversially appealed to as a medium of "truth" in which the natural world (often the landscape—place—itself) lays its impress on the physical material of the filmstrip.[10] This same understanding has been revised, and even abjured, by an understanding of cinema as depending less on its debt to the world it photographs and more on its operations as a text, or as an instance of speech, language act, or code.[11] Place, meanwhile, as we have seen, can be experienced or understood both as the ultimate, entirely natural a priori ("To be at all—to exist in any way—is to be somewhere, and to be somewhere is to be in some kind of place."[12]) *and* as a fabrication—a product of human artifice, cultural construction, and ideology ("landscapes, like written texts, encode powerful social, cultural, and political messages that are interpreted by their viewers"[13]). The theorizations of cinema and place are therefore both replete with the tensions between ontology and codedness. We hope it is obvious and compelling how opening up moving image studies to the study and theorization of place might be a way of enlivening, broadening, and sharpening the debates in both fields.

Another of the aims of our collection is to redirect the long-standing attention paid to space in film studies and other humanities disciplines toward a sustained consideration of place. Space cannot exist without place, and yet cinema's relation

to place as such has not been properly theorized. The contest between these terms, *space* and *place,* has been influentially theorized by Michel de Certeau. Place, for de Certeau, is "an instantaneous configuration of positions"; in other words, it is "an indication of stability."[14] Place is the antithesis of movement and therefore of change and (revolutionary) possibility. Space names, for de Certeau, the medium through which such change is possible. Space is "actuated by the ensemble of movements deployed within it."[15] De Certeau argues that a place is like "the street geometrically defined by urban planning" that is "transformed into a space by walkers."[16] We agree with Margaret Kohn that de Certeau's terms and his definitions of them are actually "poorly chosen metaphors for a politics of domination or nostalgia."[17] We would argue that the accretion of history in a given location actually provides the traction necessary for resonant and forceful political intervention. As Kristin Ross has written apropos of the destruction by the Communards of the Vendôme Column during the Paris Commune of 1871, "an awareness of social space . . . always entails an encounter with history—or better, a choice of histories."[18]

Cinematic space and its construction by and through the cinematic apparatus was, as we know, one of the central objects of 1970s film theory's assault on realist representation. The bracing spirit of this theory and its critique of "bourgeois" perspectival vision forced us to consider the ideology of vision itself, though it did so in a way that suggested that the apparatus's ideological power to look outstripped the significance of whatever it might look *at.* Nevertheless, intrinsic to the problematizations of apparatus theory and psychosemiotics was a concern for the relationship between ideology and vision's organization through cinematic conventions that sought to tame the disruptions of spectacle, the details, embodiments, and textures of the profilmic, to serve (classical) narrative form and flow. If we reconstruct the concerns of these theories in relationship to place, and the difficult kernel of the locational "real," we see the ways in which the preoccupation with spatiality, coherence, and flow was always tarrying with the disjunctive power and inherent fascination of the profilmic. In wresting place from its status as mere setting and narrative "support," this collection focuses on the generative structures, aesthetic conditions, and political implications of the profilmic, drawing background to foreground, periphery to center.

The attention we pay to specific places is meant furthermore to answer a range of questions. We are interested in how films—whether they are fictional or documentary—can act as archives of specific places. What kind of historical knowledge does film grant us about places and the ways they have been inhabited and used? How does cinema's archive of place (an archive produced, in many cases, almost

unconsciously) interact with our memory of places as well as our contemporary use and habitation of them? How can films and other moving image technologies transform places through modes of exhibition? What is the work of the site-specific film or video installation? And to what extent can any projection of a film in a given place be considered specific to that site? How can film be mined for an understanding of general rhetorical and cultural discourse of and on place? When do places matter, and when do they not? How does a specific location allow itself to be subsumed as background, and how can it resist such subsumption? How can a political and politicized practice of attention to the place of the moving image serve to reanimate the practice of politicized image making more generally?

We ask and seek to answer these questions in resistance to pervasive discourse that proclaims the purported death of place in the era of late (or global, postindustrial) capitalism. Such claims about the end of place are usually predicated on the fact that many places look the same as other places and are populated by people who dress the same and consume the same consumer goods as people everywhere else. The situation, according to some observers, has become so dire that the very reality of place has been superseded; place has acceded to what anthropologist Marc Augé calls the *nonplace*, "a space which cannot be defined as relational, or historical, or concerned with identity."[19] Augé's conceptualization of the nonplace is suggestive to the point of ambivalence;[20] however, despite his acknowledgment that "thought based on place haunts us still,"[21] his category of the nonplace seems to us to possess a potentially colonizing and ontological nonspecificity not unlike the nonplace itself. We mean this collection to resist a too-rapid or too-fashionable accession to the repetitive enjoyment that seems to attend the prophesying of the advent of the nonplace. We draw inspiration from the work of geographers like Doreen Massey and John Rennie Short, who have argued that it is precisely now, in our contemporary moment of postindustrial globalization, that place—as both material location and theoretical practice—becomes ever more vital.[22] We believe—perhaps too optimistically—that a stubborn insistence on place might serve as a tactic (and even a topos) with which to resist the forces (ideological, material, rhetorical) that have threatened to flatten our notion of the uniqueness, the power, and the political potential of both place and the moving image.

LOCALLY GLOBAL

Place might be anticipated here to emerge as a term heroically opposed to *space*, the local in opposition to the global and so on. Certainly a redirection from space (as a uniform property of cinema) to place (as a strikingly heterogeneous and specific element recorded by or sensible in a film) is one of this collection's concerns. This

consideration, however, it shares with film theoretical work that has long been canonical within the discipline of film studies.

Stephen Heath's indispensable essay "Narrative Space" understands place as but one specificity among others that is contained, harnessed, and in short, instrumentalized by the narrativizing function of dominant cinema. Heath speaks of "the conversion of seen into scene"—in other words, the translation of a specific view of a specific place in the world into an abstract unit of narration.[23] The narrative film demands and enacts "a constant welding together: screen and frame, ground and background, surface and depth, the whole setting of movements and transitions, the implication of space and spectator in the taking place of film as narrative."[24] Heath describes narrative cinema's process of abstraction: so much specificity and contingency (of places, bodies, etc.) are but quantities of fuel for the smooth functioning of storytelling's machinery, for the production of a satisfying (if not always happy) ending.

In Heath's account, shots of a specific location would only be able to express that location's uniqueness to the extent that such expression will not impede the film's enunciation as narrative and the spectator's grasp and enjoyment of that narrative. For Heath, narrative labors self-effacingly to produce *spatial coherence,* a term that might as well be called *ideology:* narrative cinema's formal spatial unity creates a wonderfully sturdy cavity inside of which are poured (false) contents, the belief in the coherence of the hegemonic social order. The disruption of narrative cinema's ideological coherence is made possible through the disruption of its spatial system. Heath's essay ends with an illustration of how a shot taken from an "impossible place"[25] makes us aware that "events take place"[26]—in other words, that the contingent variety of the real, of the world, of social totality is exactly that which is hidden by narrative cinema's luminous, coherent spaces.

Heath's account suggests that our attention to a space–place dialectic might play a defining role in understanding the nature of cinema's address to reality. Cinema's construction of its own coherent space or its referencing of its own construction of space will be the grounds from which a truly critical practice of cinema can emerge. What Heath's invigorating approach misses, however, is the way in which, as Roger Cardinal writes, we might "pause over peripheral detail,"[27] in which a shot of a place that we can identify as *this* place and not just *a* place may be the condition of an engagement of film that is not as constricted as Heath's account would allow. He misses what Kracauer understands to be the ability of an image of a place to "open up a dimension much wider than that of the plot" and in the decentered wandering over the details and surface of the frame that Cardinal extols. In fact, narrative cinema's propensity for changing scenes and consuming scenery could,

while satisfying the demands of abstract narrativization, actually create the grounds of a critical engagement, or at least a less-instrumentalized and managed spectatorship precisely through the sheer proliferation of places seen in the film frame.

Heath's fascination with the primacy of space as a key to cinema's diffusion of ideology and its link to social totality is shared by Fredric Jameson in *The Geopolitical Aesthetic*. Jameson's theorization of postmodernism is as spatializing as it is temporalizing (or periodizing); the postmodern is a spatializing of experience at the expense of history. The totality of social relations under postmodernism is that which cannot be represented through what Jameson famously refers to as "cognitive mapping." Jameson develops this spatial terminology from Kevin Lynch, whose analysis of the postwar city argued that irregular, sprawling urban forms that were not "imageable" were often experienced unhappily by their inhabitants.[28] In other words, a theoretical term that was born out of Lynch's encounters with places like Jersey City became, through Jameson's fruitful but almost wildly totalizing redeployment of it, perhaps the most persuasive term for diagnosing the condition of postmodernity. The local had prepared the way and given way to the global, in other words.

For Jameson, the films that he analyzes in the first section of *The Geopolitical Aesthetic* (films that he calls conspiracy films) give evidence of a crisis in representation. For Jameson, space becomes the medium through which we recognize our own incapacity to represent an inconceivable totality of social and economic relations in the era of postmodernity; however, at the same time, by serving as the medium of the mute utterance of this incapacity, space thereby also serves as the means through which this totality's unrepresentability is at least recognized as such. Space becomes the vehicle through which "local items of the present and the here-and-now can be made to express and to designate the absent, unrepresentable totality."[29] In other words, spaces, and even specific places, become the grounds for a thinking of totality, even if that thinking will always be a thinking of the totality's unrepresentability. In fact, although Jameson does not use the term *place*, his analysis of the appearance of (and insistence on) a specific place at the end of *All the President's Men* (Alan Pakula, 1976), the Library of Congress, provides "the impossible vision of totality." This particular place (and, we would venture— although Jameson does not quite say this—the film's implicit insistence on this place's particularity) offers a vision of "what organizes history, but is unrepresentable within it."[30] Ultimately, the social totality cannot be mapped, but the desire, the demand, and in the end, the necessary but impossible demand for an effort toward mapping can be, at least, pictured: the shot of the Library of Congress "suggests the possibility of cognitive mapping as a whole and stands as its substitute and

yet its allegory all at once."[31] In other words, to apprehend this cinematic image of a particular place is also to apprehend the existence of that (and all that) which cannot be apprehended. Although Jameson tends to prefer the term *space* to *place*, places, localities, and specific sites all function for him as necessary grounds for contending with the largest of global totalities. We need only consider how much Jameson depends on the Bonaventure Hotel in downtown Los Angeles to produce his theory of postmodernism.[32] Global totality cannot be thought without reckoning with local specificity. In other words, place, in its specific concreteness, does not act as a hurdle to abstract and generalizing thought but instead is the means through which such thought is able to articulate and materialize itself. This is the inversion of the bumper sticker's imperative to "think globally; act locally"; rather to think locally, Jameson suggests, is to make way for the possibility of acting (and, of course, continuing to think) globally.

We might note that the movement from locality to totality is a function of human thought: the individual example will always illuminate a general principle. Moreover, as John Durham Peters has argued, "the global has become a graphic part of our local experience."[33] The two terms cannot be disentangled. Peters links what he calls an increasingly "bifocal" vision of the world to modernity, a period in which an awareness of the awesome scale of global relations is constantly being pressed on our consciousness. However, the way in which the instance of a specific place organizes and gives concreteness to a universal condition of spatiality becomes especially crucial when we think of how such an embodiment literalizes certain conditions of the local and global. The terms *local* and *global* are derived from the discourse of topography, geography, and cartography; these are the very discourses of place itself. To think about a specific place, or images of a specific place, in relation to discourses of locality and globality is to speak this discourse in a very literal way. A place, an actual locality that is in turn englobed by and in the global, offers us a firm ground on which to conceptualize critical questions about locality and globality and their relation to media in a way that does not simply spend itself in unfocused generalization.

In an era of multinational capitalism and the imbalances produced by globalized neoliberal economic practices, we tend to value the local as the site of resistance to capitalist predation. Seattle, Genoa, Davos: the place-name names both the instruments of global capital and the history of a resistance to it. We are tempted to think, initially, at least, that any politics that is worthy of the name—that is to say, that is truly based on conflict in the public sphere—will need to be local before it can act globally. But we should be alert to the interest that neoliberalism might have in coopting an interest in local specificity to serve its own enshrinement of

private liberty and individualism as themselves forces of particularism. As media scholars, we believe that we are obliged—compelled, even—to consider the way in which, as Peters has written, the "authority of the local . . . is often undercut by image totalities."[34] The images that we are so used to trafficking in and sifting through play a crucial role in the derealization of our experience of the local. At the same time, the ability of an image of a place to be circulated globally suggests that such an image may be one of the most powerful means at our disposal to pose challenges to the unimageable, unrepresentable totality of our globalized contemporary condition.

MODES OF ATTACHMENT

Rather than simply align place with the authenticity or specificity of culture, this collection hones in on a tendency in recent film and media theory to explore the epochal questions of cinema's materiality in the wake of its seeming obsolescence. Our investment in place as a heuristic is not unreconstructed nostalgia for the medium of film nor a nostalgia for the immediacy of place itself as a lost arcadian topos that the cinema unproblematically salvages, preserves, or reconstructs. It is, in fact, the very natural-seeming predisposition of the moving image toward an indexical recording of place, and the naturalization of such access to location, that we see as the very site of this collection's intervention. We would like to ask how it is that place gets sedimented within the very definitions of cinema, as form and social practice, and how cinema gets embedded in, attached to, particular places. If 1970s film theory made us skeptical about the insinuating powers of the "reality effect," then we have yet to understand place's embeddedness within this effect or the ways that place attaches itself to the machine and how the machine attaches itself to place. The simultaneity of these processes transforms both place and cinema, binding each to each in contingent and unpredictable ways. It is precisely the contingent quality of place's indexical documentation by the moving image that makes this simultaneity a profoundly political matter.

Recent film scholarship has returned to those formative questions of the reality effect: indexicality, contingency, and referentiality. This work is especially pertinent to our concerns here as it has renewed and reinvigorated an interest in the functions, rather than the mere representational content, of the profilmic for the import of the film medium.[35] Philip Rosen, in his book on the legacy of Bazinian criticism for contemporary film studies, engages with the powers and historicity of the profilmic field.[36] For Rosen, the cinema has numerous operations through which the unmotivated or excessive detail is managed, "rationalized," and put in the service of diegetic aims.

In his discussion of the function of detail in the historical film, Rosen empha-
sizes place as a fundamental feature of the profilmic by analyzing a few transitional
frames from *The Return of Martin Guerre* (Daniel Vigne, 1982). In these isolated
frames, we see villagers crossing a bridge to Toulouse and smoke as it is produced
by boats on the river below. Rosen contends that the unique status of the histori-
cal film layers the time(s) and spatial processes of the film's production over the
supplemental referentiality of the past time that the film aims to "reconstruct."
Rosen describes an oscillation between these profilmic details working as document
(the smoke emitted by the boats, recorded by the camera in 1982), its "conversion"
into "narrationally positioned diegetic detail" (the virtual world of the historical
narrative), and the subsequent "conversion" back into a "quasi-document" that
portends a level of historicity, in the reassurance of its historical resemblance of
the phenomenal universe circa 1560.[37] The indexical force of the profilmic resides
in this oscillation between different temporalities, in a spectatorial process that
shuttles between investment in documentary and investment in fiction.

Rosen's argument here as it extends beyond the particularity of his chosen
subject bears importantly on our project. Even in Rosen's choice of an illustrative
example, the stolidity of the stone bridge and the contingency of the smoke ris-
ing from the water below, we sense an indelible emplacement. If "the fluidity of
boundaries between historiographic appeals and fictional genres on the level of the
profilmic field suggests the inevitability of film as documented and documenting,
but also, always film's insufficiency as document,"[38] then we want to conceive of a
comparable epistemological process in the manifestations of place and geographical
detail in cinema and the ways in which cinema is itself "placed." Similarly, place
seems to reside in three spatiotemporal registers at once: (1) in its own obstinately
distinct world that exceeds the borders of the film frame, (2) in a world furnished
for our immersed view, and (3) in a realm that exists somewhere between (and
in tension with) the first two registers. It is in this dialectical third term that we
can conceive of place as a product of an agonistic relation, instead of an essence,
truth, or pure matter that needs to be properly preserved, rescued, or excavated.

Just as the collection means to inhabit the ambivalences of an attachment to the
profilmic and to indexicality, so does it insist on place as a fruitfully and inescap-
ably ambivalent territory of thought and experience. Both the discourse of place
and the discourse of the moving image's indexicality speak a common language
of attachment that threatens always to collapse into a language of naturalness or
essence. Doreen Massey's *Space, Place, and Gender* is invaluable for its careful
negotiation of the unstable ways in which place is invoked by voices of progress
and conservatism. Place is claimed by some to be a curative force that salves the

abrasions of the "insecurity and unsettling impact"[39] of postmodern culture's "time–space compression," our world's frenetic "movement and communication across space . . . the geographical stretching-out of social relations."[40] Given the danger that a call for a return to place might summon "reactionary nationalisms," "competitive localisms," and "introverted obsessions with 'heritage,'" Massey calls for the need "to think through what might be an adequately progressive sense of place, one which would fit in with the current global–local times and the feelings and relations they give rise to, *and* which would be useful in what are, after all, political struggles often inevitably based on place."[41]

If the invocation of place is a highly unstable—even at times dangerous—rhetorical gesture, so then is constitution of place itself likewise fraught with uncertainty and provisionality. Place itself is thought to name the entirely natural, the authentic—something alien to artifice, something that unproblematically belongs to us and to which we belong. Place would seem to be the result of an impartial, almost geological sedimentation of attributes. However, as Massey has also argued, "the 'identity of a place' is much more open and provisional than most discussions allow."[42] Places are, in Massey's terms, "unfixed in part precisely because the social relations out of which they are constructed are themselves by their very nature dynamic and changing."[43] If the indexicality of the moving image might be better understood to name an impatient desire for reference rather than a means of actually securing the referent, so, too, is place a term and object of desire. As the indexical image opens up an ever-shifting series of epistemological and hermeneutic movements and countermovements, so, too, is "the identity of any place . . . for ever open to contestation."[44]

PARTS AND WHOLES

The image of a place on-screen would seem, if we followed Kracauer's antinarrative cathexis of it, almost too dense, too specific, too singular. Such an image of a place would be so forested with particulars that it might not only resist the onward pull of the film's narrative but also resist theorization. As an irreducible plenum, the image of place might seem to stand only for itself. To stand for itself: this would be the condition of a literal image, an image in which signifier and referent would threaten to converge or collapse in identity. Here is an image of New York City. It stands for . . . New York City. New York City might, however, in turn, stand for any number of things: a metonymic figure for Western capitalism, for America itself, for the idea of the "urban." The image of place oscillates between a standing for itself and a standing in for other entities, abstractions, or values.

If we observe the fiction of Pier Paolo Pasolini, we see that his obsessive desire

to document Rome in its dense particularity led him into extravagant displays of what Yi-fu Tuan has called "topophilia" or "the human love of place."[45] Here is Pier Paolo Pasolini narrating how his characters get from one place to another in Rome in his novel *The Ragazzi*:

> After they had elbowed their way to the grade crossing, they found a line of police there, blocking the street. Agnolo and Riccetto tried to argue their way past, on the ground that they lived in Donna Olimpia, but the cops had orders to let no one through, so the boys had to turn back. They tried to go down from the Viale dei Quattro Venti on the side where there was a sheer drop, taking the path that the workmen had made, down past the grade crossing. But there were policemen stationed there too. The only thing left to do was to go the long way around to Donna Olimpia by Monteverde Nuovo. Agnolo and Riccetto returned to the Ponte Bianco, where still more people had gathered by this time, and went up the hill by the Gianicolo, taking turns riding on the handlebars, and doing long stretches on foot when the hill was too steep. It was at least a mile and a quarter to the piazza at Monteverde Nuovo, and then another quarter-mile downhill, across fields, by the barracks-like buildings housing the refugees, and the construction lots, to get down to Donna Olimpia from the opposite side.[46]

The exorbitance of this excessive topographic specificity may only be an exaggerated instance of realism's desire to get the facts right so that we might mistake its artifice for document. Realism itself—whether novelistic, cinematic, or painterly—might seem to amount to little more than the proliferation of details, the anchoring of a fiction or an image in *this* world, from which it is materially indisseverable.

The particularity of the realist text, however, accedes quickly, perhaps automatically, to the general. To some extent, this is a symptom of (again, "bifocal") reading practices: how the realist artifact reads the world it represents and how we read the realist representational artifact. We notice some key shifts and slippages in T. J. Clark's account of a painting of a specific place, a nineteenth-century Parisian slum. The painting is Van Gogh's *The Outskirts of Paris* (1886). Clark claims that the painting is not a generic or composite image of peripheral squalor; instead, Clark claims that the painting is "saved from merely belonging to one artistic *banlieue* or another by its very emptiness, and the *literalness* with which the signs of change are spelt out in it obtrusively."[47] Clark's typically ekphrastic analysis attends as specifically to Van Gogh as Van Gogh did to his *banlieue*. And yet, by the end of this crucial early passage, Clark says that the painting "*stands in for* the casual disrepair

of this whole territory" (of the *banlieues*) and that this disrepair was, furthermore, a representation, Clark tells us, of "the aftermath of Hausmannization."[48] We are struck by the move from "literalness" to "standing for," a move, we might say, from metonymy to allegory (and perhaps from realism to naturalism), and how this move happens in and through, seemingly as a matter of course, the (realist) depiction of a specific place, the impoverished landscape of the Parisian slum.

The political work of describing this poverty, of documenting it, for us depends on its obeisance to the specificity of a place. But the more specific the artwork is in its documentation of particularity, the more it seems it opens out onto a broader, even global plane of significance, identification, and engagement. If we think again of Pasolini, of films like *Accattone* (1961) and *Mamma Roma* (1962), we will notice how the films vaunt their use of what strike us as extremely peculiar, or at least specific, locations. The films' particular relation to Rome's own particularity (its squalid history of shoddy real estate development and frenetic expansion that benefited the rich and punished the poor) and our understanding of these particular relations may enhance our ability to grasp these films' meanings and politics. Yet, if we allow the particularities themselves to occlude from our sight the way in which these films are not *only* about the abuse of Roman urban space but are also about broader histories of poverty and dispossession and the relation of the aesthetic to these histories, then we know less about the films than someone who knows nothing of Rome. Again, we confront here the way in which places (and the images we have of them) grant us an experience of the minutiae of local life as well as a (frail, tenuous) purchase on the immensity of the global.

UNIVERSALLY PARTICULAR

There are other oscillations we notice in thinking about place and its relation to the moving image. The rich specificity of any place will be both captured and eluded by moving image media. Set up a movie camera in front of a place, any place (town, city, countryside). The place will be both exactly what the camera records and exactly what it cannot bear witness to. Any image of a place will be identifiable at least as *some*place, but no image can impart to us the whole place. Because the moving image seems to give us so much of places and to give this so naturally, it is frustrating that, in a sense, it gives so little. A novel can dazzle us with addresses, place-names, material details (the color of wall, the view of the sky from *this* street corner, the play of light on *that* bridge at *that* time of day) and can, therefore, tell us a lot about a place. The moving image, on the other hand, need hardly exert itself and *there we are*: Rome, Pittsburgh, Oklahoma, Okinawa. The emplaced plenitude that such media, such moving images, offer—perhaps

because they are so full and seem so effortless—is undercut in the same instant by these images' partiality, their insufficiency. (What is behind that building? What does the same place look like at night? What did it look like fifty years before?) Thinking about place in and through the moving image, thus, becomes a valuable way of thinking about the moving image's own elaboration of and investment in an oscillation between particularity and universality.

On the question of particularity and universality in the context of political theory, Ernesto Laclau has written that the "universal . . . does not have a concrete content of its own (which would close it on itself), but is an always receding horizon resulting from the expansion of an indefinite chain of equivalent demands. . . . The universal is incommensurable with the particular, but cannot, however, exist without the latter."[49] This condition of incommensurability might depress us: how do we make democracy when there is no way of connecting so many parts to the largest projects of emancipation? Laclau's answer to this condition is this: that "different groups . . . compete between themselves to temporarily give to their particularisms a function of universal representation."[50]

If we return to cinema and to the wider array of moving image media that might offer us some vision of place, how does the moving image's proliferation of places offer us anything other than a swarm of particularisms? Laclau's notion of a temporary and contingent absorption into a particularism as an experience of the universal leads us to think, perhaps somewhat irresponsibly, of the cinema. When we watch a film, its world and its images of a world become our own: we are impinged on, pressed on and by places that consume—however temporarily—our attention and push other places out of our minds. We do not lose the other places to which we belong and that belong to us, but we do forget them, however briefly. Our experience of moving in and out of a moving image's geographic, emplaced particularity and our ability, through the image, to know places we can/not ever know grant us a model for an engagement with the world, which is both a world and worlds. The moving image offers us a means of placing ourselves in others' places, not to annihilate their specificity or ours, or the specificity of these places, but rather so that we find a way of finding in the world's manifold particularity a universality worth sharing—everywhere.

The fifteen essays we have collected here were, with one exception, commissioned especially for this volume. Given the immense diversity of places and practices that might have figured in these pages, we do not intend the book to cover various geographical or even theoretical areas. We saw early on that such coverage would run the risk of undoing our desire that the book testify to specific encounters—between places and moving images and between our writers and the

places, films, and practices about which they have chosen to write. We feel that the book offers a series of orientations to the larger questions we have outlined earlier. Some of our essays are minutely historicist in inclination, whereas others traffic in some of the largest philosophical abstractions imaginable. But taken singly and as a group, the essays indicate a variety of paths down which we might go in exploring the rich relations between places and moving images.

The book's first section, "Cinematic Style and the Places of Modernity," offers four intensely situated essays, each of which traces the entwinement of a film style with specific urban histories. The essays move from the early to the late twentieth century, from the expansion of modernized urbanism and suburban development to the emergence of the postindustrial city. Charles Wolfe explores two of Buster Keaton's short comedies, both examples of what has been called *California slapstick*: *The High Sign* (1922) and *The Balloonatic* (1923). Both films, which were shot in and around the seaside resort of Venice, California, give evidence of a peculiar moment in the social and material geography of metropolitan Los Angeles during a critical period in the city's and the Los Angeles–based film industry's histories. Apart from the stimulation of their entertaining, intensely physical hilarity, Keaton's films give us an example of the mutual implications of the film technology and suburbia, both of which were involved in making sense of modernity's propensity toward an experience of dislocation. John David Rhodes traces the cinematic fortunes of the EUR suburb of Rome, a neighborhood originally designed by the fascist regime to host a World's Fair (that of 1942) that never took place. After World War II, the area became developed as a polite residential zone of modernist apartment blocks, middle-class villas, and corporate office buildings. Rhodes shows how the monumental architectural rhetoric of the original (fascist) EUR has served Italian filmmakers as a figure for the history of fascism itself, whereas the later, postwar EUR has been used to stand in for the supposed decline of moral sentiment in the second half of the twentieth century. At stake in both cases are the historiographic effects of making the material singularity of a place stand in for larger, more general historical processes or abstractions. The cinematic afterlife of EUR reveals a need for thinking about modernism and modernity in terms that keep in sight and in tension the fullness and the absence, the persistence and the fraught instability, of the figural landscape. Elena Gorfinkel explores the ways that 1960s sexploitation cinema, particularly films produced in New York City, sets its sights on the ecstatic mass cultural plenitude of Times Square and examines how place accentuates the ruptures between the films' diegetic aims and their documentary effects. As products of an independent cottage industry that found its base of operations on the levels of both production and exhibition

in and around the Deuce, sexploitation films, in Gorfinkel's analysis, archive and are archived by the shifting terrains and ideological investments of this emplaced crossroads of sex and commerce, anonymity and embodied contact. London's Docklands and Derek Jarman's unusual interest them are the subject of Mark W. Turner's essay. Turner's analysis of Jarman's *The Last of England* reveals how the film's locations ground us in a moment of intense political struggle in Thatcher's Britain. By thinking in and through Jarman's use of the Docklands, Turner argues for a reading of the film as marking the historical (and ongoing) rupture that was the rise of neoliberalism in the 1970s and 1980s.

The title of the book's second section, "Place as Index of Cinema," obviously inverts the priority that would ordinarily obtain in our thinking of the relations between place and cinema, in which an antecedent place lends itself to cinema's indexical representation. The essays gathered in this section show that places can be made and remade by the various activities of film production. Noa Steimatsky's groundbreaking essay on the uses of Rome's Cinecittà film studios as a refugee camp in the immediate aftermath of World War II asks us to rethink the history of neorealism in a radical way. Displacing a number of stubborn myths about the aesthetic and political culture of neorealist filmmaking, Steimatsky traces a history that forces us to confront the burden of the past and our failure to confront this burden—a burden, moreover, embodied by the imposition of soundstages on Roman soil and the subsequent housing of miserable bodies therein. Linda A. Robinson's essay records the attempts of Mason City, Iowa, the inspiration for the setting of *The Music Man,* to adapt itself to its on-screen double, River City. In its efforts to emulate a nonexistent referent—the turn-of-the-century American small town—Mason City succeeded in confusing the materiality of its own life with the spectacular nostalgia of its on-screen counterpart. Aurora Wallace delineates how a similar history has been enacted in present-day Toronto. Fueled by a desire to offer itself as a stand-in for either New York City or the metropolitan, Toronto has made itself potentially obsolete as a center of film production. Now that New York has made a bid to make sure that movies *set* in the five boroughs are actually *shot* there, the film industry no longer needs Toronto to look like anything other than Toronto, which is what Toronto no longer looks like, unless we understand that Toronto should look like a version of New York. Both Robinson's and Wallace's essays reveal places to be fragile and mutable, things that are in many ways as malleable as the media that represent them. Ara Osterweil excavates Dennis Hopper's almost-forgotten, misbegotten masterpiece *The Last Movie,* a film that offers an object lesson in Hollywood (and American) imperialism. The film's allegorization of the inevitable homogenizing impress that even liberal Hollywood

filmmaking leaves on the global landscape offers Osterweil the occasion to analyze Hopper's film as the historically and theoretically engrossing site of a confrontation between place and space, between the political aspirations of Third Cinema and the personal hubris of New Hollywood auteurism.

"Geopolitical Displacements" collects essays that are centrally concerned with the moving image's investment in drawing together disparate geographies to make specific political claims at and on specific places but that nonetheless resonate much more globally. Frances Guerin gives us a new way of conceiving of site-specific moving image installations in her essay on William Kentridge's *Black Box,* an allegorical work of film animation that does not depend on place's indexical trace on filmstrip but rather on its exhibition's emplacement on a dense historical terrain as a means of expanding the geopolitical force of the moving image. Through the lens of Dario Argento's filmmaking, Michael Siegel probes the contest between the representational capacities of the film medium and the challenges posed to it by the radical unevenness of Roman urban development. Siegel uncovers not just the challenge to representation that a city poses but, more crucially, the ways in which cities, films, television, and international mass transit are all globalizing spatial (and temporal) media whose relations to one another are as unstable as they are unsettling. Ji-hoon Kim scrutinizes Stan Douglas's challenging moving image installations—a body of work that has taken an inscription (if not always a documentation) of specific places as a primary element of its practice. In his study of several of Douglas's key, seriously emplaced works, Kim asks us to think about how Douglas moves the most exacting strains of moving image installation practice of the 1970s into new aesthetic and political territory. Moreover, Kim's essay asks us to consider the centrality of media and mediation to site-specific artistic practices. Rosalind Galt's essay takes up the question of how the geopolitical operates on the level of aesthetics and explores how Christopher Doyle's film *Away with Words,* which shuttles between Hong Kong and Taketomi Island, articulates place through a notion of synaesthetic transfer. As Galt illuminates, Doyle's cinematography, long identified with East Asian cinema, introduces a language for speaking the sensory and material experience of place in a transnational register.

In the book's last section, "(Not) Being There," three probing theoretical essays propose radical, radically different, but also profoundly interconnected ways of conceiving the theoretical status of place and its image in film and television. Brian Price explores Heidegger's notion of *Dasein* in relation to images of place to argue that images, like places, offer us an imperfect but legitimate and necessary way of imagining and experiencing our imperfect belonging to and sharing of the

world. In so doing, Price offers a refreshed understanding of how and why places and images matter. Hugh S. Manon approaches a "desire for the local" (in this case, for western Pennsylvania) in George Romero's first film *Night of the Living Dead* (1968). Through a novel engagement with Lacan, Manon argues that when real locations (those clearly coded as specific but unknown to a generalized mass audience) are emphasized by the fictional filmic text, what results is a sort of extrusion of unknowable specificity, a blind spot in the field of spectatorial vision. Even spectators who know the place visible on-screen will run the risk of falling for their own supposedly privileged access to the image's (and the place's) plenitude. The desire for the local is, like desire itself, impossible to satisfy. Last in our collection, Meghan Sutherland offers a forceful reconceptualization of television that moves away from canonical accounts of this medium's derealization of place. Sutherland argues for an understanding of the vital role that the image of place serves (both materially and rhetorically) in the televisual representation of disaster as a means of providing an always-contingent but nevertheless indispensable grounds for the representation of the social world. In an essay that brings together Immanuel Kant, Ernesto Laclau, 9/11, and Hurricane Katrina, Sutherland offers a new way of understanding television and a new way of understanding place.

In their various ways, the essays collected here testify to the vitality of place as a heuristic for the analysis not just of moving image media but also of social life and political practice. Our ability to project images and information about ourselves into the world through the manifold technologies of electronic communication has endowed us with the experience of seeming to be in many places at once. And yet many of us may live into an age in which the speed and ease with which we are used to moving from one place to another will no longer be possible. Our world contracts and expands in unpredictable, exhilarating, and terrifying ways. Making this world a place worth living in will depend on a radical appreciation of how our own places in the world interact with our (often unacknowledged) reliance on and experience of the material reality, the philosophy, and the rhetoric of emplacement. Our work begins here.

NOTES

1 Siegfried Kracauer, *Theory of Film: The Redemption of Physical Reality*, with an introduction by Miriam Bratu Hansen (Princeton, N.J.: Princeton University Press, 1997 [1960]), 303.

2 Laura Mulvey, "Visual Pleasure and Narrative Cinema," in *Narrative, Apparatus, Ideology: A Film Theory Reader*, ed. Philip Rosen, 198–209 (New York: Columbia University Press, 1986); Roland Barthes, "The Third Meaning," in *Image, Music, Text*, trans. Stephen Heath, 52–68 (New York: Macmillan, 1988).

3 Recent scholarship has tended to privilege various genres of places: the rural, (so-called natural) landscapes, and cities. For scholarship on the first two categories, see Catherine Fowler and Gillian Helfield, eds., *Representing the Rural: Space, Place, and Identity in Films about the Land* (Detroit, Mich.: Wayne State University Press, 2006), and Martin Lefebvre, ed., *Landscape and Film* (New York: Routledge, 2006). Scholarship on cinema and the city has recently become quite a large and fast-moving field of study. For work in this area, in which the particularity of cities figures importantly, see Charlotte Brunsdon, *London in Cinema: The Cinematic City since 1945* (London: BFI, 2008); Edward Dimenberg, *Film Noir and the Spaces of Modernity* (Cambridge, Mass.: Harvard University Press, 2004); Sabine Haenni, *The Immigrant Scene: Ethnic Amusements in New York, 1880–1920* (Minneapolis: University of Minnesota Press, 2008); David James, *The Most Typical Avant-garde: History and Geography of Minor Cinemas in Los Angeles* (Berkeley: University of California Press, 2005); Ranjani Mazumdar, *Bombay Cinema: An Archive of the City* (Minneapolis: University of Minnesota Press, 2007); John David Rhodes, *Stupendous Miserable City: Pasolini's Rome* (Minneapolis: University of Minnesota Press, 2007); and Noa Steimatsky, *Italian Locations: Reinhabiting the Past in Postwar Cinema* (Minneapolis: University of Minnesota Press, 2008). For work on cinema and place from a more geographical perspective, see Stuart C. Aitken and Leo E. Zonn, eds., *Place, Power, Situation, and Spectacle: A Geography of Film* (Lanham, Md.: Rowman and Littlefield, 1994).

4 Edward S. Casey, *Getting Back into Place: Toward a Renewed Understanding of the Place-World* (Bloomington: Indiana University Press, 1993), xiii.

5 Ibid., xv.

6 J. Nicholas Entrikin, *The Betweenness of Place: Towards a Geography of Modernity* (Basingstoke, U.K.: Macmillan, 1991), 1.

7 Denis E. Cosgrove, *Social Formation and Symbolic Landscape* (Madison: University of Wisconsin Press, 1998); Denis Cosgrove and Stephen Daniels, eds., *The Iconography of Landscape: Essays on Symbolic Representation, Design, and Use of Past Environments* (Cambridge: Cambridge University Press, 1988); W. J. T. Mitchell, ed., *Landscape and Power* (Chicago: University of Chicago Press, 1994); Dydia DeLyser, *Ramona Memories: Tourism and the Shaping of Southern California* (Minneapolis: University of Minnesota Press, 2005).

8 Henri Lefebvre, *The Production of Space,* trans. Donald Nicholson-Smith (Oxford: Blackwell, 1991), 26; emphasis original.

9 Mark Jancovich and Lucy Faire, with Sarah Stubbings, *The Place of the Audience: Cultural Geographies of Film Consumption* (London: BFI, 2003).

10 This is the understanding of cinema proposed most forcefully by André Bazin and Siegfried Kracauer. Cf. Bazin, *What Is Cinema?* 2 vols., trans. Hugh Gray (Berkeley: University of California Press, 1970–71).

11 This is the understanding of cinema proposed by a number of theorists. Among the most influential of these are Christian Metz, *Film Language: A Semiotics of the Cinema,* trans. Michael Taylor (New York: Oxford University Press, 1974); Peter Wollen, *Signs and Meaning in the Cinema* (London: Secker and Warburg/ BFI, 1968); and Roland Barthes, *Image-Music-Text,* selected and trans. Stephen Heath (London: Fontana, 1977).

12 Edward S. Casey, *The Fate of Place: A Philosophical History* (Berkeley: University of California Press, 1997), ix.

13 DeLyser, *Ramona Memories,* xviii.

14 Michel de Certeau, *The Practice of Everyday Life,* trans. Steven Rendall (Berkeley: University of California Press, 1984), 117.

15 Ibid.

16 Ibid.

17 Margaret Kohn, *Radical Space: Building the House of the People* (Ithaca, N.Y.: Cornell University Press, 2003), 21.

18 Kristin Ross, *The Emergence of Social Space: Rimbaud and the Paris Commune* (London: Verso, 2008), 8. First published 1988 by University of Minnesota Press.

19 Marc Augé, *Non-places: Introduction to an Anthropology of Supermodernity,* trans. John Howe (London: Verso, 1995), 77–78.

20 "Place and non-place are rather like opposed polarities: the first is never completely erased, the second never totally completed" (79); "The possibility of non-place is never absent from any place" (107).

21 Augé, *Non-places,* 114.

22 Doreen Massey, *Space, Place, and Gender* (Minneapolis: University of Minnesota Press, 1994), esp. the essays "A Global Sense of Place" (146–56) and "A Place Called Home?" (157–73); John Rennie Short, *Global Dimensions: Space, Place, and the Contemporary World* (London: Reaktion Books, 2001).

23 Stephen Heath, "Narrative Space," in *Questions of Cinema* (Bloomington: Indiana University Press, 1981), 37.

24 Ibid., 43.

25 Ibid, 49. Heath has taken the term from Edward Branigan's "Narration and Subjectivity in Cinema," PhD dissertation, University of Wisconsin, Madison, 1975.

26 Ibid., 19. Heath also borrows this phrase from Michael Snow. Snow's remarks to this effect appear in "Ten Questions to Michael Snow," an interview by Simon Hartog; cf. Michael Snow, *The Collected Writings of Michael Snow,* with a foreword by Louis Dompierre (Waterloo, Ont., Canada: Wilfred Laurier University Press, 1994), 51–52.

27 Roger Cardinal, "Pausing over Peripheral Detail," *Framework* 30–31 (1986): 112–30.

28 Jameson's account of this state of affairs is found in the first chapter of his *Postmodernism, or, The Cultural Logic of Late Capitalism* (Durham, N.C.: Duke University Press, 1991), esp. 50–54. The work of Lynch's on which Jameson draws here is *The Image of the City* (Cambridge, Mass.: MIT Press, 1994 [1960]), esp. 1–13. Bill Brown performs a brilliant reading of Jameson's turn to Lynch and the wider implications of Jameson's investment in space, spatial bewilderment, and allegory in his essay "The Dark Wood of Postmodernity (Space, Faith, Allegory)," *PMLA* 120, no. 3 (2005): 734–50.

29 Fredric Jameson, *The Geopolitical Aesthetic: Cinema and Space in the World System* (Bloomington: Indiana University Press/BFI, 1992), 10.

30 Ibid., 79.

31 Ibid.

32 Jameson, *Postmodernism*, 39–42.

33 John Durham Peters, "Seeing Bifocally: Media, Place, Culture," in *Culture, Power, Place: Explorations in Cultural Anthropology*, ed. Akil Gupta and James Ferguson (Durham, N.C.: Duke University Press, 1997), 82. Doreen Massey has also addressed similar concerns. See her "A Global Sense of Place," in Massey, *Space, Place, and Gender*, 146–56. See also Joshua Meyrowitz, "The Rise of Glocality: New Senses of Place and Identity in the Global Village," in *A Sense of Place: The Global and the Local in Mobile Communication*, ed. Kristóf Nyíri, 21–30 (Vienna, Austria: Passagen, 2005).

34 Ibid., 81.

35 E.g., see Ivone Margulies, ed., *Rites of Realism: Essays on Corporeal Cinema* (Durham, N.C.: Duke University Press, 2002).

36 Philip Rosen, *Change Mummified: Cinema, Historicity, Theory* (Minneapolis: University of Minnesota Press, 2001).

37 Ibid., 178–79.

38 Ibid., 183.

39 Massey, *Space, Place, and Gender*, 151.

40 Ibid., 147.

41 Ibid., 151–52.

42 Ibid., 168.

43 Ibid., 169.

44 Ibid.

45 Yi-fu Tuan, *Topophilia: A Study of Environmental Perception, Attitudes, and Values* (New York: Columbia University Press, 1990).

46 Pier Paolo Pasolini, *The Ragazzi*, trans. Emile Capouya (Manchester, U.K.: Carcanet Press, 1986), 57. This passage and the wider question of the significance of Rome as the location of Pasolini's writing and filmmaking are pursued in detail in Rhodes, *Stupendous*.

47 T. J. Clark, *The Painting of Modern Life: Paris in the Art of Manet and His Followers* (Princeton, N.J.: Princeton University Press, 1984), 28; emphasis added.

48 Ibid., 30; emphasis added.

49 Ernesto Laclau, "Universalism, Particularism, and the Question of Identity," in *Emancipation(s)* (London: Verso, 1996), 34–35. Laclau has written elsewhere that "politics and space are antinomic terms. Politics only exist insofar as the spatial eludes us." Laclau, *New Reflections on the Revolution of Our Time* (London: Verso, 1990), 68. By this Laclau intends something very similar to de Certeau's unhelpful distinction between place and space. For a critique of Laclau's position, see Doreen Massey, "Politics and Space/Time," in *Space, Place, and Gender*, 249–72. Interestingly, "Universalism, Particularism, and the Question of Identity" is absolutely riddled with spatial and geographic metaphors, in particular, the term *terrain*.

50 Ibid., 35.

PART I | Cinematic Style and the Places of Modernity

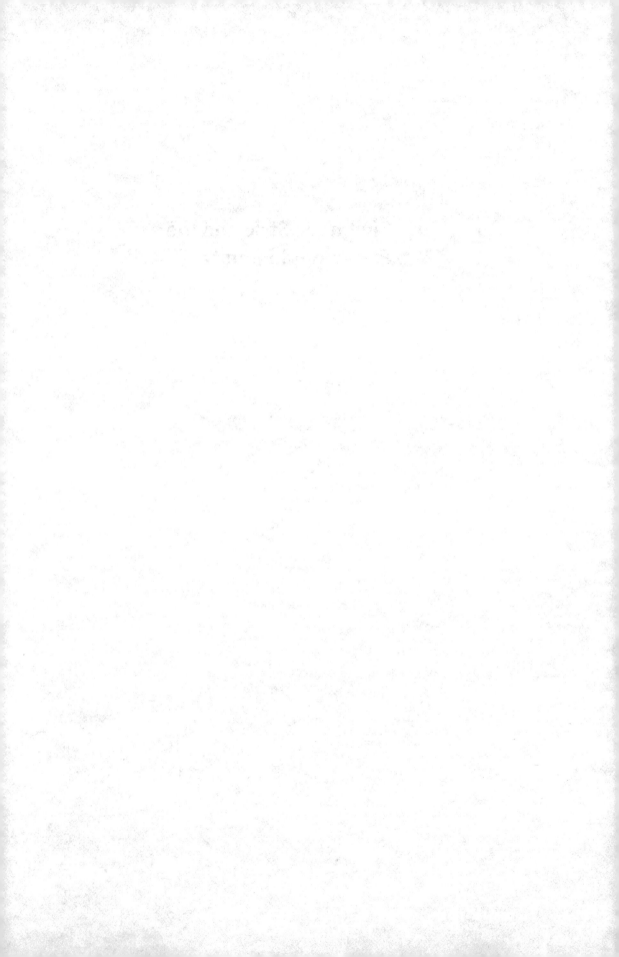

1 | From Venice to the Valley: California Slapstick and the Keaton Comedy Short

CHARLES WOLFE

"California slapstick," Jay Leyda's label for screen comedy that emerged with the migration of the American motion picture industry to the West Coast in the 1910s, succinctly evokes the distinctive topography and comic physicality of the film genre Buster Keaton inherited when he gained control of his own production company in 1920.[1] In California slapstick, popular film forms derived from early chase comedies in Europe and the United States came into contact with the transformation of Southern California as a built environment during the late nineteenth and early twentieth centuries. Spurred by railroad and real estate speculation, the population of the Los Angeles metropolitan area grew from 33,000 in 1880 to 2.3 million in 1930.[2] Agricultural, commercial, and residential development proceeded in a patchwork fashion across the Los Angeles basin and inland valleys, pockets of which remained largely rural into the 1920s. Keaton's short comedies register an impression of this world: its home-in-a-box housing tracts and seaside resorts; downtown alleys and palm tree–lined boulevards; village storefronts and blacksmith shops; oil derricks and railway crossings; flatlands, foothills, and cliffs. Through these and other settings moves an inquisitive "Buster," at times demonstrating the physical contours of an environment through the speed, direction, and clarity of his movement; at times at the mercy of forces that emerge unexpectedly from within or beyond the borders of the frame; and at times suspended in mid-motion, marking the still point of an image in which a sense of balance is temporarily secured. In all these instances, Keaton choreographs a relationship between figure and ground in service of comic action with kinetic force and social import.

Between 1920 and 1923, with the assistance of Eddie Cline, Keaton wrote, directed, and starred in nineteen of these short films, two or three reels in length. All were filmed in California, mainly in various areas of Los Angeles and Orange counties, with the Keaton studio in Hollywood the center of activity but location

shooting occurring far and wide across the region. As a child star on the vaude-
ville stage, Keaton learned how to arrest the attention of an audience by moving
acrobatically within the space of a proscenium frame—upstage and down, through
trick backdrops and trapdoors in the floor, and in from and back out the wings.
This theatrical training served him well when he launched his career as a physical
comedian in motion pictures. But Keaton was very clear about the value of location
filmmaking for the brand of slapstick comedy that he took up after joining Roscoe
"Fatty" Arbuckle's Comique Film Company in March 1917. Exterior locations, he
discovered, extended the spatial boundaries of a comic performance, and unfamiliar
locations suggested novel gags.[3] After operating in New York City for its first six
months, Arbuckle's company relocated to Long Beach, California, in fall 1917, a
move Keaton attributed to the greater opportunities for exterior filmmaking and
varied scenery on the West Coast.[4] For the next two years, except for a ten-month
stretch in the military, Keaton honed his skills as a motion picture performer and
director in the Los Angeles area. In 1920, he set up shop at his own independent
studio in Hollywood, next to the larger plant of Metro Pictures, with whom he
signed his first distribution contract.

One benefit of "California slapstick" as a critical label is its invitation to consider
the relation of comedy films produced in Southern California during the 1910s
and 1920s to the social geography of the region.[5] The growth of Los Angeles as
a metropolitan center was predicated on the development of new transportation
corridors—initially interurban railways, then paved roadways for automobiles—
that connected subdivisions across stretches of undeveloped land, extending
from the city center to the valleys north and south and across the wide basin to
the Pacific coast. This variegated, expansive terrain favored open-air chases and
other broad trajectories of movement common to slapstick comedies. At the same
time, California slapstick films articulated new relations among different interior
and exterior settings as comic figures navigated the fictional circumstances oc-
casioned by a comic plot. Through the staging and stitching together of bits of
comic action, these films demonstrated how diverse settings could be traversed
and inhabited, contrasted and conjoined, with studio sets and exterior locations
treated as congruent spaces for imaginative play.

In the remarks that follow, I examine spatial play of this kind in two of Keaton's
silent comedies, one made early in his cycle of nineteen shorts, the other late.
Viewed by Keaton as a preliminary experiment, *The High Sign* was shot in spring
1920, prior to his signing with Metro, and was withheld from circulation until
April 1921, when an injury forced Keaton to suspend production and *The High
Sign* filled the gap in his distribution schedule. Shot in fall 1922 and released the

following January, *The Balloonatic* was Keaton's penultimate silent short before he moved on to feature filmmaking in 1923. Chronologically, then, the two films roughly bracket Keaton's work in the short silent comedy format. They invite comparison, moreover, in that both were partially shot in the seaside resort community of Venice, California, and neighboring locations. Viewed side by side, *The High Sign* and *The Balloonatic* illustrate how geography relates to the spaces found in Keaton's slapstick shorts, a function of the effort of the ex-vaudevillian to explore both the physical environments he occupied and the distinctive capacities of the new medium in which he worked.

ABBOT KINNEY'S VENICE OF AMERICA

Built by Abbott Kinney on vacant sand dunes and marshes in 1904–5, Venice of America was a colorful nodal point in the development of the Southern California coastline. By the early 1910s, Kinney's planned community featured a public beach and major amusement pier, a three-thousand-seat auditorium, a dance pavilion, an aquarium and bird land, a vaudeville-nickelodeon theater, an amphitheater, a boat house, and a bathhouse with a heated saltwater pool, or "plunge," among other attractions. A mile-long public boardwalk linked Venice to its parent development to the north, Ocean Park, forming an integrated recreational zone along the Santa Monica Bay. Programs and special events marked the community calendar. There were Saturday promenades, parades, band concerts, bathing beauty contests, boating and swimming events, car races for adults and children, and aerial shows of various kinds.[6] For filmmakers newly settled on the West Coast, Venice thus offered scenic views and lively popular attractions around which comic action could be staged.

Like other amusement parks that sprouted up on the Southern California coast during this period, Venice was modeled in part on entertainment complexes founded on Coney Island in New York, including Steeplechase Park (1897), Luna Park (1903), and Dreamland (1904). In an effort to capitalize on this connection, local promoters on occasion referred to the amusement district along the Santa Monica Bay as the "Coney Island of the Pacific" or the "Coney Island of the West."[7] Moviemakers who migrated to Southern California, in turn, drew inspiration from slapstick comedies filmed at the Coney Island parks. As Lauren Rabinovitz observes, these comedies exploited the distinctive public space of the amusement park, which fostered flirtation and bodily contact between men and women, including strangers, and celebrated the kinetic pleasures of modern technology made available by rides and other seaside amusements.[8] On both the East and West coasts, movie scenarios involving sexual attraction, physical jostling, and slapstick

aggression were plausibly staged in resort settings featuring beaches, boardwalks, boats, bath lockers, concession stands, and mechanical amusements of various kinds. Keaton knew this bicoastal slapstick genre well. In 1917, he appeared with Arbuckle in *Fatty at Coney Island,* a Comique short in which suitors couple and uncouple promiscuously amid the attractions of Luna Park. After Comique's move to Long Beach, Keaton then assisted Arbuckle in the making of *The Cook,* released in 1918, which concludes with a lively chase-and-rescue sequence staged on the roller coaster that dominated the Long Beach Pike.[9]

Influences on the design of Kinney's Venice of America, however, were more complex than analogies with Coney Island suggest. A cultivated entrepreneur–developer who had been educated in Europe, and who was respected for his writings on natural science and popular philosophy, Kinney initially conceived of Venice as a theme-based residential community combining education and recreation with the physical benefits of a seacoast setting—in his words, "a place of pilgrimage for cultured people."[10] Toward this end, he borrowed key planning elements from the city's historic namesake, which had impressed him during his travels in Europe (Figure 1.1).[11] At the town center, a saltwater lagoon was carved out of the alkali earth and connected to the ocean's tidal action through a pair of underground pipes. To the east, the lagoon fed a network of canals, including the half-mile-long Grand Canal and six other tributaries. In 1905, the Short Line Railroad concurrently developed the Venice Canal Subdivision, linking Kinney's network to the Playa del Rey Lagoon, which came to define Venice's southernmost boundary. Rialto-style bridges spanned the canals at multiple points. Gondoliers imported from Italy guided a fleet of gondolas through the waterways, and colonnaded walkways modeled after the Piazza San Marco lined Windward Avenue, the central thoroughfare between the lagoon and the amusement pier.

Through both planning and circumstance, Venice of America also placed these emblems of Old World culture in a national and regional context.[12] Despite many setbacks, Kinney pushed hard to have the community open over a national holiday, Fourth of July weekend 1905, when an estimated forty thousand visitors flocked to the heavily promoted event. He spoke of building a new American center of art and culture, an ambition exemplified by the inauguration that same weekend of the Venice Assembly of Chautauqua, an adult educational movement founded in upstate New York and featuring summer camps for learning in rural and semirural areas. In its first years of operation, Venice of America offered tourists and residents the opportunity to attend literary readings, lectures, sermons, concerts, and other performances in the three-thousand-seat auditorium erected at the entrance to the pier.[13] Venice of America also assimilated local styles. Venetian Renaissance

Figure 1.1. A copy of Abbot Kinney's original plan for Venice of America. Courtesy of the Library of Congress.

architecture may have defined the town's core, but modest California bungalows fronted many canals as well as sections of Ocean Front Walk, and most homes and businesses throughout the city were plain in style. When Kinney's plans for the development of a Venetian-themed residential village along the Grand Canal ran into difficulty, a more rustic Tent City went up in its place, providing less expensive accommodations for summer residents.[14] Gondolas, moreover, were not the sole mode of public transport. The train tracks of the Los Angeles Pacific Electric Railway, the presence of which was essential to Kinney's development of Venice, formed an outer, triangular boundary of his canal system. A miniature railroad, starting and ending at the base of the lagoon, also looped around the canals' perimeter to the south and east and bisected the network on its return route over four canal bridges back to the roundhouse. A diverse and changing assortment of rides, storefront amusements, and concession stands added still other eclectic elements to the cityscape.

This mix of vernacular and high cultural themes and styles reflected yet another influence on Kinney's early plans—the landmark World's Columbian Exposition, held in Chicago in 1893. Built on lowlands along Lake Michigan, the exposition

put into practice a chief tenet of the contemporary City Beautiful movement: that social harmony and civic virtue could be secured through comprehensive town planning, incorporating open public spaces and inspiring architecture. In planning his lagoon and canal system, Kinney drew on the design of the exposition's monumental White City, which featured Beaux-Arts–style buildings arrayed imposingly around a Venetian lagoon.[15] Fairgoers crossed the water in gondolas; a railroad shuttle provided additional transportation. Perpendicular to the White City, the exposition also hosted a contrasting mile-long sideshow, the Midway Plaisance, featuring an eclectic assortment of popular amusements, including the first Ferris wheel; fun houses, games, and concession stands; and an ethnological "human zoo."[16] After losing money on the first season's lecture series, Kinney sought to increase profits by opening a Midway Plaisance on the south side of the lagoon in January 1906. Among its carnivalesque attractions, the Midway included exhibits, restaurants, and amusements with Indian, Egyptian, Turkish, Spanish, Japanese, and Klondike themes. From the recently completed Lewis and Clark's Exposition in Portland, Oregon, the Midway also imported a presentation of native Igorots from the Philippines, of exotic ethnological interest in the wake of the U.S. government's victory in the Spanish–American War.[17] Even more fully than at the Columbia Exposition, the Midway Plaisance was integrated within the Venetian design of the town's central lagoon and canals.

This marriage of architectural elements did not last long, however. By the following summer, city officials complained that the "freakish" Midway had degenerated into a thoroughfare for gambling, and Kinney struggled to collect rental payments from the Midway's lessees.[18] In 1907, he brought in a new amusement company that promised to promote higher-class acts, but questions of public safety along the Midway continued to be raised.[19] Buffeted by complaints and now cool to the project, on July 4 weekend, 1911, Kinney replaced the Midway Plaisance with a single attraction: a towering, dual-track racer coaster, the first of its kind on the West Coast, labeled the "Race thru the Clouds."[20] The decision reflected a heightened competition among California amusement parks for large-scale mechanical rides that could serve as anchor attractions. That same year, in an article predicting that Venice and Santa Monica would someday become the "kingpin cities of the amusement world," the Los Angeles Times distinguished the "delirium-producing constructions of Coney Island" from the new amusement parks of coastal Los Angeles, which would be "allegorical not phantasmagorical, educational rather than titillating."[21] No doubt, the authors had Abbot Kinney's philosophy in mind. By the end of the decade, however, Kinney's initial vision for Venice of America was fading, and purely thrilling mechanical rides were coming to dominate the coastal resort scene.

This pattern accelerated with Kinney's death in November 1920. As a residential community, Venice suffered from deficiencies in the tidal water and sewer systems on which the lagoon and canal system depended, a matter of long-standing dispute among residents, Kinney's lawyers, and the city trustees based in Ocean Park.[22] Subject to state and regional pressures, Venice finally was annexed by the city of Los Angeles in 1925, a move Kinney had long opposed. Shortly thereafter, Los Angeles officials ordered the paving over of the Venice Lagoon and much of the original canal network to improve the flow of automobile traffic and facilitate modern commerce, erasing the core features of Kinney's original plan. The Race thru the Clouds and miniature railroad also were razed, shifting Venice's recreational zone wholly to the boardwalk and pier.[23] By the end of the decade, oil extraction supplanted tourism as Venice's most lucrative business, adding industrial pollution to the town's environmental failings.

Keaton's decision to shoot portions of *The High Sign* and *The Balloonatic* in Venice thus came at a transitional moment in the community's early history. Physical traces of Abbot Kinney's Venice of America are present in both films. The colonnaded walkways of Windward Avenue can be spotted in several shots, and the tracks of the Race thru the Clouds coaster serve as a background element in both films. But the lagoon and canals are not on view in either comedy, nor is Venice's signature coaster exploited for kinetic or dramatic effect. Buster's trajectory in both films is migratory and aspirational, leading the roving hero away from the public amusement park to alternative environments—interior and domestic in *The High Sign*, exterior and rustic in *The Balloonatic*—where earlier events in each film are reworked in a different but related key. In subtle ways, however, these comedies incorporate the high cultural themes of Kinney's Venice, in part through their displacement of the technological attractions of the modern amusement park onto other sites.

OUTSIDE IN: *THE HIGH SIGN*

An introductory title heralds Buster's arrival: "Our Hero came from *Nowhere*—he wasn't going *Anywhere* and got kicked off *Somewhere*." As a train speeds through the first shot, an airborne Buster descends from the left at close range and lands hard on his back. Rising, he turns away from the camera and toward the tracks, lifting his flat hat to his head. The train has vanished, revealing the deep space of an oceanfront street, with two waiting passengers on the track's far side. A hands-on-hips stance of one of two distant figures, motionless on the other side of the tracks, briefly mirrors Buster's own (Figure 1.2). Exiting right, entering left, Buster comes upon a revolving carousel, which he briefly studies before adroitly

snatching a newspaper from a passing rider (Figure 1.3). When another, watchful passenger circles into view, Buster hurries off, again exiting right.

Cut to a boardwalk with rows of empty benches. Buster enters from the left, glances back in the direction from which he came, and takes a seat on the front bench. He opens the paper, unfolding it once, twice, thrice, until, on the fifth unfolding, the defective, uncut paper shrouds his entire body. To gain a purchase on the unwieldy sheet, he stands up on the bench seat. The paper now opens fully, billowing in the wind. As Buster struggles to regain control, the front bench topples, and he with it, then the bench behind (Figure 1.4). A close-up reveals that a tear in the paper has delivered into his hand a help wanted ad for a shooting gallery marksman. Back at the carousel, a rider dismounts, discovers his newspaper is missing, and retraces Buster's path to the bench. Approaching from behind, he plucks the now refolded paper from under Buster's arm, hands him a coin, then turns and exits left (Figure 1.5). Buster departs to the right, help wanted ad in one hand and coin in the other, richer twice over for this exchange.

Where have these events taken place? Our answer to this question will depend in part on what we choose to look for in and across the seven shots and three settings that make up this brief opening. We can scan the images, for example, for photographic clues to the *locations* where the scenes were filmed. This is the approach of John Bengtson, who, thanks to a sharp eye and astute research, has identified all three sites: railroad tracks that ran past Moonstone Beach, roughly thirteen miles south of Venice; the Looff Carousel on the Long Beach Pike, seventeen miles farther down the coast; and the Venice boardwalk, near the intersection of Windward Avenue and Ocean Front Walk.[24] Thus viewed, the opening sequence to *The High Sign* documents Keaton's comic performances at three different locations along the Los Angeles County coastline.

To speak of the seven shots as an opening sequence, however, is to presuppose that we are capable of imagining that they represent another kind of place— a fictional *story world*. Here our sense of location yields to the settings Keaton's comic protagonist inhabits, as prompted by the introductory title. Coming from "nowhere," heading "anywhere," "our hero" is "kicked off somewhere," a place that we anticipate the scenes to follow will map out. The train tracks, carousel, and public benches cohere as elements of a unified setting—a sparsely populated seaside resort—in service of a developing story. Subsequent scenes extend the boundaries of this story world, with the help wanted ad providing a narrative hook. Ad in hand, Buster next arrives at a fruit and vegetable cart, where, as a policeman flirts with a young woman and the vendor dozes, he swipes a pistol from the cop's holster and replaces it with a banana. Then on to a sandy beach, where

Figure 1.2. From *The High Sign* (Buster Keaton, 1921).

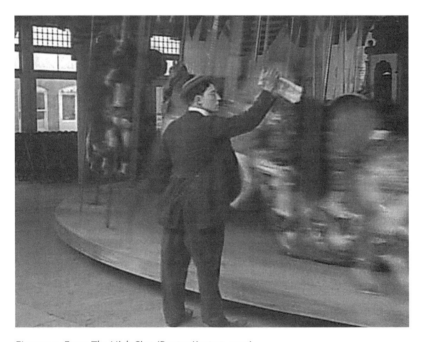

Figure 1.3. From *The High Sign* (Buster Keaton, 1921).

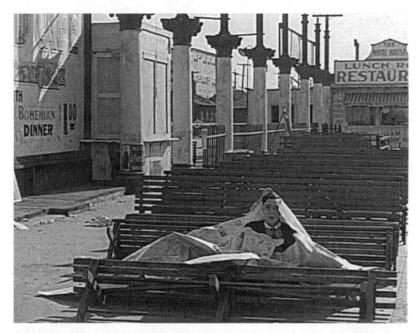

Figure 1.4. From *The High Sign* (Buster Keaton, 1921).

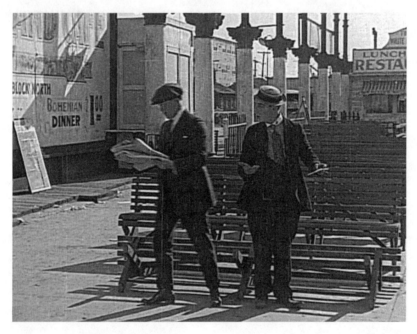

Figure 1.5. From *The High Sign* (Buster Keaton, 1921).

he undertakes target practice, with the aid of a clownish figure played by Al St. John. Next Buster makes his way to the shooting gallery, where, through trickery, he wins the marksman's job. At the gallery, the film's plot is further knotted when his bogus marksmanship earns him employment as both August Nicklenurser's bodyguard and the same man's assassin, a dilemma complicated by Buster's attraction to Nicklenurser's daughter (Bartine Burkett). Through these sequential, and consequential, actions, a fictional world is built up.

We can also choose to focus our attention on a third kind of space, a *cinematic field* constructed through mise-en-scène, camera work, and editing. Such space is not the same as the locations and studio sets in which Keaton and the other actors performed, which had a material integrity of their own, nor is this space the same as the story world, which encompasses fictional places and events implied but never seen. Instead, this is screen space, at once visual and plastic, delineated through framing, focus, lighting, and movement within and across individual shots. Many of Keaton's pictorial strategies, of course, are designed to help the viewer construe the story world. For example, Buster's constant screen direction, exiting left and entering right across a series of cuts, fosters a sense of spatial contiguity and narrative continuity across the three opening settings. But the effects of Keaton's stylistic choices are not exhausted by the requirements of clear and efficient storytelling. The beauty and rigor of Keaton's physical comedy follows in part from his exploration of the relation of his body as a performer to the spatial parameters of the projected film image and his sensitivity to the rhythms of movement on the screen.

From the outset of *The High Sign,* Keaton exploits the formal possibilities of the film frame as the boundary of the viewer's field of vision and uses motion within and across the frame as a device for directing the viewer's eye. The close view of a rapidly moving train, for example, initially undercuts our capacity to gain a spatial bearing, a disorientation we share with Buster at the moment of his seat-of-the-pants entrance. The blurred movement of the locomotive is then echoed in the spinning of the carousel, also left to right, although with the wooden horses and riders now circling back around. The second shot of the carousel, followed by the victim's retracing of Buster's steps to the bench, provides another rhyming effect, involving not only physical but conceptual "circling"—what comes around, goes around—leading to the recycling of the newspaper between the two men. At the same time, depth to the images provides counterweight to the lateral figure movements. After the train passes out of the opening shot, attention is called to what can only be briefly glimpsed prior to the engine's entrance: retreating lines of wooden beachfront buildings leading to a patch of sea at the image's vanishing point. The

boardwalk newspaper routine is framed at a slightly elevated angle, adding subtle emphasis to the orderly arrangement of benches, a pattern repeated vertically in the spaced row of iron pillars also receding to the background.

As is typical in Keaton's silent comedies, graphic patterns also emerge across separate scenes and sequences. In *The High Sign,* a key motif in this regard involves sight lines and ballistics in spaces of varyingly complexity. Following Buster's acquisition of the pistol, his physical skills are tested in different ways during four successive sequences. The first of these, at the beach, consists of a series of variations on the simple theme of drawing a bead on a target. Buster places three bottles at equal distance along a fence, while St. John, more comic kibitzer than helpmate, stands off to the right. Our view is from directly behind and slightly above Buster, with the fence at mid-range and a distant pavilion in the background (Figure 1.6). The deliberation and exactness of the staging heightens the comic effect of what follows: in violation of what this optical configuration leads us to expect, bottles to the right and left shatter in lieu of the one in the sight line. Variations ensue, with St. John included among the targets. In the final permutation, Buster sneaks up to the center bottle and fires at close range, only to be struck by a dead goose that falls from off-screen above. Keaton thus caps the scene by introducing a vertical vector at the very close. The setup is simple, with camera perspective restricted to a single axis, but Keaton explores the geometry of false sight lines assiduously.

At the shooting gallery, Buster's efforts with available weaponry again fail. Here targets are arrayed on a flattened and potentially animated wall at the end of the arcade gallery. When conventional ballistics go awry, Buster changes his approach, devising a mechanical aid: a hidden string and pulley system, operated by a foot pedal, at the end of which a bone dangles before a dog, which in turn is tethered to a bell. Each time Buster steps on the pedal, the bell rings, confirming his marksmanship. The action requires more complex cinematic staging than did target practice at the beach. With precise aim now beside the point, Buster's increasingly flamboyant performance is principally observed from the side so that his maneuvers with the pedal are clearly visible (Figure 1.7). The mechanics of the device are delineated through a series of cuts, drawing our attention to a chain of causal events hidden to the gallery spectators, who take Buster's marksmanship as authentic. While Buster is assembling the gadget, moreover, cutaways to the cellar hideout of the gang of extortionists, the Blinking Buzzard, and to the home of their target, August Nicklenurser, establish the story line in which Buster soon becomes enmeshed.

An outdoor chase follows, involving Buster and the cop from whom he has swiped the pistol and serving as an interlude between Buster's conscription by

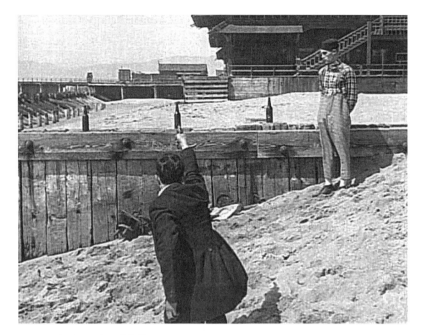

Figure 1.6. From *The High Sign* (Buster Keaton, 1921).

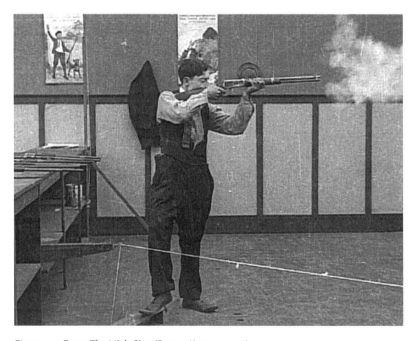

Figure 1.7. From *The High Sign* (Buster Keaton, 1921).

the Buzzards and the plot's resolution at the Nicklenurser home. Staged mainly along the Venice Speedway—a narrow alley more suited to a speedy foot chase than vehicular traffic—and two perpendicular cross streets, the chase is shaped by the rectilinear grid of streets between Venice's Ocean Front Walk and the Lagoon (Figure 1.8). Movement is horizontal, back and forth along the streets and at right angles at the corners. The overall form of the chase is modular—with new spaces revealed as we follow the trajectories of the two participants—but also conceptually circular, with a series of reversals in direction leading to a return to the fruit and vegetable stand where, ironically, the cop remains oblivious to the very crime that justifies his pursuit.

The most intricate setting is reserved for *The High Sign*'s climactic interior chase. Choosing romance with Nicklenurser's daughter over confederation with the gang, Buster now finds himself the target of the Blinking Buzzards within her private home, a place set apart from the seaside city proper. The interior layout features two rooms upstairs, two rooms down, with hallways to the rear connected by a set of stairs. Movement through these rooms circles around the two levels but is also constrained by the matrix of rooms. The direction of the two-minute chase is constant, with four clockwise circuits through the rooms completed in rapid succession. Yet the choreography is delightfully unpredictable, with comic variations spun off these basic patterns. In part, this is because the Nicklenurser home has been transformed into a mystery house with trick walls and hidden passageways, in response to which Buster devises highly inventive methods of escape.

During the first stage of the chase, the film frame is roughly coterminous with the interior walls—each shot is a room and each room is a trap. When Buster scrambles up the exterior of the right side of the house, however, we get a broader, two-tiered view, one mirrored in his descent down the exterior left side moments later. At the conclusion of the second cycle of the chase, moreover, the two-tiered exterior shots are complemented by a cross section of the left interior rooms, stacked on one another. During the third and fourth cycles, the action is framed by a cross section of the entire house. Only now does the array of interior rooms and escape routes come into view as a coherent spatial system: a grid now projected on a vertical plan (Figure 1.9). The cross section of the house vividly demonstrates how a studio set can divide space into a set of compartmentalized, theatrical proscenia for the activities on display and calls attention to the film frame itself as a component part of the chase's broader circular construction.

The inversion of scale in the four-panel shot also transforms the space of the chase for the spectator into something like an arcade game, with miniature action figures passing through revolving panels and trapdoors in a broader circular

Figure 1.8. From *The High Sign* (Buster Keaton, 1921).

Figure 1.9. From *The High Sign* (Buster Keaton, 1921).

pattern, moving like clockwork. The cross section thus provides the film's final variation on a motif of circular, mechanical movements inaugurated with the revolving carousel at the seashore and reiterated in a series of small-scale actions, as when Buster and Tiny Tim trade positions by lifting and spinning themselves over the shooting gallery counter, as if riding a turnstile, or when, during the final chase, Buster spins a revolving door between the two upstairs bedrooms through two and a half rotations, stopping it with precision to place his attacker in the line of fire of another gangster's gun. Here the sight line patterns of both the carousel and shooting gallery scenes elegantly coincide, as Buster exercises control over an amusement park aesthetic that has invaded the Victorian home. In this fashion, *The High Sign* treats a scene of domestic violation—a trope of the short melodramas of D. W. Griffith at Biograph a decade before—as a vertical carousel, an animated shooting gallery, a fun house maze.[25]

With the ranks of assailants finally reduced to Tiny Tim, the scene is set for the story's resolution by way of yet another spatial boundary—a mechanical trapdoor in the floor of the parlor. Prior to the chase, the operation of the device is carefully established when Buster, fascinated by the drapery cord that triggers the trap, narrowly averts dropping both August and his daughter down the hatch. Now, with a dramatic flourish, Buster emerges from hiding in the base of a grandfather's clock and pulls the cord on Tiny Tim, who holds the daughter threateningly. After the villain drops through the floor, the grateful daughter embraces Buster, who glances down the trap hole and flashes the Blinking Buzzard's "high sign." "Our hero," unceremoniously kicked off the railroad car at the outset, in the end delivers the chief villain into an off-screen cellar and transposes the gangster's "high sign" into a mocking gesture. Buster's journey in *The High Sign* thus delineates a path from placelessness—a hero from "nowhere," not going "anywhere," kicked off "somewhere"—to domestic enfranchisement, with different forms of physical ejection, social affiliation, and spatial mastery explored along the way.

INSIDE OUT: *THE BALLOONATIC*

Like *The High Sign, The Balloonatic* begins with Buster's ejection; however, in this instance, the story starts in an interior space, the dimensions of which are initially uncertain. Framed in medium close-up, Buster looks down, the top of his flat oval hat forming the central graphic element of a dimly lit opening shot. Striking a match and cradling its flame between his hands, he glances up and scans the space before him, left to right, his expressively lit face registering alarm and puzzlement (Figure 1.10). As if in response to the protagonist's disorientation, the film then systematically discloses the boundaries of the darkened space Buster occupies,

Figure 1.10. From *The Balloonatic* (Buster Keaton, 1923).

directing our attention to five of six possible directions in which he might find a way out. With the foreground an unpromising escape route, Buster tries the doors on each of three walls, left, right, and back. Behind each door resides a ghostly lit figure or form: a skeleton, a devil, a Chinese dragon. Buster's movements from door to door trace an equilateral triangle, with the rear double door serving as its apex. As the camera follows these movements, *The Balloonatic* builds cinematic space geometrically. Angled shots of the doors to the left and right mirror one another, and a more distant view of the back wall highlights the symmetry of the ornately appointed chamber. Scurrying back to the center of the room, Buster stands with his back to the camera, hands on his hips. A trapdoor springs open beneath him, and he drops from sight.

Cut to the day-lit exterior of the House of Trouble, an amusement park fun house, as Buster plummets down a slide and lands on the sidewalk, once again hard on his back (Figure 1.11). The opening to *The Balloonatic* thus recalls both the disorientation of Buster's arrival and the trapdoor finish of *The High Sign*. As Buster's ejection from the House of Trouble portends, however, the spatial trajectory of *The Balloonatic* will be inside out rather than outside in.

The story world of *The Balloonatic* divides among three settings. Action during the first four minutes takes place in the amusement park, where Buster, in short order, encounters three women. The first, plump and giggling, plunges down the

Figure 1.11. From *The Balloonatic* (Buster Keaton, 1923).

exit chute of the House of Trouble, leveling a distracted Buster flat. The second, elegantly dressed and snobbish, and the object of his distraction, rejects Buster's efforts at gallantry and departs in a sporty automobile driven by a rival escort. The third, forthright and athletic, played by Keystone star Phyllis Haver, leaves Buster bruised and disheveled after he accompanies her, without invitation, on the Ye Old Mill tunnel ride (Figure 1.12). Events during the last fifteen minutes of *The Balloonatic,* in contrast, occur in a rustic environment, where Buster camps, fishes, hunts, boats, and meets up again with Phyllis, a solo camper herself (Figure 1.13). Bridging the two settings is a two-minute passage in which Buster travels in an observational balloon, drifting over buildings, trees, and mountains to a distant valley. When the balloon is punctured by Buster's errant rifle shot, he plummets to earth, landing in the wooded area where the remainder of the story takes place, save for a brief return to the air at the very end.

The production of *The Balloonatic* encompassed more disparate locations than were required for *The High Sign*. Bengtson identifies four: the base of the Race thru the Clouds coaster at the Venice Lagoon, from which Phyllis departs following her physical reproof of Buster; a vacant lot close to Keaton's studio in Hollywood, where the balloon is accidentally launched; a mountain ridge west of Chatsworth, in the northwest corner of the San Fernando Valley, which the balloon passes over just prior to its deflation and descent; and the Garden of the Gods

Figure 1.12. From *The Balloonatic* (Buster Keaton, 1923).

Figure 1.13. From *The Balloonatic* (Buster Keaton, 1923).

section of the Iverson Movie Ranch, also in Chatsworth, whose remarkable rock formations provide a striking backdrop to some of the outdoor activities of Buster and Phyllis.[26] A newspaper report from the period confirms what an alert eye can also detect: some exterior scenes were shot along the Truckee River, in the High Sierras. The setting for Buster's outdoor explorations in *The Balloonatic* thus is a hybrid of at least two rural California landscapes—one southern and semiarid, the other northern and relatively lush.[27]

A story of incidental adventures and flirtation, *The Balloonatic* is less tautly plotted than *The High Sign,* unfolding through a series of episodic events, with opportunities for romance quickening when Buster and Phyllis find themselves alone in the woods. No antagonists must be defeated, only Phyllis's antagonism dispelled, for the resolution of the slender romance plot to occur. In the absence of a focused chain of narrative events, motifs and associations come to the foreground as primary structuring elements. Some of the associations are generated locally through crosscutting: Phyllis wades into the river to fly cast, and we next see Buster do the same, with some comic differences. Others are dispersed over the course of the entire film and point up contrasts between Buster's and Phyllis's experiences in various recreational settings—urban, rural, and finally, aerial. Throughout *The Balloonatic,* for example, Buster's romantic initiatives take place near different bodies of water, inspiring different modes of courtship. With the snobbish lady, Buster invokes the legend of Sir Water Raleigh by spreading his jacket over a puddle along a curb, only to see the coat crushed under the tires of the rival's car. His eye next caught by Phyllis, Buster abandons all formality and takes the liberty of joining her on the Ye Old Mill boat ride. The viewer is left to infer the precise details of his offense during their trip through the tunnel, but not its negative effect, which is clearly evident in Buster's battered appearance on their exit and in Phyllis's incensed look as she rapidly departs the scene.

During their subsequent encounters in the woods, incremental changes in Buster's standing are registered by Phyllis as they respond to the physical demands of the wilderness environment, including full immersion in the river's running waters. The first of their encounters is wholly accidental. Knocked off his feet when a small dam he has built gives way, Buster is swept downstream into Phyllis's path as she dives into the river for a swim. Their collision, echoing that of Buster and the plump woman at the House of Trouble, sparks an angry tirade from Phyllis. Subsequent interactions are more purposeful and positive, however, as each seeks to rescue the other from possible danger, albeit with comically mixed results. Three times a victim within the sphere of commercial amusements—twice at the House of Trouble, once in the Ye Old Mill—Buster, in the end, succeeds at romance at

the campsite by demonstrating skills and ingenuity of an idiosyncratic rather than industrial kind.

Keaton withholds the revelation of Buster's mastery until the very close. Gliding downriver in a canopied canoe, nestled in Phyllis's arms, Buster again seems unaware of the danger to which a series of crosscut shots alerts the viewer: the canoe is heading toward a calamitous drop over a towering waterfall. Given recurring events, a catastrophic ending may seem fitting. Over the course of the story, Buster's initial tumble down the fun house chute has been rehearsed in a series of incidents in which a ground of support—a balloon basket, a fish basket, a canoe bottom—gives way. Now, as Buster and Phyllis approach the immense drop of the second waterfall, there is good reason to expect that gravity will again do its work, in ways appropriate to a story patterned in part on collapses and descents of various kinds.

But *The Balloonatic* also provides sufficient clues for us to imagine a happier outcome at the waterfall. Recall that the opening scene highlighted only five of six possible directions in which Buster might find a way out of the House of Trouble: forward, left, right, back, and down. In the end, space *above* the film frame proves the critical dimension. The morning after landing in the woods, we see Buster reinflating the repaired balloon and assembling a sectional canoe, the Minnie-Tee-Hee. A handcrafted striped canopy is visible in the background. Later, on attaching the canopy to the canoe, Buster glances up, in the direction of guide wires that extend above the film frame (Figure 1.14). Rather than revealing the object of Buster's glance, however, the next shot is of Phyllis, trapped by a bull and calling for help. Attention is thus deflected away from Buster's inventive handiwork until the very end. As the couple float down the river, Phyllis gives Buster a quick kiss. Cut to a miniature shot of the waterfall. At the top of the frame, the canopied canoe passes over the edge of the waterfall and sails on across the sky. Back in the canoe, Buster directs Phyllis's gaze upward (Figure 1.15). The next shot explains the trick; held aloft by the balloon, the Minnie-Tee-Hee floats high above the Garden of Gods (Figure 1.16). Back to the couple, another kiss, and the front and back sections of the canoe fall away. Buster's legs jut out horizontally, into the open air (Figure 1.17). Thanks to the vertical rigging, however, gravity is counterbalanced, and the bottom finally holds. The visual wit of the final shot capitalizes on *The Balloonatic*'s recurring up–down pattern, concluding now with an image of the lovers seemingly floating on air.

Buster's journey in *The Balloonatic* also has clear social import. Whereas his physical encounters with women at the amusement park follow the conventions of Coney Island slapstick, his inland journey over residential and commercial

Figure 1.14. From *The Balloonatic* (Buster Keaton, 1923).

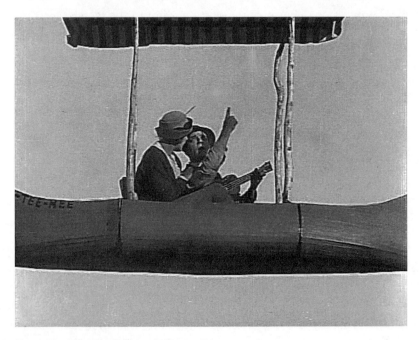

Figure 1.15. From *The Balloonatic* (Buster Keaton, 1923).

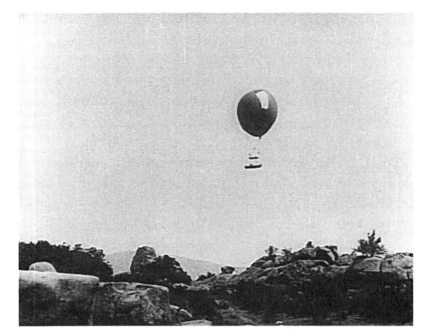

Figure 1.16. From *The Balloonatic* (Buster Keaton, 1923).

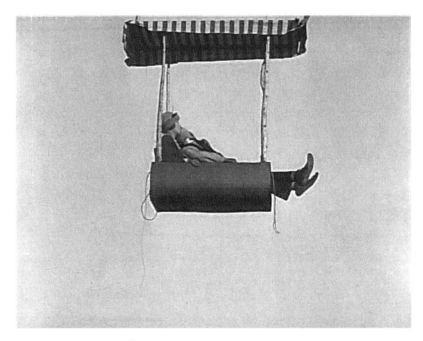

Figure 1.17. From *The Balloonatic* (Buster Keaton, 1923).

neighborhoods leads to a different sort of recreational setting. When Phyllis steps outside her tent in a formfitting swimsuit, the pose Haver strikes is borrowed from the physical vocabulary of Mack Sennett's Bathing Beauties, of whom she had once been a member, and whose beachside performances included featured appearances at Venice parades.[28] But her presence in The Balloonatic is not orna-mental. With the ease of a practiced sportsperson, Phyllis camps and takes to the river, and when push comes to shove, she wrestles a bull to the ground without Buster's aid. Meanwhile, Buster, though at times comically maladroit, resourcefully tinkers with the tools at his disposal. Along the river, Buster and Phyllis pursue recreation in the open air, far removed from the fun house's haunted chamber or the lightless, narrow tunnel of love. Here technologies of recreation—a fishing pole, a hand-built dam, a modular and malleable canoe—are personally manipu-lated, free of industrial or commercial imperatives. At the same time, the cinematic staging of these story events depends on Keaton's facility with the mechanics of collaborative moviemaking. When Buster's aeronautical device is disclosed in the film's capstone gag, The Balloonatic signals the film's own comic engineering as a form of playful art.

CINEMATIC DISPLACEMENTS

Kinney's initial vision of Venice of America was premised on a notion of social uplift in which cultural refinement would follow logically from educational pro-grams mounted in an artfully designed, recreational setting. Keaton, in contrast, came to filmmaking from the popular tradition of theatrical knockabout, and he enthusiastically embraced moviemaking as a means to amplify the effects and extend the commercial reach of physical comedy as he had practiced it on the stage. From this angle, The High Sign and The Balloonatic might be said to exem-plify wider trends in popular amusements that rendered the concept of Venice of America already quaint at the time of its founding in 1905. Yet to draw a sharp line between Kinney's ambitions as the developer of Venice and Keaton's as a slap-stick filmmaker newly settled in Los Angeles is to miss a more complex dynamic evident in the spatial design of these short comedies. Keaton entered the motion picture industry at a time when movie slapstick was increasingly under attack for its violence, hackneyed themes, and general offense to refined sensibilities. By the late 1910s, new hybrid comedy forms were emerging that combined the visceral appeal of slapstick with character-centered stories, told in a polished film style. In this regard, Keaton was engaged no less than Kinney in responding to changing cultural expectations within a sphere of leisure-time amusements, and he brought his own sense of refinement to this endeavor.

The High Sign and *The Balloonatic* display a more subtle and systematic way of thinking about the spatial dimension of bodily movement than is found in rougher forms of slapstick comedy. This is especially true of the latter film, in which the single scene of retaliatory violence—the journey of Buster and Phyllis through the dark tunnel—occurs entirely off-screen and in which the architecture of the comedy relies substantially on the viewer's ability to connect events and discern spatial patterns across different scenes and settings. Moviemaking enabled Keaton to translate the concept behind some modern amusement park attractions—say, Venice's Mill Chutes ride, which ended with a steep drop into a lagoon, or its Captive Balloon ride, which offered spectacular aerial views of the city and seascape—into comic events, stressing Buster's mechanical ingenuity in a natural setting.[29]

If we look closely, moreover, traces of Kinney's original Venice of America are woven into the fabric of *The Balloonatic*. A *ferro,* the distinctive metal ornament found on the front of a Venetian gondola, decorates the prow of the otherwise boxy wooden craft that transports Buster and Phyllis through the Ye Old Mill ride. Phyllis's sturdy campsite tent seems a more portable version of the summer tent houses that lined the Grand Canal during the early years of the resort. Just before Buster and his canoe, the Minnie-Tee-Hee, topple over a low waterfall, we see him drifting along the river, wholly absorbed in the magazine he is reading. Buster's misdirected attention sets up the gag to follow, but the image also pro-vides a Chautauqua-like picture of learning in a bucolic setting. During Buster and Phyllis's final outing on the river, moreover, the striped canvas canopy that Buster affixes to the Minnie-Tee-Hee matches the style of protective canopies that, on occasion, were added to gondolas in the Venice Lagoon.[30] Buster's makeshift vehicle thus not only fuses different kinds of transportation but carries compound cultural associations: a Native American canoe; a Venetian gondola; and an em-blem of nineteenth-century aeronautics, the observational balloon. Steering clear of the hurly-burly of the amusement park, the final image of Buster and Phyllis, suspended aloft, precariously balanced in the center of the frame, ends the film on a contemplative note, on "uplift" of a physically comic kind.

Keaton's short comedies, like other works of California slapstick, bear traces of places that have vanished over time. Minor details in *The High Sign* and *The Balloonatic* offer clues to the city that Abbot Kinney, in an act of imaginative in-vention, erected along the California coastline, the distinctive design of which was largely erased in the decade after his death. The urban history at stake here, however, involves not simply sites but situations, including comic trajectories that illuminate a social imagination. California slapstick offers prime evidence of the range of settings and stories that were imaginable across a topographically

variegated terrain during a period of rapid demographic and environmental change. The films also demonstrate how the experience of traversing and inhabiting this terrain found expression in cinematic form. As a neophyte director working in Los Angeles, Keaton learned quickly how to shape and delineate the choreography of his own movement in accord with the optics of the camera and in response to the environment he now occupied. Navigating the cultural waters on whose shoals Kinney's Venice of America foundered, Keaton crafted comedy out of an experience of dislocation, for movie viewers—"anywhere"—who were negotiating their relationship to modern life.

NOTES

1 Jay Leyda, "California Slapstick: A Definition," in *The Slapstick Symposium*, ed. Eileen Bowser, 1–3 (Brussels: Federation Internationale des Archives du Film, 1988).

2 Robert Fogelson, *The Fragmented Metropolis: Los Angeles, 1850–1930* (Berkeley: University of California Press, 1967), 1–2.

3 Buster Keaton, with Charles Samuels, *My Wonderful World of Slapstick* (New York: Doubleday 1960), 93, 142.

4 Christopher Bishop, "An Interview with Buster Keaton," *Film Quarterly* 12, no. 1 (1958): 15–22, repr. in Kevin Sweeney, ed., *Buster Keaton Interviews* (Jackson: University of Mississippi Press, 2007), 49; Bishop, with George C. Pratt, "'Anything Can Happen' and Generally Did," in *"Image" on the Art and Evolution of the Film,* ed. Marshall Deutelbaum, 195–204 (New York: Dover, 1958), repr. in Sweeney, *Buster Keaton Interviews,* 33; and Herbert Feinstein, "Buster Keaton: An Interview," *Massachusetts Review* 4, no. 2 (1963): 392–407, repr. in Sweeney, *Buster Keaton Interviews,* 33.

5 I explore this idea at greater length in "California Slapstick Revisited," in *Slapstick Comedy,* ed. Rob King and Tom Paulus, 169–189 (New York: Routledge, 2010). For general background reading on the social geography of Los Angeles during this period, see, in addition to Fogelson, *Fragmented Metropolis,* Carey McWilliams, *Southern California Country: An Island on the Land* (New York: Duell, Sloan and Pearce, 1946); Roger Banham, *Los Angeles: The Architecture of Four Ecologies* (London: Allen Lane, 1971); Allen J. Scott and Edward W. Soja, eds., *The City: Los Angeles and Urban Theory at the End of the Twentieth Century* (Berkeley: University of California Press, 1996); Greg Hise, *Magnetic Los Angeles: Planning the Twentieth-century Metropolis* (Baltimore: Johns Hopkins University Press, 1997); and Jeremiah B. C. Axelrod, *Inventing Autopia: Dreams and Visions of the Modern Metropolis in Jazz Age Los Angeles* (Berkeley: University of California Press, 2009).

6 On the development of Venice of America, see Jeffrey Stanton, *Venice California: "Coney Island of the Pacific"* (Los Angeles: Donahue, 1993), 4–143. Stanton's detailed study is based on newspaper accounts, photographs, and personal

interviews, although unfortunately, it lacks specific citations. Also see Carolyn Elayne Alexander and the Venice Historical Society, *Images of America: Venice* (Charleston, S.C.: Arcadia, 2004).

7 The Santa Monica Municipal League registered concerns about the city being thought of as "the Pacific counterpart to Coney Island" as early as May 1905, when it announced plans to produce literature describing the city as a "conservative residence." "Find Body by Long Wharf," *Los Angeles Times*, May 15, 1905, II7. By 1911, however, commercial promoters were billing the Santa Monica Bay as "the coming amusement center of the Pacific Coast," offering three East Coast resorts in one: Newport, Atlantic City, and a "Western Coney Island that will outshine the original 'Coney' itself." Display ad, *Los Angeles Times*, May 14, 1911, VI4. Also see *The WPA Guide to California* (New York: Pantheon Books, 1984; first published in 1939), 417, and Stanton, *Venice California*, 75.

8 Lauren Rabinovitz, "The Coney Island Comedies: Bodies and Slapstick at the Amusement Park and the Movies," in *American Cinema's Transitional Era: Audiences, Institutions, Practices*, ed. Charlie Kiel and Shelley Stamp, 171–90 (Berkeley: University of California Press, 2004).

9 The power of Coney Island as a model is reflected in Keaton's description, in a conversation with a New York journalist prior to *The Balloonatic*'s release, of the Ye Old Mill attraction in the film as "a Coney Island ride." See Gertrude Chase, "Buster Keaton Can Smile and Yawn, Too If He Wishes," *New York Telegraph*, October 8, 1922, 2.

10 Kinney, as quoted in Harry C. Carr, "Dream and Disappointment and Hope of Venetian Doge," *Los Angeles Times*, March 17, 1907, II1.

11 Ibid.

12 Encapsulating this sentiment, the subheading to a *Los Angeles Times* article in summer 1906 described Venice of America as an "Old World City in a New World Setting." "Fair Venice of America," *Los Angeles Times*, July 20, 1905, III1.

13 "Thousands Go to See Venice" and "Venice's First Fourth of July," *Los Angeles Times*, July 3, 1905, I4; "Throng Storms Fair Venice," *Los Angeles Times*, July 5, 1905, I10; Stanton, *Venice California*, 3–35.

14 Carr, "Dream and Disappointment," II1.

15 Ibid.; Stanton, *Venice California*, 18.

16 Robert W. Rydell, "Rediscovering the 1893 Chicago World's Columbian Exhibition," in *Revisiting the White City: American Art at the 1893 World's Fair*, ed. Smithsonian Institution, 18–61 (Hanover, Mass.: University Presses of New England, 1993).

17 "Old Midway to Be Destroyed," *Los Angeles Times*, April 1, 1911, II7; "Midway Feels Crack O' Doom," *Los Angeles Times*, April 3, 1911, II2; Stanton, *Venice California*, 44.

18 "Sheriff Has the Midway," *Los Angeles Times*, July 25, 1906, II2; "Sheriff Seizes Their Coffers," *Los Angeles Times*, July 30, 1906, I16; "The Plot Now Deepens," *Los Angeles Times*, October 25, 1906, I16.

19 "Short Has Midway," *Los Angeles Times*, January 3, 1907, II10; "On a Queer Quest," *Los Angeles Times*, April 29, 1907, I16; "Venice," *Los Angeles Times*, June 18, 1907, II10.

20 A remodeled version of the Race thru the Clouds, promising "all new big sensational rides," was built on the same site in 1920. See Stanton, *Venice California,* 66–69, 88–89, 116.

21 "Beach Glory Shifts Atlantic to Pacific," *Los Angeles Times,* August 27, 1911, V17.

22 "Odorous Suit over Sewage," *Los Angeles Times,* August 25, 1907, I16; Stanton, *Venice California,* 51, 87.

23 Stanton, *Venice California,* 143–46, 164–69.

24 John Bengtson, *Silent Echoes: Discovering Early Hollywood through the Films of Buster Keaton* (Santa Monica, Calif.: Santa Monica Press, 1999), 41; "Search for Buster," *Keaton Chronicle* 11, no. 1 (2003): 5.

25 Barry Salt describes the climactic circular chase through *The High Sign*'s four-panel house set as the "apotheosis of the room-to-room movement constructions" explored by D. W. Griffith and passed on to slapstick comedians by way of Mack Sennett's tenure at Biograph. See Salt's "D. W. Griffith Shapes Slapstick," in *Slapstick Comedy,* ed. Tom Paulus and Rob King, 37–48 (New York: Routledge, 2010).

26 Bengtson, *Silent Echoes,* 108–12. Venice and Chatsworth were linked in 1905 when Kinney imported boulders from the rocky area to build a breakwater to protect the Windward Avenue pier. Alexander, *Images of America,* 18.

27 Grace Kingsley, "Flashes: Buster, Jr., to Flit," *Los Angeles Times,* August 31, 1922, II13. Edwin Shallert reported two weeks earlier that Keaton's company had scheduled location trips to Big Bear and Sacramento, but the trip to Truckee may have replaced these plans. See "Playdom: A Luminous Program," *Los Angeles Times,* August 17, 1922, III1.

28 "Keystone Beauties in Great Bathing Parade at Venice," *Mack Sennett Weekly,* January 25, 1917, Mack Sennett Collection, Margaret Herrick Library, Academy of Motion Pictures Arts and Sciences, Beverly Hills, Calif. During preproduction, Keaton's current distributor, First National, announced that in addition to Haver, several other Sennett's Bathing Beauties had been signed for the making of the film, suggesting that perhaps a Venice beach scene was originally planned. Display ad, *Los Angeles Times,* September 10, 1922, III33.

29 Stanton, *Venice California,* 65, 105. Anticipating Buster's balloon ride in *The Balloonatic,* the Captive Balloon broke free of its cable tether on December 15, 1912, with the pilot and two passengers on board. After puncturing the balloon, the pilot eventually landed safely in waters off San Pedro. Emphasizing the perilous nature of the accident, the *Los Angeles Times* reported that "the involuntary aeronauts were the playthings of the elements," a phrase Keaton might have appreciated. See "Captive Balloon Free Imperils Three Lives," *Los Angeles Times,* December 16, 1912, II2.

30 A photograph of a Venice of America gondola with the striped canvas cover is reprinted in Alexander, *Images of America,* 39.

2 | The Eclipse of Place: Rome's EUR from Rossellini to Antonioni

JOHN DAVID RHODES

I want to begin this essay with a description of a place—a building, really—found in a curious travel book called *A Time in Rome,* written by the novelist Elizabeth Bowen and published in 1960. Bowen's itinerary takes in the usual sites—Forum, fountains, Quirinal—but also many things that the polite mid-century female tourist might just as well have skipped. Intrepidly peripatetic, she submits herself, for instance, to a semipsychogeographical walk around the entirety of the Aurelian walls, and she heads into the periphery, as well, into areas of Rome better known to Pier Paolo Pasolini and subproletarian laborers than to modernist Anglo-Irish novelists. Near the end of the book, Bowen describes her visit to the Esposizione Universale Romana—EUR, as it is commonly called today—that was to have been (had World War II not intervened) a World's Fair and exhibition of twenty years (1922–42) of Fascist progress, built just seven kilometers to the south of central Rome. Its incomplete pseudo-classicist travertine monumental structures constituted a somewhat embarrassing curiosity in the early 1950s. Bowen says that her trip to EUR stemmed from a desire for historical knowledge, not so much of Fascism as of ancient Rome: "Anxiety to see what Augustan Rome as a whole did look like was one of the reasons for my excursion to the '1942' Exhibition, where a model vouched perfectly to scale and correct detail was said to be on view." Bowen's visit is in advance of this model's inauguration; thus she is forced to wander through the EUR's "spectral avenues" of "rows upon rows of square-cut, unmeaning windows"; the area's "horror . . . was its emptiness."[1] The episode reaches a pitch of reproachful lyricism in Bowen's description of the Palazzo della civiltà italiana (Figure 2.1), the project's most famous structure, which she describes as "an immense columbarium-structure consisting almost entirely of arched apertures."

> On each of its six floors, pierced by daylight, statues could be seen standing; and the approaches were guarded at the four corners of its terrace by

nude colossi, with Neanderthal foreheads and bulging biceps, each with a cubist horse. This is a landmark for miles—today, the irresponsible little Metropolitana railway train had put me off immediately underneath it, on the exterior side, so that I could no wise enter the exhibition without passing near it, which I was loth to do. Later, while I was gazing at it from the central square, a safe distance, I saw a long file of German seminarists, in their scarlet soutanes, sweep up the terrace steps and into the arches—the effect was, a trickle of blood reversed, returning to the wound.[2]

Bowen's account performs a number of the gestures that, following the fall of Fascism and the conclusion of World War II, became typical of attempts to respond to the persistence of EUR. She is at turns appalled and bored, repelled and frightened. Her sense of moral and historical superiority finally figures itself in an allegorical image that suggests the insalubrious entwinement of the unfinished business of modernism and the unresolved legacy of Fascism.

Most of the ways in which EUR has been imagined, represented, and criticized in the postwar period are strikingly consonant with Bowen's squeamish fascination with this particular place. Moreover, Bowen's account offers us an example of what seems to be the primary tension in many cultural and aesthetic responses to place. Approached from one perspective, place is either the site or the embodiment of an irreducible singularity: *this place and no other.* However, approached differently, place is a singular site that nonetheless acts as the portal to broad (often the broadest) generalization. In this second approach to place, it is often, in fact, a place's singularity that allows it to be (rhetorically, figuratively) harnessed to the project of generalization. Thus we witness Bowen witnessing EUR from her midcentury perspective: she obeys first the realist novelist's impulse to observe EUR in its particularity, but through the particularizing work of her description, she produces an image of and a figure for the historically unprecedented violence of the twentieth century. In doing this, perhaps she merely recapitulates the ontogeny of human abstract thought: thought's capacity for generalizing synthesis will always be founded first on the grounds of an initial particular instance. However, the movement still seems odd given that place would seem to name an experience that cannot but be particular: because a place cannot help being anywhere else than where it is, it can only be what it is. Human beings, despite the irreducibility of their traits that distinguish even identical twins one from another, can move from place to place or exchange places with another, whereas a place, it seems, can only be what and where it is. Place, therefore, would seem even to outstrip the unique human individual as the guarantor and sign of irreducible singularity.

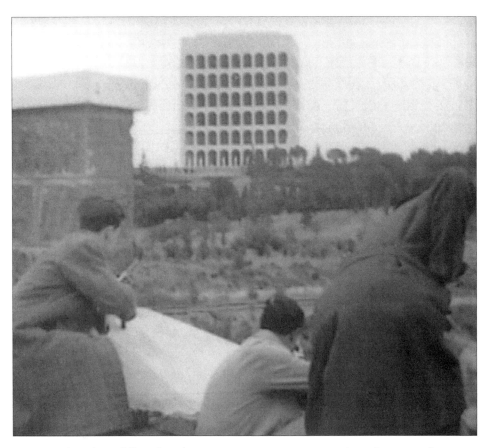

Figure 2.1. The Palazzo della civiltà italiana, EUR, as seen in *Rome, Open City* (Roberto Rossellini, 1945), just following the death of Pina. Note the emptiness of the surrounding countryside.

Similarly, the thereness of places would also seem to suggest that place names an experience of permanence. And yet, a place that has accreted over time a specific concrete texture and thus assumed an air of permanence may, in shockingly little time, be destroyed or translated out of familiarity. So, too, may places frequently be wrenched out of the peaceful equanimity of their singularity to be deployed in larger projects of generalization, forced to stand in for larger totalities. Perhaps because either to make or to destroy a place will require tremendous intentional, concerted effort, or else an awful irruption of violence, places become signs of both the fixity and particularity of identity (cultural, urban, geographic) *and* symbols of historical violence and its capacity to make and unmake the permanence that place would have seemed to promise. Places thus possess a doubleness that permits them, fluctuatingly, to stand for the permanence they seem mutely and instransigently to materialize *and* (though we may consider this less often) for the impermanence to which all places, ultimately, are subject.

For Bowen and—more importantly for my concerns in this essay—for a whole generation of Italian filmmakers and intellectuals, EUR, as a place, and as an image of a place, exuded a kind of traumatic glamour. It could not be overlooked, but once looked at, its specificity seemed always to disappear into myth, even though that myth revealed itself through the concreteness of its architecture. In what follows, I want to pay particular attention to responses to EUR registered in the cinematic and architectural cultures of postwar Italy of the 1940s, 1950s, and 1960s. In an historical era characterized, throughout Italy, by the pressing concerns of massive migration to cities (in particular, to Rome, the capital), debates around urban planning, housing shortages, and the accelerated production of housing, it is perhaps no wonder that this newly and extravagantly urbanized area of Rome might become, as I shall here argue it did, a visual trope in postwar Italian culture and cinema. Functioning as more than mere location (or setting), EUR served as a historical marker for a shift, or series of shifts, in Italian culture. More precisely, it acted as the medium through which Italian cinema—perhaps the scene of the most robust modernist activity in Italy's postwar period—historicized itself in relation to the past. EUR, I want to argue, acted as both material embodiment and symbol, something compulsively deployed or assimilated in the variety of responses to the vertiginous acceleration of Italian postwar modernity.[3] I want to turn now to constructing a clearer picture of EUR's inception—both architectural and ideological—before analyzing its persistent figuration on and of the postwar Italian landscape.

MONUMENTAL BLUNDER

EUR began its life as a would-be World's Fair. Italy had submitted a request to host the next World's Fair (scheduled for 1941) in 1935. On June 25, 1936, the Bureau International des Expositions granted Italy's request. This date fell roughly six weeks after Mussolini's proclamation of a new Italian empire following the fall of Addis Ababa on May 5, 1936, and three weeks before the economic isolation of Italy was lifted by the League of Nations.[4] In other words, the neighborhood is emphatically a product of the regime that desired, designed, and built it, but it is also a product of its worst (colonialist and racist) excesses. The year 1941 was, as the regime could not have failed to notice, suggestively proximate to 1942, the year that would mark twenty years of Fascist "progress." The regime slyly began to advertise it as the "Exposition of 1941–42" and eventually simply as E'42, the bureau having by that time given its permission to Italy to hold the exposition a year later than originally intended.[5] The mere fact of the anniversarial intentions of EUR immediately suggests its relation to a problematic of periodization and

historicity. The deepest intentions of its framers (with Mussolini playing a very hands-on role among them) were to deploy it as a period marker or a marker of periods: the Fascist period (1922–42) that filled up the space-time of whatever came before it and the same Fascism that would continue (it was hoped, believed) as an ongoing, self-generating period (from 1942 onward) that would extend into time, yet without ever aging.[6]

EUR was never understood merely as something *opposed to* Rome's (actually) ancient center. It was rather understood as a continuation of Rome proper as it proceeded toward Ostia, to the sea and Fascism's longed-for *mare nostrum,* a revival of ancient Rome's dominion over the Mediterranean basin. EUR's principal axial street, the Via Imperiale (now Viale Cristoforo Colombo), leads directly back to Piazza Venezia. Even more literally, the area occupied by the original exhibition site was planned to occupy an area exactly equal to that of Rome's *centro storico.* Entwined with but also somewhat independent of the project's ideological and symbolic overdetermination was the desire that EUR also guide Rome's growth. After fulfilling its function as a World's Fair, EUR's monumental core would serve as a nucleus of conurbation that would encourage an orderly expansion of Rome's suburban growth.

EUR's planning committee included the figures who dominated the Italian architectural scene during the 1920s and 1930s: Giuseppe Pagano, Marcello Piacentini, Luigi Piccinato, Ettore Rossi, and Luigi Vietti. The two most prominent figures in this group were Pagano, architect and editor of the influential architectural magazine *Casabella,* based in Milan, and Piacentini, architect and editor of the rival periodical *Architettura,* based in Rome, and best known for his *piano generale* of the University of Rome, a project to which Pagano also contributed. Pagano and Piacentini represent two major and diverging strands of Fascist-period architecture. Pagano was affiliated with the Movimento Italiano per l'Architettura Razionale (MIAR), whose activities most closely resembled advanced modernist architecture in other parts of Europe. Piacentini, on the other hand, was an eclecticist with strong monumental and historicist tendencies. In the early 1930s, Mussolini showed serious interest in the MIAR and even signaled his approval by attending the second exhibition of rationalist architecture in 1932, held in Rome.[7] As the 1930s wore on, however, Mussolini came to favor the much more ideologically legible rhetoric of Piacentini's brand of historicist monumentality.[8]

The architectural values that would prevail at EUR are best and most famously typified by the building that Bowen describes, the Palazzo della civiltà italiana. Designed by the team of Giovanni Guerrini, Ernesto La Padula, and Mario Romano, the building, which beat out its more rigorously modernist–rationalist

competitors (pretenders in glass and steel), is heavily historicist with its rigorous (or monotonous, depending on your point of view) and imposing succession of arches. It is often referred to as the "cubed" (or "squared") "Colosseum"—*il colosseo quadrato*. The plan as submitted called for seven floors with eleven arches each and for the building to be made of concrete. Piacentini intervened to see that the building would finally be executed with a shell of travertine—a more classicizing material—and that there would only be six floors with nine arches per floor, a slightly less energetic, more stolid solution.[9]

Thanks to the prodigious activities of the Fascist newsreel documentary service Istituto Luce, Italian film audiences were given regular evidence of EUR's progress. Luce newsreels documented a variety of activities at EUR: Mussolini planting the first pine tree at the newly opened construction site in May 1937, several visits by various members of the royal family, even a demonstration of the showers in the workers' dormitories at the building site's *villagio operaio* (workers' village). Roughly a dozen short newsreels, produced between 1937 and 1941, show the central monuments, and most insistently the Palazzo della civiltà italiana, going up with what one of the newsreel voice-over commentators describes as "Fascist rhythm."[10] In addition to these newsreels, a more sustained documentary, *Milizie della civiltà* (Militias of Civilization), narrates a day in the life of the workers living in EUR's *villagio operaio*. A moving camera glides among workers as they rise from their beds in the early morning, take their coffee and rolls, and begin their day. Following footage of their labors at the construction sites, the film lets drop its interest in workers' bodily exertions. The central passage of the film consists of stately moving camera footage of the uninhabited streets and newly completed monuments of EUR's core. The film then returns us to the workers, watching them showering, eating dinner, playing bocce, and finally settling down to a good night's rest. Equal parts ethnography and publicity, *Milizie della civiltà* marks, according to what I have found in the Istituto Luce's archive, the last documentary or newsreel made by the regime about EUR.[11]

The war would ultimately prevent EUR's completion. By the end of 1940, one-quarter of the four thousand laborers at EUR building sites were let go.[12] By the end of 1942, although a number of its central monuments had been completed (most notably the Palazzo della civiltà italiana and the Palazzo dei congressi), EUR had become, according to urban historians Luigi di Majo and Italo Insolera, a "gigantic marble deposit." Vittorio Cini, the general commissioner of the project, would admit, in his 1942 end-of-year progress report, that EUR was at a "dead end," though he optimistically voiced his hope that the project could be resumed in 1947 or 1948. But by this point, Mussolini had given up responding to Cini's

memos.[13] After the fall of the Fascist government on July 25, 1943, EUR played host first to German troops then the Allies, both of whom used the workers' village as a barracks.

THE CONCRETE FIGURE

The entire area of EUR was almost completely deserted in the immediate aftermath of the war, yet long before planners in Italy's transitional government had even begun to think about how EUR would be transformed, put to use, or otherwise rehabilitated, Italian postwar cinema had already cast it in its first feature-length motion picture. I am here referring to the fleeting but overwhelmingly important appearance of the Palazzo della civiltà italiana in that ur-text of Italian postwar filmmaking, Roberto Rossellini's *Rome, Open City* (*Roma città aperta*; 1945). This vision of the building and of the desolate environs of an unfinished, abandoned EUR follow immediately on the heels of the most important and impressive moment in the film: the death of Pina (Anna Magnani). Here we see the Palazzo looming in the background; the building is an absurd ghostly presence—something that is already obsolete. The building's situation in the background, of course, rhymes in terms both visual and symbolic with the use of St. Peter's at the film's end, when the child partisans are seen against the backdrop of the great baroque dome, a shot that is, perhaps, the most famous image in all of postwar European filmmaking.

Looking at this shot of EUR in 1945 (the date of the film's release), one might have even imagined that the building would share the same fate as the regime that had built it, which would be, in terms of the historiographic rhetoric of the film, extinction. Instead, EUR suffered (or perhaps enjoyed) a different fate, one shared by the regime: recuperation as convenient political other. Despite how fleetingly we glimpse the Palazzo della civiltà italiana and its bleak environs in this shot, the shot's place in the film's narration endows it with a significance that outlasts its on-screen duration. Clearly we are meant to regard it as hostile and false, something that belongs to the corrupt world of Fascism and Nazism that these Partisans have struggled and sacrificed themselves to destroy. More important, the shot's rhetorical, obviously historicosymbolic use of EUR prefigures much of the way in which the area has been understood and used by later filmmakers as a sort of architectural–historical–ideological shorthand.

The opposition that the film sets up between the past and the future, between the Fascist state, emblem of which is EUR (and specifically this building), and the church, emblem of which is St. Peter's, must have been reassuring in 1945. However, the use of buildings as rhetorical, symbolic forms is indicative of the way

in which Rossellini's film smoothes over uncomfortable historical truths: the easy symbiosis of Catholic church and Fascist state after the conciliation of 1929; the fact of *Italian* Fascism itself; the collaboration during the occupation between Italians and Nazi forces. I want to argue here, though, that this architectural–symbolic shorthand works particularly powerfully through its documentary deployment of *actual place*: the site of EUR. Many of the film's most rhetorically charged scenes (those of the interrogation and torture sequences at Gestapo headquarters) were quite obviously filmed on a set. Those scenes give a sense of being hermetically sealed off from Italian life as such, from the recognizable actual geographic locations like EUR and St. Peter's. Contemporary Italians might have liked to think that such a binary division of space—both moral and architectural—between themselves and the Nazi occupiers was both definite and true. Should they ever doubt such a neat division shown to them by the obvious binary strategies of the film, then the rhetorical deployment of "real" architecture (Fascist on the one hand, Catholic on the other) would reassure them that even outside "Gestapo Headquarters," in the world of actual, inhabitable space, such a division—both ideological and periodical—remained intact and impermeable. In other words, the film's documentary–realist impulse—its documentation of EUR—provides the material support for the melodrama of its rhetorical, moral, and perhaps most important, historical claims. David Forgacs, who has paid special attention to the way in which specific Roman geographies play an important role in the narrative and symbolic economies of *Rome, Open City*, notes the fleeting appearance of EUR in the film. As Forgacs argues, in a manner consonant with my argument here, despite the film's "concreteness" and "documentary value as an account of occupied Rome," its geographical and architectural discourse becomes "hardened into rhetorically polarised and moralised oppositions."[14]

The rhetorical use of binary architectural codes (Fascist vs. Roman baroque)—especially in so fundamental a document as *Rome, Open City*—should be seen as contributing to the general failure of postwar Italian culture to investigate radically what impact twenty years of fascist government had had on the country. Already in 1945, EUR seems to have entered the culture's imaginary as an image whose primary purpose was to define and confine Fascism as historical other, as historical past. The symbolic use of location and architectural monument here describes (and, in a minor way, helps produce) the premature reification of political discourse and a stalling of serious postwar political and historical analysis of the Fascist period and its aftermath.[15] I don't by any means intend that Fascism or post-Fascist culture or Rossellini were unique in their deployment of binary representational codes; rather I am interested in how a kind of historical thinking, tending toward

melodramatic binarism, takes shape in and around this particular place. *Rome, Open City*'s use of this site as a privileged marker of historical pastness is especially interesting given that the site was imagined and constructed to symbolize Fascism's organic connection and untrammeled access to Roman imperial history as well as the regime's existence as perpetual present-as-future.

According to Italo Insolera, for postwar Italians, "EUR had a specific image: the old Fascist exhibition, its abandoned and fenced-off ruins . . . an image in need of annulment, from which nothing good could be reclaimed."[16] However, if there was a way of reclaiming EUR from Fascism, it would be by way of the project's less ideologically overdetermined aspirations of creating a planned suburban residential conurbation to ease the problem of Rome's population, which had grown under Fascism and only continued to do so at an accelerated rate in the postwar period. Thus, in the early 1950s, Virgilio Testa, the postwar commissioner of EUR charged with the redevelopment of the project, launched a publicity campaign in which EUR's characteristics as a modern, progressive residential and business district, necessary to Rome's orderly expansion, were emphasized, to occlude as much as possible its indelible association with Fascism. Furthermore, by 1951, Rome had become a candidate for the 1960 Olympics, and EUR would become integral to the preparations for this competition.[17] The choice of EUR as one of the main sites of the Olympics dramatically spurred its growth and development and encouraged speculative real estate investment in the area. Practically, the strategy of symbolic rechristening worked. EUR expanded as both a residential suburban quarter, inhabited by both large apartment blocks and detached dwellings, and an administrative–clerical office district. A number of government ministries moved their headquarters to the area, where they built themselves glass-and-steel international-style office buildings. ENI, Italy's national energy corporation and one of the prime movers of Italy's dramatic postwar economic recovery (commonly referred to as the economic miracle), built its twenty-one-story skyscraper on the banks of EUR's artificial lake.[18] Because of its concentration of upper-middle-class housing and the offices of so many bureaucratic agencies and industrial capitalist concerns, by the end of the 1950s, EUR had translated itself into a new symbolic register. According to Manfredo Tafuri, its new constructions signified (and materialized) "Italy's confidence and optimism as it 'modernized' itself in the midst of a real economic miracle."[19]

EUR's new symbolic function as trope for Italian postwar modernization is appealed to insistently in cinema of the late 1950s and 1960s. A range of popular comedies align its architectural landscape with mild, moralizing reflection on the new ethical dilemmas posed by Italy's rapid modernization and its effects on

traditional institutions. For instance, in Vittorio De Sica's *Il boom* (1963), a construction industry executive must sell one of his eyes to a real estate speculator to maintain his standard of living, symbolized by his EUR penthouse apartment overlooking the ENI building.[20] In *Adulterio all'italiana* (Adultery, Italian Style; Pasquale Festa Campanile, 1966), the scene in which two women discover that they are sharing the same man is pointedly located in one of EUR's most dramatic modernist landmarks, the *fungo*, a giant mushroom-shaped water tower completed in 1959 (a monument to which I shall shortly turn in more detail).[21]

In Federico Fellini's *La dolce vita* (1960), Steiner, the intellectual who murders his children and then kills himself, is associated with EUR: from his apartment's balcony, we see the *fungo* looming conspicuously in the distance when Marcello (Marcello Mastroianni) arrives to survey the gruesome crime scene.[22] Given that this shot is contrived through the use of a painted scenographic flat, EUR appears as mere image, symbolic backdrop, a rhetorical reinforcement of the alienation that, the film suggests, has driven Steiner to murder and suicide. Fellini's contribution to the anthology film *Boccaccio 70, Le tentazioni del Dottor Antonio* (1962) registers one of the most theatricalized uses of EUR. Dottor Antonio is an unreconstructed right-wing Catholic living in EUR who organizes a community protest against a large billboard advertising milk with a gigantic image of a supine Anita Ekberg, her décolletage unsurprisingly functioning as the billboard's chief attraction ("*Bevete più latte,*" the sign announces: "Drink more milk"). The film makes much of the area as a ready-made stage set, literalized by Antonio's dream sequence, in which a real-life Anita Ekberg is made to seem giant by stalking an obviously miniature model of EUR. Through its emphasis on its original monumental core and the commercialized language of consumption and prosperity, Fellini avails himself of EUR's associations with both its Fascist origins and Italy's postwar consumerist modernization.[23] Fellini's fascination with EUR is most fully articulated in a short television documentary from 1972, *Fellini e EUR,* in which the director, photographed adjacent to the Palazzo della civiltà italiana, speaks of the area in almost mystical terms, suggesting that it symbolizes a "future already forgotten" and "a dream interrupted." For Fellini, EUR's buildings seem to have been "created for ghosts," and he appreciates the way in which its landscape invites "the projection of oneself onto its empty spaces."

EUR's easy, tropical availability in postwar filmmaking is hardly surprising, given the ways in which architecture is, in a sense, always imbricated and implicated in the logic of the symbolic and its articulation of historical meaning. One feels, however, some unease with the projection of value onto an architecture already so overburdened with historical meaning. Though positing EUR as the

architectural–historical bad object (either a grotesque, sepulchral remnant of a superseded Fascism or a sterile manifestation of recent consumerist prosperity) seems an understandable enough option for the historicist and ideological projects of postwar filmmakers, doing so risks participating in the symbolic economy of Fascism itself. For EUR was designed, theoretically at least, to embody and symbolize a transcendental notion of Fascism. Later filmmaking practices, while they want to distance themselves from Fascism (whether from the trauma of historical Fascism or the ongoing banality of the fascism of consumer capitalism[24]), nonetheless reinstantiated the fundamental Fascist belief in EUR as a pure, efficacious symbol of a historical period and as the medium for a moralizing discourse on the same.[25]

Both *Rome, Open City* and the comedies of the 1960s participate in an instrumentalization of the built environment as ideological shorthand. Fascism's original conception and execution of EUR is haunted by an anxiety regarding modernity. The architects and planners who envisioned this "new classical city" could not conceive of the new, the modern, without an explicit, literal, and theatricalized citation of the past. *Rome, Open City*—a paradigmatic instance of much of what was wrong with postwar (neorealist) culture—fell prey to the same logic, the same compulsion to ideate futurity through the logic and legibility of pastness. The temporal vectors of the economic miracle sex comedies point in a different direction but obey the same logic. The EUR of postwar affluence and dissolute luxury (whose constructions bloomed around the buildings of the original Fascist exposition) becomes the too-convenient figure of an anxiety either that Italy had become modern in advance of itself or that the nation's present was nothing more than a melodramatically degraded declension of its past.

There has been, however, at least one radical exception to the seeming inevitability of converting architecture into a vernacular medium for the smoothing over of historical complication, particularly with regard to EUR. I mean here Michelangelo Antonioni's *L'eclisse* (The Eclipse; 1962), the film that embodies the most sustained meditation on EUR's architecture and (sub)urban spaces. *L'eclisse* occasions what I think is the first and perhaps only antisymbolic, antirhetorical use of EUR as location. However, strangely enough, more than any other film set in EUR, its use of this location has suffered the most oversymbolized, and therefore the most mistaken, interpretation by critics and commentators. This long history of misreading would not be worth criticizing were it not that *L'eclisse* constitutes one of the most rigorous events in Italian visual modernism. Engaging both the nature of the film's use of EUR and the nature of the film's reception, I hope, will point the way toward a more compelling understanding of *L'eclisse* but also help

to lay bare a fundamental problematic of Italian modernity and modernism. This problematic, in turn, I want to argue, illustrates one of the fundamental conditions of the experience of place.

DISEMBOWELED VISION

There is something old-fashioned about *L'eclisse*'s stubborn, but nonetheless ambiguous, attachment to the real. Famously (perhaps, as we shall see, too famously), much of the film is shot on location in EUR. The crucial issue of location is announced in the film's first scene. Minutes into the film, in her soon-to-be ex-lover Riccardo's house, Vittoria (Monica Vitti) opens the curtains to reveal the *fungo* looming outside the window. The tower appears again as Vittoria walks home. This monument fastens us metonymically and historically to EUR. The film will linger, off and on, in this neighborhood, though significantly, much of the film's duration is spent in a fairly small area—really just a corner of this large suburb.

Lest we succumb to a generic reading of the film's location, Antonioni's camera is careful enough to show us that Vittoria lives at the Viale dell'Umanesimo (Humanism Boulevard), 307. Somewhat later in the film, Vittoria begins a rather desultory (and therefore, by the way, entirely typical[26]) affair with Piero (Alain Delon), a trader in Rome's stock market, who lives in the center, sometimes on his own, in a bachelor pad whose interiors we see several times, and sometimes with his parents, who live in Roman patrician luxury on—again, the film is careful enough to let us see this—Piazza Campitelli, adjacent to the Capitoline hill, Piazza Venezia, and the Theater of Marcellus. I am interested in teasing out the implications of the film's use of these two locations, its alternation between center and periphery. This same alternation has been the aesthetic strategy that commentators on the film have been most eager to interpret. However, rather than allowing any ambiguity to inform the "meaning" of the film's locations, critics of *L'eclisse*, with a stultifying uniformity, use these locations as the key to the film's interpretation. The symbolic reading of EUR and what critics assume to be its opposite, Rome's center, leads invariably to a reading of the film in moralizing terms.

In fact, having *something* to say about the spaces and monuments of EUR is the one strategy that almost all of the film's critics share in common. Here, as evidence of what I think is an almost uncannily univocal critical consensus, I give a survey of these interpretations, ranging across examples from the film's first critics to the work of later commentators. From a review of the film published in *Bianco e Nero* in May 1962, in one of the film's first serious reviews, G. B. Cavallaro writes that "Antonioni's analysis dwells in the world of the bourgeois, of which it collects various fundamental items: a rational landscape, icily futuristic, of vast

empty spaces, a world 'in construction.'"[27] This landscape, Cavallaro goes on to say, produces a subject who is "ever more anonymous, alone, excluded, incapable of communicating."[28] Cavallaro specifically names EUR as the site of this malaise, citing Vittoria's "continuous immersion in its vast geometrical spaces."[29] Later critics have followed Cavallaro's lead in using EUR as a metaphorical key for the interpretation of the film. Seymour Chatman asks of one of the film's privileged locations, the zebra crossing at the intersection of the Viale della Tecnica and the Via del Ciclismo, a crossing near Vittoria's house, where she and Piero often meet, "Why this anonymous street corner in EUR? The drab intersection is not mere scenery. It is the sign of a general predicament. It is not only a place where a representative couple fail to meet, but a culprit for that failure. It exemplifies, both as instance and as reason, the general incapacity of the modern city to facilitate meeting."[30] Frank Tomasulo claims that the neighborhood's "distinctive modern environment . . . is a metonymy for all the constant human change of the modern age."[31] David Bass understands EUR to have supplanted the role of the film's human characters, becoming "a lonely and uneasy protagonist with nothing to say for itself."[32] Even David Forgacs suggests that "EUR functions as an abstract, generically modern space, in distinction both to the historical city centre and the older residential districts which are hardly seen in the film."[33] I want to push against the critical tendency always to interpret L'eclisse along the same lines: as a sterile, alienated place that serves as the fitting allegorical setting for the sterility and alienation of the lives of the central characters. I prefer to understand the film as rigorously refusing to compliment its viewers' sense of superiority over the modern suburb.[34] Rather I tend to see Antonioni's use of EUR as involved in a peculiar interpretation of Italian modernity, one that draws together apparently disparate places and histories, one that looks for another way of looking at Italian modernity—especially Roman urban modernity—and its emplacement.

In his reticent, almost total avoidance of the monumental core of EUR, Antonioni distances himself not only from other filmmaking practices but also from contemporary architectural discourse of the late 1950s and early 1960s. For example, in each issue of L'architettura—a serious, if glamorously glossy, mainstream architectural magazine edited by the historian and architect Bruno Zevi—from 1957, there appeared a feature titled "Venti anni fa" ("Twenty Years Ago"). Tucked in amid the magazine's critiques and photo spreads of contemporary architectural practice, "Venti anni fa" was a running history lesson on the follies of Fascist architecture, with EUR figuring, always, of course, as a model best avoided. Even in the magazine's feature coverage of contemporary design and construction, new buildings in EUR were consistently discussed as being distinct from the

tainted history and aesthetics of EUR's original Fascist monuments. An article titled "Villino all'EUR," published in 1957, begins, "Even in EUR, among the scenographic specters of extreme militaristic folly, there is beginning to sprout new architectural work that breathes an air of civility."[35] Another article on the newly completed Ministry for Foreign Commerce (a perfectly standard embodiment of international-style architecture) closes by gesturing to EUR's history: "Amid the typically 'official'—also macabre and squalid—architecture of the buildings in EUR, this one stands out for its simplicity and composure. This building inserts itself into the academic tradition of 'ministerial' architecture with accents more modern and more human. More, perhaps, could not be asked of it. With this work the State has made a step towards the citizen."[36] Like the architectural journals of the period, Antonioni favored the spaces and monuments that were created and constructed during EUR's postwar period of development, all of them very typical examples of international-style modernism. Though it is ubiquitous in other filmmaking practices, we glimpse only once the Palazzo della civiltà italiana, when it appears faintly and matter-of-factly in the very distant background.

And yet one of the ways in which the Fascist past reappears in the film is actually through the film's use of another crucial location, that of Piazza Campitelli, overlooked by Piero's family's sumptuous apartment. According to Forgacs and most other critics, this flat and its environs constitute the city center that exists "in distinction to" EUR's putatively "generic" spaces. We see and make note of this piazza, however, through one of the most curious and intense of the film's formal repetitions. The shot that frames Vittoria's back as she looks out over Piazza Campitelli repeats exactly the composition of the shot of her looking out of Riccardo's window at the *fungo* (Figures 2.2 and 2.3). This same shot immediately gives way to a disarticulated series of obliquely framed shots of life in the piazza, none of which can be satisfactorily linked to Vittoria's optical point of view. As these shots work to fragment the film's composition, ominous minor piano chords sound faintly on the sound track. Given that the shot over Vittoria's shoulder is a careful formal repetition, we should not miss that this complex of formal strategies (fragmentary shots tending toward abstraction scored by spare, dissonant piano chords) will be repeated—at greater length and finally absent of either Vittoria or Piero—in the film's notorious finale, perhaps the most-discussed conclusion, or nonconclusion, of any film in film history.

I want, however, to focus attention on the camera's gaze over Vittoria's shoulder and into Piazza Campitelli and this shot's repetition of the earlier shot in which the *fungo* seemed to function as object of the camera's (and Vittoria's?) gaze. Significantly, our view of the piazza is not overwhelmingly organized around the dominating

Figure 2.2. The view over Vittoria's shoulder and through the window in EUR, through which we see the *fungo* at the beginning of *L'eclisse* (Michelangelo Antonioni, 1962).

Figure 2.3. The view over Vittoria's shoulder and through the window at Piazza Campitelli, toward the end of *L'eclisse*. We see not only the piazza but also, in the furthest background, the Via del Mare—product of the *sventramenti* and umbilical connection to EUR.

monumental feature of the piazza: Carlo Rainaldi's energetic facade for Santa Maria in Campitelli, a church built in the late seventeenth century and dedicated in devotional thanksgiving for the lifting of the plague of 1656.[37] The view takes in the church but extends toward the street beyond, the Via Teatro di Marcello. The reason the camera (or "we" or Vittoria) have this view from this window is because the entire area at the end of the piazza was cleared of the medieval habitations that had existed there up until the Fascist *sventramenti* (disembowelings) of 1926–32, clearances of dense, ancient housing stock, undertaken ostensibly to "liberate" the ancient Theater of Marcellus and open it to visual apprehension and appreciation. The real—or, for the regime, the more urgent—object of the *sventramenti,* however, was the removal of laboring-class citizens from Rome's center and the adaptation of the ancient city for modern automobilized traffic. Such liberation of classical monuments was, of course, central to Fascist urban planning of the late 1920s and 1930s, a history that culminates in the design and initial construction of EUR as both classicizing symbol and modern urban planning experiment.[38]

Even more concretely and particularly, the widened avenue made by clearing the buildings that would have stood at the far end of Piazza Campitelli constituted the first tract of the Vial del Mare, whose lanes of traffic would speed Romans in their cars on their way to Ostia, reachable, via this route, in a mere thirty minutes. In other words, the dream of Rome's expansion toward the *mare nostrum* that would give rise to EUR begins *precisely* here, at the far end of the piazza.[39] Moreover, the entire neighborhood around Piero's flat on Piazza Campitelli, also known as the Ghetto, had been planned as a site of severe Fascist cleansing and reorganization to complete the work begun on the far side of the piazza. An article published in 1940 in the Fascist planning journal *Urbanistica* documents the "improvement"—not, the article is careful to point out, the *sventramento*—planned for the neighborhood:

> Life in these indecorous habitations has a nefarious influence on the bodies and morals of their inhabitants, even though they are endowed with the good qualities that exist in the heart of all authentic Romans. The children here, forced to live in the streets, end up turning into veritable hoodlums.[40]

As was the case with EUR, these plans never came to fruition, owing to the war's intervention. However, the effects of Mussolini's pickaxe define the entire area: the neighborhood's spatiality is absolutely implicated in the spatial and architectural practices of EUR. Whether one turns right or left out the Piazza Campitelli, the urban thoroughfares of modern Rome (for many Romans, the most taken-for-granted feature of Fascism's legacy) will carry you speedily to the

south and to EUR, some seven kilometers away. In other words, thanks to Fascist urban planning, the Piazza Campitelli is umbilically connected to Vittoria's flat at the Viale dell'Umanesimo, 307.

The modernity of this umbilical connection and its concomitant history of the forced displacement of citizens in the name of visual and directional order haunts the view from Piero's window as much as the *fungo* haunts the view from Riccardo's window at the film's beginning. Though I do not intend a totalizing collapse of these two places into one another, I do believe that an understanding of their historical connectedness can avert us from the luxury of metaphorical moralizing and from a too-simple reading of *L'eclisse,* of Roman urban space and architecture. The nature of Roman urban modernity is felt perhaps more powerfully in the voids created by Fascist *sventramenti* than in front of any monument at EUR. Clearing out entire neighborhoods in the center of Rome effected not only a displacement of bodies but also an effacement of actual places. Whether one knows it, to walk or drive down the Via Teatro di Marcello is to walk through walls that are no more, to traffic insensibly with ghosts; it is to experience the horrible ephemerality of place, its ability to disappear, despite that its very ground—the earth on which it constituted itself—remains. The reckless speed of cars hurtling past the Theater of Marcellus, through the core of ancient Rome, is but one material embodiment of Roman modernity. Another is Vittoria's distracted languor as she traverses EUR, a place where lives are being lived—hers and others—perhaps not exactly as they are being lived in the center but in a manner more strikingly related than not.

In an eclipse, one body obscures the vision of another body by interposing itself between an observer and the body to be observed. The film's title, therefore, not only suggests itself as a potential metaphor for the obscurity of human relations but also cues our awareness of how the sight of one thing might temporarily obscure the sight of something else. The spatial disposition of the celestial bodies involved in an eclipse produces an experience in which one body blinds observers to the vision of the other owing to their too-perfect spatial alignment in our field of vision. In a sense, the too-perfect relation that obtains between the two windows out of which Vittoria stares means that we—like most critics of *L'eclisse,* or even most Romans—might miss the spatial and historical alignment that binds these two spaces permanently (unlike the fleetingness of a celestial eclipse) together— permanently, that is, until some new historical force, some new program of urban disemboweling, undoes or makes even more obscure their interrelatedness.

If EUR began its life as a shrill and noxious attempt to make a place, and if its architecture symbolizes an ideology, Antonioni's use and inhabitation of it in 1962 makes us wonder about the seductive entwinement of symbolization and

place. Symbolic architecture and the symbolic deployment of places enact the presumptions and exhibit the limitations of the literal figure. A place or a monument that is inscribed in a symbolic economy will act as both metaphor and metonym; indeed, symbolic sites and buildings provide some of the most enthralling examples of the collapse of these tropic or figurative modes into one another.[41] Approached skeptically, Antonioni's attempt to picture differently EUR's associations with both the Fascist past (which it indelibly inscribes and—so long as it stands—immutably embodies) and his economically miraculous present could be judged to perform something of a cleansing act for the neighborhood. Such may be at least one of the activities that *L'eclisse* performs, whether or not this was Antonioni's intention. Similarly, my emphasis on understanding EUR in slightly less symbolically overdetermined terms might run the risk of participating in what has been, in Italy, a recent and often suspicious attempt to rehabilitate the history of Fascist architecture as nothing other than a major episode in the history of Italian modernism.[42] However much such risks may be run, I think *L'eclisse* offers us something more complicated—it offers us, in fact, a practice of spatial, historical, and aesthetic complication.

L'eclisse performs, indeed, theatricalizes vision as a material practice—one that must find its way through repetitions, hard-headed attempts to see the same thing from a different angle or else to see different places from the same angle. Such a practice will be able to apprehend both the traumatic density of the apparently absent and the fragile contingency of the obviously present. To produce this sort of vision would mean, I think, a commitment of our attention to what T. J. Clark, in a valedictory meditation on postwar Italian aesthetic culture, has called modernism's "picked up threads and uneven development," "its purism and opportunism, its centripetal and centrifugal force."[43] Such a vision would maintain a critical skepticism, whether one is looking out of a window in Piazza Campitelli or on the Boulevard of Humanism.

One of the lessons of *L'eclisse,* it seems to me, is that *place* might be a word or figure better suited to name an experience of frailty and flux than one of permanence and solidity. (Rome's own putative eternality as a place has been predicated on and purchased by its subjection to unrelenting change and fluctuation.) A single moving image will only give us evidence of how a place looked at a given moment in time. That moment in that place, seemingly fixed on film, gives us evidence of that place's lack of historical of fixity. Film, however, like place, is a medium of flux, in which one moment collapses into and transforms the next, no matter what place the filming camera has found or where it has found itself.

EPILOGUE (ECLIPSED)

Antonioni died in August 2007 and so did not live long enough to see Silvio Berlusconi returned to power in the April 2008 Italian elections. A music video featuring a song called "Menomale che Silvio c'è" ("Thank Goodness Silvio's Here"), lip-synched by various construction workers, call center employees, and young men serving gelato, ends in distressingly familiar terrain. On the steps of the Palazzo della civiltà italiana, its row upon row of arches seeming to soar heavenward, a crowd of young Italians sings along to the insipid but distinctly aggressive nationalistic lyrics of the song. Despite our wishes, some places seem to have a stubborn figurative permanence or else seem permanently to appeal to and embody a mythical investment in a period of history—that of Fascism—that cannot be forgotten by those who regard it as an atrocity, and will not be foresworn by those who cling to it as the *summa* of Italian culture. With regard to the instance and the moment of this building's and this place's resurgence *as* a symbol, perhaps we might recall the closing sentence of Clark's *Farewell to an Idea,* not as solace, but as a provocation: "The present is purgatory, not a permanent travesty of heaven."[44]

NOTES

I would like to thank Rosalind Galt, Michael Lawrence, Michael Siegel, and Noa Steimatsky for their responses to drafts of this essay. A much shorter and very different version was published as "Place as Period: The Case of EUR," in *Le età del cinema* [The Ages of Cinema], ed. Enrico Biasin, Roy Menarini, and Federico Zecca, 269–75 (Udine, Italy: Atti del XIV Convegno Internazionale di Studi sul Cinema, 2008).

1 Elizabeth Bowen, *A Time in Rome* (London: Longmans, 1960), 161.

2 Ibid., 162–63. Bowen mistakenly exaggerates the degree to which the building is adorned by statuary. There were never statues on each of the building's floors.

3 For compelling and informative accounts of this process of intensive postwar modernization, especially with regard to the urban and architectural growth of the city of Rome, cf. Italo Insolera, *Roma moderna: un secolo di storia urbanistica,* new ed. (Turin, Italy: Einaudi editore, 1993), and Vittorio Vidotto, *Roma contemporanea* (Bari, Italy: Editori Laterza, 2001). The first hardback edition of the latter carries a single image: a photograph of the Palazzo della civiltà italiana. For an English-language account, cf. Robert C. Fried, *Planning the Eternal City: Roman Politics and Planning since World War II* (New Haven, Conn.: Yale University Press, 1973). For an account of a single filmmaker's critical response to Rome's rapid postwar urban expansion, see my *Stupendous, Miserable City: Pasolini's Rome* (Minneapolis: University of Minnesota Press, 2007), the first chapter of which provides an overview of the rapid growth of twentieth-century Rome.

4 Giorgio Ciucci, "The Classicism of the E 42: Between Modernity and Tradition," trans. Jessica Levine, *Assemblage* 8 (February 1989): 79.

5 Ibid., 80. A note on terminology: though the project was initially referred to more often as "E'42" under Fascism, I will use the acronym EUR throughout the present essay. This is the name that came into more frequent use in the postwar period and the one by which it is commonly called today.

6 Vittorio Cini, appointed by Mussolini as general commissioner of the Ente EUR, the agency set up to administer the construction and management of the project, describes the guidelines for the style of the buildings in the exposition thus: "The exhibition in Rome intends to create the definitive style of this epoch: that of the twentieth year of the Fascist Era, the style 'E'42.' It will obey the criteria of grandiosity and monumentality. It is to be hoped that the sense of Rome that is synonymous with the eternal and the universal will prevail in the inspiration and execution of the buildings destined to last in such a way that within fifty or even 100 years their style will not have aged, or worse, become degraded." Quoted in Giorgio Ciucci, *Gli architetti e il fascismo* (Turin, Italy: Einaudi, 2002), 184.

7 Pagano gives a breathless, sycophantic (but undoubtedly politically very astute) account of Mussolini's visit to the exhibition in his article "Mussolini e l'architettura," first published in *Rassegna illustrata mensile* (Brescia, April 1932) and reprinted

in Giuseppe Pagano, *Architettura e città durante il fascismo,* ed. Cesare De Seta, 5–8 (Bari, Italy: Editori Laterza, 1990).

8 Ciucci, *Gli architetti e il fascismo,* 93–128.

9 Rossana Bossaglia, ed., *Ritratto di un'idea: arte e architettura nel fascismo* (Bologna, Italy: Mondadori, 2002), 101. According to Bossaglia, the architects were so dissatisfied with Piacentini's revisions to their original plans that they refused to claim authorship of the building as it was constructed.

10 These newsreels are all available for streaming at the Istituto Luce Web site, http://www.luce.it/. "Fascist rhythm" is extolled in Giornale Luce B1558 (February 8, 1939), "Lavori all' E'42."

11 *Milizie della civiltà* was directed by Corrado D'Errico, a director of some note, whose credits include Fascist Italy's only real contribution to the European "supercity" films of the 1920s and 1930s: *Stramilano* (1929). The film's archival catalog entry in the Luce archive reads "Istituto Nazionale Luce, Milizie della civiltà, D'Errico, Corrado."

12 Luigi Di Majo and Italo Insolera, *L'Eur e Roma, dagli anni Trenta al Duemila* (Bari, Italy: Editori Laterza, 1986), 63.

13 Ibid., 63–65. Translations from Italian here and elsewhere are my own.

14 David Forgacs, *Rome Open City* (London: BFI, 2000), 45. For Forgacs's detailed and useful discussion of the film's geography, see 34–45. Forgacs emphasizes how little of Fascist Rome we see in the film. Though he is correct in terms of the amount of screen time given over to the representation of Fascist monuments and urban spaces, the appearance of EUR at such a critical moment in the film's narration imbues that appearance with a significance belied by its brevity.

15 On the question of the failed project of *epurazione* (the purging of former Fascists from the Italian government and its bureaucracy), cf. Paul Ginsborg, *A History of Contemporary Italy: Society and Politics, 1945–1988* (London: Penguin, 1990), 89–93.

16 Di Majo and Insolera, *L'Eur e Roma,* 86.

17 Ibid., 85–89.

18 This building, one of EUR's most impressive postwar constructions, was completed in 1962 and was designed by Marco Bacigalupo and Ugo Ratti. Cf. Piero Ostilio Rossi, *Roma: guida architettura moderna, 1909–2000* (Bari, Italy: Editori Laterza, 2000), 232.

19 Manfredo Tafuri, *History of Italian Architecture, 1944–1985,* trans. Jessica Levine (Cambridge, Mass.: MIT Press, 1990), 81.

20 Other comedies to employ EUR as setting in this mode include *Nel blu dipinto di blu* (Piero Tellini, 1959), *I mostri* (Dino Risi, 1963), *Il giovedì* (Dino Risi, 1964), *Oggi, domain, dopodomani* (Eduardo De Filippo/Marco Ferreri, 1965), and *L'ombrellone* (Dino Risi, 1966). Ubaldo Ragona's *L'ultimo uomo della terra* (The Last Man on Earth; 1963), starring Vincent Price in its lead role, uses EUR as the setting for a postapocalyptic world inhabited almost exclusively by zombies. In a similarly sinister but more upbeat fashion, Elio Petri's *La decima vittima* (The

Tenth Victim; 1965) uses EUR to imagine a dystopic future in which humans are legally allowed to hunt other humans for sport. For a filmography of movies shot in EUR, cf. Laura Delli Colli, *EUR è cinema* (Rome: Palombi Editori, 2008).

21 The film's title alludes to the better-known *Divorzio all'italiana* (Pietro Germi, 1961), a comic treatment of Italian divorce laws. An entire range of films whose titles incorporate "all'italiana" were spawned in the 1960s and 1970s, many of them sex comedies. The *fungo* was designed by architects R. Colosimo, A. Martinelli, and S. Varisco (1957–59).

22 Steiner's apartment was actually shot at Cinecittà; the *fungo* appears thanks to a painted flat.

23 One of EUR's most curious tourist attractions is a huge model (or *plastico*) of ancient Rome, designed by Italo Gismondi (based on the archeology of Rodolfo Lanciani and his Forma Urbis Romae), begun in 1937 and housed in the imposing Museo della Civilta Romana, one of the building's in EUR's original monumental core. The model was planned by Gismondi for the Mostra Augustea della Romanità (1937). It reproduces the city of Rome at the time of Constantine and occupies an area of two hundred square meters (scale 1:250). Also, while EUR was under construction in 1937–41, visitors to the construction site were invited to marvel at a scale model of the project.

24 Pasolini's insistent theme in the last years of his life was that consumer capitalism outperformed Italian Fascism in creating a culture of uniformity. Cf. Pasolini, *Lutheran Letters,* trans. Stuart Hood (New York: Carcanet Press, 1987).

25 EUR was also used in the 1950s and 1960s as a location for a number of so-called peplum films—also called "sword and sandal" films—often set in ancient Rome or based on pagan mythology. E.g., *Goliath contro i giganti* (Goliath against the Giants; Guido Malatesta, 1961) features a fight scene that is identifiably shot on the colonnade of the Museo della civiltà romana on Piazza Agnelli in EUR's original core. These films obviously instrumentalize EUR's architectural simulation of ancient Rome; however, they do so in the service of fiction and do not point the spectator's attention to EUR itself.

26 I will confess never to have understood the moral condescension with which critics have consistently discussed the love affair between these characters. Surely most human loves begin and end in an atmosphere of uncertainty or even indifference.

27 G. B. Cavallaro, "*L'eclisse,*" *Bianco e nero* XXIII, no. 5 (1962): 59–60.

28 Ibid., 60.

29 Ibid.

30 Seymour Chatman, *Antonioni, Or the Surface of the World* (Berkeley: University of California Press, 1985), 108.

31 Frank P. Tomasulo, "The Architectonics of Alienation: Antonioni's Edifice Complex," *Wide Angle* 15, no. 3 (1993): 11.

32 David Bass, "Insiders and Outsiders: Latent Urban Thinking in Movies of Modern Rome," in *Cinema and Architecture: Mélies, Mallet-Stevens, Multimedia,* ed.

François Penz and Maureen Thomas (London: BFI, 1997), 92.

33 David Forgacs, "Antonioni: Space, Place, Sexuality," in *Spaces in European Cinema,* ed. Myrtos Konstantarakos (Bristol, U.K.: Intellect Books 2000), 103. It seems strange that EUR would be the "generic" space, given that it can actually be named, whereas "the historical city centre" and "older residential districts" name those locations only via generic association. For other evidence of this uniformity in interpretation, cf. Joan Esposito, "Antonioni and Benjamin: Dialectical Imagery in *Eclipse,*" *Film Criticism* IX, no. 1 (1984): 32; Clara Orban, "Antonioni's Women: Lost in the City," *Modern Language Studies* 31, no. 2 (2001): 19; Sandro Bernardi, *Il paesaggio nel cinema italiano* (Venice, Italy: Marsilio Editore, 2002), 177–80; and P. Adams Sitney, *Vita Crises in Italian Cinema: Iconography, Stylistics, Politics* (Austin: University of Texas Press, 1995), 165. One major exception to this strain of criticism on *L'eclisse* is Karen Pinkus, "Empty Spaces: Decolonization in Italy," in *A Place in the Sun: Africa in Italian Colonial Culture from Post-unification to the Present,* ed. Patrizia Palumbo (Berkeley: University of California Press, 2003), 299–320. In this essay, Pinkus gives a fascinating and historically specific account of the film as a document of decolonization. She makes excellent sense of how EUR's very real association with Italian colonialism impinges on the meaning and formal construction of *L'eclisse.* Paradoxically, despite her specific attention to EUR's history, she nonetheless refers to EUR as a "noplace" (312). Despite this objection, Pinkus's speculative combination of theory and history makes hers one of the most interesting discussions of Antonioni's film.

34 According to Jacopo Benci, who is currently writing a long analytical and archival study of *L'eclisse* and its iconography, Antonioni actually worked in the offices of E'42 during the period of its first construction. Antonioni grew up and was educated in Ferrara and, following university, worked there as a journalist and movie critic. Evidently, he procured his post at E'42 through the influence of his employer at the *Corriere Padano,* who was friendly with Vittorio Cini. See also Benci's essay "Michelangelo's Rome: Towards an Iconology of *L'eclisse,*" in *Cinematic Rome,* ed. Richard Wrigley (Leicester, U.K.: Troubador Books, 2008), 63–84.

35 Fabio Tedeschi, "Villino all'EUR a Roma," *L'architettura* II, no. 15 (1957): 651.

36 Gino Cipriani, "Ministero del Commercio con l'Estero all'E.U.R., in Roma," *L'architettura* IV, no. 32 (1958): 87.

37 Cf. Giulio Carlo Argan, "Santa Maria in Campitelli," *L'architettura* 55 (May 1960): 50–57.

38 My book, *Stupendous, Miserable City,* gives a brief history of the *sventramenti* (1–16). For more complete accounts, cf. Insolera, *Roma moderna,* 127–42; Emilio Gentile, *Fascismo di pietra* (Bari, Italy: Editori Laterza, 2007), 57–83; and Borden Painter, *Mussolini's Rome: Rebuilding the Eternal City* (New York: Palgrave Macmillan, 2005).

39 Gentile, *Fascismo di pietra,* 73–74.

40 "La sistemazione dei rioni Campitelli—S. Angelo a Roma," *Urbanistica* IX, no. 3 (1940): 133.

41 I have discussed the nature of the literal and the figurative in relation to Italian modernist architecture in my essay "Collective Anxiety: Corviale, Rome, and the Legacy of '68," *Log* 13–14 (Fall 2008): 75–86.

42 The catalog edited by Rossana Bossaglia and the exhibition that it accompanied, Ritratto di un'idea, cited in note 9, is an example of such creeping and creepy rehabilitation of Fascist art and architecture. This show was on exhibition in Rome from May 11 to July 21, 2002, in the Palazzo Valentini.

43 T. J. Clark, *Farewell to an Idea: Episodes from a History of Modernism* (New Haven, Conn.: Yale University Press, 1999), 406–7.

44 Ibid., 408.

3 | Tales of Times Square: Sexploitation's Secret History of Place

ELENA GORFINKEL

American sexploitation cinema of the 1960s has long been associated with the environment of the mythically seedy grind house theater, its blazing marquees and lurid come-ons pasted on one-sheets at theater front, beckoning unsuspecting passersby. Though sexploitation films were shot and their production companies were located across the United States, the major producers were headquartered predominantly in New York and Los Angeles. In both their production histories and their construction of fantasized scenarios of sexual adventure, sexploitation films were inextricably tied to the spatial specificity, to the particular places, of New York City in the 1960s (Figure 3.1).

As an independent mode of production, the emergence of sexploitation cinema in the late 1950s and early 1960s dovetailed with the decline of Hollywood product, changes in national obscenity laws that branded nudity as permissible filmic content, and the expansion of available screens in ailing theaters, exhibition spaces newly freed up by the fallout of the 1948 Paramount divestiture decision. An offshoot of an older exploitation film tradition that spanned back to the late 1910s, sexploitation films were defined by their small economic means; an overweening focus on narratives that featured lurid, sexual subjects; and their indulgence in erotic tease and innuendo in their marketing.[1] For audiences in the 1960s, sexploitation's primary draw was its promise of the exposure of nude female bodies and its treatment of salacious "hot topics" ripped from the latest tabloid headlines, lewd men's magazines, and sexology manuals. Though there were hundreds of sexploitation films made in the 1960s, and though they varied in budget, style, and genre, most sexploitation films were produced on an average of ten to forty thousand dollars and in one or two weeks' time.[2] Sexploitation films negotiated a tightrope walk between the permissible and the obscene, often needling the censors and provoking perpetual confrontations with obscenity law. Aesthetically, these films developed a soft-core syntax that would defer sexually explicit action

Figure 3.1. The convergence of electricity and Eros in Times Square; the fictionalized streetwalker strolls through sexploitation's denotative mise-en-scène in *Prostitutes Protective Society* (Barry Mahon, 1966).

off-screen, although by the late 1960s, simulated sex with full frontal (primarily female) nudity became more common. The New York–based films garnered a certain identity as cheaply made, gritty, black-and-white potboilers produced by a small network of independent producer–entrepreneurs—Stan Borden, William Mishkin, Chelly Wilson, Jerry Balsam, and others—who often used the same retinue of actors and crew, and sometimes even the same stock music. Sexploitation films' bare-bones mise-en-scène and their employment of quasi-amateur actors gives them an emblematic status within the pantheon of "bad" or "trash" films preferred by contemporary cultist audiences.

As Eric Schaefer has noted, one of the significant historical values of 1960s sexploitation films is in their documentation of the backroom locations and low-brow places of 1960s cultural experience.[3] The plethora of urban scenes of 1960s New York this mode of production presented were often informed by economic and material necessity, as most low-budget sexploitation outfits eschewed the luxuries of the studio set and would film in a rough-hewn pidgin, vérité style on the available streets of the filmmaker's home base and, in some cases, in his own or friends' apartments. The cinematic topography of sexploitation in its urban

insert shots and luridly melodramatic settings of darkly lit bars, urban storefronts, littered streets, lower-middle-class apartments, restaurants, bucolic city parks, and suburban homes provides a rich archive of social life in the middle to late 1960s that would otherwise be lost to film and cultural history.

It may be easy to relegate such images of place to a simple function of museological authentication, of providing a kind of geographic realism to augment their filmic narratives of vice and erotic corruption, or to see them as a product of brute economic necessity. However, this footage of specific historical locations has a force both synchronically and diachronically, with a peculiar capacity to stand on its own and sometimes to exceed the frames of the films' thin narrative directives. The places often featured in sexploitation films indicate how the larger genre was fused, in its ideological address and cultural identity, to urban sites of sexual tourism, underclass labor, and pedestrian, working-class leisure. The IRT subway entrances near 42nd Street; the theater marquees, advertising, and signage along the Square; the brightly lit shop windows along Broadway and 7th Avenue; the fast-food restaurants, haberdashers, and bookstores; and the variegated pedestrian traffic all get embalmed by the sexploitation lens.

CINEPHILE AND CULT GLEANINGS

One of the retrospective attractions of watching these images of New York in their bedraggled, unpolished materiality, I would argue, is in their documentary value, a place-based veracity at odds with, or unmoored from, the films' narrative pretenses or drives. Though sexploitation films were narrative fictions in orientation, their overwhelming reliance on erotic spectacle and their hybrid, promiscuous appropriation of various generic modes—action films, thrillers, pseudodocumentary, sex exposé, travelogues, educational films—allowed for the production of texts that were more loosely organized by plot coherence, plausible characterization, or seamless narrative flow. Sexploitation films are also more difficult to organize cross-textually around an auteurist model of analysis, as economic exigencies militate against readings of aesthetic vision or consistency of conceptualization.[4] Therefore sexploitation films, in the fragmentary nature of their construction, and their less than continuous form, facilitate and perhaps encourage a diachronic position of spectatorial wandering, a scanning and exploration of the film frame for telling details that can spark some form of geographical recognition.

This process of scavenging or gleaning is not uncommon among contemporary sexploitation fans, who have long remarked on the materiality of place the films unwittingly reveal. For example, film reviewer Casey Scott extols the virtues of

Barry Mahon's *The Sex Killer* (1967) and its place-based charms, even above that other profilmic lure, the nude female body:

> *SEX KILLER* is a painless 56 minute sleazie, but I can tell you this: if the film was shot somewhere else, it would be the longest 56 minutes of your life. Granted, nothing much happens in this movie, let alone much killing. But the real star of the movie is New York City itself, with grimy streets, a real mannequin factory and actual bars and coffee shops with regular everyday employees and patrons, the world-famous NYC subway system, and those infamous shabby apartments, all with live recorded sound. This is the type of low-budget moviemaking that is long-gone in 2003. . . . In time, I lost interest in the barely there story and just gazed at the time capsule footage of New York City in its bustling heyday. . . . The surroundings in each scene provide great eye candy. If anything, be glad the film is preserved here for nostalgia purposes! You even get glimpses at 42nd Street in the nighttime, with a marquee advertising *LOVE HUN-GER! SEX KILLER* is much like John Water's [*sic*] Baltimore-based *MONDO TRASHO*: it's a gutter movie casting the city and its charms as character(s) in the movie.[5]

As Scott's enthusiasm for this otherwise unremarkable film's setting attests, a relationship is established with the film's documentary capacities as they sit in conflict or exceed the pretexts or limited coherence of the fictional diegesis. The insinuating power of place seems to exert itself on this particular viewer, opening up another avenue of experience that weds a selected aspect of the profilmic field with a reflexive historicity and infuses the mise-en-scène with the traces of the conditions of sexploitation's mode of production. Indeed, *The Sex Killer* is a film that is more concerned with location than motivation, and the haphazard precondi-tions for its making—a place to shoot and a formula of erotic spectacle—provide the recipe for a distracted ambulatory gaze, aided certainly by the capacities of DVD technologies and their freeze-frame, zoom, and slow controls.[6]

In its counterintuitive nature, this process of cinematic gleaning converges two modes of spectatorship—the cinephile and the cult, perhaps secret allies all along. The former cinephile mode of viewing, articulated most sensitively by Roger Cardinal in his essay "Pausing over Peripheral Detail," champions a relationship to art cinema that prizes the accidental meandering of the eye to objects that evade the foregrounding direction of the film's maker. Outlining the pleasures in hap-pening on, if not seeking, the Barthesian *punctum* in the physicality of arbitrary

profilmic minutiae, Cardinal states that "there comes a point where material detail entirely escapes directorial sponsorship, to take its place before the viewer quite autonomously. . . . It obstinately refuses to be drawn into a perspective of idealism or artifice."[7] But Cardinal also attends to what he calls the "materialist" tendency in this pleasure of the peripheral, through moments in films where detail becomes indicative of an unvarnished, ragged historicity, of the persistence of the social and cultural space outside the film's illusive diegetic world.

This concern with extradiegetic reality links to the second mode of spectatorship that images of place in sexploitation seem to summon, that is, the *paracinematic* mode elaborated by Jeffrey Sconce. Sconce examines the impulses of the connoisseurs of trash and cult film and their penchant for excess, "an excess that often manifests itself in a film's failure to conform to historically delimited codes of verisimilitude, calls attention to the text as a cultural and sociological document and thus dissolves the boundaries of the diegesis into profilmic and extratextual realms."[8] What is relevant here in relationship to this discussion of place are the ways in which sexploitation films encourage, if not necessitate, forms of viewing that take account of their historical conditions of production and exhibition, indeed demanding a knowledge of the extratextual world of the films.

The imaging of place serves as such a marker of historicity, both resisting full integration into the trajectory of the narratives and serving as a signpost of the relationship of this mode of film production to the physical locations it documents and to the ways those locations are inscribed onto, refracted within, the filmic texts in a reflexive loop. Watching place in sexploitation films thus leads one toward a crablike cinephilic wandering, exploring the profilmic world to find traces of the forgotten geographies that persist just outside the margins of the films' frame. That sexploitation films are often called "time capsules" of the 1960s speaks to this documentary, denotative quality of the genre—and suggests a contemporary relationship to the films that is oriented around an *accidental,* while nonetheless pervasive, topophilia.[9]

BODIES, PLACES, AND THE PROFILMIC

Sexploitation film archives many locations that have now been irrevocably altered by real estate and economic development and transformation and promises its viewer a potential familiarity of certain streets and locations, places that have inevitably changed or disappeared over the passage of time. This relationship toward the residues of placeness that inhere in this genre is particularly pointed when it concerns as layered and storied an urban location as the hyperspecularized radius of New York's Times Square. The notion of the "old" Times Square,

before its radical redevelopment in the 1990s, now spectrally animates its history and identity, even through absence. Analogously, sexploitation films' own extinction by the early 1970s, with the arrival of hard-core, feature-length pornography, multiplies the archival status and meaning of these films. They double as ruins, testaments to the existence of what seems a vanished New York and emblems of the obsolescence of their own mode of production.

What remains striking about these preserved images of Times Square, along with other areas of Gotham seen in sexploitation films, is the extraordinary ordinariness of the footage, in which the places of the city resist any easy compartmentalization, riddled with a kind of opacity, a thickness that eludes any convenient exegetic frame. Geoffrey Nowell Smith remarks, in his discussion of the valence of location shooting for a history of Italian neorealism, that "locations, however carefully researched, are impure. Whatever idea the filmmakers may have, the location cannot be guaranteed to enact it. . . . Most interesting . . . are the films in which it acts as a conditioning factor on the fiction precisely by its recalcitrance and its inability to be subordinated to the demands of the narrative. The city becomes a protagonist, but unlike the human characters, it is not a fictional one."[10] This notion of place as character may be a colloquial one, as we saw earlier in the review of *The Sex Killer* by Scott, but it is also suggestive in anthropomorphizing place, intensifying its affective qualities, in an exchange between human and object worlds. The richness of the specificity of location tarries with a challenge posed to modes of cinematic knowledge, in which an encounter with location refuses or overwhelms narrative. As background moves into foreground, the force of place displaces or interacts in unexpected ways with the plane of figure movement or human action, establishing its own demands and contingent laws.

In the clothing and unclothing of the human, usually female figure, sexploitation cinema seems to privilege the corporeal components of the profilmic, operating as a mode of film practice contingent on the oscillating dynamic of concealment and exposure so central to the structure of the erotic tease of 1960s representational address.[11] However, even nude bodies are marked by their housing environments; the conflict that sexploitation cinema stages is one between the different elements of the profilmic and how they compete, unevenly, for spectatorial attention. An echo of Nowell-Smith's observations regarding the recalcitrance of the geographical detail can be found in sexploitation cinema's own moments of reception. The poet Fred Chappell, reflecting evocatively on the function of body, skin, and surface in the mid-1960s sexploitation film, suggests that the nude female body attains a certain integral heaviness that resists interpretation:

In almost all nudie films there is a true but unarticulated idea . . . that physical nature itself is corrupt, has in itself the possibilities for its destruction; and is always unwittingly shown corrupted, flimsy under the grasp of society. But the human body, often exhibited as sadistically and masochistically degraded, as soiled and contemptible, burns through whatever attitudes the film tries to enclose it in. It maintains its integrity. Veins, pores, blemishes, follicles are stoutly independent and inform us that this kind of indignity is temporary, that the nonchalance of merely being defeats a superficial morality. . . . Does that girl's body . . . also resist the imagination? It's not malleable material for the camera, cannot be moralized or attitudinized. *But it can be placed.* It cannot be made shocking, nor more interesting than it already is. *But it can invest its surroundings with some measure of stateliness or, at the least, with the brassy taste of the incongruous.*[12]

Chappell's attention to the existential heft and phenomenological tactility of the female body returns to the notion of sexploitation's disjunction between its commercial aims and the manifestations of the existing product, and between diegesis and document.[13] In suggesting that the mute body of an unknown sexploitation actress can only be "placed," staged in dialogue or juxtaposition to the profilmic environment, Chappell is speaking to the peculiar ways that sexploitation cinema heightens spectatorial awareness of the cleaving between two cinematic temporalities, between the scene of the film's production and the time of the story world.[14]

Ivone Margulies has elaborated on how Andre Bazin—in his refusal of verisimilitude as the anchor of the cinematic "reality effect"—has left a rich critical legacy for contemporary reevaluations of realism, necessitating a reexamination of "corporeal cinema." Sexploitation's circumstantial difficulties with enacting or achieving a conventional ideal of verisimilitude position it as a mode of production worth exploring with respect to such materialist engagements with the profilmic. Margulies notes that "images that bear the mark of two heterogeneous realities, the filmmaking process and the filmed event, perfectly illuminate [Bazin's] search for visceral signifiers of the real. And the registered clash of different material orders best defines for him that which is specifically cinematic."[15] In this sense, the conflict between what is filmed and what is seen, between labor process and diegetic event, becomes a visible tissue within a sexploitation film. Margulies's project considers a reexamination of modernist and avant-garde cinematic traditions alongside realist ones, in which the filmmaker is given the primary role as sculptor or manipulator of different referential registers of profilmic reality. However, I would suggest that

the particular conditions of possibility of sexploitation cinema—limited economic means, commercial orientation, a negligible relationship to authorial voice or vision, yet also an emphatic stress on the function of the eroticized body—produce films that perform a different confrontation between bodies, places, and modes of film practice. Contingency exists as much in the field of production as within the film frame itself, and it is sexploitation's very failure as an illusionist mode that facilitates the accidental recovery of geographical detail in its unpredictable energies. It is to this convergence between place and bodies that I will now turn, vis-à-vis an embedded history of Times Square and its inscription by adult cinema and adult cinema's inscription by Times Square.

PLACING TIMES SQUARE

As both "crossroads of the world" and "devil's playground," Times Square has functioned within the local and national imaginary as a complex signifier of urbanism, commerce, sexuality, and a particular ecstatic anonymity to be found amid the teeming crowds. The body, its erotic expression, sociality, and regulation have always been instrumental to these designations.[16] The Square, which had long served as the transportation nexus of the city, with its density of converging subway lines, also signaled the city as a profoundly spectacularized cash nexus, the place where commerce, labor, traffic, and exchange turned into a flashing tapestry of entertainment and spectacle. Marshall Berman, for example, reads the hedonistic mythos of Times Square through the twinned forces of electricity and erotics, rhapsodizing that "the special allure of Times Square comes from being a place where sexual energy and electrical energy, and where perennial and modern urbanity, are very richly interfused, and where beauty is like that of the first woman after the fall."[17] Indeed, the delicate line between the metropolis in a state of a certain ecstatic dynamism facilitated by excess—in consumption, spectacle, and sex—and in a state of declension or decline in many ways speaks to the interstitial experience of Times Square in the 1960s. In the 1960s, and especially by the 1970s, Times Square became synonymous nationally with the purported moral decay of the inner city as well as the spreading impact of sexual commodities and entertainments. As James Traub suggests, it was in this period that "Times Square, which for generations had been understood to exemplify the freedom and the energy and the heedless pleasure seeking of New York, now came to be seen as a city deranged by those very attributes."[18]

The incremental transitions of the area toward becoming the benchmark of a symbol of urban degradation and vice, synonymous with crime and red-light districting, can be seen taking shape from the early 1960s onward. From 1963 through

1965, religious groups and politicians had taken businesses in Times Square to task for disgracing the city and for creating a public nuisance through the sale of lascivious films, books, and magazines. Monsignor McCaffrey, one vociferous critic who had led a church congregation on 42nd Street, represented this view in 1963, suggesting that Times Square had become a "magnet for degenerates and criminals who 'gravitate' there to satisfy their desire for obscenity," and went on to suggest that with the upcoming World's Fair to be held in New York the following year, a cleanup was necessary to give a better impression to tourists visiting the city for the first time.[19] Indeed, the pressure of the presence of the World's Fair served as one factor in the particular instance of New York City's attempts to regulate sexually oriented businesses such as bookstores and film theaters in the Times Square area. By 1964, these crackdowns and antismut campaigns were focused largely on local bookstores and newsstands that potentially provided access to illicit materials and nudie magazines to minors.[20] New York City's Mayor Wagner, by August of that year, had initiated his own "smut drive," culling together a twenty-one-member citizens' antipornography group, including members from civic, labor, and business organizations, to serve as a steering committee for the campaign, with the attention predominantly given to newsstands and print materials. Attempting to avoid raids, book burnings, or other such on-the-ground confrontations, the committee was to address the so-called pornography problem through the courts and legislation, and the mayor claimed that New York had become a "dumping ground" for these materials.[21]

This offensive seemed to have spilled over to, or dovetailed with, for a brief period, attentions given to the film exhibitors in the area. City licenses commissioner Joseph Di Carlo applied pressure on theater owners to remove suggestive, sexualized marquees, windows, and storefront displays from a number of movie houses, which the theater owners had agreed to undertake of their own volition, after complaints from religious and civic organizations as well as pedestrians and tourists. According to the *New York Times,* the displays included "nude or semi-nude photographs to pictures about drug addiction, forced prostitution and perversion," and "some of the material has also been found to be misleading. Frames that were cut from films by state censors have on occasion been blown up into display photographs to lure customers." Community pressures could also be felt from local ethnic organizations, as Joseph Mawra's sexploitation film *White Slaves of Chinatown* (1964)—which featured an inky version of the Lower East Side and East Broadway as the site of a fantasized brothel and drug den—was credited with igniting protests from the Chinese Consolidated Benevolent Association, who claimed that the film presented a distorted, jaundiced view of their ethnic

enclave.[22] Although the theaters, including the Tivoli, the Rialto, the World, the Globe, and the Forum, had pledged compliance, by the following year, the city appeared again hamstrung by the tenor of the obscenity decisions coming down from the courts, as the marquees had inevitably returned to their lewd come-ons. Of course, these forms of dissimulation were central to the drive of sexploitation exhibitors in their marketing of the films, as they had discovered that the obscenity controversy was a boon for profit. Interestingly, by 1965, the complaints had come to include the Broadway Association, a business organization for shop owners in the area, who felt that the sexploitation marquees blighted their business image and the patina of the area in general as an appealing space for consumers. The association stated in a letter to the commissioner of licenses, "How much can a public, including as it does, thousands of children, be expected to take?" Conflating the public with the receptive innocence of children, the business owners' grievance was considered just one year later an anachronism, as the commissioner replied that the marquee titles, such as "The Rape—It Goes All the Way" and "Uncut, Uncensored Shame Dame," might have "in Victorian days made the fair damsel blush," but under the current rulings of the federal courts, these come-ons were no longer legal grounds for prosecution.[23]

Real estate redevelopment plans were consistently afoot throughout the 1960s, and by the mid-1960s, police cleanup campaigns to get rid of crime and so-called undesirables from the area were being set against the undeniable profit brought in by adult bookstores and film theaters, not to mention the twenty-hour-a-day first- and second-run theaters.[24] The year 1966 witnessed the introduction of modernized peepshow machines, which soon began showing short loops of explicit sex, to a number of adult bookstores on 42nd Street between 7th and 8th Avenues; by 1969, the peeps had spread to thirty-five or forty venues all around the city, with an approximate four hundred peep machines operating.[25] As threats of the conversion of theaters to office buildings and the razing of this bawdy district by developers hung in the air, engaged observers came to reflect on the identity of Times Square and its decidedly scruffy features, hoping that the lowbrow popular culture teeming within this area would not be swept away by an inauthentic mass culture of high-rise apartment towers.[26] In the context of the controversial demolition of the historically venerable Astor Hotel on 44th Street and Broadway, one reporter cataloged the variety of divertissements still up for grabs on and around 42nd Street and stated that alongside the peep shows, adult films, prostitution, and gay cruising scene,

> a stroller in Times Square can, as the whim seizes him, go bowling, drink
> coconut champagne, watch flapjacks being flipped in a window grill, be

analyzed by a perceptive computer, buy foreign periodicals, play billiards, roll rubber balls into slots in Pokerino parlors, trip the light fantastic with amenable lovelies at the Tango Palace, or take part in sundry other diversions.[27]

This rubbing of elbows between underground, so-called illegitimate sexual practices and erotic commerce and the consumer culture emblematic of the carny distractions of the amusement park was something specific to the roiling energies of this radial location, in this particular transitional moment. It was incontrovertibly an indulgent and sensually stimulating place, in which the body of the stroller, shopper, or tourist was appealed to based on multiple registers of hunger, desire, and curiosity for varied modes of spectacle and divertissement.

Up through this time, one-hundred-year-old zoning ordinances had kept the vertical upsweep of new buildings at bay on the West Side, contributing to the multipurpose and street-level dynamics of the place, with its interaction of tourists, shoppers, locals, gawkers, street vendors, shop owners, hustlers, and scam artists. Architectural critic Ada Louise Huxtable feared in 1968 that Times Square and its rollicking and unkempt character would be steamrolled by what she called the "slab city" currently taking hold on the East Side and noted that this burgeoning tenderloin, despite its unsavory aspects, "has what planners call a sense of place."[28] By 1969, the New York City chief investigator, referring to the rise in muggings, assaults, drug sales, and the sex trade in the area, exclaimed that the area had become the "cesspool of the world. . . . The dregs of the whole country drain into our sump."[29] For Marshall Berman, looking back and periodizing the stages of Times Square's symbolic and mythological meanings in relationship to the national sense of self, the post-1950s period of Times Square's history signaled a transformation from a space that could represent American ideals of work, industry, and public prosperity to a logic of disconnection from a national and collective identity.[30]

For cinephiles, Times Square has an especial brio of significance because of the historical density of motion picture theaters showing double and triple features of first-run, second-run, and foreign films at theaters like the Victory, the Apollo, the Harris, and the Liberty. This place has become the object of an effusive retrospective literature of elegiac longing, loss, and, at times, nostalgia, discourses often animated in opposition to the fate of Times Square after its redevelopment and commercial mainstreaming—what some have called its "Disneyfication"—since the 1990s. The varied oral histories and memoirs of old 42nd Street, from the 1960s into the 1980s—such as Bill Landis and Michelle Clifford's hyperbolic narrative of grind house theaters, their films and denizens, in *Sleazoid Express*;

the 1970s gay cruising mosaic by Samuel Delany, *Times Square Red, Times Square Blue*; and Josh Alan Friedman's *Tales of Times Square,* in its anarchistic portraits of this metropolitan underbelly in the 1970s and 1980s—all contain a measure of longing for a semipublic space and sociosexual scene, a scene inextricable from and facilitated by the adult film theaters that contributed to this chaotic physical and human landscape.[31] These forms of memorialization echo what Susan Stewart delineates in the structure of nostalgia itself as not only a mourning of a vanished mode of production but also an "extinct mode of consumption," of a filmic reception sphere in its grounded materiality and geography within the layers of social circulation that defined New York's urban and cultural life.[32]

Sexploitation producers and distributors—such as Stanley Borden, William Mishkin, Barry Mahon, Chelly Wilson, Joseph Brenner, and Jerry Balsam, among others—had their office headquarters in this midtown area, and their films would often show on dedicated screens, such as the Cameo, the Lyric, the Avon, the Globe, the World, and the Malibu, in the same area. These producers and distributors developed a variegated yet embedded relationship to this place—as a base of business operation, as shooting location, as exhibition locale, and as mythic grist for the mill of their potboiler erotic narratives. It is no wonder, then, that many films of the middle to late 1960s set in New York would often feature establishing shots and supporting scenes that would orient the filmic action in this notorious area—shots panning nighttime marquees, taken from moving cars of the midtown area in lights—and would often use a 360 degree pan around the point of intersection between Broadway, 42nd Street, and 7th Avenue, attempting to define the spatial expanse and sense of stimulus through a vertiginously mobile surround. There is a measure of autodocumentation at work in these films—representing a reflexive loop or an intertwining set of relationships: as the sense of place accorded to Times Square is associated with the exhibition of these lurid films, so the images of these exhibition spaces and locales of public leisure and promised pleasure become ones that these filmmakers naturally incorporated into the fabric of their (sometimes shoddy) diegetic worlds. As much as the moving image within these low-budget films indexed the place of 42nd Street, so 42nd Street and its surrounding locales became indexed by these modes of independent cinema.

STREETS AND STREETWALKERS

The placing of female bodies in and by the environments of New York in sexploitation cinema depended on a set of rhetorical conflations between sex and urbanism, between work and leisure, between public and private spaces, and between a generalized notion of urbanity—in which this city could stand in for

all cities—and the specificity of place of Times Square, in which locale is irreducible and nonabstractable. As a cinema inordinately preoccupied with the dangers posed by the sexual autonomy of women, particularly as they became unbound from domestic and reproductive space in a post-Kinsey era of the birth control pill, Helen Gurley Brown's eponymous "single girl," and the stirrings of sexual liberation, sexploitation often capitalized on the trope of the small-town girl in the big metropolis and, in a moralistic, leering register, would detail the depredations that would inevitably befall the naive and the unwitting when caught in the grip of the "naked city."[33] The inevitable narrative trajectory from working girl to sex worker mapped a path that limited the possibilities of autonomy, in which the only capital that a woman could deploy, when unmoored in the city, was her body. In the fantastic dystopian universe of sexploitation's city films, all work became sex work, as this mode of production was still anchored to the moral circumspection of an older generation who looked on the lifestyles and ideals of 1960s youth culture with some suspicion. Characterizing city life as a space of duplicity and sexual predation, their vantage point tended toward the anachronistic, adopting a discursive tradition that spanned as far back as the silent film *Traffic in Souls* (1913) and found new resonance over the decades in film noir and the urban confidential films of the 1940s and 1950s.[34]

In the 1960s, sexploitation's documentation of New York places linked the eroticization of consumption and male leisure time to fragmentary travelogue images of the city streets, in day and night, the heterogeneity of their organization and their syntactical placing often conflicting with the film's preoccupations with narratives of social decay, disorder, and malaise. The symbolic currency of the sex worker as the lodestone to the underground secrets of city space, and to Times Square specifically, in Berman's earlier invocation of the "first woman after the fall" was harnessed by many New York–based sexploitation films. Though sexploitation cinema may have promulgated an ideology that insisted on the city as a corrupted, abstracted space inhospitable to women's bodies, in its visual and aural manifestations, it presented the specific irreducibility of place, its indeterminacy—with its senses of chaotic inhabitation, layered history, and quotidian familiarity.

Barry Mahon, one of the most prolific directors of sexploitation films in New York, produced grimy urban melodramas that capitalized on the textural possibilities of the city for stories of crime, erotic vice, and sexual ruin. Mahon, who, in the middle to late 1960s, directed ten to twelve films per year, was fond of shooting amid the flows and eddies of midtown and Times Square, near his offices in the Film Center at 45th Street and 9th Avenue, as well as in the West Village.[35] His 1966 film, a sex-action film titled *Prostitutes Protective Society,* embodies some of

the hallmark effects of geographical specificity set in conflict with sexploitation's broader aims toward erotic spectacle. The film details, in a flatly descriptive mode, the violent confrontations that ensue between a network of prostitutes, headed by Madame Sue, and a phalanx of gangsters who would like to extort a commission from these female free agents. Narratively, two different subterranean urban economies are put into an agonistic relation—the racketeers and their shady extortion and the illegal trade in sex for money. As Madame Sue's "Times Square Girls" begin to be murdered one after the other by the mobsters, the women fight back—the film concludes with the lead racketeer, Carny Bill, getting kidnapped and castrated by the women out in the country.

The film operates as a series of disruptive alternations between moments of erotic display and punctuating violence, as the struggle for the sovereignty of the streets and for the prostitutes' economic autonomy from the gangsters becomes a punitive war. As the prostitutes resist paying a commission, the gangsters serially murder girls to convince them that their "protection" is needed. Interspersed with the shootings, stranglings, and knifings are sequences in which Sue and her coterie of women sit in sparse, nondescript apartments in their lingerie or topless in panties discussing their next line of attack. The film thus cleaves the diegetic space of the film into a set of distinct places, organized around interiors and exteriors, the spaces of stagy corporeal display and of erotic circulation and transit. The female body is exposed and displayed indoors, where conversations are filmed mainly in synchronous sound, in brightly lit rooms in lower-middle-class apartments and hotel rooms, with often stationary cameras and minimal reframing. In the street scenes, usually filmed at night to capitalize on the lightshow aesthetic of the Deuce, the body is put into motion, blending in with the shuffle and stimulus of the more overtly documentary sights of New York after dark. It is not merely that domestic space and interiors get aligned with sexual spectacle and that exterior shots signal the public risks of specularity for the prostitutes, along the axis of how public and private space have historically been associated and regulated as sites of proper and improper sexuality; rather the juxtapositions between and cuts from indoor to outdoor places give the film a bifurcated, disjunctive quality, bound only by the bodies of the women who move between these locations and that give this film its main diegetic raison d'être. In this twinned articulation of place, the profilmic spectacle shifts registers between an organization around the contingent aesthetics of street life and a series of awkwardly performed corporeal intimacies for the camera.

The film opens with an establishing overhead shot of the convergence of Broadway and 7th Avenue at 42nd Street, seen from a highly framed vantage point,

before descending to the street action and pedestrian activity below. The madam's thickly enunciated English, marked by a trace of a Swedish or an Eastern European accent, serves as the guiding voice-over narration as she describes the basis of her operations. The voice-over minimally guides the images on-screen as Sue states that the tourism brought by the World's Fair has facilitated the proliferation of her business. What we see is a set of shots of the streets adjacent to the Square crossroads, as three different women nonchalantly emerge from the documented crowds, strolling and pausing from one location on their way to other undisclosed ones. Privileging long shots and medium shots over close-ups, Mahon never fully signals if these women are primary protagonists. This style produces an indeterminacy between perceiving the women as part of the unfolding diegesis and conceiving them as belonging to the documentary aspects of the image, merely passing pedestrians who have happened to enter the frame. A short-haired blonde framed and backlit by the shop windows of London's Luggage store at 49th Street and 7th Avenue occupies the profilmic space uneasily. Her posture makes it unclear whether she is posing, acting, or "being," as she adjusts her position around the storefront, looking expectantly off-screen. Another young woman wearing sunglasses and a kerchief quickly replaces her, as the shot cuts across the street. She, too, hesitates and pauses performatively a bit too much to be only a pedestrian, as she lingers on the corner outside a restaurant, and we begin to realize that the relationship being established between them is a relay, hinting at a form of seriality in which one woman passes off the baton to another, and the connection between their membership in a secret sisterhood is made (one of the alternate titles for this film in its distribution was *The Secret Society*). The second woman passes by the Metropol, a popular jazz club at the time, its marquee announcing that Dizzy Gillespie is playing, and the shot cuts to the dancing, gyrating woman in the club's window—which a crowd of tourists and gawkers is watching. The live performance of the girl in the window of the Metropol accentuates the place as one oriented around staged pleasures and sexual commerce—just as the ambulatory path of the fictional streetwalkers to whom we are introduced marks their place in the locale as one of commodity, albeit a less visible one. All the while, Madame Sue continues her voice-over as we see an image of another woman walking across the Square. We recognize that the voice has finally matched the body of its owner, as she says, "My name is Sue," strolling haltingly in full shot along Broadway, as cars and street traffic move northward on 7th Avenue and spill out of frame.

The slow establishment of narrative pretext—between Sue's cartel of streetwalkers and the insinuating interest of the mobsters in their business—effectively mixes the materials of the documented setting with the film's fictional aims. As

Sue describes the petty crooks and mobsters who want to lay claim to their operations, the film presents a series of shots of three men in suits congregated on the edge of the street on 7th Avenue, with the Metropol marquee peeking out at the edge of the frame. One of the gangsters is having his shoes shined by an African American man, and a young African American boy watches with hands on his hips then turns haltingly to look directly at the camera, while the three actors are positioned off center and behind him in full shot (Figure 3.2). Here document and diegesis are blurred, as the "real" street life and its inhabitants intermingle with the hired actors. This moment of direct address by a nonactor, much like the evidentiary quality of the go-go dancer in the window of the Metropol, is only one of many sequences in which the interaction between the visibility of the film's mode of production and the construction of the fiction is palpably felt. It is also a moment, however fleeting, in which Times Square's capacity to signify and to communicate overwhelms the purposes of the film's plot.

In many subsequent scenes, the film's actors walk into an already existing frame of urban activity, self-consciously *taking a place* within the mobile landscape of a documented and documenting city. In a later scene, in which one of the mobsters is attempting to track a down prostitute, the corner at the Metropol again becomes a site of collision between the teeming world of anonymous crowds and the staging of a fiction. A shot at this corner shows the congregation of groups of young and middle-aged men standing and gawking at the Metropol window. We see a police officer shoo away two youngsters from a presumably salacious storefront. As the actor who plays one of the gangsters walks into the frame and through the crowd, and from background into foreground, the police officer springs into a quick dancing jig for the crowd and then walks back into place. The serendipity of this moment, while easy to miss, says a great deal about the Square as a location for performance, both rehearsed and unrehearsed, documentary and diegetic. While the gangster becomes the object of our focalizing attention, the contents of this shot direct the viewer outward toward the edges of the frame and to the persistence of peripheral detail so eloquently expostulated by Cardinal and discussed earlier in this essay. The placing of Times Square thus becomes a nexus between chance and staged encounters, between the arbitrary recording of actual commercial, regulatory, and pedestrian exchanges and the film's fantasized transactions and contests between prostitutes, johns, and would-be pimps. The aleatory qualities of the place of Times Square meet with the arbitrary elements of the profilmic.

Prostitutes Protective Society has the feeling of a silent film travelogue to which sound and narrative detail have been added after the fact, and in which the bare skeleton of a story of vocational solidarity is performed for the viewer, assembled

Figure 3.2. The entwinement of diegesis and document in a moment of direct address on 7th Avenue. From *Prostitutes Protective Society* (Barry Mahon, 1966).

ad hoc. The performative woodenness of the female actors who enact the interior dramas in austere and harshly lit bedrooms and living rooms foregrounds the process of fiction making and filmmaking itself. The stark frontality of nude presentation, the actors' awareness of their own performance, sits in extreme contrast to the ways these same bodies move through the particularity of city streets, oscillating between anonymity and individuation. Multiple scenes of women in everyday, banalized undress, either starting their day or preparing for bed, are shot in stationary takes, with the framing of doorways serving as high-contrast accentuation. In one scene, two prostitutes alternate positions in the doorway of their apartment's bathroom, bare backsides facing the camera, while breasts become visible in the mirror. One woman, a tall, lithe blonde, fixes her hair and talks to her coworker, occasionally turning around. The voice off-screen appears positioned as if coming from behind the camera. The blonde exits the bathroom, and the owner of the voice enters, taking the same position, an African American woman who performs the same actions as the conversation continues.[36] In another scene, two of Sue's working girls framed in medium shot lean against their apartment wall, which is harshly lit as if by one bare source of strong key

Figure 3.3. Female nudity austerely placed and framed by high-contrast, harshly lit interiors. From *Prostitutes Protective Society* (Barry Mahon, 1966).

light. One of the women puts on a sweater as another enters frame right with her shirt unbuttoned and breasts exposed. They engage in a conversation related to the shakedown of the mobsters of their coworkers. These scenes give a sense of a complex interplay between self-consciousness and naturalism, authenticated by the spectacle of dressing and undressing, everyday bodily comportments, and the textural gestures of average women, working in front of and *for* the camera. If the film stages the streets of the Square and its surrounding environs as a rough-edged, if incomplete, *panorama,* then the interior spaces in which female flesh is unveiled have a strange affinity to the *diorama,* in which frames, windows, mirrors, and doorways organize the architectural rigidity of modes of looking so central to sexploitation's licentious attraction (Figure 3.3). The architectonic and spare quality of these sequences bears a certain flatness, in which the textures and surfaces of the body are made to speak, however inchoately, of their place in both the fiction and the mode of production itself.

Numerous other sexploitation films of this period took part in this complex process of incorporating, and being incorporated by, Times Square and environs, among them *Bad Girls Go to Hell* (1965), *The Lusting Hours* (1967), *Hot Skin Cold*

Figure 3.4. Tracking an ambulatory gaze on competing models of spectacle in the Deuce. From *Prostitutes Protective Society* (Barry Mahon, 1966).

Cash (1965), *Aroused* (1966), *Career Bed* (1969), and *Vibrations* (1968). In them, the placeness of Times Square as a local and intimate geography and as a symbolic system bears out a larger cultural and ideological narrative regarding inner cities, moral blight, and urban development. What sexploitation cinema tracks in this period, particularly in the middle to late 1960s, is the very reconfiguration of the meanings of Times Square both regionally and nationally in relationship to erotic commerce and the meanings of public space, through the contingencies and unexpected synergies of the local. *Prostitutes Protective Society*, as one example of sexploitation product in this period and of this place, articulates, circa 1966, the ways that Times Square was transforming in relationship to the very adult businesses that sexploitation emblematized but also the tenors of sexual culture that would soon make sexploitation itself an obsolete cultural and film industrial form. As one character in *Prostitutes Protective Society*, a mustachioed gangster in a polo shirt, walks by three adjacent storefronts on Broadway—first a lingerie shop with exotic and racy garments on mannequins in the window; then Broadway Playland, a traditional amusement arcade that proffers Pokerino, Skeeball, and photo booths; and then a cocktail lounge with a ladies' night special—we see a cross section and

coexistence of competing models of urban entertainment embedded in the frame as well as in the history of the Square's enticements and promises of anonymous pleasures, embodied and vicarious thrills (Figure 3.4). Laurence Senelick discusses the ways the history of Times Square converged the urban tourist with the sexual tourist, "who could breathe a heady aroma of freedom from small town mores . . . and submerged in its crowds, experience a reassuring assumption of anonymity . . . the privacy of the crowd."[37] This combination of privacy and anonymity, social and erotic contact, articulates the experiential extremes, the fusion of distance and proximity, that Times Square, as well as the adult cinema that, for a long period, housed itself in the very center of its crossroads, offered its visitors and spectators.

NOTES

1 For the definitive account of the "classical exploitation" film, see Eric Schaefer, *Bold! Daring! Shocking! True! A History of Exploitation Films, 1919–1959* (Durham, N.C.: Duke University Press, 1999).

2 An article detailing the economics of exploitation written by a disgruntled screenwriter provided an estimate for an average film made in 1963 at approximately thirty-five thousand dollars. Frank Ferrer, "Exploitation Films," *Film Comment* 1, no. 6 (1963): 31–33.

3 Eric Schaefer, "Dirty Little Secrets: Scholars, Archivists, and Dirty Movies," *The Moving Image* 2, no. 2 (2005): 79–105.

4 Nevertheless, within the small field of academic scholarship on sexploitation films, an auteurist approach has developed that has begun to think about the bodies of work of particular directors, especially those of Doris Wishman, Joseph Sarno, Andy Milligan, and the most economically successful of the sexploitation-era directors, Russ Meyer.

5 Casey Scott, "Zodiac Killer/Sex Killer DVD Review," *DVD Drive In,* http://www.dvddrive-in.com/reviews/t-z/zodiackiller70.htm.

6 Laura Mulvey discusses how this capacity to return to the still frame with the aid of new moving image technologies reinvigorates a historiographic mode of spectatorship in her book *Death 24 × a Second: Stillness and the Moving Image* (London: Reaktion Books, 2006).

7 Roger Cardinal, "Pausing over Peripheral Detail," *Framework* 30–31 (1986): 122.

8 Jeffrey Sconce, "Trashing the Academy: Taste, Excess, and an Emerging Politics of Cinematic Style," *Screen* 36, no. 4 (1995): 387.

9 Yi Fu Tuan, who brought the term into wider scholarly usage, defines *topophilia* as the "affective bond between people and place" in his *Topophilia: A Study of Environmental Perception Attitudes and Values* (New York: Columbia University Press, 1990), 4.

10 Geoffrey Nowell Smith, "Cities: Real and Imagined," in *Cinema and the City: Film*

and Urban Societies in a Global Context, ed. Mark Shiel and Tony Fitzmaurice (Oxford: Wiley-Blackwell, 2001), 103–4.

11 Thomas Waugh, "Cockteaser," in Pop Out: Queer Warhol, ed. Jennifer Doyle, Jonathan Flatley, and José Esteban Muñoz (Durham, N.C.: Duke University Press, 1996), 62.

12 Fred Chappell, "Twenty Six Propositions about Skin Flicks," in Man and the Movies, ed. William R. Robinson, with George Garrett (Baton Rouge: Louisiana State University Press, 1967), 53–54; emphasis added.

13 Philip Rosen has elaborated on the complex ways that historicity functions in our experience of the detail of cinematic images, particularly in the operations of the traditional historical film and in the Hollywood historical epic, in the relay and conversion between those aspects of the profilmic that are perceived as document and those that are in service of the diegetic world of the film. Philip Rosen, "Detail, Document, and Diegesis in Mainstream Film," in Change Mummified: Cinema, Historicity, Theory, 147–200 (Minneapolis: University of Minnesota Press, 2001).

14 This critical example also problematizes the notion that sexploitation audiences, as constructed by both the cottage industry's rhetoric and popular discourse, were mere dupes, suckers to the bait and switch of sexploitation's tactical and erotic lures.

15 Ivone Margulies, "Bodies Too Much," in Rites of Realism: Essays on Corporeal Cinema (Durham, N.C.: Duke University Press, 2003), 3.

16 Numerous histories have tracked the larger arc of this argument through specific case studies, including Timothy Gilfoyle, City of Eros: New York City, Prostitution, and the Commercialization of Sex, 1790–1920 (New York: W. W. Norton, 1994); Christine Stansell, City of Women: Sex and Class in New York 1789–1860 (Chicago: University of Illinois Press, 1987); George Chauncey, Gay New York: Gender Urban Culture and the Making of the Gay Male World 1890–1940 (New York: Basic Books, 1995); and Andrea Friedman, Prurient Interests: Gender, Democracy, and Obscenity in New York City 1909–1945 (New York: Columbia University Press, 2000).

17 Marshall Berman, "Too Much Is Not Enough: Metamorphoses of Times Square," in Impossible Presence: Surface and Screen in the Photogenic Era, ed. Terry Smith (Chicago: University of Chicago Press, 2001), 43.

18 James Traub, The Devil's Playground: A Century of Pleasure and Profit in Times Square (New York: Random House, 2004), 121.

19 George Dugan, "Priest Denounces Smut in Times Square," New York Times, May 6, 1963, 32.

20 "Crackdown Hits Smut Specialists: Most Times Square Shops Now Sell No Banned Material," New York Times, February 26, 1964, 39.

21 Charles G. Bennett, "New Smut Drive Planned by City," New York Times, August 7, 1964, 31.

22 "Film Houses Plan Display Clean-Up: City Receives Pledge from Times Square Theaters," New York Times, September 15, 1964, 32.

23 "City Seen Powerless on Movie Marquees," New York Times, October 28, 1965, 46.

24 "Lurid but Profitable 42nd Street Hopes to Survive New Cleanup," *New York Times*, March 26, 1966, 26.

25 Richard F. Shepard, "Peep Shows Have New Nude Look," *New York Times*, June 9, 1969, 58.

26 Marc Eliot, *Down 42nd Street: Sex, Money, Culture, and Politics at the Crossroads of the World* (New York: Warner Books, 2001), 116–27.

27 McCandlish Philips, "Planners Ask: Will Success Spoil Times Square?" *New York Times*, July 24, 1969, 39.

28 Ada Louise Huxtable, "Will Slab City Take Over Times Square?" *New York Times*, March 25, 1968, 40.

29 Thomas F. Brady, "Times Square New York: Cesspool of the World," *New York Times*, February 21, 1969, 50.

30 Berman, "Too Much Is Not Enough," 67–68.

31 Bill Landis and Michelle Clifford, *Sleazoid Express: A Mind Twisting Tour through the Grindhouse Cinema of Times Square* (New York: Fireside/Simon and Schuster, 2002); Samuel Delany, *Times Square Red, Times Square Blue* (New York: New York University Press, 1999); and Josh Alan Friedman, *Tales of Times Square* (Portland, Oreg.: Feral House/Delacorte Press, 1986).

32 Susan Stewart, "Objects of Desire," in *On Longing: Narratives of the Miniature, the Gigantic, the Souvenir, the Collection* (Durham, N.C.: Duke University Press, 1993), 144.

33 This motif extended beyond the sphere of the New York sexploitation films and could be seen in films by West Coast producers, e.g., in William Rotsler's 1965 film *The Agony of Love*, in which a sexually deprived housewife leaves her husband to escape into the city, only to find a string of exploitative, depressing encounters as a prostitute.

34 Tom Gunning, "From Kaleidoscope to X-Ray: Poe, Benjamin, and *Traffic in Souls*," *Wide Angle* 19 (1997): 25–61. See also Will Straw, "Urban Confidential: The Lurid City of the 1950s," in *The Cinematic City*, ed. David B. Clarke, 110–28 (London: Routledge, 1997), on the urban confidential films of the 1950s.

35 Vincent Canby, "Films Exploiting Interest in Sex and Violence Find Growing Audience Here," *New York Times*, January 24, 1968, 38.

36 This sequence recalls the style of framing of a radically different 1960s film-maker, Andy Warhol, particularly his cleaving of on-screen and off-screen space in *My Hustler* (1965).

37 Laurence Senelick, "Private Parts in Public Places," in *Inventing Times Square: Commerce and Culture at the Crossroads of the World*, ed. William Taylor (Baltimore: Johns Hopkins University Press, 1991), 338.

4 | Derek Jarman in the Docklands: *The Last of England* and Thatcher's London

MARK W. TURNER

> My world is in fragments, smashed in pieces so fine I doubt I will ever re-assemble them.
>
> —Derek Jarman

In spring 1986, Derek Jarman directed *The Queen Is Dead,* three linked music promos for the zeitgeist Manchester indie band The Smiths. This cinematic triptych for the songs "The Queen Is Dead," "There's a Light That Never Goes Out," and "Panic" captures something of both the band's and Jarman's deeply felt anger about the cultural and political malaise at the heart of Margaret Thatcher's 1980s Britain. The Smiths' jangling guitars with lead singer Morrissey's sharp, aching lyrics are heard over a montage of urban alienation, quickly cut images of derelict urban sites that foreground a city of isolation and disconnection in which the center doesn't hold.

The third film in the triptych, for the song "Panic," focuses our attention on an isolated young man on Waterloo Bridge, the footage captured by the Super 8mm camera moving around him and offering fleeting glimpses of the built environment on both sides of the Thames: Denys Lasdun's modernist Royal National Theatre and the tower blocks of south London beyond; the iconic Houses of Parliament; the 1930s Shell-Mex and BP Ltd. building; and the eighteenth-century former palace Somerset House, once home of the Internal Revenue. Jarman had a keen interest in architectural history, developed when he studied under Nicholas Pevsner while a student at King's College London, but here the monumental presence of the eclectic architecture at the center of the capital is juxtaposed with the bleak, abandoned spaces of the East End, with its boarded-up buildings and streets in decline, uneasily highlighting the dereliction at the city's margins. At several moments during "Panic," graffiti flashes across the screen, providing snatches of text

Figure 4.1. "Local Land for Local People," found graffiti in *The Queen Is Dead* (1986), Jarman's film for the Smiths.

that locate *The Queen Is Dead* in a specific political moment. "LDDC are Bloody Thieves," "Local Land for Local People," and "Hands Off our Waterfront," we read; these slogans all point to the ongoing social conflict over the urban regeneration of the warehouses, wharves, and docks in the East End of London (Figure 4.1). The view from the bridge in "Panic" is a reminder of the young man's disenfranchisement from establishment London.

The politics of place were important to Jarman, and from his Super 8mm films of the 1970s and his punk-inspired dystopian feature *Jubilee* (1978) to the Smiths promos and *The Last of England* (1987), the spirit of resistance and anger expressed is deeply connected to an understanding and knowledge of specific London sites and their ongoing, ideologically motivated transformations under Thatcher. "I wouldn't wish the eighties on anyone," Jarman writes in *At Your Own Risk*. "It was the time when all that was rotten bubbled to the surface."[1] In *The Last of England*, perhaps his most fluent, personal, and political feature-length film, art and politics coalesce, though not in any tidy way. The process of the filmmaking (a collaborative, opportunist, unscripted, shoestring venture) and the content of the film (a nonlinear narrative focused around a set of overlapping political ideas) find their meeting place in London's Docklands. The use of this location is no accident. The redevelopment of the Docklands was a flagship project for

Thatcher's radically neoliberal, market-driven restructuring of Britain. Describing the feeling of "complete catastrophe" depicted in the film, William Pencak notes, "Thatcher's economic policies in the eighties led not only to the destruction of traditional England, but even modern factories and housing projects degenerated into slums and then ruins."[2] In the mid-1980s, the derelict industrial sites where Jarman locates his film are places richly layered not only with historical but also with contemporary political meaning. In a condition-of-England film that seeks to explore the collision of the past and present as filtered through Jarman's individual memories, London's Docklands represent many things: an endpoint of industrial modernity, a contemporary social struggle in the context of Thatcherite neoliberalism, a paradoxical site of both spiritual malaise and artistic freedom at the city's margins, a place of departure (even possibility?) for those set adrift in the film's conclusion. The place of the Docklands in *The Last of England* is the place of Britain in the 1980s: brutal, spent, and undergoing the radically damaging forces of neoliberal ideology.

JARMAN'S WAREHOUSES

From 1969 to 1979, Jarman lived on the river Thames in disused warehouses in varying states of decline, and it was in these abandoned buildings that he developed fully his artistic and filmmaking practice. As he recalls in his first book of autobiographical reflections, *Dancing Ledge* (1984), these warehouses were central to his art across different media; it was "an entire style of life that had enabled me to paint, and to make the Super 8 films."[3] His first "exhilarating" warehouse was an abandoned corset factory in Upper Ground near Blackfriars Road, "the old brick buildings—all of which have now disappeared under improvements—a delight":

> The area was deserted since the docks had been moved further down river. Returning home late at night down these empty streets you felt the city belonged to you. In the mornings you would be woken up by the tug *Elegance* towing the barges down river. The seagulls would desert them for a moment and come to catch the bread from your hand. The riverside was my world for another nine years, before the invasion I pioneered with Peter [Logan] turned the few remaining buildings into DES. RES.[4]

The sort of creative community he helped establish there continued when he was forced to leave Upper Ground when his building was planned for demolition to make way for the King's Reach tower that would house the IPC media group.

From Upper Ground, he went to the top floor of a warehouse in Bankside, nearly opposite St. Paul's, where his artistic community flourished anew:

> That summer was an idyll, spent sitting lazily on the balcony watching the sun sparkle on the Thames. When I wasn't painting I worked on the room and slowly transformed it into paradise. I built the greenhouse bedroom, and a flower bed which blossomed with blue Morning Glories and ornamental gourds with big yellow flowers. On Saturdays we gave film shows, where we scrambled Hollywood with the films of John du Can from the Film Co-op—*The Wizard of Oz* and *A Midsummer Night's Dream* crossed with Structuralism. There were open poetry readings organized by Michael Pinney and his Bettiscombe Press. Peter Logan perfected his mechanical ballet, and Michael Ginsborg painted large and complicated geometrical abstracts. Keith Milow came down and worked for a month, discovering a plasterer's comb which he drew though his thick paint in spirals.[5]

Elsewhere, Jarman describes the light dancing across the river and the pink clouds that turn "all the colours of Pontormo angels" before becoming "emerald shadows floating away to the sea"; light through windows is transformed into "the richest of ruby necklaces," and the flaming sun splashes "scarlet into the eddies left by the barges."[6] Jarman's romanticized vision of warehouse life in those halcyon days of 1971 combines the intense colors of a Turner landscape with the urban poetics of a Whistler nocturne. His artistic life among friends and amid the relative emptiness of the warehouses provided him with an environment in which his creativity thrived.[7] Moved on once again by the arrival of regeneration and the wrecking ball, Jarman bid farewell to Bankside with a cinema tribute:

> We closed the doors for ever at Bankside this evening after a showing of *A Midsummer Night's Dream* and *The Wizard of Oz*. When the films were over I didn't turn the lights on, so we all crept out of the building in the dark. Downstairs I shut the massive padlock. The demolition men, who have been tearing down the buildings all around us, will be in next week. Before winter there will be just a hole in the ground and Horseshoe Alley will be no more.[8]

From Bankside, he moved to his final warehouse, one of London's largest Victorian warehouse structures at Butler's Wharf, east of Tower Bridge, where he stayed until 1979.

The derelict warehouses were revived by Jarman and his friends, and significantly, the warehouses provided the environment in which he developed his Super 8mm home movies, which are at the very center of his artistic practice. Short films like *Studio Bankside* and *One Last Walk One Last Look Bankside,* both shot in 1972, capture something of warehouse life in the early 1970s and provide a lasting record of these long since regenerated buildings (i.e., converted to expensive flats and shops). One of the things that drew Jarman to warehouse living was the possibility for a world—or lifestyle, at least—beyond the reach of conventional, heteronormative private property and ownership. That same politics drew him to Super 8mm filming, which offered the freedom of being apart from official systems of cultural production. "I disliked the subsidized 'avant garde' cinema," Jarman tells us, "but super 8, which cost next to nothing, allowed one to ignore that. The resources were small enough; so if independence were a form of purity, I had my hands on the philosopher's stone."[9]

These 1970s warehouse movies, shot on a basic Nizo Super 8mm camera, echo the home movies shot by Jarman's father and grandfather, an important feature of *The Last of England.* Documenting his life along the river and using his home and adjacent spaces as locations for his work was, in a sense, familiar and natural, even as it placed his life and home at the center of his art. As his biographer Tony Peake suggests:

> As a painter, Jarman had never shown much inclination towards portraiture; as a film-maker, this was to become one of his strongest impulses. Super-8 suggested how he might more fully expand his life into art, thereby closing the circle. It was a way of further escaping Hockney's shadow and countering all those Californian pools with a celebration of specifically London friends in a specifically London milieu. A way of more truly becoming a London Warhol. Of finding a visual voice.[10]

The practice of Super 8mm filming, developed gradually in those various river warehouse spaces, remained prominent, even after Jarman moved relatively inland, to a tiny flat off Charing Cross Road. The interweaving of Super 8mm films and home movies seen in the Smiths promos is explored further in many of his feature-length films. *Jubilee, The Angelic Conversation* (1985), *The Last of England, War Requiem* (1989), *The Garden* (1990)—all these use Super 8mm to some extent, either blown up to video, which "gives you a palette like a painter," or to 35mm, which gives you an effect "like stained glass" with "wonderful colours."[11]

In his general resistance to 35mm and preference for Super 8mm, Jarman's

aesthetic sensibilities, his antiestablishment politics, and the filmmaking process itself all converge. First, these films often have an incomplete, even unprofessional style about them; they willfully refuse finish and polish, and though many of the films are heavy in symbolism and metaphor, there is rarely anything like conventional linear narrative.[12] In the first of two *Last of England* notebooks that Jarman kept in 1986–87, in which we can see the ideas for the project developing, Jarman jots down precisely such thoughts:

> *Intentions* to explore through metaphor and dream imagery, the deep seated malaise in current Britain. Stepping away from the traditional narrative feature in the social realist tradition whence structures are imported from without to explore in particular the roots of current rightwing philosophies and their necessity to find scapegoats. To set up a pattern of fear for repression and systems of control. To this end to explore the structure in which the image is controlled by emphasis on "quality" and therefore expense leading to the deliberate creation of rarity and monopoly.[13]

Later in the same notebook, he returns to this sentiment yet again:

> The film constructed round an almost imperceptible narrative (spontaneity is the life blood of Super 8 film). Freed from the constraint of narrative, and the control of formal film making in G.B. The image can take flight. Film here is manacled by the word the formal script necessary for a feature.

The improvisatory nature of the script is extended to the methods of production, which end up sounding haphazard, even random:

> We created a formal shoot at the Victoria Docks for a week in November and improvised within it. By this time I had several cameras on each scene; sometimes the people turned up. If not, I got on with it. Sometimes the cameramen got bored and wandered off with some of the actors. The location was pretty spectacular. You could get lost quite easily in the hundreds of derelict rooms. I gave as few directions as possible. Most of the scenes directed themselves.[14]

Following from his resistance to conventional film content and production, his Super 8mm films were mostly shown privately in the 1970s, outside art house

(let alone mainstream) networks of distribution and ownership, a kind of refusal to engage fully in the systems of capital that controlled cultural production and consumption. In *The Last of England,* the legacy of history is expressed particularly well by the juxtaposition of his father's and grandfather's home movies with his and his collaborators' Super 8mm footage. This produces a raw texture that Jarman believed would mitigate against the fetishization of quality that 35mm cultivates.

According to Jarman, *The Last of England* "works with image and sound, a language which is nearer to poetry than prose,"[15] beyond the grip of narrative and altogether different from the social realism of his peers, including Ken Loach and Mike Leigh.[16] Though there seem to be discrete sections to the film (which in part correspond to different moments when filming was possible, in spring, summer, or autumn 1986), and though there are distinct scenes—the manic disco, the parodic wedding, the firing squad, and so on—there is no sense of linear development. Images and ideas reappear, accumulate, and reverberate—images of fire and water, violence, and urban decay. The anchor for the film is its use of London's Docklands, which both metaphorically suggest waste, exhaustion, and fear and metonymically suggests the larger state of the nation in decline. If, as Jarman says in the second *Last of England* notebook, the film is about "the Dead Sea of post industrial decline whose stagnant waters erode the crumbling cities" and the "imperial twilight" in the context of a whole new developing class of "Margaret Thatcher's dream children, rich on style,"[17] the place that embodies and expresses this decline is London's Docklands.

"LOCAL LAND FOR LOCAL PEOPLE"

The Last of England is a kind of extended collage of contemporary footage shot in Liverpool, New York City, and London. Almost all the London footage was shot in locations hugging the river Thames in areas of postindustrial decline and/or burgeoning regeneration, in particular, the Royal Victoria Docks and their Spillers's Millennium Mills and Beckton, around the disused Victorian gasworks. The eastern reaches of the river beyond Tower Bridge—"miles of desolation with the odd post-modern office building," as Jarman describes it—had a high visual impact at the time: desolate, crumbling, eerie, uncanny, seemingly empty. As several critics of the film have noted, these sites are used for the suggestive way they provide an implicit critique of Thatcher's Britain by the mid-1980s. However, the specific sites in *The Last of England* locate the film in a more explicit political and historical moment, in which the state-endorsed forces of urban renewal and the rights of local communities clashed. Jarman's Docklands point to both a more

localized and a more globalized understanding of the film than has as yet been acknowledged.[18] On one hand, the Docklands were the site of a struggle between the wishes of government, private enterprise, and the mostly working-class local citizens in the context of a gradual undermining of local borough powers; on the other hand, the ongoing transformation of the Docklands needs to be seen in the context of Thatcher's radical revision of contemporary Britain and the global rise of neoliberalism.

The Royal Victoria Docks at the center of *The Last of England* have a particularly interesting history that allows us to see clearly the neoliberal turn in late modernity. The mile and a half of open water and ten miles of quays known as the Royal Docks, or "Royals," includes the Victoria Dock (established in the 1850s) and the Albert Dock (dating from the 1880s). Developed by railway tycoons, the Victoria complex of docks and wharves was notable for its innovative technologies: it was the first dock to be developed expressly for steamships and hydraulic machinery, and it linked directly with the railways that made their way to the wharves. This joined-up system of transport and distribution, linking steamship to railway, provided an almost seamless movement of goods (mostly grain) to and from America and colonial ports to the metropolis and beyond. In the 1930s, the Royal Victoria was extensively rebuilt for a new era, with a vast new complex of warehouses, grain elevators, and silos replacing their Victorian predecessors. It was at this time that Spillers's Millennium Mills—the place where most of the warehouse interiors and all the dockside footage was shot for *The Last of England*—was built.[19] By the 1950s–1960s, the docks were becoming increasingly out of date and disused, and as the commercial activity of the docks decreased, local unemployment increased, reaching a staggering 20 percent in the 1980s.[20] In the spirit of urban planning that gripped many western European cities in the postwar period, major plans for reconstruction were considered. As the *Docklands History Survey* puts it:

> Planning was not concerned with the simple care and maintenance of what already existed, even if it was seen to be working well. Planning was about change—largely with directing and partly with initiating it but, in either case, with continuous change seen as not merely natural but absolutely necessary.[21]

Various plans for change, great and small, continued throughout the 1970s, and increasingly radical ideas for redevelopment took hold. Tellingly, the kinds of redevelopment projects that forced Jarman from his warehouse homes in the

1970s and turned those sites into luxury residences and shops were being con-
tested in relation to London's vast Docklands. By the 1980s, the interests of the
state, private enterprise, and local residential communities (working class but
increasingly multicultural as new immigrant populations arrived from, e.g., East
Africa) collided as the Docklands became the site of one of the most ambitious
urban redevelopment plans in Europe in the twentieth century.

The battle lines were drawn with the establishment, in 1981, of one of the
government's new Urban Development Corporations, the London Docklands
Development Corporation (LDDC), which Sue Brownhill calls "the flagship of
the radical right's attempts to 'regenerate' inner city areas by minimising public
sector involvement and maximising the private sector's."[22] It was the election of
Thatcher's Conservative government in 1979 that enabled the private enterprise
model of urban regeneration to take hold, and the regeneration of the Docklands
was the highest-profile instance of the new private enterprise–led initiatives:

> The LDDC came to be seen as the epitome of this policy, with its gov-
> ernment-appointed board replacing locally elected councillors, its lack of
> attention to the views and needs of local residents, its concern to attract
> high-value developments and its ideology of allowing the private sector to
> play the leading role in determining the pattern of land uses.[23]

What is striking about the LDDC is the extent of its powers, as its own literature
acknowledges:

> To enable it to set about its task, Government provided the Urban Devel-
> opment Corporation with unprecedented powers, unprecedented in that
> they were previously only exercised by local authorities acting as elected
> bodies. The Board of the Corporation, some 12 members in all, was made
> directly responsible to, and appointed by the Secretary of State for the
> Environment.[24]

This would be redevelopment from the top down, overseen by a minister in
Thatcher's cabinet, the free-market evangelist Michael Heseltine. According to
a 1981 report on the founding of the LDDC, the tensions between corporate,
financial forces and local people were there from the very beginning because the
LDDC was seen as an "attack on local democracy," a ruling body "imposed on the
area against the wishes of the local authorities."[25] As it was mandated to do, the

LDDC moved swiftly in making changes, and by 1982, so-called enterprise zones had been established in the Docklands, a new transport system (the Docklands Light Railway, or DLR) had been proposed to Parliament, and a design guide had been produced for the Isle of Dogs area of the Docklands. This was merely phase 1 of the LDDC's plans. By 1987, the Royal Docks redevelopment had been agreed, the London City Airport and DLR had opened, and plans for Europe's largest commercial tower block, Canary Wharf, were under way in an attempt to lure the financial industries east and create a "Wall Street on Water." This was phase 2 of the LDDC's plans.[26] The LDDC's extensive redevelopment plans, in the interest of private enterprise, were not the only options available, and local government councils and numerous local groups put forward a range of initiatives for how the disused Docklands might be used. However, in the power struggle with national government and the LDDC, local interests never had much of a chance, and concessions were limited.

The Royal Docks constituted one of the largest land areas in the wider Docklands project, and with its rich history, the site was a magnet for fierce opposition to LDDC plans. Newham Council, the borough where the Royals are located, and the Greater London Council (GLC), a London-wide administrative body overseeing local government that was disbanded by Thatcher's government in 1986, joined forces to produce the so-called People's Plan for the Royal Docks:

> The GLC linked up with the Newham Docklands Forum to present an alternative strategy for the area, based on the principle of "meeting needs and making jobs." In this way the Plan was concerned to link employment proposals with housing and community issues, in an attempt to restructure the locality on non-market criteria. As such it stood in stark opposition to the LDDC's plans for the Royal Docks and the restructuring of housing and the local economy. . . . This was to be an alternative way of linking housing and labour markets, and an alternative way of involving people in redevelopment.[27]

An example of the GLC's popular planning initiative, the People's Plan sought to incorporate the views not only of local groups but also of trade unions. "Taking a wider view of democracy," Brownhill writes, "and through consultation and trying to overturn the social control aspects of planning, popular planning was part of the attempt to be 'in and against the state.'"[28] The reasons for the LDDC's defeat of the People's Plan are complex and intricate; suffice it to say that the market-driven

LDDC had money, power, and the blessing of the national government behind it. When Jarman captures the graffiti "LDDC are Bloody Thieves" and "Local Land for Local People" in his Super 8mm footage, it is precisely this local struggle that he brings to bear on his films.

The Royals—the largest, most innovative, and most visually impressive of the nineteenth-century docks—were once a symbol of the strength of a prosperous industrial economy, with all the social inequalities it necessarily entailed. By the 1980s, they were a symbol of the shift in late modernity from production to finance—the docks had been converted into either an airport that serviced international financial institutions or luxury flats, hotels, and convention centers. David Harvey's work on the rise of neoliberalism over the past fifty years helps us place the local struggles in the Docklands in a global context. In Harvey's account, "the interests of private property owners, businesses, multinational corporations, and financial capital" converge to shape what constitutes the freedom of the individual.[29] Thatcher was one of the great proponents of radical neoliberalism, and the LDDC was shaped in the image of Thatcherism. According to Harvey, Thatcher's plan to reverse the "stagflation" trend of the 1970s

> meant nothing short of a revolution in fiscal and social policies, and immediately signalled a fierce determination to have done with the institutions and political ways of the social democratic state that had been consolidated in Britain after 1945. This entailed confronting trade union power, attacking all forms of social solidarity that hindered competitive flexibility (such as those expressed through municipal governance, and including the power of many professionals and their associations), dismantling or rolling back the commitments of the welfare state, the privatization of public enterprises (including social housing), reducing taxes, encouraging entrepreneurial initiative, and creating a favourable business climate to induce a strong flow of foreign investment (particularly from Japan). There was, she famously, declared, "no such thing as society, only individual men and women"—and, she subsequently added, their families.[30]

Certainly local communities, local government, trade unions, and others did not have anything like the power or money to hold back the neoliberal forces at work in reshaping the Docklands. In short, the LDDC's transformation of the East End provides a case study in the processes of radical neoliberalism.

The myth at the heart of neoliberal wealth creation is that though extreme

wealth is created for new financial elites, the benefit of that wealth will somehow trickle down; the myth at the heart of neoliberal urban regeneration is that local communities will necessarily benefit (through increased employment, facilities, and the like). Neither seems to have been the case in the Docklands. The new employment that was promised in the first decade never fully materialized, not in the net numbers expected. Many of the jobs created in the Docklands were simply job relocations from other parts of London—for example, the newspaper industry moving east along the river—and many of the job training programs envisioned through LDDC-sponsored courses never created newly trained, skilled workers for the local market.[31] Affordable housing wasn't even part of the LDDC's brief when it was established in 1981, so efforts to build new homes, or to rehouse people displaced by redevelopment, were never a primary focus. In short, "up to 1986, the LDDC was convinced that redevelopment itself would benefit the whole community—by removing dereliction, giving a choice of housing, and bringing jobs into the area. The trickle-down never materialised, and as the 1980s came to a close both the LDDC and the government acknowledged the need to integrate 'social programmes' into the Corporation's remit."[32] In the case of the Royals, the story is more telling still because the much-promised redevelopments have never been completed. Today, on the north side of the Royal Victoria sits the gleaming white, architecturally insignificant exhibition and conference building called the Excel Centre; on the south side sit rows of identical flats, but also the empty quays and warehouses still owned by the LDDC. Millennium Mills, like the silos and other warehouses alongside it, sits empty and unused, ironically protected as a national heritage site, though one surrounded by security fences and protected by closed-circuit television.

IMPRISONED MEMORIES

Though some redevelopment plans considered for the Docklands included getting rid of the docks and wharves altogether by filling in the water to create more land on which to build, the LDDC understood (if in a misguided way) that the unique landscape of the waterways in the Docklands provided a special sense of place. The LDDC hoped to exploit the particularity of the Docklands by selling them as Manhattan-meets-Venice. "Looks Like Venice. Feels Like New York" stated one marketing slogan for the Isle of Dogs.[33] Denying the actual history of the docks, its communities and buildings, the LDDC opted for a heritage-lifestyle version of history manifested, for example, in the craze for so-called warehouse living in the 1980s and 1990s. If not quite a total denial of place, it was certainly a travesty of history.

Jarman's book of memoir and recollection, also called *The Last of England* and covering the period of making the film, emphasizes the complex, sometimes tense relationship between past and present, and the sense of rupture at the center of Thatcher's Britain is imagined as a set of temporal disjunctions.[34] For him, the film is a kind of dream allegory led by the figure of the author (Jarman, seen writing at the beginning of the film). "Here," he tells us, in a particularly modernist formulation, "the present dreams the past future":

> The audience should be able to "read" the film fairly easily. This man is destitute, this is a marriage. Its structure suggests a journey: pages turn in a book bringing with them new turnings in direction, building up an atmosphere without entering into traditional narrative.[35]

Later, he says that *The Last of England* "is a film that works by evoking memories; these will be different for each person, the film is illusive."[36] Jarman's own memories appear through the home movies that link his middle-class childhood in suburban villas on Royal Air Force bases to the wasteland of the present: "I gave the desolation continuity in the film by relating it to the camouflaged married quarters at RAF Abingdon with their garden fences topped with barbed wire, and RAF Lossiemouth with its H-Blocks."[37] In one sequence toward the end of the film, home movie footage shows both young Jarman playing in the back garden of his RAF home and marching guardsmen and soldiers on parade; this older footage is juxtaposed with contemporary Super 8mm images depicting the sort of violence and militarism that thematically and visually link past and present throughout the film. We see urban terrorists, whom Jarman says represent "the establishment,"[38] wearing balaclavas, carrying machine guns, and prowling the docks; we see a poppy wreath in water, evoking our ritual memorialization of twentieth-century conflicts. As we watch the home movies, we hear first Elgar's triumphant "Land of Hope and Glory," almost a theme song for British nationalism, and then the wailing of air-raid sirens as the image on screen shifts back to the present, to the dock at Millennium Mills. In another sequence, historical memory accumulates similarly. On the edge of the dock, a group of refugees (or outcasts? or prisoners?) sit around a fire, watched over by the urban terrorists (Figure 4.2). In the distance, on the north side of the dock, we see the odd, imposing shape of the docks' old hydraulic lifts, and we hear Marianne Faithfull singing "The Skye Boat Song," a traditional Scottish song recalling the escape of would-be Stuart heir Bonnie Prince Charlie after the Jacobite defeat at the Battle of Culloden in 1746. The romantic

Figure 4.2. A terrorist oversees refugees on London's Royal Victoria Docks, where Jarman filmed much of *The Last of England* (1987). The hydraulic lifts that define the disused landscape were awaiting development by the London Docklands Development Corporation at the time Jarman was filming.

fantasies of British nationalism (Elgar) and Scottish nationalism ("The Skye Boat Song") provide the sound track for contemporary militarism, only a few years after Thatcher's nationalistic Falklands War.

The frenetic montage sequences in the film, with their rapid editing of sound and image, suggest narrative possibilities without ever insisting on or fully developing them. If the film is a modernist dream allegory that works through historical juxtaposition, it is also a kind of tempestuous memory chamber. "The film is an attic," Jarman says, and "I've opened the doors":

> Think of the mead hall in Beowulf, with the swallow flying through. . . . Think of that mead hall full of the junk of our history, of memory and so on; there's a hurricane blowing outside, I open the doors and the hurricane blows through; everything is blown around, it's a cleansing, the whole film is a cleansing.
>
> I need a very firm anchor in that hurricane, the anchor is my inheritance, not my family inheritance, but a cultural one, which locates the film IN HOME.[39]

Interestingly, Jarman conflates two very different eighth-century texts here—the heroic epic *Beowulf* and Bede's *Ecclesiastical History of the English People*—both of which are founding texts in understanding the origins of England and English culture. The King's mead hall in *Beowulf* is where the hero defeats monstrous Grendel in

an act of symbolic cleansing, which clearly sticks in Jarman's mind. But the story of the swallow (in fact, a sparrow) who flies out of a violent winter storm into the king's hall comes from Bede, in which the sparrow's flight signifies a profound temporal and epistemological shift because the "junk of our history" that is being blown about comprises fundamental belief systems now challenged by the arrival of Christianity.[40]

Millennium Mills in Royal Victoria Dock, where most of the staged scenes, including the wedding, the disco, the spinning globe, and the execution, are set, is like an attic of memories, and its vast industrial interiors are like Bede's hall, made turbulent by the clash of old and new. Jarman seeks to capture this turbulence, in particular, toward the end in the sequence of Tilda Swinton's frenzied, whirling dance in the wedding dress. The warehouse not only evokes Jarman's personal history by recalling his warehouse homes of the 1970s but also suggests other local, national, and global historical possibilities, all blowing around in the film at once. The warehouse at Millennium Mills stands in for "home": a complicated concept, enmeshed with ideas of nation, tradition, creativity, and place, to which Jarman returns frequently in his films and writing.

Simultaneously, Jarman's particular past is embedded in the montage of sound and images alongside "things that happened to us all."[41] "Hope lies, if anywhere," Pencak suggests, "in remembering the past, in scavenging the trash—that is, in a critical awareness of history."[42] Put another way, Jarman's hope for a collective cultural inheritance, "which locates the film IN HOME," is imagined through an aesthetic of fragmented images that appear throughout the *Last of England* note-books. These snatches of text, the junk of our literary history, show us many possible points of reference and contact, all blowing around in Jarman's mind. On a page in the first notebook, in gold ink on black paper, he writes:

> Father mortgaged his 3 score years and 10 1.65 kids overdrawn at the bank— a nuclear family on the never never. His fathers fathers fathers presentation clock a black marble mausoleum celebrating 50 years in insurance—ticked out the generations * and you Johnny after all that skooling falling off the fucking cogs of the wheel of misfortune—a bender in 501s out to lunch notching up the ponces in the disco.[43]

This fragment gets rewritten and developed to become one of the prose poem voice-overs that punctuate the film:

> My teacher said, there are more walls in England than Berlin, Johnny. What were we to do in those crumbling acres, die of boredom?—or re-create

ourselves, emerging from the chrysalis all scarlet and turquoise as deaths-heads from gyp plants, moths of the night, not your clean-limbed cannon fodder for the drudgy nine-to-five, sniffing glue instead of your masonic brandies. We fell off the cogs of misfortune, out to lunch in 501s, notching up the pricks in the disco, we heard prophetic voices. I saw the best minds of my generation destroyed by madness, starving, hysterical, naked, not with a bang but a whimper. And gathered everything you threw out of your dream houses, treasured your trash cans, picking through the tatters of your lives, we jumble the lot and squat in your burnt-out hearths. Your world, beavering away at its own destruction, serviced the profit machine and creaked to a halt, not with a bang. Even our protests were hopeless; neat little marches down blind alley. . . . Citizens stood mute, watching children devoured in their prams, and all you did in the desperation was celebrate the Windsors yet again, old cows staggered to the slaughterhouse to emerge as roast oxen.

There is, of course, no one-to-one, illustrative correlation between verbal text and image, and the prose poem is excessive, piled up, continually pushing the viewer–listener outside the content of the film. The Berlin Wall and the freedoms won in the wake of World War II, the threat of nuclear annihilation, the consumerist hedonism of urban gay life, the redundancy of monarchy in the late twentieth century—all these find their way into the voice-over. This latter-day modernist poem conspicuously cites other radical, formally experimental voices. Allen Ginsberg's queer performance poem "Howl" (1956)—a railing against American consumerism, militarism, and compulsory heterosexuality—begins:

> I saw the best minds of my generation destroyed by
> madness, starving hysterical naked,
> dragging themselves through the negro streets at dawn
> looking for an angry fix,
> angelheaded hipsters burning for the ancient heavenly
> connection to the starry dynamo in the machinery of night . . . [44]

Jarman combines Ginsberg's opening lines with the last line of T. S. Eliot's "The Hollow Men" (1925)—"This is the way the world ends / Not with a bang but a whimper"—and creates a collage of words that puts his film in touch with another kind of history, a literary history of radical innovation.[45]

It is the romantic visionary William Blake, however, who haunts the pages of the *Last of England* notebooks. Jarman's fragmented reflections about nuclear apocalypse, the atom bomb, and dysfunctional nuclear families in thrall to private property sit alongside numerous references to Blake's lyrical poem of social criticism, "London." On one page, Jarman writes:

> Blakes Poem. *London*
> on each street
> marks woe
> etc.

Elsewhere, he incorporates the famous "Harlot's cry" into a poem fragment or simply writes the poem out in full. There are many reasons why Blake's "London" might provide a touchstone at the time Jarman is thinking through the possibilities for his film. In "London," the city's "mind-forg'd manacles" suggest a kind of psychological imprisonment in the city,[46] and perhaps Jarman has in the back of his mind Blake's "charter'd streets," which seem to echo in the clash over land in the contemporary Docklands. But we need not be too literal about Jarman's interest in Blake, who was, after all, a prophetic radical and dissident artist who worked across media and reconfigured texts drawn from a distant, mythic English past. According to Gray Watson, Jarman was drawn to "the giant Albion, the original (and androgynous) Cosmic Man, an image of perfection and completeness, who is fallen (broken) and must be redeemed (re-membered)":

> Albion, in his fallen state, was the subject of the 1984 painting series "GBH," as well as of the films *Jubliee, The Last of England* and *Imagining October*. If England, this sceptered isle, has fallen into chaos and disarray, and needs to be redeemed, this is the manifestation at a national, political and historical level of an archetypal pattern of fall and redemption which embraces each individual psyche as well as the whole cosmos.[47]

GBH—or grievous bodily harm, as it is officially known in English law—lingers in the *Last of England* notebooks as a possible title for the film and suggests an imaginative link for Jarman with the dissident Blake but also a way of bringing into the present a romanticized English past.[48]

Jarman's quoting of literary history should not be interpreted as a form of playfully postmodern historical pastiche. Jarman is a latter-day modernist, searching

for a form that somehow holds in place, if not quite fully contains, fragments and layers of culture that might provide some cultural resonance, if not quite cohesion, at a time when Thatcher tells the nation that society does not exist. The Royal Victoria Docks provide a place where histories collide. Both a site of contemporary political struggle in the rise of right-wing neoliberalism in Britain and a relic of the industrial past, the abandoned docks and quays, with their curious decrepit beauty in the midst of late modernity, provide a place of historical rupture. In *The Last of England*, Bede's mead hall becomes a warehouse; Jarman opens the door to memory and history and lets the junk blow around.

NOTES

Thanks to Jason Narlock for his excellent research assistance and many helpful conversations and to Nathalie Morris at the BFI National Library Special Collections.

1 Derek Jarman, *At Your Own Risk: A Saint's Testament* (Minneapolis: University of Minnesota Press, 2010), 95.
2 William Pencak, *The Films of Derek Jarman* (London: McFarland, 2002), 144.
3 Derek Jarman, *Dancing Ledge* (Minneapolis: University of Minnesota Press, 2010), 196.
4 Ibid., 88.
5 Ibid., 97.
6 Ibid., 107.
7 Jarman enjoyed the warehouse culture of other cities, too. He writes of his summer in New York in 1974, spent having orgies in gay bathhouses and cruising the West Side piers: "On the derelict piers you left the imprisoned daylight world behind. . . . You walked through a succession of huge empty rooms, with young men often naked in the shafts of light which fell through the windows. The piers had their own beauty; surrounded by water, they were a secret island." Derek Jarman, *The Last of England*, ed. David L. Hirst (London: Constable, 1987), 63. Not only a site of cruising for queer culture, the West Side piers also became an important artists' space in the late 1970s; see, e.g., artist and writer David Wojnarowicz's account of the warehouses in *In the Shadow of the American Dream: The Diaries of David Wojnarowicz*, ed. Amy Scholder (New York: Grove Press, 1999), 116–129.
8 Jarman, *Dancing Ledge*, 109.
9 Ibid., 120.
10 Tony Peake, *Derek Jarman* (London: Little, Brown, 1999), 180.
11 Jarman, *Last of England*, 185.
12 On the deeply metaphorical and allegorical nature of Jarman's films, see Steven

Dillon, *Derek Jarman and Lyric Film: The Mirror and the Sea* (Austin: University of Texas Press, 2004).

13 *The Last of England* notebooks, Derek Jarman Collection, Box 12, BFI Special Collections.

14 Jarman, *Last of England,* 197–99.

15 Ibid., 186–87.

16 For a range of discussions of Jarman and his filmmaking peers in the 1980s, see the collection of Lester Friedman, ed., *Fires Were Started: British Cinema and Thatcherism* (Minneapolis: University of Minneapolis Press, 1993), and see Peter Wollen, "The Last New Wave: Modernism in the British Films of the Thatcher Era," in *The British Avant-Garde Film, 1926–1995: An Anthology of Writings,* ed. Michael O'Pray, 239–59 (Luton, U.K.: University of Luton Press, 1996).

17 *The Last of England* notebooks, Derek Jarman Collection, Box 12, BFI Special Collections.

18 Though critics commenting on the film have noted the prominence of derelict warehouses and urban wasteland, they have not been specific or detailed about the precise areas of dockland Jarman shoots. See, e.g., Michael O'Pray, *Derek Jarman: Dreams of England* (London: BFI, 1996), 158–59.

19 On the history of the Royal Victoria Docks, see D. J. Owen, *The Port of London: Yesterday and Today* (London: Port of London Authority, 1927) and John Pudney, *London's Docks* (London: Thames and Hudson, 1975).

20 London Borough of Newham, "The Newham Story: A Short History of the London Borough of Newham," http://www.newham.gov.uk/AboutNewham/HistoryofNewham.htm.

21 Greater London Council, *Docklands History Survey: A Guide to Research,* preliminary ed. (London: Greater London Council Historic Buildings Division for the Docklands History Survey Management Committee, June 1984), 1.

22 Sue Brownhill, *Developing London's Docklands: Another Great Planning Disaster?* (London: Paul Chapman, 1990), 1. For a more detailed discussion of Thatcherism and urban planning, see Philip Allmendinger and Huw Thomas, eds., *Urban Planning and the New Right* (London: Routledge, 1998), and for another study of the development of docklands, see Janet Foster, *Docklands: Cultures in Conflict, Worlds in Collision* (London: UCL Press, 1999).

23 Brownhill, *Developing London's Docklands,* 5.

24 London Docklands Development Corporation, *Initiating Urban Change: London Docklands before the LDDC* (London: London Docklands Development Corporation, 1997), 13.

25 David Billingham, *The Creation of the LDDC: A Study of the Conflict between Central and Local Government* (London: Polytechnic of Central London, School of Environment Planning Unit, 1981), 52. The undemocratic nature of the government's Urban Development Corporations is noted even by those who generally support them. See, e.g., John Loveless's report for the Adam Smith Institute *Why Wasteland? A Critique of Urban Land Policy* (London: ASI Research, 1987),

33: "The example of the London Docklands Development Corporation in getting devastated areas of East London moving again after decades of deliberate blight is certainly one which should be applied elsewhere. However, as essentially undemocratic institutions, UDCs can have no long-term justification in a democratic society, and like the New Town Development Corporations, they should be given a limited lifespan and be required to dispose of their assets at the end of it."

26 On the phases of LDDC development, see Gerry Vignola, ed., *The Docklands Experiment: A Critical Review of Eight Years of the LDDC* (London: Docklands Consultative Committee, 1990), 8.

27 Brownhill, *Developing London's Docklands*, 125.

28 Ibid.

29 David Harvey, *A Brief History of Neoliberalism* (Oxford: Oxford University Press, 2005), 7.

30 Ibid., 23.

31 Vignola, *Docklands Experiment*, 28.

32 Ibid., 58.

33 Brownhill, *Developing London's Docklands*, 48.

34 A number of critics have commented on history and memory in the film; see, e.g., Pencak, *Films of Derek Jarman*, 145, and Lawrence Driscoll, "The Rose Revived: Derek Jarman and the British Tradition," in *By Angels Driven: The Films of Derek Jarman*, ed. Chris Lippard (Westport, CT: Greenwood Press, 1996), 77.

35 Jarman, *Last of England*, 188.

36 Ibid., 204.

37 Ibid., 200.

38 Ibid., 196.

39 Ibid., 208–11.

40 See Bede, *The Ecclesiastical History of the English People*, ed. and trans. Judith McClure and Roger Collins (Oxford: Oxford University Press, 1999), 94–96. Thanks to my colleague Clare Lees, who pointed out the conflation of the two Anglo-Saxon texts in Jarman's recollection.

41 Jarman, *Last of England*, 207.

42 Pencak, *Films of Derek Jarman*, 145.

43 *The Last of England* notebooks, Derek Jarman Collection, Box 12, BFI Special Collections.

44 Allen Ginsberg, *Howl* (San Francisco: City Lights, 1956/1959), 9.

45 Eliot's "The Waste Land" (1922) looms large in the film, and there are many references, both direct and indirect. At one point, we see footage of a crowd on a bridge crossing the Thames, surely reminding us of Eliot's "unreal city": "Unreal City, / Under the brown fog of a winter dawn, / A crowd flowed over London Bridge, so many, / I had not thought death had undone so many." On Jarman's use of Ginsberg and Eliot, see Dillon, *Derek Jarman and Lyric Film*, 170, and Pencak, *Films of Derek Jarman*, 145.

46 Susan J. Wolfson writes of this image that "the manacles are invisible in the social and institutional forces of their forging; it is their consequences, a city where 'every Man' . . . cries in pain before sighing into death, that is the devastating recognition." See Wolfson, "Blake's Language in Poetic Form," in *The Cambridge Companion to William Blake,* ed. Morris Eaves (Cambridge: Cambridge University Press, 2003), 81.

47 Gray Watson, "An Archaeology of the Soul," in *Derek Jarman: A Portrait* (London: Thames and Hudson, 1996), 44.

48 Although *The Last of England* is a personal and particular dystopian vision of London, it can usefully be compared with other London films that address industrial and national decline. See esp. Patrick Keiller, dir., *London* (1994), with its focus on the built environment of the city and its use of a highly literary voice-over to explore the state of the nation.

PART II | Place as Index of Cinema

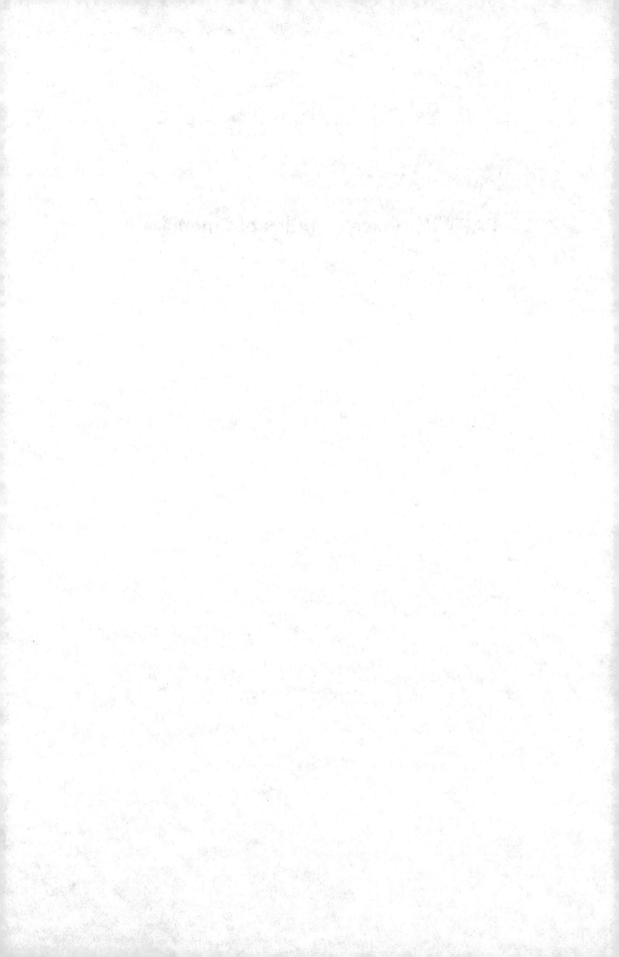

5 | The Cinecittà Refugee Camp, 1944–50

NOA STEIMATSKY

> Yes, they have sacked and destroyed it; the few remaining build-
> ings accommodate only destitute, displaced families. But permit
> me to believe that on the highest wall, within the concealing yel-
> low foliage, an empty movie camera continues to roll on, its lens
> focused on the clouds, waiting for a poet to find it, dust it off, set
> it finally before men and facts and, with neither fake models nor
> backdrops, expose it, *al naturale,* to our sorrow and our hopes.
> —Gino Avorio, "Schedario segreto," *Star* I, no. 1 (1944)

The conversion of one of Europe's largest movie studios, Cinecittà, to a refugee camp
has always seemed an odd footnote to the chronicles of Italian cinema. However,
as one recognizes its material and historical vicissitudes, its true magnitude, the
duration of its existence, and the broader social and political forces that governed
its development, the camp emerges as a stunning phenomenon and, in effect, a
prime allegorical tableau of its time. Once confronted, the existence of the camp
marks our vision of postwar film history and, in particular, of neorealism.

In that postwar era, the difficulty of obtaining shelter and basic sustenance
presented a most urgent material problem, acknowledged as such and as a symbolic
touchstone for the Italian imagination in the culture of reconstruction. It was in
this spirit that neorealism claimed to represent an authentic or pure reality of the
street, of hitherto unseen urban or regional locations. As a movement, it defined
itself *against* the perceived corruption of the studio, whose rhetoric of the colos-
sal and whose elaborate sets had been coopted and tainted by Fascism. Filming
on location—turning one's back on the studio as both institution and production
space—was also in part a practical solution to the Allied requisitioning of Cinecittà.

It now appears, however, that aspects of this practice, aesthetic, and ideology—
the central tenets of the neorealist mythos—were also founded on concealed, or
denied, vestiges of wartime events, on material circumstances and a human plight

whose astonishing reality was unfolding within the space of the film studio itself. This space, categorically rejected by neorealism, emerges, in the history to be re-counted here, as a glaring reality, as urgent and as eloquent as—though perhaps more complex and multifaceted than—that sought by the neorealists out in the street. The refugee camp—an entity meant to answer the basic needs of those who had survived the war but lost everything—was an eerily concrete counterpart to the artificial, fantastical world of the film studio. For like the film studio, it was a placeless place, set apart from the life outside. Compounding so many of the con-tradictions of its time, the Cinecittà camp emerges as a hidden, obverse figure of neorealism. In refocusing a light long extinguished, one can project it back on the very culture of reconstruction that could not incorporate it within any of its official narratives. The archival documents and images, and the gaps that still plague the history of the camp, will join in a description of the overlapping uses and mean-ings, the physical and figurative implications, of a uniquely warped space, at once actual and phantasmatic, allegorical and cinematic.

Looking through the first issues of *Film d'oggi* (Film of Today), a weekly paper of some eight pages, launched in the immediate postwar era, we find Vittorio De Sica, Luchino Visconti, and Gianni Puccini on the editorial committee. The war in Italy was just over, although Rome had been liberated a year earlier. In September 1945, it would see the premiere of Rossellini's *Rome, Open City,* the official launch of the neorealist season. The general outline of neorealist history is familiar: turn-ing their back on the Fascist studio production with its generic "white telephone" comedies, Rossellini and his colleagues turned to a more makeshift mode of pro-duction—part necessity, part ideology—in this first postwar moment. Beyond the circumstances of production companies and studios in disarray, the decision to go out to film in Italy's streets was motivated by a newfound interest in the chronicling of the everyday: key themes in this postwar, anti-Fascist vernacular are the urgent concerns of housing, sustenance, work, and importantly, the circumstances of children. Location shooting as neorealist ethic and aesthetic—though so often joined with melodramatic fiction—was invested with the authenticating value of reportage, witness to hitherto unseen corners and aspects of Italy. Attention to contemporary urban or regional spaces in the wake of war was matched by a rejection of institutional modes of studio production and of its crowning symbol, pride of the Fascist era: Cinecittà.

There seems to be little trace of this on the cover of the June 16, 1945, issue *Film d'oggi,* with its seductive glamour portrait of Vera Carmi from a film made that year in the studio tradition that never did die: Mario Soldati's *Le miserie di Monsu Travet* (The Misadventures of Mr. Travet), made by LUX, the single most

active producer of the time.[1] But already on the following page, the neorealist ethos is articulated: an announcement on the part of the journal and the Catholic production company Orbis for an open competition on the theme "It Really Happened," offering prizes of five, ten, and fifteen thousand lire (the equivalent today would be roughly 250, 500, and 750 euros, respectively).[2] The photograph depicts a man—who reminds us of the protagonist of *Bicycle Thieves* (1948)—comedically leaping in the air and beneath him the caption "HURRAH . . . I found what I have been looking for: a way to earn a nice sum of money by writing a letter, a postal card, or calling *Film d'oggi*. . . . EVERYONE can participate in this competition": a competition whose jurors will include, the announcement says, De Sica, Visconti, Michelangelo Antonioni, Cesare Zavattini, and among others, Alida Valli.

This was very much in line with neorealism's great call, so clearly voiced by its major advocate Zavattini and following the heroic thematics of the Resistance and the Liberation, for the cinematic exploration of the everyday. "Our competition aspires to the truth of daily life," specifies the announcement. "We want true facts that happened during the war. Report those to us as well as you can, without concern to embellish these facts, or to write them 'well.' This is the novelty of our competition. EVERYONE, from worker to housewife, can become an author, a film author, simply by informing us of a true story." In his authoritative history of Italian cinema, Gian Piero Brunetta comments on this ad, noting the gap between the trust in the potential creativity of individuals that encapsulates the heart of Zavattini's poetics and the devastated structures of film production in this moment. Yet here was an immense and optimistic energy capable of evolving even in the absence of stable structures of production.[3] The impoverished condition of the studios made a virtue of necessity. The institutional crisis was in fact to serve diverse production practices and ideological variants, even within neorealism, though all claimed a more authentic witnessing vis-à-vis the apparatus of studio production. Zavattini's call for a cinema of facts and the truth of daily life was itself more radical in theory than in practice, especially when one considers his own production at that time: the fairy-tale vision of children trotting away on a white horse in *Sciuscià* (Shoeshine), his work with De Sica in 1946, and later on, their depiction of a band of the dispossessed flying off on broomsticks in *Miracle in Milan* (Miracolo a Milano; 1951). Bittersweet films such as these, driven by earnest concern for those excluded from earlier Fascist fare, sought to smooth out the tensions of the moment, to establish a restorative narrative of affinities among classes and ideologies and across the ruined landscape: a redemptive vision exportable beyond Italy via the international dissemination of neorealism. But even harsher neorealist images, such as Rossellini's Neapolitan rubble heaps

or the open, vulnerable expanses of the Po delta in *Paisà* (1946), sought to forge an image of a purer Italy out of a "year zero" vision of reality—an authentic terrain to be found in the urban streets and in the regional landscape, sorted out from among the ruins of a more primal Italy.[4] Indeed, the reconstruction of Italian cinema was predicated on a founding myth that would distinguish it from the fictions and spectacles of Fascism—the tales and sets of the colossals and other genres that were epitomized by Cinecittà, which functioned as the state-owned prime producer of escapist artifice and propaganda.

Leafing through *Film d'oggi* in this as in subsequent issues, one finds an odd hybrid: eloquent photographs of a hitherto unseen terrain (Figures 5.1 and 5.2). These images have the haunting familiarity of neorealist iconography, yet we are not in any of its typical locales. We are in a unique site between bare postwar survival and ghostly fantasyland. This is the "desolate landscape of Cinecittà," as one caption reads, and these are among the few photographs documenting the grounds in summer 1945. They are accompanied by fund-raising ads on behalf of the journal itself. The first announcement reads:

> Cinecittà is no longer the easy kingdom of Fascist cinema . . . [which] did everything possible to forbid the true anxieties and sufferings of our people access to the Cinecittà studios. Whoever had once dared show—between one shot and the next—a barefoot and destitute child, or a mother forced to beg, would have been struck like a felon by the Minculpop [the Fascist Ministry for Popular Culture].
>
> Here they are now, these barefoot children. . . . Here are these mothers. They have been forced to storm the Cinecittà warehouses because they are now homeless, because their villages have been destroyed, and because Mussolini's war made them lose their remaining pittance.
>
> Today the reality that the dignitaries of yesterday's cinema did their utmost to exclude erupts violently in the old stately center . . . a serious lesson for our cinema, and to be kept in mind during the period of re-construction. This is a commitment that the Italian cinema must assume before the Nation.
>
> Meanwhile, in Cinecittà—not yet restored to the artists, the techni-cians, and workers of the Italian cinema—there are hungry children. This is why *Film d'oggi* has launched a fundraising initiative, the receipts of which—be it in cash or goods—will be entrusted to the Hon. Zaniboni, High Commissioner for Refugees. Anyone can contribute.

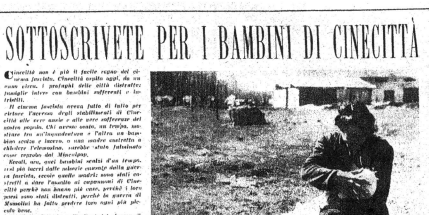

Figure 5.1. Fund-raising for the children of Cinecittà. Published in *Film d'oggi* I, no. 2 (1945). Courtesy of Biblioteca "Luigi Chiarini," Centro Sperimentale di Cinematografia, Rome.

The public is asked to follow the example of the starlet of the magazine cover and other personalities—from Gianni Agnelli and Carlo Ponti to Clara Calamai and Maria Michi, the new feminine face of neorealism—and contribute something for these destitute children, displaced in Cinecittà.[5] The neorealists on the board of *Film d'oggi* and sponsors of the fund-raising initiative were doubtless aware of the destitution of the refugees that now populated the studio grounds. The welfare of children was a widespread, grave problem everywhere: the Red Cross estimated that thirteen million children in Europe lost their natural protectors in the war.[6] It was indeed a major cinematic theme in this era. But the neorealists were to locate their raggedy little protagonists elsewhere. "Anyone can contribute," and perhaps "everyone" can make a film, yet for the children of Cinecittà, the neorealists donated something—even before the starlets and the industrialists contributed their money, Zavattini had come up with one kilogram of sugar—and went to work with their backs to the studio and to the camp.

Filming on locations insistently removed from the Fascist studio and its sets thus entailed a certain blindness. Filmmakers would not consider the possibility of

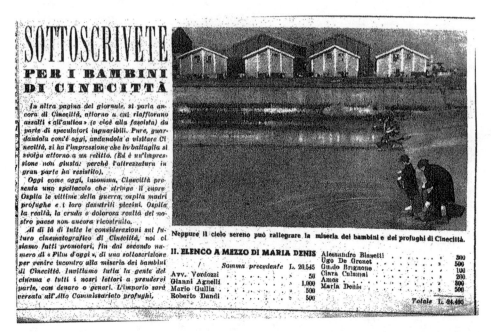

Figure 5.2. Fund-raising for the children of Cinecittà. Published in *Film d'oggi* I, no. 3 (1945). Courtesy of Biblioteca "Luigi Chiarini," Centro Sperimentale di Cinematografia, Rome.

locating in Cinecittà itself a reflection of the odd turns of reconstruction, wherein the urgent material and social ramifications of the war and its aftermath for daily life *itself* penetrated the very space of cinema. Neorealist culture could not tackle the ironic implications of a refugee camp being situated within the entity that was Cinecittà. One notes a certain degree of denial in the face of the extraordinary phenomenon of the camp. Both Giuseppe Rotunno and Marcello Gatti—cinematographers who had been imprisoned for anti-Fascist activities and returned to work in Rome in this period—recounted on separate occasions how professionals in the industry were aware of the camp on the studio grounds but could not face the *poveri disgraziati,* the "miserable wretches," who now populated to capacity what had previously been a state-of-the-art movie studio.[7] Film histories have been consistent with this attitude: the existence of the camp in Cinecittà is acknowledged, but with little detail and no analysis of this extraordinary six-year period, so closely considered in every other respect.[8] It obviously did not fit into the mythos of Cinecittà nor into that of neorealism. The refugees had been scattered over the globe, and many of those locals who lingered in the camps were the poorest of the poor and without communal support to preserve their memory. Thus avoidance, denial, or repression invested the refugee camp at Cinecittà with a certain psychic weight: it was an image that could not be confronted, an obverse reflection that could not

be incorporated by neorealism. But one must first briefly consider this setting in the period just preceding and as it brings us to this critical historical intersection.

Nine kilometers south of the Eternal City, the state-owned "cinema city" was inaugurated by Benito Mussolini on April 28, 1937.[9] Constructed in record time, it was deemed an achievement of Italian rationalist architecture and a demonstration of the up-to-date technical equipment and services that could be commissioned to support all stages of production for some sixty films per year, with about twelve hundred persons—considered government employees—under regular contract there. It consisted of sixteen soundstages and a pool for marine sets[10] as well as executive offices and three restaurants, all within a network of streets and piazzas, gardens and flower beds. From the time of its founding until July 1943, the genre produced in greatest abundance was comedy, but dramas, historical and costume films, adaptations from opera and literature, war films, and a body of propaganda films were also created there. An article titled "L'amante grassa" ("The Fat Concubine") by Adriano Baracco—one of the very few critics to address the events considered here as they were unfolding—summarized the early glory of Cinecittà in the first issue of the review *Star* in August 1944, a couple months into the liberation of Rome. Baracco writes:

> Cinecittà was the official concubine of Fascism, the fat, bedizened whore required by any nouveau riche. . . . Cinecittà was a kept, easy-living woman. The authority of her protector spared her any financial concern. She displayed the opulent bad taste proper to a woman of the street, of the kind endowed with prominent breasts, vast hips and flashy clothes. She was provincial and somewhat ridiculous. She had budgets of 160 million, and she was State Property.[11]

During the first three years of the war, Cinecittà more or less maintained this routine. The war entered the studios full-blown late in 1943, following the September armistice with the Allies and the subsequent German occupation. Production was interrupted, all workers were dismissed, and the place was deserted. Hungry inhabitants of the nearby *borgate* (the outlying lower-class neighborhoods) searched the studio for firewood and metal to resell, but they were driven out by the occupying Germans, who used it to store ammunition and as a transit camp for prisoners. In January 1944, the studios suffered direct Allied bombardment as part of a general campaign of fifty or so aerial bombardments on Rome, particularly on its peripheral, though inhabited, working-class neighborhoods. Principally damaged

was Istituto Luce, the film propaganda wing of the regime located next door, as well as three of Cinecittà's soundstages, with some damage also to other stages, warehouses, and hangars. It is likely that the Allied bombings did not focus their attack on this industrial zone, with its railroad depot, by chance. Baracco recounts:

> German troops were staying in Cinecittà. Tanks and cannons circulated in the soundstages, with little benefit to the isolating wooden floors; in others they amassed hundreds of horses. *Wehrmacht* corporals slept in the divas' dressing rooms, and improved their leisure time smashing the bathrooms, sinks, and toilets with hammers. In the meantime, they stole whatever possible: they stole vehicles and fake beards; tens of thousands of bricks, nails, screws, iron wire, string and various stuffs in the amount of 2 million; they stole chainsaws, pots, tables and plates from the restaurants . . . they uprooted trees . . . they broke glass, smashed doors, demolished expensive equipment with pickaxes. When they departed, of their own initiative, because of a difference of opinion with the American Army, they left behind 36 million in damages, and the desolate spectacle of a great structure in ruins.[12]

On June 4, 1944, after some nine months of traumatic occupation, the Allies entered Rome, and immediately thereafter, on June 6 (D-Day, as it happened), the Allied Control Commission (ACC) took possession of Cinecittà, drawing up a property requisition paper (Figure 5.3).[13] One short page with sections in Italian and English, it is not an altogether coherent document; its opacity—comprising linguistic confusion or perhaps even puns—demonstrates the chaos of the moment, when the stress of war, the politics of a shifting occupation, and personal motives were mixed. Carmine Gallone, one of its cosigners, was among the most prestigious filmmakers under the Fascist regime, the director of the first megaspectacle produced in Cinecittà on its founding, *Scipione l'africano* (Scipio the African; 1937). One might now wonder to what extent it was the Fascist fantasy of Roman supremacy, writ large in the film, or Gallone's doubtful role in the Cinecittà requisition process that brought him the honor of being one of only three directors to be purged after the war.[14] Baracco immediately suspected Gallone's illegitimate intervention in the process observing that "fearing he was going to be purged, [Gallone] decided to proclaim himself a purger" by taking possession of the studios, in the face of the Allies.[15] To Baracco's scathing suggestion, the famed director himself responded defensively on the pages of the same journal a couple of weeks later, insinuating that he had performed heroic feats on the liberation of Rome by serving as key

PROPERTY REQUISITION
REQUISIZIONE DI PROPRIETA'
ROME AREA COMMAND

8A

DATE _6 June 1944_

THE FOLLOWING PROPERTY HAS BEEN TAKEN FOR USE OF THE ARMED FORCES
OF THE UNITED NATIONS.

(LA SEGUENTE PROPRIETA' E' STATA REQUISITA PER ESSERE USATA DALLE
FORZE ARMATE DELLE NAZIONI UNITE.)

INDIRIZZO DELLA PROPRIETA'_ _Opere E. Giorni Di CineCitta_

DESCRIZIONE DELLA PROPRIETA'_ _Motion Picture Production &_

CONDIZIONI DELLA PROPRIETA': (OTTIMA) (BUONA) (MEDIOCRE) (CATTIVA)

NOME DEL (PROPRIETARIO) (LOCATARIO)_ _Sig. Guido Oliva -(Im du Direttore)_

INDIRIZZO_ _Largo Chigi #19_

THE PROPERTY DESCRIBED ABOVE IS REQUIRED FOR IMMEDIATE USE IN THE
MILITARY SERVICE. NO PAYMENT HAS BEEN MADE FOR USE OR POSSESSION.

LA PROPRIETA' SOPRA DESCRITTA E' NECESSARIA PER L'IMMEDIATO USO A
SCOPO MILITARE. NESSUN PAGAMENTO E' STATO EFFETTUATO PER L'USO ED
IL POSSESSO.

FIRMA DEL RICEVENTE
DELL'ORDINE DI REQUISIZIONE_ _A. C. Gallone - Gallone_
 (PROPRIETARIO) (LOCATARIO) (CUSTODE)

INDIRIZZO_ _Via Lucullo 11 (Scalsion)(representative)_

DATA DELLA FIRMA_ _6 June 1944_

FOR THE ROME AREA COMMANDER:

John W R Pass 1319
REAL ESTATE SECTION, ROME AREA COMMAND

FILE_____

Figure 5.3. Property requisition form, June 6, 1944. Allied Control Commission documents, box 108, reel 432D, Archivio Centrale dello Stato, Rome.

mediator between the Resistance and the Allies, then between the Allies and the Cinecittà management, and that it was under the auspices of the latter that he also worked to preserve parts of the studios for continued film production.[16]

However, the contradictions between Gallone's convoluted claims and the requisition paper, as well as what in fact transpired, all suggest slippages in authority and legality at that moment. With the collapse of order and state control, with a management in disarray, and with personal manipulations on the part of personages wishing to clear themselves during this historical transformation of Italy, an obscure web of power relations, distortions, and confusion evidently plagued the requisition process. The lack of transparency might have affected both sides of the deal between the Italian representatives and an exhausted Allied officer in charge of the real estate section of the Rome Area Command, working under stressful conditions.

There were in fact reports that a Cinecittà committee of managers and workers did have a chance during a brief transitional period to inspect the studios and to observe that enough equipment had been rescued to support production of three films per month.[17] Yet in the requisition paper as signed by Gallone, the condition of the property is marked as "very poor," and no film production or reorganizing projects are mentioned here, nor were any undertaken for a few more years in Cinecittà. The requisition was sealed and acted on, and it seems likely, in retrospect, that neither it nor, perhaps, the earlier bombardments of the area were hasty or arbitrary choices on the part of the Allies. Certainly earlier, in the heat of the Italian campaign, and later, during the Allied control of Rome and its aftermath, in the reorganization of the Italian state, economic calculation on the part of the American industry was not alien to decisions in the field concerning sites to bomb, how to use industrial properties, and what powers and personalities were to be reckoned with in the process. This, at least, is what is suggested by the presence of a report in the ACC files on the history and hierarchy of the Cinecittà organization, together with a detailed outline of its administration and directorship since the late 1930s, updated until January 1944.[18]

Gian Piero Brunetta tells of another report on Cinecittà that was drawn up by the U.S. Army in May 1944, on the eve of the Allied entry to Rome, and passed on from the occupying troops to the Psychological Warfare Branch (PWB)—which was in close contact with American studios—and then on to the American Embassy. That inventory stated that not *some* but *all* the cinematographic equipment had been looted and that not three but seven soundstages had been destroyed. Furthermore, as Brunetta notes, the report identified Cinecittà with the Italian film industry at large, which allowed it to assert, mistakenly, that film production

in Italy had been *completely* annihilated and to imply that it would be legitimate, therefore, to occupy this space—Cinecittà—and for American exhibitors to occupy the Italian film market.

All this suggests that the requisitioning of Cinecittà followed at least some research and planning—planning that was not limited to the strictly technical appraisal of its structures as they may have benefited displaced persons operations but that fed into American interests at large. Published in a Roman daily on June 13, 1944, is an information bulletin on the part of the PWB stating point by point its right to regulate and control all aspects of film production, distribution, and exhibition.[19] Also in June, according to Lorenzo Quaglietti, the stunned Italian representatives to the Film Board were to hear Admiral Elery Stone, the board's head and chief of the ACC in Italy, state:

> The so-called Italian cinema was invented by Fascism. Therefore it must be suppressed. Also to be suppressed are the instruments that have given body to this invention. All of them, Cinecittà included. There has never been a film industry in Italy, there have never been cinema industrialists. Who are these industrialists? Speculators, adventurers, that's who they are. Besides, Italy is an agricultural country; what need have they for a film industry?[20]

Already evident is the pressure to open up the Italian market as part of the anti-Fascist mission for the democratic remaking of Italy: to free it from state regulation and taxation, to free it for Hollywood imports with a view projecting beyond the Allied departure. Hundreds of American films, which had at best limited European distribution during the war, flooded Italy immediately. Already in that first liberated month of June, a Roman daily spelled out the PWB's investment in the distribution of Allied, mainly American films, stating that some forty titles—among them RKO's Astaire and Rogers vehicle *The Story of Vernon and Irene Castle* (1939), Warner Bros.'s *Sergeant York* with Gary Cooper (1941), Universal's *It Started with Eve* with Deanna Durbin (1941), and Metro-Goldwyn-Mayer's (MGM's) *Joe Smith American* (1942)—were "ready for projection . . . with Italian subtitles."[21] These, among others, made up Hollywood's reassurance of democratic values in liberated zones such as the city of Rome. As Brunetta commented, it was almost as if a generous dose of movies was seen as equal to the donation of food packs and other such necessities to those in need.[22]

About a month after the requisition, the Cinecittà company, which no longer had access to the studios, asked for an appointment with the ACC to discuss "a

possible partial resumption of production," but to no avail. A later appeal to the commission (October 1945), now by the Italian Ministry of Industry and Commerce, stressing the need to engage unemployed persons and contribute to the public treasury, was tersely rejected: "It is regretted that studios cannot be released to you owing to anticipated commitments."[23] One wonders why more suitable structures were not found—not only for the benefit of the industry but first and foremost to support the stricken refugee population. In fact, some discussion to this effect took place after the war but bore no fruit until—we shall see—late in 1947.[24] Displaced persons in Rome were initially dispersed all around the city, often housed in school buildings, for example. But for Allied purposes, and subsequently for Italian control, concentrated sites away from urban centers were deemed better for the management of both foreign refugees and of increasingly frustrated populations of Italians who had lost their homes.[25]

Although a charitable undertaking and formally supported by humanitarian agencies, the displaced persons' camp was a confined space set apart from the ordinary run of reality—of territory and state conditions, of daily life, work, the freedom of action, and choice. To put it bluntly, as Hannah Arendt wrote of similar camps across Europe, such sites of "manufactured irreality" were also meant to keep a "surplus" of survivors, homeless or stateless persons, out of the way or until they could be made deportable again.[26] These were the survivors of local bombardments or of distant death camps, displaced persons who had been in transit for years, torn from communities, towns, and homes that no longer existed; they were families who had lost everything, children who had lost everyone or had themselves been lost, deprived, traumatized in body and mind, some of them quite literally identity-less: the youngest, whose very names it was difficult or impossible to recover.[27] In this placeless place, enclosed by walls, they were gathered within structures that had once served for fantastical reconstructions of everything from Roman temples to luxurious boudoirs. This miniature phantom city, once a workplace and factory of dreams, was now ravished, deserted, and transformed into a strange location—painfully real and ghostly, an echo of the life outside in the bare beginnings of the reconstruction of what remained of Europe. And it is here that we locate an allegorical tableau of the postwar remaking of reality. A hidden figure comes to light from beneath neorealist culture: its contours emerge quite sharply as we confront the material conditions of this particular refugee camp.

Having been immediately requisitioned, as we have seen, by the military, Cinecittà was reorganized and divided into two distinct camps, both initially run by the ACC. The Italian camp—housing refugees from former colonies such as Libya and Dalmatia as well as from the country itself—was shifted on August 21,

1944, to Italian administration, which set up a Subministry for Postwar Affairs and, within it, a Commission for "Moral and Material Assistance to War Refugees."[28] On the other side of the camp, an international section continued to be administered by the ACC Displaced Persons Subcommittee. Early in 1946, the United Nations Relief and Rehabilitation Administration—UNRRA (the term *United Nations* initially designating the Allied nations)—took over the international camp as part of its work for displaced persons in Italy, which it had begun in March 1945. UNRRA managed the camp until June 30, 1947, when it handed over administration of all its camps in Italy to the International Refugee Organization (IRO).[29]

ACC's archives for the first period of the international camp identify over thirty different nationalities therein, including Yugoslavs (of all ethnicities), Poles, Russians, Tartars, Chinese nationals, Egyptians, Iranians, Ethiopians, and Jews from everywhere. In May 1945, the numbers in the international camp added up to some nineteen hundred refugees. Recorded on the Italian side in August 1944 were over fifteen hundred persons, and by December of that year, that number had increased to twenty-four hundred. Reports until late in 1947 cited over three thousand refugees as being in the Italian camp. The total over time added up to more than the average number of three thousand inmates per camp in Europe.[30] About half of inmates were under the age of eighteen. Children ran around the grounds by the hundreds, though eventually, schools and a playground were opened by Catholic organizations. In the Allied camp, UNRRA would mobilize intellectuals from among the refugees—professors happy to teach in freedom again—to be involved in the education of children.[31] By some accounts, Cinecittà emerged as an administrative capital for displaced persons in Italy, where much of the displaced-persons press was printed by various groups, including political parties, partisans, Jews, and so on.[32]

Throughout the existence of the Italian camp, water was obtained from collective containers, and cooking was done outdoors on coal stoves. Rations in the camp were significantly lower than in the Allied section, whose kitchen was staffed by Chinese cooks. In addition to food stuffs, the Americans would at times also present a show or project a film to entertain the inmates.[33] But in fact, conditions were poor on both sides of the camp: in the ACC files, one finds reports on administrative "confusion," on violence, theft, political tensions, the black market, suicides, typhoid and tuberculosis, the lack of proper disinfectants, and appalling conditions in the hospital itself, where a grave shortage of drugs and instruments made it impossible to handle obstetrical cases.[34] On September 14, 1944, the general command of the carabinieri reported that conditions in the Italian camp were so bad as to warrant discussion regarding the

possibility of the Allies reassuming its management, though because this would amount to publicly confessing the Italian inability to self-govern, the proposal was finally rejected.[35]

In late January 1945, a rare piece of detailed reportage, including photographs (Figure 5.4), appeared in the crime weekly *Crimen*. Signed by Paola Masino, former Resistant, journalist, and later a film critic and radio personality, the article was titled "Valley of Josaphat" and constituted an eloquent appeal for public attention and decisive action in the Cinecittà camp. It described conditions in the Italian camp as directly resulting from the Allied withdrawal of its management, starting from the removal of basic equipment:

> In these conditions, with 2,100 refugees to feed and lodge and clothe and cure, and with no blankets, undergarments, beds, or pots on the market at any price, the High Commissioner [for Refugees, Tito Zaniboni] inherited nothing but space.
>
> The space of Cinecittà, that elusive place that we all knew under the populous reign of the Talking Larvae, no longer bears any trace of what it was. . . . Suddenly, this vacuum is filled with an accusing crowd of 2,100 persons, precipitated into a tight whirlpool by a catastrophe for which they are not responsible. . . . I advise the High Commissioner to let Romans take a tour of the refugee camps. . . . We have seen the soundstages used as dormitories, the restaurant as a nursery, the executive offices as a hospital. But what dormitories? What nursery? What hospital?

Masino goes on to praise the miracles worked by Commissioner Zaniboni for those now "damned" in the Valley of Josaphat:

> These men and women, these damned souls, are crammed by the thousands within the soundstages, grouped by families in narrow uncovered boxes with straw divisions the height of a man or a bit more. On the floor a mattress, a makeshift table, some clothes hanging on a nail, a cord with a few rags drying, and all around the sounds of others, coughing, crying, laughing, talking, and the smells of others, and the suspicions of others, the curiosity of others, the filth of others. The boxes in long parallel lines demarcate lanes within the blind belly of the edifice that rises above the thousand habitations to give them a single remote ceiling, crisscrossed by bridges, ladders, cables. . . . Consider their night: in mid-air, the foggy breath makes the ceiling ever more remote; hundreds and hundreds and

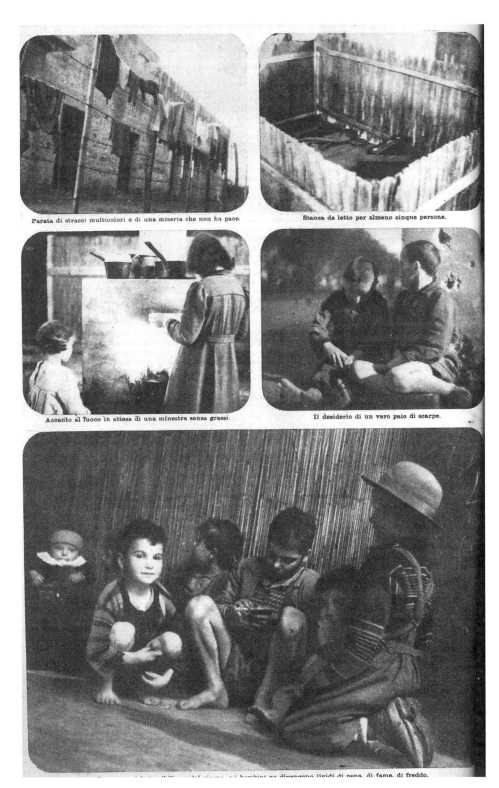

Parata di stracci multicolori e di una miseria che non ha pace.

Stanza da letto per almeno cinque persone.

Accanto al fuoco in attesa di una minestra senza grassi.

Il desiderio di un vero paio di scarpe.

Figure 5.4. From *Crimen* I, no. 1 (1945). Biblioteca di Storia Moderna e Contemporanea, Rome.

hundreds of eyes fixed on it, seeking sleep. Consider most of all the wide eyes of children who, without memories, are looking for life.

. . . They surround you and they stare. They try to figure out: how is one made who is not a refugee?[36]

It is perhaps in light of all this that Francesco Rosi, the future filmmaker, would tell how, the first time he ever saw the gates of Cinecittà in August 1944, he sought to escape for fear of getting locked up indefinitely therein: having already escaped the Germans and the Fascist *repubblichini* of Salò, he says, he did not want to fall into American hands.[37] Rosi could not tell at that point that Italian refugee fortunes were to be even harsher under Italian authority than they were under the Allies. One also juxtaposes his and Masino's impressions with certain Jewish testimonies of the camp that, after unspeakable experiences, years of escape, and continued hardship, describe Cinecittà as a sort of paradise.[38]

For all its renown as a film capital, and for all the pieces of equipment still sitting idly in its warehouses, only a few actual images can be found of the refugee camp at Cinecittà. The newsreels add up to no more than a minute or two of footage, none of it from the early period of the camp. A December 6, 1946, *Settimana Incom* newsreel reports on various forms of refugee housing, among them schools, archaeological sites such as the Domus Aurea, and industrial properties, a category under which we glimpse the Cinecittà front gate and an eloquent view of the bare, puddle-spotted main piazza with a few scattered figures moving through it (Figure 5.5). A November 12, 1947, newsreel opens with a high-angle, almost deserted view of the grounds, followed by a few shots that depict the distribution point for coal, outdoor cooking, laundry drying on lines, and children on swings. Footage of ruined studio structures is then juxtaposed with the celebratory parading of new equipment and the young Giulio Andreotti, then undersecretary of state, visiting the studios in an official gesture of support toward resumption of production. An October 14, 1948, newsreel already posits itself as a retrospective overview of "the road between 1944–1948" and may account for the mistaken assumption that the case of the Cinecittà camp was resolved by that time. It incorporates earlier newsreels of the camp, and with the rhetorical question "where will this roofless [i.e., homeless] cinema find a place?" plunges quickly into a celebration of neorealism, with Rossellini shooting on the roofs of Rome. The newsreel then picks up again with Andreotti's November 1947 visit and a managers' tour of the impeccably cleared spaces of soundstage interiors as well as a display of new lighting and sound equipment.

There's a dearth of images and reportage, then, of Cinecittà as refugee camp.

Figure 5.5. From *Settimana Incom* 35, newsreel, December 6, 1946. Archivio Storico Istituto Luce, with the support of Ente dello Spettacolo, Rome.

It is perhaps telling, therefore, that the most penetrating views are not in a proper chronicle but in an obscure fiction film, one that itself has dropped out of film history.[39] This is *Umanità* (Humanity), directed by Jack Salvatori, a British-Italian who had apparently specialized in independent bilingual productions, working in France and the Netherlands in the 1930s before returning to Italy to help the partisan efforts and, after the war, participating in small roles in several productions, including De Sica's *Bicycle Thieves*. *Umanità* was produced in 1946 by the barely functioning Istituto Luce, with the support of the two organizations that were running the Cinecittà camp at this point: UNRRA and the Italian Subministry for Postwar Assistance.[40] With its contrived plot and mediocre dialogue scenes, *Umanità* is not distinguished as a piece of cinema. Made by an outsider as a work of institutional propaganda, it does not belong with neorealism nor with the period's commercial production and has received hardly any mention in the literature. But its dropping out of history itself sheds light on the case of the Cinecittà refugee camp with which it engages. For neorealism's categorical rejection of Cinecittà as an institutional symbol of the Fascist past meant that *as location*—not just as studio or set—the place could not be confronted: not even for the harrowing contemporary reality of occupation and displacement that it discloses. For this,

as for its value as a primary source for images of Cinecittà in 1946, *Umanità* is a unique document of its time, offering within the framework of a fiction film the most extensive visual testimony of the camp.

The critic Tatti Sanguinetti has pointed out *Umanità*'s status as a kind of historical text, one that celebrates UNRRA's aid to Italy and foreshadows the Marshall Plan's uniting of U.S. interests with those of Italian Christian Democracy—all of which seems allegorized in the film's "comedy of remarriage" scenario of double couples, American and Italian, uniting after a long car trip north toward the Brenner pass.[41] One observes how this emblematic movement—as if reappropriating the length of the peninsula in the Allied footsteps—is analogous to the trajectory of *Umanità*'s exact contemporary, Roberto Rossellini's *Paisà*. Between the film's generic rhetoric of romantic comedy—comparable perhaps to those films produced in Cinecittà's earlier incarnation—and its documentation of the neglected phenomenon of the refugee camp, a symbolically and psychically resonant space opens up in *Umanità*'s image of Italy.

Spanning some seventy minutes, the film is structured in three parts. The first narrates the misfortunes of a group of people suffering under the German occupation of their town, obliquely referred to as Cassino.[42] An exceptional sequence, whose iconography and pathos are worthy of the best in the neorealist tradition, shows the execution of partisans and their Allied supporters in a piazza while women look on. Among the survivors evacuating the town is the young Barbara (Carla Del Poggio), separated from her deported fiancé and traumatized in body and mind owing to her assault by a German soldier. The subsequent, longest part of the film (forty-five minutes) locates these survivors in the Cinecittà camp, presided over by a UNRRA official, Jack Kenny (Gino Cervi).[43] An estranged American couple, both physicians who reunite by chance in the camp hospital, are added to the core group of protagonists, along with a lost child, a *sciuscià* (shoeshine boy), picked up in the streets of Rome to be rehabilitated there. The inclusion of this prototypical neorealist character is no mere sentimental whim; it alludes, we now know, to the vast number of children among Cinecittà's refugee population and to UNRRA's work in support of orphaned and homeless children in Italy at large. It is through the child's point of view that we are offered the establishing shots that describe the exterior spaces of the camp: the studio grounds and its principal edifices are recognizable as authentic locations. The broader gallery of characters and their depicted activities, including the cultivation of a fresh vegetable patch, provide the occasion for protagonists and spectators to learn that people emerging from diverse sides of the conflict—including even a German prisoner of war—may be made of the same stuff as the protagonists (the earth) and worthy of its labor,

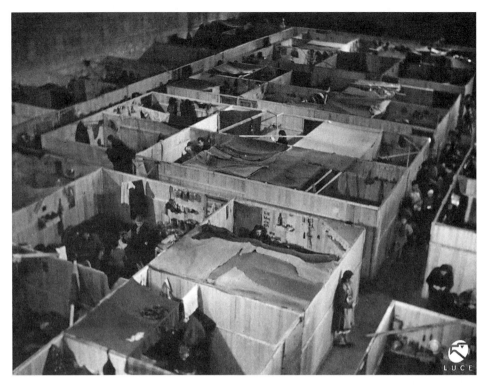

Figure 5.6. From *Umanità* (Jack Salvatori, 1946). Archivio Storico Istituto Luce, with the support of Ente dello Spettacolo, Rome.

though it is inconceivable that a German prisoner would be mixed with this Italian part of the camp population, which was, as we know, strictly separated from international refugees.[44]

Despite simplifications, fictionalized associations, and ideological adjustments, *Umanità* still offers detailed and vivid images of the camp. Though most interiors, such as the hospital scenes, were apparently filmed in a studio, one exceptional category of interiors commands our attention. Certainly the most astonishing images of *Umanità* consist of its documentation of the refugee habitation units within what the film designates as *padiglione numero 5* (pavilion number 5), also alluded to in archival documents of the camp. Punctuating the central part of the film are several high-angle panning shots of a vast interior space, subdivided with cardboard, wood planks, and sheets, exposed from above, a veritable *borgata* in which daily life unfolds in a labyrinth of boxes to fulfill the barely elemental habitation function (Figure 5.6). Though narrow and crowded, there appears to be a relatively ordered, even appearance to these units, suggesting that guidelines on space allotment within a specified footprint in the soundstage were well controlled.[45] One wonders, however, if this management was in fact equaled on the Italian side

of Cinecittà, which was not handled by UNRRA and, as we know, was in need of donations. Indeed, the few images we have seen, in *Crimen* (cf. Figure 5.4), of the actual Italian habitation units suggest even poorer, less solid structures built from straw and, at least at that early phase, containing no furniture to speak of. But the closer shots in *Umanità* show household effects within the boxed bedrooms, neatly divided by narrow alleys, spaces that hardly afford room for the camera. The camera capitalizes, therefore, on the structure and equipment of the soundstage: its elevated spot can be easily identified in a visit to the studio, for we must be in Cinecittà's Teatro 5: this is Fellini's legendary soundstage, where Via Veneto was later to be reproduced, along with much else in some of the most ambitious sets in film history. Testimonies suggest that this big soundstage—thirty-five by eighty meters—housed as many as fifteen hundred people in hundreds of cubicles, like an improvised shantytown all contained, compressed within the solid building. Other stages that were not too damaged were similarly employed.

A close comparison of the soundstage as it appears in *Umanità* vis-à-vis the structure today suggests an interesting difference: for production purposes, the soundproof edifice has no windows, yet in the film, interior as well as exterior shots reveal several small, elevated windows that may have been added for the ventilation and lighting of the refugee housing. Inside, it might have still been dark and stifling in summer—we already noted that, weather permitting, many spent their time out of doors cooking, washing, playing, or lingering about. The production lighting in *Umanità,* surely unlike everyday lighting therein, conveys nuanced effects as if "by day" and "by night." It is hard to tell if such adjustments were a matter of routine, by way of reproducing an affable diurnal system—but really a cinematic effect—within this artificial environment.

The actual testimonies regarding the architectural circumstances of these stage interiors qua living units are in fact far more astonishing than what *Umanità* admits to or dares to explore. In his testimony for Yad Vashem archives, and in conversation with me, Mordechai (Marco) G. elaborated on how he, a Jewish teenager from Trieste, thus lived in an improvised cubicle within one of these soundstages with his mother and younger siblings; they had been on the run and in hiding in northern and central Italy for some two years before being brought to safety in Cinecittà by British troops in August 1944.[46] There they stayed for nine months, until they were able to immigrate to Palestine. The family was initially allotted an area within a soundstage and had to put together, on their own, a tiny living unit *from the remnants of colossal movie sets*: Mordechai specifically recalls the "plaster works, Roman-style columns, and so forth." His and other testimonies confirm what, indeed, makes perfect sense given this fantastical location: Cinecittà's habitation

units were constructed out of and furnished with the remains of studio equip-
ment, used sets, and decor. We have before us, then, an architectural bricolage:
basic refugee housing constructed out of the remains of the Fascist movie sets and
reassembled within the contained and controlled space of the soundstage. The
conversion of colossal movie decor into essential building materials for minimal
habitation—in some sense the sort of housing that epitomizes the bare begin-
nings of the reconstruction of life in postwar Italy—creates a vast ensemble and
a spectacular cinematic image. But its interest and symbolic, ironic resonance are
not explored in *Umanità*.

One can only speculate as to how such a warped, compounded image of the
camp might have inflected our sense of neorealism were a filmmaker like Visconti,
De Sica, or Antonioni to treat it in fiction or documentary.[47] But as we have ob-
served, their search was for another, more innocent space—that of the proverbial
"year zero"—that could serve as the ground for a new image of Italy and of Italian
cinema, free of the Fascist connotations of the studios. Yet it is precisely Cinecittà
as refugee camp that condenses most truthfully and eloquently the odd reversals
of the historical moment when the circumstances of war in Europe and of Italian
reconstruction, the social and material reality of daily life, and film culture all co-
incided in an ironic reversal of the neorealist abandoning of the studios. In some
sense—and perhaps like internment and refugee camps still around the world
today—the relationship of Cinecittà to the ordinary run of official reality, history,
and the media remained equivocal.

Of that entire generation, it appears that only Adriano Baracco understood this
equivocation, with its irony and its pathos—the studio–camp's reflective potential
as deep historical figure and cinematic image:

> Where once Doris Duranti stamped her foot because her car was three
> minutes late; where Baron Osvaldo Valenti initiated young admirers into
> the foggy nirvana of cocaine; where *grand'ufficiali* committed frauds and
> *commendatori* set the erotic "menu" of the evening, where aristocratic lap-
> dogs whined because contaminated by workers' impure hands; where so
> much arrogant luxury, tainted business, so much millionaire's prostitution
> nested . . . now distressed peasant families camp—hundreds of families
> that once had the wealth of the poor: house, field, work. And they saw it
> all destroyed. In the vastness of the soundstages each family has a space
> of a few square meters. Some shades taken down from the windows are
> used as mats on the floor; on the mat a blanket. Nearby: bundles, suitcases,
> rags. All that these people own is here. One solitary displaced person used

as his night table one of those luminous metal signs on which is written "Alt! Silenzio, si gira!" [Stop! Silence, we're rolling], a sign that once sternly prohibited access to the soundstage.

In another building the displaced persons have set up boxes with the stuccoed and gilded doors that had served for the interiors of royal or patrician palaces. The contrast between the atrocious misery of men and the foolish opulence of ornamental sets is terrible.

Hundreds of children run around, play, explore, make discoveries, handle interesting things. For these children, the great wreck of Cinecittà, full of little scraps, is a paradise of toys.

One has the impression that a movie of colossal proportions is being filmed in Cinecittà, a film that Carmine Gallone would have wanted to direct, with thousands of extras in rags.[48]

Throughout 1946 and 1947, the Cinecittà company sent many letters to the Interior Ministry in charge of postwar assistance—with the endorsement, finally, of the Italian Ministry of Finance and the Prime Minister's Office—appealing for the "liberation" and "restitution" of Cinecittà. An August 19, 1947, note from the Prime Minister's Office asserts that within twenty days, the great soundstage number 5 can be handed back to the cinematographic industry. And in fact, over the course of August and September 1947, the Italian part of the camp was "liberated" of refugees. The government entities argued where they might be housed: the barracks of Centocelle emerge, in these documents, as a principal destination for Italian camp inmates with no arrangements of their own, although common knowledge in the Quadraro neighborhood surrounding Cinecittà was that these homeless persons were eventually settled in the housing project of Acilia.[49] We have mentioned Undersecretary Andreotti's visit to the studios on November 10, 1947—this was ostensibly in response to the Cinecittà company's invitation to "participate" in the production of *Cuore* (Heart; 1948), Duilio Coletti and Vittorio De Sica's adaptation of the De Amicis classic presentation of patriotic and sentimental tales of a unified nineteenth-century Italy. Newsreel recorded Andreotti's official gesture of government support toward resumed production:

> I am delighted to see work at Cinecittà pick up again, not only for the restoration of our film production, but because this is also testimony to the fact that the long overdue and delicate problem of the refugees and those who have suffered by the war is on its way to a definitive solution.[50]

Solutions to the "delicate problem of the refugees" were not quite so "definitive," however. Housing remained a grave problem and was far from properly solved—especially around Rome. Indeed, the Quadraro area surrounding Cinecittà remained for many years spotted with improvised and illegal housing, as under the nearby Roman aqueduct. As to the resuming of work in the studios, it appears that many of the films formally labeled "Cinecittà" even in 1948 were in fact technically produced across the street, in the facilities of the Centro Sperimentale di Cinematografia, the film school that could offer equipment and a large soundstage.[51]

But even when production in Cinecittà proper did start up, the story of its refugees did not end. The derequisitioning of the international camp was slow, as suggested by the numerous exchanges between Andreotti's office, the Administration of International Assistance, and the Foreign Ministry. The IRO held on to and continued to use the camp for over two more years. As late as June 1, 1950, a letter from Andreotti to the Administration of International Assistance complains of rumors that, despite assurances, the number of inmates in Cinecittà, now seven hundred, threatens to rise again to twelve hundred persons! Only at the end of that summer of 1950 was it announced that the last occupied structures would be restored on August 31 to the Cinecittà company.[52]

In 1950, the high neorealist season was practically over, though it continued to inform film culture, in oscillation with the prevailing logic of the industry and its commercial genres. The dismantling of the camp and restitution of Cinecittà thus roughly coincide with the end of the first phase of Italian postwar reconstruction, itself articulated in, and, in a sense, synonymous with, neorealism. It is also apparent, however, that the Americans were here to stay. Production of MGM's Technicolor spectacle *Quo Vadis,* directed by Mervin LeRoy, with Robert Taylor, Deborah Kerr, and Peter Ustinov, had been in full swing on these premises since 1949, while at least the seven hundred refugees cited by Andreotti were still in residence.[53] Some of them, protagonists of the history I have mapped, may have been among the fourteen thousand extras in that colossal extravaganza—"a film that Carmine Gallone would have wanted to direct" (Figure 5.7).

This megaproduction, which occupied the greater part of Cinecittà, was instrumental in the studio's return to fully professional functioning. Certainly its mythical narrative of the tumultuous beginnings of Christianity in Rome, with the forces of good emerging to triumph over the excesses of Nero, can be seen as a colossal allegory of the liberation of Rome—of Italy, of Europe—from tyranny. Its dazzling color images seem, like pop art collages, to conceal and reveal the history with which I have been concerned. We can no longer *not* see here the real-life

Figure 5.7. From *Quo Vadis* (Mervin LeRoy, 1951).

"extras in rags"—that surplus of refugees that, we now know, hover on its margins.

But the ostensible opposite, neorealism, now itself appears in a new light. Both the Allied occupation of Cinecittà (involving the repression and the subsequent Americanization of the Italian studio) and much of neorealism as we know it (outside the immediate studio orbit) appear complicit in the myth that a new Italian cinema and a new Italy might be constructed from "year zero," from raw and innocent origins: either because, as some Americans said, Italy is "an agricultural country" and "there has never been a film industry" here or, as the neorealists implied, a purer, untainted reality was to be found out in the streets rather than among the ruins of the Fascist state studio and its contrived apparatus of fictions. In fact, reality was being constructed, quite literally, out of the colossal sets and the ruinous remains *of* that apparatus, and in Cinecittà.

NOTES

Research for this project was launched with a 2004–5 National Endowment for the Humanities Fellowship at the American Academy in Rome, with additional support from the A. Whitney Griswold Faculty Research Fund and the European Studies Council Faculty Research Grant of Yale University. At the Cineteca Nazionale in Rome, I am grateful to director Sergio Toffetti, and especially to Mario Musumeci, the first who encouraged me to explore this topic. At Istituto Luce, Edoardo Ceccuti and staff helped with essential film materials and frame enlargements. Also in Rome, I was supported by Dario Viganò, Luca Venzi, and staff at the Ente dello Spettacolo and by librarians and archivists at the Biblioteca "Luigi Chiarini" of the Centro Sperimentale di Cinematografia, at the Archivio Centrale dello Stato, and at the Biblioteca di Storia Moderna e Contemporanea. The Yad Vashem archive in Jerusalem provided some of my connections with survivors who had been to Cinecittà. In various phases, I benefited from feedback from Sean Anderson, Marco Bertozzi, Flaminio Di Biagi, Moshe Elhanati, David Joselit, Adam Lehner, Annette Michelson, Irene Small, Frank Snowden, Katie Trumpener, and Claire Zimmerman.

1 *Film d'oggi* 1, no. 2 (1945). All subsequent citations are from this issue, whose page numbers are not clearly marked. Except where otherwise indicated, translations in this essay are mine, with the help of Paolo Barlera.

2 Exact values are difficult to determine because of wartime inflation; online currency charts going back to the period conform roughly to David Forgacs's calculations in his book *Rome, Open City* (London: BFI, 2000), 27.

3 Gian Piero Brunetta, *Storia del cinema italiano,* vol. 3, rev. ed. (Rome: Riuniti, 1993), 6–7.

4 I treat these topics extensively in *Italian Locations: Reinhabiting the Past in Postwar Cinema* (Minneapolis: University of Minnesota Press, 2008).

5 Maria Michi was featured in Rossellini's *Rome, Open City* (1945) and *Paisà* (1946). The preceding sample of donors' names is drawn from the variety of these and subsequent fund-raising announcements.

6 See Mark Wyman, *DP: Europe's Displaced Persons 1945–1951* (London: Associated University Presses, 1989). In what follows, I use (as do many accounts) both terms *refugees* and *displaced persons* (DP). One might distinguish, as Wyman notes, "the factors that set the displaced persons apart from other refugees. . . . They had become a stateless people, outside the people–territory–state condition that had traditionally been the basis of a nation" (86–89). In Italian, one finds *rifugiati* or *profughi* (refugees) and *sfollati* (evacuees) sometimes used interchangeably.

7 I met Rotunno in August 2005 in Rome and interviewed Gatti over the telephone on July 23—that happened to be the anniversary, Gatti told me, of his arrest and deportation in 1943 for charges of anti-Fascist graffiti: he had drawn a caricature of a decapitated Mussolini on a wall in Cinecittà. Gatti was to become the cinematographer for, among others, Gillo Pontecorvo's *Battle of Algiers* (1966), whereas

Rotunno is renowned for his work as Visconti's director of cinematography.

8 That an unspoken avoidance, even repression, of this phenomenon was at work is suggested by the fact that histories of Cinecittà are quite elaborate on earlier and later phases but vague on the period that concerns me here. Franco Mariotti, ed., *Cinecittà tra cronaca e storia 1937–1989*, 2 vols. (Rome: Presidenza del Consiglio dei Ministri, 1989), a government publication, does not offer even a full paragraph on this topic. Oreste Del Buono and Lietta Tornabuoni, eds., *Era Cinecittà: vita, morte e miracoli di una fabbrica di film* (Milan, Italy: Bompiani, 1979), offer a short summary. Roberto Burchielli and Veronica Bianchini, *Cinecittà: La fabbrica dei sogni* (Milan, Italy: Boroli, 2004), has a chapter titled "Refugee Village," but in it, fewer than four pages, vaguely documented, are actually devoted to the camp. There is a striking paucity of discussion by historians on camps in Italy in the wake of the war. Possibly this is due to the alleged loss of the files of the Ministero dell'Assistenza Post-Bellica, as I am told by Maria Pina Di Simone of the Archivio Centrale dello Stato in Rome (EUR). Alberto Valentini's "Il dopoguerra di Cinecittà," *Quaderni del CSCI* (2006): 184–92, offers a detailed chronology of exchanges between the Cinecittà company, the various Italian ministries, and the Allied Film Board. See my own related pieces on the subject: "Un film dimenticato, una storia rimossa: *Umanità*," in *Annali 8/Schermi di pace* (2006), 99–104, and "Cinecittà irreale: appunti attorno a un campo profughi," in *Neorealismo e presente dell'immagine*, ed. Luca Venzi (Rome: Ente dello Spettacolo, 2008), 161–76. My two-part "Cinecittà campo profughi," *Bianco e nero* 560, no. 1 (2008): 164–81; 561–62, nos. 2–3 (2008): 171–94, offers the most comprehensive documentation and images that I've published to date.

9 These facts and figures are largely drawn from Del Buono and Tornabuoni's *Era Cinecittà* and Buchielli and Bianchini's *Cinecittà*.

10 These stages are still considered world-class for lavish productions. I recognized this in a tour I took in spring 2005, when seeing the remains of Martin Scorsese's sets for *Gangs of New York* (2002), upon which was creeping a palatial Venetian waterfront perhaps for Michael Radford's sets for the *Merchant of Venice* (2004). This overlapping of sets confirmed what studio personnel explained: that sets are not dismantled until their parts or the particular spaces in which they are lodged are needed for another production. This tradition is obliquely reflected, we shall see, in the recycling of sets for habitation purposes in the camp.

11 Adriano Baracco, "L'amante grassa," *Star* 1, no. 1 (1944): 3. Though his sustained metaphor of the fat whore is not without misogynist edge, foreshadowing Fellini's favorite figure, it does not detract from the acuity of Baracco's analysis. Baracco became the editor of the restored journal *Cinema* in 1948 and also developed a career as a producer and screenwriter.

12 Ibid.

13 EUR, ACC box 108, reel 432D. The original ACC documents are in the National Archive in Washington, D.C. For this and all subsequent references to this body of documents, I have used the microfilms at the Archivio Centrale dello Stato.

14 This meant being barred from work in the film industry for six months. As

Callisto Cosulich suggests in "Neorealismo e associazionismo 1944–1953: Cronaca di dieci anni," in *Il neorealismo cinematografico italiano,* ed. Lino Miccichè (Venice, Italy: Marsilio, 1999), 90–91, this could not have seemed such a grave punishment in a period when so many others were out of work.

15 Baracco, "L'amante grassa," 3–4.

16 Carmine Gallone, "Gallone Scrive," *Star* 1, no. 3 (1944): 7.

17 This estimate, cited by Bracco, is affirmed in the *Corriere di Roma,* August 20, 1944, 8. The *Cronaca di Roma* reports on the same date that salvaged equipment could support production of some thirty films per year. It also mistakenly reports that the Allies released several soundstages for immediate production work.

18 EUR, ACC box 109, reel 503C.

19 "Quotidiano di informazioni a cura del P.W.B./Spettacoli cinematografici: disposizione per il fonzionamento," *Corriere di Roma,* June 13, 1944, front page.

20 Lorenzo Quaglietti, *Storia economico-politica del cinema italiano 1945–1980* (Rome: Editori Riuniti, 1980), 37–38. Since Quaglietti does not provide a written source, this citation from Stone might be based on a witness's memory or on hearsay and might be accused of distorting benevolent Allied intentions. Yet it is not inconsistent with the measures of limitation and control by the PWB mentioned earlier. What Stone must have intended to convey in no uncertain terms was surely the purging of Fascism and Fascists from the film industry—an agenda that was not, however, adhered to all that strictly. Cf. David Forgacs and Stephen Gundle's repositioning of Admiral Stone's remarks vis-à-vis the board's formal press release in *Mass Culture and Italian Society from Fascism to the Cold War* (Bloomington: Indiana University Press, 2007), 132–40. That the liberation and occupation of Italy was, among other things, also an American business opportunity surprises no one and is explored by Quaglietti, *Storia economico-politica*; Brunetta, *Storia del cinema italiano*; and Forgacs and Gundle, *Mass Culture and Italian Society,* among others.

21 *Corriere di Roma,* June 27, 1944. Interestingly, a clipping of this article is also among the EUR, ACC box 220, reel 955D.

22 Brunetta, *Storia del cinema italiano,* 165.

23 EUR, ACC box 109, reel 503C.

24 See, e.g., the note of May 8, 1946, from the Italian delegation for relations with UNRRA to the Presidenza del Consiglio dei Ministri–Gabinetto (Italian Prime Minister's Office). EUR, PCM 1944–47, 1.1.2.10474–12. All subsequent references to this folder will be noted as PCM. See also the detailed chronology of these exchanges in Valentini, "Il dopoguerra di Cinecittà."

25 On such problems in Rome, see "Deliberazioni della Giunta Municipale," *Capitolium* (1945–46), in the Archivio Capitolino, Rome, http://10.144.93.11/main/database. On DP populations in Italy, see UNRRA, *Operational Analysis Paper no. 49: UNRRA in Europe 1945–1947* (London: UNRRA European Regional Office, 1947), 74–75.

26 Hannah Arendt, *Origins of Totalitarianism* (Cleveland, Ohio: Meridian/World Publishing, 1958 [1951]), 278–89, 296–97, 444–45; despite the forcefulness of

her discussion, I remain uncomfortable with Arendt's drawing of a continuity between diverse kinds of camps, including extermination camps.

27 See Wyman, *DP*, 86–105, on this problem, one of a host of legal, social, and psychological difficulties associated with the war refugees.

28 The PCM folder contains documents defining the Subministry for Postwar Affairs and its posts. However, the files specific to this office were reportedly lost. The *Cronaca di Roma*, August 21, 1944, reported that the largest number of Italian populations in the camp came from the nearby area of Castelli Romani.

29 The Italian state's accords with UNRRA, signed on March 9, 1945, were reported the following day on the front page of the Roman paper *Il giornale del mattino*. However, it is evident that UNRRA's actual reach to various needy sectors and camps was gradual. The transfer date from UNRRA to IRO authority is cited in an August 19, 1947, memo of the Prime Minister's Office (in PCM).

30 Wyman, *DP*, 47, juxtaposes the "holding operations" by which the military initially managed much larger camps with the subsequent "average refugee center with 3,000 DPs . . . run by a thirteen-person UNRRA team" whose project was more advanced, including "rehabilitation: physical, psychological, vocational." There are reports by the Italian Subministry for Postwar Assistance (in PCM) on efforts to reduce the number of Italian inmates in Cinecittà, mainly by transfer to other camps.

31 According to Wyman, *DP*, 100, schools, organized nationally, were among the first institutions created in DP camps. See also UNRRA, *Operational Analysis Paper*, 91–92. Cinecittà schools are also mentioned by Mordechai (Marco) G., who tells of math and English classes in his testimony for the Yad Vashem archive in Jerusalem, file 0.3/8309, which I complemented in a personal interview in Tel Aviv in June 2005.

32 This evaluation is by the U.S. Holocaust Memorial Museum's online resource, which devotes a paragraph to Cinecittà: http://www.ushmm.org/museum/exhibit/online/dp/camp2b.htm. My interviews with former refugees as well as fragments of information in files of the YIVO Institute for Jewish Research, New York, support my suggestion that the camp was a lively Jewish center.

33 A report (in PCM) dated October 18, 1944, to Zaniboni, the high commissioner for refugees, contains an itemized comparison of food rations in the Italian and Allied camps: both quantities (in grams per person) and varieties of food are considerably in favor of the international camp. Mordechai G. recounted the curious detail regarding the Chinese cooks in Cinecittà. Lea Bersani mentions the movie screenings in the camp in Burchielli and Bianchini, *Cinecittá*, 55–56.

34 This list is a condensed summary of numerous reports in EUR, ACC box 108, reel 432D; ACC box 109, reel 503C; ACC box 220, reel 955D. It is consistent with accounts of other camps across Europe. Wyman, *DP*, 60–85, describes some of the common reasons for tension and violence, such as vigilante justice done with collaborators, or later, when repatriation picked up, the abhorrence of Eastern European DPs to return to countries under Soviet control, which resulted, at times, in suicides. Histories of Cinecittà, e.g., Del Buono and Tornabuoni's

Era Cinecittà, hardly touch on such details but do tell—to take one example that perpetuates the Cinecittà myth—how a Yugoslav refugee who worked in the camp hospital, Dr. Milko Skofic, met therein his future wife, Gina Lollobrigida.

35 See correspondences regarding this debate through the end of 1944 in EUR, ACC box 109, reel 503C.

36 *Crimen: documentario settimanale di criminologia* 1, no. 1 (1945): 15. According to Renato Lefevre, then head of the Rome police press office, *Crimen* was one of many popular magazines of that era covering crimes and sensational topics of the day; see "Giornali e riviste romane nel dopoguerra," *L'Urbe* 11, no. 5 (1948). Interestingly, an abridged translation of the article and Allied correspondences debating how to respond to it are found in EUR, ACC box 109, reel 503C.

37 Rosi's testimony is cited in Burchielli and Bianchini, *Cinecittà,* 55.

38 I have encountered this perspective in the testimony of Mordechai G. and in that of another former refugee, Libby Tannenbaum (September 26, 2007; telephone conversation in the United States).

39 The exception to this is are the few critics who singled out this film when it was screened in 2003 in Bologna. Archivists at the Cineteca Nazionale and at Istituto Luce, where I located it, were themselves surprised to find out that it exists in its entirety. Later documentaries that mention the camp, such as *Il mito di Cinecittà* (Istituto Luce/Giovanna Gagliardo, 1992), seamlessly join snippets from *Umanità* with the *Settimana Incom* newsreel I have cited.

40 Scripted by Salvatori with his producer Umberto Sacripante, *Umanità* was photographed by Vittorio Della Valle and Carlo Montuori (De Sica's cinematographer for *Bicycle Thieves* of 1948) and edited by Mario Serandrei, who already had among his credentials Visconti's *Ossessione* (1943), the documentary compilation *Giorni di gloria* (1945), and by some accounts, the coining of the term *neorealism.* I was aided here by Sanguinetti's program notes to a screening of the film in the Cinema Ritrovato festival at the Cineteca di Bologna (2003)—perhaps its only public viewing since the 1940s. It is hard to determine how and where the film was first distributed: one would guess it was to nonpaying refugee camp audiences in Italy and perhaps beyond. See my essay "Un film dimenticato," which elaborates on it further. I have been corrected, recently, on aspects of Salvatori's biography by information kindly offered by his son, Ray Holland, to whom I am deeply grateful. It is clear that Salvatori's curious and short career—he died in 1949—deserves further study.

41 Sanguinetti's program notes.

42 This might be the source of Sanguinetti's claim to me (in conversation) that Cinecittà's largest refugee population was of the survivors of Cassino, though no mention of such a population is to be found in the camp registers that I have examined. It is unlikely, furthermore, that the locations used in the early part of the film are those designated by its narrative since Cassino had been thoroughly destroyed, and not yet rebuilt in 1946.

43 The name "Jack Kenny" echoes that of the film's director, combined with "M. Keeny," head of the UNRRA mission to Italy, with whom Prime Minister Bonomi

had signed the accords, as reported on the front page of the Roman paper *Il giornale del mattino*, March 10, 1945.

44 Leonardo Tiberi of Istituto Luce told me of a pilot held at the Cinecittà camp (along with other Fascist personages from the Republic of Salò) who encountered German prisoners of war therein (conversation in Rome, March 2009). This interesting sliver of testimony might be explored further. It remains unlikely that the diverse categories of inmates at the camp would all mix together, certainly not as idyllically as they do in *Umanità*.

45 A similar model is also documented in photographs of other European DP camps (see Wyman, *DP*, 48) and is followed to our time in refugee management in civic centers such as the temporary housing for survivors of the May 12, 2008, earthquake in Sichuan, China; see *New York Times*, May 23, 2008, front page.

46 Mordechai G. testimonies.

47 With Zavattini's contribution, one could easily imagine a more coherent and engrossing *Umanità* directed by De Sica. Visconti would be my top choice for such materials: indeed, one might consider his *Bellissima*, produced in 1951 within and about Cinecittà, as sustaining such deeper historical echoes. Also, Antonioni approached Cinecittà as location, in both documentary and fiction, with the short *Tentato suicidio* (1953) and *La signora senza camelie* (1952–53) and in his contribution to Fellini's *White Sheik* (1952). Complementing these belated visitations to Cinecittà as location, one might consider the oppressive DP camp images in such films as Rossellini's *Stromboli* (1950) and *Donne senza nome* (Géza Radványi, 1950).

48 Baracco, "L'amante grassa," 4.

49 All documents in PCM. In a May 19, 1947, meeting of the Cinecittà company executives with the Subministry for Postwar Assistance, the barracks of Centocelle as well as the E-42 (EUR) workers' village are designated. Pending Allied deaccession of the real estate, the ministry assures that such *sfollamento* (evacuation) can take place within three months.

50 The letter of invitation from the Cinecittà company to Andreotti is dated November 7, 1947 (PCM). Andreotti's speech is from the *Settimana Incom* newsreel of November 12, 1947, cited earlier in text.

51 Other than the PCM documents, I learned about housing solutions and the continued difficulties of the Italian *sfollati*, as well as about the use of the Centro Sperimentale for Cinecittà labels, in my many conversations with Mario Musumeci, head of restoration at the Cineteca Nazionale, who is at home in all these domains—due both to his family history in Quadraro and to his intimate knowledge of the archive. Musumeci also showed me the documentary film *Cecafumo: storia di un territorio* (Maurizion Ciampa and Pietro De Gennaro, 10th Municipality, Rome Cinecittà, n.d.).

52 PCM.

53 Russell Merritt brought to my attention a two-part article by cinematographer Robert L. Surtees on the making of *Quo Vadis*, published in *American Cinematographer* 32 (October 1951): 398–99, 417–19, and 32 (November 1951): 448,

473–76. Surtees report that the building of sets and preparation of equipment and costumes for this lavish production took place in 1949, while filming started in April 1950. He further describes the technicalities and shortcomings at the studios and his own ravished experience of filming among the Roman ruins—though of course, it is largely in fabricated ruins-within-the-ruins of Cinecittà that the film was made. Surtees also reports on a system of extras recruitment, locally organized by *Capo Grupos*—captains who would manage Italian mobs from their neighborhoods and then distribute their pay received collectively from the American producers. It is needless to comment on the obvious corruption to which such a system must have been susceptible.

6 | Right Here in Mason City: *The Music Man* and Small-Town Nostalgia

LINDA A. ROBINSON

It was just as if the movie had come to life, as if they were actually experiencing the thrill Professor Harold Hill sang about when "Gilmore, Liberatti, Pat Conway, the Great Creatore, W. C. Handy, and John Philip Sousa all came to town on the same historic day!"[1] This sunny Tuesday was the high point, some might say, of the town's entire history. Visitors had begun arriving on Monday, or even earlier, during the weekend: high school students and their chaperones; Warner Bros. representatives; members of the press from all over the country; and most exciting of all, movie stars, *real* movie stars! All told, an estimated seventy-five thousand people descended on Mason City, Iowa, in June 1962 to watch or participate in *The Music Man* National Marching Band Competition—the annual North Iowa Marching Band Competition expanded into a national competition for this single year—and to celebrate the press premiere of Warner Bros.'s film version of the successful Broadway musical. That Warner Bros. had chosen to hold the film's press premiere in Mason City, a north central Iowa town with a population of thirty thousand, was due to its author's good sense in having been born there. And by far the most revered guest at the festivities was Meredith Willson, Mason City's favorite son, who had spent his boyhood there and then honored the town by memorializing it as *The Music Man*'s fictional River City—first in his Broadway hit and now, forever captured on film, in the Warner Bros. movie.

Throughout the postwar era, the American small town at the turn of the last century had been an object of nostalgic affection: in published memoirs such as Roderick Turnbill's *Maple Hill Stories*;[2] in films such as *On Moonlight Bay* (1951) and *Pollyanna* (1960); and—in concrete form—in Disneyland's Main Street, USA, first opened to the public in 1955. This nostalgia positioned the turn-of-the-century small town as offering the utopian solutions, in Richard Dyer's terms, of energy (in the form of pastoral return) for modern-day exhaustion, transparency (honest

133

communications and relationships) for modern-day manipulation, and perhaps most of all, community for fragmentation.[3] A long-anticipated film based on a Broadway hit whose music had been in widespread circulation since 1957, *The Music Man* was the epicenter of this 1950s to early 1960s nostalgia for America's moment of lost innocence, and that nostalgia, in fact, was the experience Warner Bros. sold to 1962 audiences.

In turn, it was Warner Bros.'s turning *The Music Man* into a national event that made the film a feasible and attractive hook for Mason City's self-promotion in the twenty-first century. The forging in popular imagination of a tie between a particular place or locale and a particular film is a phenomenon that occurs with some regularity, reflecting perhaps a desire to bring a piece of cinema's fictional world into our own, such as when travelers to Madison County, Iowa, seek out the covered bridge from *Bridges of Madison County* (1995). The on-location film premiere, while probably designed primarily to generate excitement about the film's release, can also serve as an opportunity to emphasize such a relationship between place and film, as in the 1939 premiere of *Gone with the Wind* in Atlanta, Georgia, home to the novel's author, Margaret Mitchell. In the case of Mason City and Warner Bros.'s 1962 film *The Music Man*, this connection was forged, with the full force of the Hollywood publicity machine behind it, to such a degree that the blurring of identities between Mason City and River City has become a confusing circular dance: today, Mason City promotes itself by adopting the identity of its fictional counterpart, River City, which is, in turn, a fictional version of Mason City itself.

Nonetheless, the effect of Mason City's twenty-first-century attempt to market *The Music Man* and its 1912 setting differs significantly from Warner Bros.'s efforts in 1962, and not simply because of the great discrepancy in resources and visibility. In 2011, the sights and sounds of turn-of-the-century America are no longer in popular circulation, and neither, for the most part, is *The Music Man* itself. Thus Mason City's effort seems to have come too late, given that it seeks to capitalize on commercial products—*The Music Man* and River City—that, without the familiarity made possible with such cultural circulation, have outlived their nostalgic range.

FROM CONCEPTION TO STAGE TO SCREEN TO NATIONAL PHENOMENON, WITH A CELEBRATION IN MASON CITY ALONG THE WAY

Meredith Willson, author of *The Music Man*, was born in Mason City, Iowa, on May 18, 1902, to a comfortably middle-class family.[4] The Willsons were a musical family, and Willson grew up playing several instruments.[5] After graduating from high school, he left Mason City in 1919 to study music in New York City.[6] He never

lived in Mason City again, although he returned for visits for the rest of his life. In the late 1920s, he moved to the West Coast, eventually settling in Los Angeles and finding work in radio, film, and television. In 1932, he became director of NBC's west division, and in the years that followed, he also conducted radio, television, and motion picture orchestras as well as composing symphonic material, popular songs, and the film scores for *The Great Dictator* (1940) and *The Little Foxes* (1941).

In the 1940s and 1950s, Willson cultivated a public persona in addition to pursuing his behind-the-scenes roles of composer, conductor, and radio division director. As musical director of *The Burns and Allen Show* and *The Maxwell House Showboat* radio programs, he regularly appeared on air; he was also a guest on various other radio programs, and in the late 1940s, he began hosting his own radio programs.[7] In addition, in 1948, he published the autobiographical *And There I Stood with My Piccolo*,[8] to be followed in 1955 with *Eggs I Have Laid*.[9]

Key to Willson's public persona was Mason City, Iowa, and particularly Willson's memories of his boyhood there in the first two decades of the twentieth century. This persona was very much a small-town boy; as one biographer describes it, Willson "fabricated a caricature of himself, an average fellow from Mason City who simply enjoyed sharing stories about his 'cousins' . . . a naïve, dim-witted character whose presence in the script complemented [radio] stars . . . like Frank Morgan and Gracie Allen."[10] The degree to which this "homespun" and "folksy"[11] persona was a fictional construction—and Willson's devotion to self-promotion is evident throughout his career—is of less relevance here than how it positioned him to be perceived by American audiences and readers. Specifically, Willson was situated to serve as a *public* representative of his generation, the last to have experienced the American small town before its complete conversion from its premodern to its modern form. Certainly Willson's many references to—indeed, the association of his public persona with—turn-of-the-century Mason City were the reason that Broadway producers Ernie Martin and Cy Feuer approached him in 1951 to write a musical comedy about his Iowa boyhood.[12]

After a long and difficult birth—Willson began writing the play, his first, in 1951—*The Music Man* opened on Broadway on December 19, 1957, and was an immediate hit. It won multiple Tony Awards[13] and ran for 1,375 performances;[14] the Broadway cast LP album was a best seller.[15] In late 1960 or early 1961, Warner Bros. Studios purchased the screen rights.[16]

In doing so, Warner Bros. was acting in the manner dictated by Hollywood industry conditions of the time. The various factors acting on the film industry throughout the 1950s had caused a tightening of the economic risks involved with filmmaking.[17] As a result, Jerome Delameter notes that "the major studios all but

stopped 'original' musical production and began to lean, instead, on the proven popularity of the Broadway show. Adaptations became the major form of musical productions in the Fifties and Sixties."[18]

The postwar decline in movie attendance and the 1950s breakup of the Hollywood studio system have been well documented elsewhere; suffice it to say that from the record $1.692 million in 1946, Hollywood's box office receipts dropped by 43 percent, to $955 million, by 1961.[19] Simultaneously, the dismantling of the studios' vertically integrated oligopoly and the reduction of their workforce, as one among several cost-cutting measures, resulted in a fundamental change in the nature of film production. Increasingly, in-house production was replaced by the package unit system, a "short-term film-by-film arrangement"[20] whereby an independent producer organized a film project, marshaling the narrative property, personnel, equipment, and production sites, and secured its financing, often from a Hollywood studio.[21] The net result was that for the studios, each film became a distinct investment risk, in contrast to films during the studio era, where exhibition divisions usually guaranteed profitability across a studio's annual film output regardless of the box office receipts of any particular film. In the 1950s, however, each film was increasingly subject to the imperative of turning a profit.

Always a cost-conscious studio, Warner Bros. continued to be profitable in the eight years after the end of the war. In 1953, however, after it had been forced to sell off its exhibition division, the studio's profits dropped to the 1940 level of three million dollars, and in 1958, it recorded annual losses for the first time since 1934.[22] What profitability Warner Bros. maintained in the postwar and postdivestiture period was achieved by cutting costs, moving into television production (one of the first of the Hollywood studios to do so), and selling its old movies to television. This, then, was the state of the industry—and Warner Bros.'s position within it—at the time Warner Bros. acquired the motion picture rights to *The Music Man*. That Warner Bros. regarded *The Music Man* as an ideal project, as close to a guaranteed hit as could be found, is reflected in an undated studio press release stating that Warner Bros. had acquired the motion picture rights to *The Music Man* for "the highest price ever paid for any theatrical property" and characterizing *The Music Man* as "the most sought after theatrical property in entertainment history . . . fully representative of the best in American tradition and entertainment"[23] and "the heaviest pre-sold theatrical property to reach the screen."[24]

Warner Bros.'s strategy for capitalizing on the box office potential of Willson's Broadway success was to make *The Music Man* an event. As reflected in the studio's fifty-page press book, Warner Bros. introduced the film with a massive publicity campaign. This campaign was launched with a nine-team publicity "hand-planting"

tour in April and May 1962, "each team travelling in a Chevrolet Impala station wagon emblazoned with the slogan 'THE MUSIC MAN is Coming,'" which resulted in "more than 70,000,000 copies of over 20 magazines [carrying] major treatment of THE MUSIC MAN by the time of the film's world premiere."[25]

According to the studio, the "spectacular climax to the tremendous pre-release publicity campaign for THE MUSIC MAN"[26] was the film's press premiere in Meredith Willson's hometown, Mason City, Iowa, well known as the inspiration for *The Music Man*'s River City. This was not, in fact, simply a movie premiere; rather Warner Bros. scheduled it to coincide with—and take advantage of—a long-standing Mason City tradition that embodied the film's central marching band motif: the North Iowa high school band competition. Since its inception in the 1930s,[27] this annual competition had always been hosted by Mason City, but in past (and future) years, it was a regional contest, limited to schools located in northern Iowa and Minnesota. When Warner Bros. decided to hold the film's press premiere in Mason City, however, the two events became linked, and the Twenty-fourth Annual North Iowa Band Festival was expanded, for 1962 only, into a national competition, believed to be the first national marching band competition ever held in the United States.[28]

Warner Bros. began publicizing the newly christened *Music Man* National Marching Band Competition a full year in advance. On June 22, 1961, the studio issued a press release promising that over one hundred high school bands would participate in the band competition and that the festivities would receive national and foreign press coverage.[29] For its part, the town of Mason City also spent an entire year in planning. Although Warner Bros. provided significant financial support, the event nonetheless required a $35,000 fund-raising campaign by Mason City's Chamber of Commerce (four times the campaign goal of previous years)[30] and the cooperation and participation of all the city's downtown merchants. In addition, given the prediction that 8,000 band members would be in town for the competition,[31] significant citizen involvement was needed to meet the demand for housing.[32]

The festival became an opportunity for municipal celebration of two of the town's greatest sources of pride: its annual band competition and Willson, its favorite son. For instance, the annual Iowa State Rose Show, held in the Hotel Hanford, where the VIP festival guests were to be lodged, presented "a floral tribute to Meredith Willson" and sponsored a special sweepstakes for flower arrangements with *Music Man* motifs.[33] A one-of-a-kind gold medal was to be presented to Willson at the premiere, and replica souvenir coins were available for purchase.[34] Sculptor Carl Carlson committed to producing a public statue of Willson,[35] and the city fathers renamed the Willow Creek footbridge, which, in its pre-1940s incarnation, served

as Willson's inspiration for the one in *The Music Man,* as the "Meredith Willson Footbridge."[36]

This celebratory participation, in fact, went beyond Mason City itself to the state of Iowa as a whole. The city's mayor and the 1961 North Iowa Band Festival queen, serving as welcoming committee, greeted not only Willson and the Hollywood celebrities when they arrived at the Mason City airport but Iowa's senators as well, both of whom attended the festivities. Moreover, as Warner Bros. had predicted, the event received widespread media exposure. The Mason City *Globe-Gazette* reported that Voice of America would cover the festival internationally.[37] In addition, newspapers throughout the United States reported on the festival and premiere, ranging from such metropolitan organs as the *Los Angeles Times,* the *Washington Post,* the *Chicago Daily Tribune,* and the *Miami News* to those of smaller cities and towns such as the *Newark Evening News,* the *Des Moines Register,* and the *Cedar Rapids Gazette.*

The band competition and film premiere took place on Tuesday, June 19, 1962, although the festivities began the evening before with such events as a motorcade of the film's celebrities through town; a dinner "for visiting dignitaries" at the Hotel Hanford; a two-hour downtown open house of local businesses for visiting band personnel;[38] and a reception for out-of-state "bandmasters and wives" and chaperones. Tuesday morning's events began with the four-hour Grand Parade of more than one hundred high school marching bands and "queens, floats and personalities." At noon, a picnic was held in Central Park for the visiting celebrities, other dignitaries, and Iowa and Minnesota bandmasters, serenaded by various barbershop quartets.

The band competition itself occurred Tuesday afternoon at Mason City's Roosevelt Field, while simultaneously, a program was held in Central Park consisting of concerts by the noncompeting bands and the presentation of the Band Festival queens. At 6:00 P.M., Roosevelt Field was opened for the "grand entry of all bands," at which time the competition winner was announced and the band queen crowned. In the evening, the festival concluded with the premiere of *The Music Man* at the Palace Theatre, emceed by Arthur Godfrey and with attendance limited primarily to members of the press.[39]

In the end, thirty-two bands competed in the band competition,[40] and press estimates of the total number of visitors rose as high as one hundred thousand, although the Mason City newspaper reported attendance at seventy-five thousand.[41] Whatever the true number, it was anticipated that crowds during Tuesday's events would be so great that postmaster Henry Pendergraft stopped downtown mail deliveries for the day.[42]

Warner Bros.'s full-court publicity press did not end with *The Music Man*'s Mason City press premiere on June 19, 1962, and the subsequent Denver, Colorado, world premiere on July 6, 1962.[43] For instance, the studio press book proclaims July 1962, the month of the film's nationwide release, to be Muzak Corporation's "MUSIC MAN MONTH," in which, each day, Muzak would feature songs from the film, to the certain enjoyment of elevator riders everywhere. In addition, as part of Warner Records's promotion of the sound track album, July 25, 1962, was named "'Music Man Day' on 750 radio stations [in 45 states] across the country."[44]

In the end, Warner Bros.'s extensive efforts to promote the film paid off; *The Music Man* earned eight million dollars in rentals in 1962, making it number seven on *Variety*'s List of Big Rental Pictures of 1962.[45] According to a studio press release, more than three hundred thousand sound track albums were sold in the first week of its release, making this the best-selling record in Warner Records history.[46] The film was nominated for six Academy Awards and won the Oscar for the best adapted musical score.[47] It also won the Golden Globe award for Best Motion Picture/Musical, Laurel Awards for Top Musical and Top Male Musical Performance (Robert Preston),[48] and the Writers Guild of America award for Best Written American Musical. On July 5, 1962, *The Hollywood Reporter* announced that seventeen magazines had chosen *The Music Man* as their picture of the month for August 1962,[49] and in its February 1963 issue, *The Sign,* a national Catholic magazine, named *The Music Man* best picture of 1962.[50]

1962 NOSTALGIA FOR 1912 RIVER CITY

From the outset, the public discourse about *The Music Man* characterized the film as an "idyllic" portrait of small-town life at the turn of the century and lauded the film's ability to re-create for audiences, at least to some degree, the *experience* of that prior time and place. Thus Warner Bros.'s approach to publicizing *The Music Man* was to foreground and celebrate its period setting. In fact, in an undated press release, Warner Bros. argued that *The Music Man*'s period setting *was* the basis for its appeal:

> Whoever believes there is nothing good about the good old days except they're gone is no judge of the public taste, particularly in movies. *Nothing seems to please moviegoers more than a nostalgic backward glance at the days of yore.*
>
> . . . For instance, currently in production at Warner Bros. [is] . . . Meredith Willson's "The Music Man," . . . which takes place in a small Iowa town in 1912.

> . . . Perhaps it is because of every man's familiarity with the past and his uncertainty about the future, but *there is apparently no better subject for a good movie than a little journey into the past.*[51]

In marketing *The Music Man* as "a little journey into the past," Warner Bros.'s strategy was to emphasize the film's period authenticity with publicity describing the studio's extensive efforts to ensure accuracy in costuming, hairstyles, and set design. Warner Bros. exploited as well the film's grounding not simply in the *general* idea of the turn-of-the-century small town but in a *specific* small town in the *specific* year of 1912, lending the film an authenticity necessarily enhanced by Willson's bona fides as long-standing raconteur of his hometown's history:

> It isn't very often that a man is privileged to stand around and watch his hometown being rebuilt in Hollywood. But this is exactly the experience which is engaging the happy attention of Meredith Willson at Warner Bros., where the storefronts and signs went up on River City, Iowa. River City is, to be sure, the fictional name for the very real town of Mason City, the background for Willson's fabulous show, "The Music Man."[52]

Most critical response to the film was also couched in terms that affectionately—at times lyrically—recalled its period setting. The *Hollywood Reporter,* for instance, predicted that *The Music Man* would be a "box office bonanza" because

> what Meredith Willson . . . succeeded in doing . . . was to create through music a whole era and atmosphere of American life, *the Midwest at its first surge of vitality, a period (1912) of nostalgia and affection, a nostalgic, pastoral way of life now irrevocably gone.*[53]

Other critics described *The Music Man*'s period setting as "the friendly days before world wars shattered [America's] tranquility,"[54] "an age now past but fondly remembered,"[55] and "the days when rural America was delightfully naive and small towns had a personality of their own."[56] Significantly, some reviews explicitly pitted the film's period setting against the present day: "[*The Music Man*] reminds us that the America of several generations ago could find pleasure in a relaxing park stroll or community dance on a moonlit Summer's evening. The Jet Age of the Soaring Sixties can too easily forget such modest-paced recreation."[57]

This perception of *The Music Man*'s 1912 small-town setting as nostalgically idyllic, however, is somewhat belied by the text itself. Admittedly, the film's ending

is celebratory: Hill is redeemed and reconciled with the town by the boys' and Paroo's faith in him, and in the film's fantastic finale, in which night becomes day,[58] Hill's ragtag boys' band is magically transformed into a huge, magnificent marching band that parades through the town performing "Seventy-six Trombones." This ending leaves the viewer with a sense of joyful community as well as what Richard Dyer has identified as the utopian feeling inherent in the Hollywood musical number. It is understandable, then, that the dominant impression of the film's setting communicated by those writing about the film would be a positive one—one, in fact, in which this satisfying and uplifting ending would cast a decidedly idyllic quality on the town's temporal distance and geographical distinction from urban and suburban midcentury America.

Nonetheless, the film's narrative arc is that River City, a dystopian town, is healed through the intervention of an outsider. Thus River City, as Hill first finds it, is a narrow-minded, repressive place, unwelcoming to strangers. Municipal government consists of a buffoonish mayor and a feuding, ineffectual school board; the town's middle-class women, dominated by the mayor's overbearing wife, are self-righteous gossipmongers. Though River City becomes a literally harmonious town by the film's conclusion—the once-feuding school board now an inseparable barbershop quartet—this transformation is effected only through the machinations of the city slicker[59] con man Hill; key to the happy ending, in fact, is the understanding that River City in its natural—i.e., pre-Hill—state *lacks* the neighborly sense of community at the heart of the myth of the idyllic turn-of-the-century small town.

To be sure, River City's dystopia is presented comically and, from Willson's standpoint at least, affectionately, which renders it less toxic than it would otherwise appear; indeed, as with all comedy, that dysfunction is part of the pleasure the film offers. This dysfunction is undercut as well by the number of occasions—beginning with Hill's first moments in town—in which the town engages in group song, suggesting on an affective level a greater sense of community than the narrative presents. And certainly by the end of the film, narrative and form converge in a demonstration of community pride and celebration. Thus the film's construction suggests that the ideal, while not necessarily inherent in this particular time and place, was nevertheless *achievable*.

Nonetheless, to some degree, this discursive theme of "nostalgia" appears to reflect a preexisting popular construction of small-town, turn-of-the-century America as an idealized moment of innocence as much as anything particular to *The Music Man* itself. Certainly Warner Bros. capitalized on this construction even as its publicity contributed to it. The presumptive belief in that innocence reflected in this discourse suggests, however, that in 1962, the concept itself was in current

cultural circulation, familiar to all, and, as a result, had in fact been largely internalized in the American public consciousness as a historical, unquestioned "given."

2011 NOSTALGIA FOR 1912 RIVER CITY

Biographer Bill Oates points out that in the early developmental stages of *The Music Man*, Willson usually denied that River City was modeled on Mason City, presumably out of concern that the play would be a flop. Once it was a hit, however, Willson "affectionately and deliberately affiliated Mason City as the original home of the 'Iowa stubborn,'"[60] and the affiliation has continued to the present day. In fact, in 2011—with the exception of DVD sales—it is no longer Warner Bros. who seeks to market *The Music Man*'s nostalgia for 1912 America; rather the entity seeking to do so is Mason City, which has effectively adopted the identity of its fictional self—River City—as a means of promoting itself to tourists. Here again is the effort to re-create—and sell—the pleasures of simpler times, but the effect of that effort is very different now from what it was in 1962; rather, today, Mason City is attempting to sell a nostalgic product increasingly unfamiliar to potential buyers, as River City in particular and the turn-of-the-century small town in general, as part of popular culture, slip more and more outside nostalgic range.

The idea of capitalizing on *The Music Man* and River City to promote tourism was first broached before the Warner Bros. film went into production. When he sold Warner Bros. the motion picture rights, Willson approached the governor of Iowa to suggest that a 1912 River City motion picture set be built near Mason City, to be "turned into a representation of bygone Iowa, a tourist attraction like Michigan's Greenfield Village or Virginia's Colonial Williamsburg"[61] after filming was completed. When the state legislature did not act quickly enough on this expensive proposition to meet Warner Bros.'s production schedule, however, the studio decided to shoot the film on its back lot instead.[62]

The Mason City press premiere generated a similar suggestion. In the midst of its June 15, 1962, coverage of the event, the Mason City *Globe-Gazette* published a large drawing of a city block of *Music Man*–style buildings, enclosing within the block what appear to be a carousel and a small circular train track. Above the drawing, the headline reads, "Dream Envisions Real River City." In the accompanying article, Luvern J. Hansen, a Mason City businessman, proposes that the city build a "River Cityland":[63]

> What would "River Cityland" be like? With a little imagination, it could be Disneyland, the World's Fair, and an introduction to the space age, all in one thrilling development. What would "River Cityland" feature? . . . As

a starter, I could suggest an authentic "River City" main street, planned after the Warner Brothers sets for Meredith Willson's The Music Man. The show windows in these replicas of by-gone days could serve as a museum of early century Mason City and trade area. . . . The more people we can get to come to Mason City . . . , the better for all who are a part of this fine city.[64]

Such a re-creation of River City did not come into existence, however, until Mason City's Music Man Square opened its doors in 2002. Housed within the Music Man Square building are the Meredith Willson Museum, the Conservatory of 1905,[65] the 1912 River City Streetscape, Reunion Hall,[66] Mrs. Paroo's Gift Shop,[67] and the Exploratorium for early childhood music education. A glossy, four-color booklet promoting Music Man Square states that future plans include a five-hundred-seat Performing Arts Center (eventually to house a summer stock theater) and the conversion of "the old Mason City Bakery building, originally developed in 1917 and once owned by Meredith Willson's father, . . . into a village-type bakery." Across the street from the Music Man Square building stands the Meredith Willson Boyhood Home, which has been restored—with some of the Willson family's original furniture—to its appearance in the 1910s. Both the Music Man Square Web site and the promotional brochure ask,

> Have you ever fantasized what it would be like to step into an actual motion picture? That's how many people feel when they visit the River City Streetscape in "The Music Man Square." It's always July 3, 1912 in the Streetscape, and Professor Hill is about to get off the train. Do the storefronts look familiar? That's because they are based on the sets used in the Warner Brothers 1962 film version of The Music Man.[68] From Mrs. Paroo's front porch to Madison Park to the Pleez-All pool hall, you'll feel as if you'd rented a video of the movie.[69]

The Music Man Square Web site explains that

> Mason City's rich musical heritage inspired Meredith Willson to use his hometown as the setting for one of America's favorite musicals, The Music Man. So it seemed only natural to celebrate the life and music of Meredith Willson by developing this multi-million dollar complex adjoining his boyhood home, not only to honor him but to sustain the spirit of "River City, Iowa."

Within this Web site, the Meredith Willson Boyhood Home Web page promises visitors "turn-of-the-century nostalgia," while "The Musical" Web page points out that "Meredith Willson's Iowa home town of Mason City, with its pool hall, foot-bridge, and annual Band Festival, is unmistakable as the inspiration for the fictional 'River City.' All the spirit and flair of this classic Americana is being captured in 'The Music Man Square'—right here in River City!" (Figure 6.1).

One item for sale in the gift shop is a video titled *It's Yesterday Once More! The History of Mason City, Iowa 1853–1962*. The video unabashedly promotes itself as nostalgia—box copy reads, "*It's Yesterday Once More* is a nostalgic 80 minute video program that captures the essence of the 140-year history of a small county seat town in northern Iowa"—and it positions Mason City as an Anytown, the embodiment or representative of all small midwestern towns, whose familiarity offers a universal nostalgic pleasure:

> [This] is the story of Mason City, Iowa, no different from a hundred other small agrarian towns in Midwestern America. . . . Seeing this program will rekindle anyone's memories of their own particular hometown and they will be reminded of the nostalgic and warm feeling they perhaps have for their own childhood.

Using still photographs, music, occasional sound effects, and voice-over narration, the video relates Mason City's story, from its founding as a traders' camp in 1853 through the industrial growth and prosperity of the 1910s to World War I and the Depression. At this point in the city's history, however, external events seem to end. Instead, the video moves into the life histories of two of its favorite sons. After relating the life story of puppeteer Bil Baird, the video summarizes Willson's biography and ends with the press premiere of *The Music Man* in 1962. Robert Preston's Broadway recording of "Seventy-six Trombones" plays on the sound track over a photograph of Willson exuberantly leading the 1962 parade, followed by a series of more contemporary color photographs of high school marching bands that appear to date from the 1970s. Preston's song then continues to play under the film's credits, which crawl over more black-and-white, early-twentieth-century photographs of Mason City and its residents.

In fact, however, *It's Yesterday Once More!* reveals that Mason City in 1912 was a very different place from the 1912 River City depicted in the Warner Bros. film. According to the videotape, Mason City enjoyed its "most prosperous period of growth" in the first decade of the twentieth century, during which an influx of southern and eastern European immigrants introduced a new diversity into the

Figure 6.1. Music Man Square Streetscape, Mason City, Iowa. Mason City Convention and Visitors Bureau.

town's predominantly West European stock. River City had a population of two thousand in 1912; in contrast, between 1895 and 1907, Mason City's population grew from six thousand to sixteen thousand, at which time it was the twelfth largest city in Iowa. By 1912, Mason City had a fifteen-year-old streetcar system, five banks, four vaudeville houses, four newspapers, numerous schools, and at least two hospitals. The first automobile had appeared in Mason City in 1903, and the city's first motor company was established in 1906; in 1913, Mason City passed its first traffic laws for automobiles and constructed the first mile of concrete highway in Iowa. One of Mason City's major industries, a cement plant on the outskirts of town, had been built before the turn of the century; the video describes the town's new immigrants as finding work not only in the cement factory but in brickyards and packing plants. The video's photographs of early-twentieth-century Mason City present a town of many large brick buildings and a well-populated business district, a very different kind of municipality from the hamlet portrayed in *The Music Man* or replicated in Music Man Square.

Still, the industry conditions that spurred Warner Bros. to promote *The Music Man* so aggressively put Mason City in the position to capitalize on its favorite son's creation. Warner Bros. not only worked to ensure *The Music Man*'s success but it literally brought that success home to Mason City, making the town, like the studio itself, both a factor in and a beneficiary of that success. Warner Bros.'s

greatest contribution to Mason City, however, was the attention it drew to *The Music Man* itself, which ultimately, through the film's popularity with audiences, gave River City sufficient stature and public presence to make it a useful promotional tool for Mason City. In addition, the Warner Bros. film itself taught Mason City that the past could be both a pleasurable experience and a marketable product, and furthermore, that a fictional past is the most likely to be successful at both.

The result is a curious circularity of identity, consumption, exploitation, and promotion, with Mason City posing as the fictional version of itself: Willson created River City from Mason City, which now re-creates Mason City from River City. Like a mind-teasing puzzle, the overlays and doublings of images and identity become confusing and seem almost impossible to untangle, like the mise-en-abyme construction of the cereal box with the picture of a sports star holding a cereal box with a picture of the sports star holding a cereal box. For example, *The Music Man* melds Mason City's long-standing pride in the marching band with the film's triumphant finale, in which River City's suddenly immense marching band fills the city's streets. Indeed, the 1962 Band Festival parade, with Willson at its head, seems itself a parallel or replication of the movie's ending. Both are exuberant celebrations of the marching band and of the small town. For that matter, both are spectacles of gratitude to the man who has brought joy and excitement to an otherwise unexceptional existence.

At the same time, however, Mason City's twenty-first-century effort to capitalize on *The Music Man* seems somewhat ill conceived. The nostalgia for sale in Music Man Square, such as in the *It's Yesterday Once More!* video, is in part the same that Warner Bros. sold with the film in 1962: nostalgia for the simpler, slower, more innocent way of life popularly associated with America's turn-of-the-century small town. In Music Man Square, however, what is also being sold is nostalgia for the 1962 film itself. Thus Music Man Square is an obvious attempt to inspire a form of what Roger Riley, Dwayne Baker, and Carlton S. Van Doren identify as *movie-induced tourism,* whereby "through movies, people are sometimes induced to visit what they have seen on the silver screen."[70] Riley and his colleagues have conducted empirical studies of tourist visitation levels at such locations as Devils Tower National Monument, Historic Fort Hays, the Dallas Book Depository, and the Dyersville, Iowa, cornfield baseball diamond, as affected by the release of the popular movies filmed in those locations: *Close Encounters of the Third Kind* (1977), *Dances with Wolves* (1990), *JFK* (1991), and *Field of Dreams* (1989), respectively. These studies confirm a significant, measurable increase in tourism (between 40% and 50%) at such sites following the films' release and for at least four years afterward. The authors report as well that, among other examples, counties and municipalities

have developed and marketed movie-related tours, such as the *Driving Miss Daisy* tour of the Druid Hills neighborhood in Atlanta, Georgia, and "in at least one case, a movie has made a small town into a boutique of movie memorabilia (*Fried Green Tomatoes* [1991])."[71] Ultimately, Riley and colleagues determine that

> the visual media of today appear to construct anticipation and allure that induces people to travel. In the case of major motion pictures, the constructed gaze is not a sales strategy for tourism promotion but an entertainment ploy where storylines, underlying themes, exciting events, spectacular scenery, and characters create hallmark events. These events create exotic worlds that do not exist in reality but can be recreated through a visit to the location(s) where they were filmed.[72]

Their research also indicates, however, that "the pulling power of movies tends to fade as other events capture the viewing public's eye."[73]

Music Man Square, however, offers its visitors a dual nostalgia: not only for the 1962 film but, at least to some degree, for that of Mason City's (fictional) former self; that is, Music Man Square attempts to provide visitors something akin to the experience of walking through the idealized 1912 community of River City itself. Thus, in addition to movie-related destinations, Music Man Square reflects the phenomenon of the "theme town" that Mira Engler reports has become "an unparalleled force in Iowa"[74] since the early 1980s. By marketing themselves as themed tourist attractions, Iowa towns attempt to "alleviate the pain of desertion by youngsters, by industry, and by retailers; to repopulate the empty stores on Main Street; to overcome a sense of placelessness and geographical anonymity; and to regain a sense of worth and pride."[75] Indeed, tourism is now Iowa's third leading industry, following agriculture and manufacture, and is crucial to the survival of many small rural towns.[76] Engler perceives the impulse that makes such efforts successful as "a desire to make the imaginary real."[77] She identifies four categories of Iowa theme towns: Old World, Frontier America, Old Town, and Agrarian America (or Country Charm); of these, Music Man Square most closely approximates the Old Town model, in which "prosperous Main Street businesses and the public life of the 1920s are captured in the 'good-old-town' experience."[78]

In fact, of course, Music Man Square is not an example of movie-induced tourism, as Riley and colleagues define it, and neither does its presence make Mason City a theme town; its curious hybridity of elements of these two types of tourist sites mirrors a certain weakness in its attempt to sell nostalgia for *The Music Man*. Rather than the film's drawing viewers' interest to an existing tourist

attraction or the film's *creating* the tourist site—as occurred most famously with the Dyersville, Iowa, cornfield baseball diamond, which became a tourist destination only after droves of movie fans began to visit it—here *The Music Man* is the excuse offered for tourism; that is, rather than *The Music Man*'s sending visitors to Mason City, Mason City dangles *The Music Man* as bait, hoping to draw visitors in. Movie-induced tourism, as defined by Riley and colleagues, is a spontaneous phenomenon, whereby filmgoers are inspired by a film to try to enter or experience it by visiting one of its shooting locations; not only is *The Music Man*, over forty years old, unlikely to have such an effect on someone who might watch it today, but what Mason City offers is not *The Music Man*'s shooting location but a *replica* of the back lot set on which it was filmed. Moreover, Music Man Square is *simply* a stage set, whereas the Iowa theme town, although often a modern-day fabrication, is nonetheless a collection of functioning establishments approximating its "real-life," historical model. Whereas Engler contends such theme towns offer a reassuring, fictional past, Music Man Square offers a replica of a fictional version of Mason City's past—indeed, it offers not even the chance to inhabit the fictional world of 1912 River City but rather the Hollywood construction of that fictional world, in a sort of museum version of a Universal Studios theme ride.

Furthermore, *The Music Man* itself is a cultural product that itself seems to have largely fallen outside nostalgic range. It is true, as *The Hollywood Reporter* noted in 1962, that "the rocketing success of the stage musical in New York and London proves it isn't necessary to have been part of that period [1912] to enjoy [*The Music Man*]."[79] Fred Davis acknowledges that a person can experience a secondary nostalgia for times and places that have been represented so frequently in mass media that he or she has the illusion of having lived through them.[80] If those frequent representations disappear from popular culture, however, such nostalgia eventually becomes impossible. The twin, albeit somewhat contradictory, requirements for pop culture nostalgia are *distance* and *familiarity*, which must exist in the proper balance for collective nostalgia to exist; too much distance and too little familiarity in the public consciousness will cause the nostalgic object to fade from sight; that is, it will fade from sight *unless* it continues to serve its psychic role, but the greater the temporal distance between the present day and the nostalgic object, the greater the chances that changed circumstances will have eliminated the object's psychic role altogether or that another, more recent nostalgic object will have taken its place. Familiarity, in turn, in the late-twentieth and early-twenty-first centuries is increasingly the product of mediation, as Jameson and others have noted in their critiques and examinations of postmodernity; a 2011 period

film set in the 1940s or 1950s is as likely to evoke a 1940s Hollywood film or 1950s television program as the lived experience of those decades. The nostalgia engendered for the turn-of-the-century small town in *The Music Man,* however, was one brought into being by the reaction between the idealized River City on screen and currently circulating cultural memory among audience members of the *lived experience* of the turn-of-the-century small town, personally known, or if not, received as firsthand accounts of that lived experience. As such, nostalgia for the turn-of-the-century small town was dependent at least in part on a circulation of cultural artifacts that had a built-in time limit—that is, the lifespan of its generation—and was in fact increasingly supplanted from the late 1970s onward by nostalgia for a more recent time and place, representations of which had been in uninterrupted circulation in American movies and television since the time of its actual existence: the 1950s–1960s small town or suburb.

Indeed, in the decades since 1962, turn-of-the-century America has lost its position within America's autobiography as the country's lost moment of innocence. Stuart Tannock posits nostalgia as having a three-part structure: a prelapsarian past, a definite break or rupture, and a post-lapsarian present. In this construction, World War I served as the break separating the pre-lapsarian turn of the century from the post-lapsarian modernity of the twentieth century.[81] A comparable break—this time in the continuity of America's apparent progress toward ever-increasing success, power, and "greatness"—occurred in the 1960s with such sociocultural disruptions as the Kennedy assassinations, the Vietnam War, and Watergate. For instance, Paul Monaco perceives 1962 as America's last year of innocence; he attributes the popular turn to nostalgia in the late 1960s and 1970s in part to American society's collective sense of disorientation resulting from the upheavals and transitions generated by these disruptive events.[82] With this new break, the pre-lapsarian world shifted from pre–World War I to pre-1965, and the object of this post-lapsarian turn to nostalgia was no longer the turn of the last century but later moments in the twentieth century such as the Depression (*Bonnie and Clyde,* 1967) and, increasingly after *American Graffiti* (1973), the 1950s and early 1960s. As for *The Music Man* itself, a recent biographer of Willson points out that

> before Willson's play finished its initial run, it placed in the top ten most attended Broadway musicals, outdistancing *The King and I* and *Guys and Dolls.* Although its position slipped before later musicals that drew more patrons, none can compare to the popularity of this musical's life in com-

munity theater and on high school and college stages, a distinction that has never diminished.[83]

Indeed, today, *The Music Man* lives on in a form closer to what Rick Altman deems "folk" rather than "mass" art, as a stage play often performed by community, college, and high school theater groups. For instance, the Music Theatre International Web site listed eighty-seven productions scheduled for summer and fall 2007 throughout the country at summer theaters, community theaters, and children's, high school, and college theater programs, with performances to be held at summer camps, churches, local opera houses, high schools, festivals, and parks.[84]

Postings on the online *The Music Man* forum hosted by the Web site Musicals. net ("The Resource for Musicals"), however, indicate certain limitations in *The Music Man*'s penetration into today's popular culture. All of the individuals posting questions or responses on the forum are involved in theatrical production; many are young people, some in high school, and are auditioning for or performing in productions of *The Music Man*. And many—especially those who produced or performed in *The Music Man*—praise the play. At the same time, however, occasional posters express a certain disdain for it: "Here in Wyoming not many people enjoy cheesy musicals like The Music Man"; [85] "Old ladies like *The Music Man*. When I was in it, we did a lot of matinees and lots of blue hairs came";[86] "The majority of us hate the Music Man. Even the director hates the Music Man."[87] More significantly, those who have been cast in the play pose questions about costuming, hairstyles, and props that reveal a complete ignorance of the period setting; in fact, postings are sometimes premised with such disclaimers as "I know absolutely nothing about the setting for this play."[88]

Thus the presence of *The Music Man* itself in cultural circulation today is a different sort of thing from other vintage cultural products of its era such as 1950s and 1960s television shows that have been in continuous circulation in intervening decades through syndication and cable networks such as TV Land and Nickelodeon. That *The Music Man* is a known quantity is reflected in references made to it in other pop culture: for instance, a character on NBC's *The West Wing*[89] refers to "Marion the Librarian"; Conan O'Brien performed a parody of "Ya Got Trouble" as host of the 2006 Primetime Emmy Awards; while *The Simpsons* spoofed *The Music Man* in an episode titled "Marge vs. The Monorail."[90] Furthermore, the Broadway play has been revived twice, once in 1980, with Dick Van Dyke as Harold Hill, and more successfully in 2000. It won the Tony that year for Best Revival of a Musical, and a made-for-TV version, starring Matthew Broderick as Harold Hill, aired in

2003[91] and is now available on DVD. Despite its critical success, however, the 2000 Broadway show was simply one of many revivals of former Broadway hits in the last several years, part of a current producing strategy of relying on "known" hits, and the 2003 broadcast of the made-for-TV version was an event that appears to have drawn very little public attention. In short, though *The Music Man* is present in the American consciousness, it seems to lurk in the background of American pop culture, something many may have encountered in a high school theater production while never having watched the 1962 film. It is undeniable, then, that *The Music Man*'s cultural presence today in no way resembles the national phenomenon that the film represented in 1962.

It is true that the Mason City Foundation reports that over three hundred thousand people have visited Music Man Square since the Meredith Willson Museum opened in May 2002.[92] Even so, Mason City's erection of the River City Streetscape seems a questionable gesture in the town's overall project of encouraging outsiders to come spend their money there, an appeal likely to attract only die-hard fans of Hollywood musicals. By contrast, one might picture Mason City's River Cityland had it been constructed in the early 1960s and in continuous operation since. It is likely that the mere existence of River Cityland would have altered *The Music Man*'s place in American cultural consciousness. Another fruitful comparison— despite widely divergent financial resources, size, and skill in execution—is with Disneyland's Main Street, USA, the obvious model for the proposed River Cityland. Both tourist attractions purport to replicate a small-town street at the turn of the last century, both do so in a manner that is blatantly idealized and sanitized, and yet both reveal the limits of nostalgic range, even though one does so by its failure and the other by its success.

That is, in 2005, the public flocked to Disneyland to celebrate its fiftieth anniversary, a celebration Disney gave the theme of "homecoming." Structurally, Main Street is the retail corridor through which visitors to Disneyland must pass on their way to its various "lands" and their rides and attractions. Today, certainly for younger visitors, the time and place it represents has been lost because the aural and visual references it contains (the horse-drawn trolley, Model-T, nickelodeon, barbershop quartet, piped-in period music, and gingerbread building styles) are no longer in cultural circulation as they were in the 1950s and 1960s.[93] Thus this Main Street, USA, facade has taken on a secondary—and now dominant—meaning as the "Entrance to Disneyland," the result of its continuous exposure to the public in this role for five decades.

In contrast, *The Music Man* has had no such continuous public exposure, and

of course, neither has the newly constructed River City Streetscape; rather, the film itself, and the time and place it depicts, have largely fallen out of nostalgic range. Ultimately, then, in attempting to sell nostalgia for 1912 River City, Mason City has taken on an alter ego with little remaining marketable value and finds itself trying to sell a nostalgia that, to a great extent, no longer exists. Thus the case study of *The Music Man* provides an illustration of the expiration of the nostalgic response and thereby highlights some of the conditions necessary for such pop culture nostalgia to exist.

NOTES

1 "Seventy-six Trombones," from *The Music Man,* by Meredith Willson.
2 Roderick Turnbull, *Maple Hill Stories* (Kansas City: Roderick Turnbull, 1961).
3 See Richard Dyer, "Entertainment and Utopia," in *The Cultural Studies Reader* (London: Routledge, 1993), 277–78.
4 John C. Skipper, *Meredith Willson: The Unsinkable Music Man* (El Dorado Hills, Calif.: Savas, 2000), 1.
5 Ibid., 19–20, 21, 23.
6 Ibid., 25–26.
7 *Meredith Willson Show* (ABC, 1948–49; NBC, 1949–50) and *Meredith Willson Music Room* (NBC, 1951–53). In addition, in 1950, Willson became cohost with Tallulah Bankhead of *The Big Show.* He even attempted television with a short-lived television program, *The Meredith Willson Show* (July 31, 1949–August 21, 1949). Ibid., 96; Bill Oates, *Meredith Willson—America's Music Man: The Whole Broadway-Symphonic-Radio-Motion Picture Story* (Bloomington, Ind.: Author House, 2005), 195–98.
8 Meredith Willson, *And There I Stood with My Piccolo* (Minneapolis: University of Minnesota Press, 2009).
9 Meredith Willson, *Eggs I Have Laid* (New York: Henry Holt, 1955).
10 Oates, *Meredith Willson,* 1–2.
11 Ibid., 71.
12 Meredith Willson, *"But He Doesn't Know the Territory"* (Minneapolis: University of Minnesota Press, 2009), 15.
13 At the 1957–58 twelfth annual Tony Awards, *The Music Man* won Best Musical, Best Actor/Musical (Robert Preston), Best Supporting or Featured Actress/Musical (Barbara Cook), Best Supporting or Featured Actor/Musical (David Burns), and Best Conductor and Musical Director (Herbert Greene).
14 Oates, *Meredith Willson,* 129. The play closed on April 15, 1961.
15 *Time,* July 21, 1958, 42.
16 Warner Bros. Studio press release, undated, *The Music Man* files, USC-WB

Collection; Bob Thomas, "'Music Man' Film/Cameras Ready to Blaze Away," *New York World Telegram,* January 13, 1961.

17 Justin Wyatt, *High Concept: Movies and Marketing in Hollywood* (Austin: University of Texas Press, 1994), 80.

18 Jerome Delameter, "Performing Arts: The Musical," in *American Film Genres: Approaches to a Critical Theory of Popular Film,* ed. Stuart M. Kaminsky (Dayton: Pflaum, 1974), 135.

19 Wyatt, *High Concept,* 67.

20 Kristin Thompson and David Bordwell, *Film History: An Introduction* (Boston: McGraw-Hill, 2003), 336.

21 Ibid.

22 Ibid., 287.

23 Warner Bros. Studio press release, undated, *The Music Man* files, USC-WB Collection.

24 Ibid.

25 Warner Bros. Studio press book, *The Music Man.*

26 Ibid.

27 Oates, *Meredith Willson,* 144.

28 "Cary, N.C. Band Advance Arranges for Appearance," *Globe-Gazette* (Mason City), [April 1962] (date unknown).

29 Warner Bros. Studio press release, June 22, 1961, *The Music Man* files, USC-WB Collection.

30 "City to Revamp Central Park Lighting before Festival," *Globe-Gazette* (Mason City), February 13, 1962.

31 "Expect 8000 High School Musicians for Band Festival," *Globe-Gazette* (Mason City), February 17, 1962.

32 See, e.g., "Who Will House Music Man Bandsmen until Blast Off?" *Globe-Gazette* (Mason City), March 28, 1962; "Need Lodging for 755 Band Guests," *Globe-Gazette* (Mason City), May 11, 1962; "No Cancellation of Housing Facilities Now, PLEASE!" *Globe-Gazette* (Mason City), June 14, 1962.

33 "Meredith Willson Tribute in Iowa State Rose Show," *Globe-Gazette* (Mason City), June 13, 1962.

34 "Gold Medal Struck for M. Willson," *Globe-Gazette* (Mason City), June 15, 1962.

35 Cliff Carlson, "Sculptor Gives Details for Proposed Willson Statue," *Globe-Gazette* (Mason City), April 9, 1962.

36 Resolution 4820, "A Resolution Expressing Appreciation to Meredith Willson, and Naming a Certain Footbridge in His Honor in the City of Mason City, Iowa," June 4, 1962; "Footbridge Named for Willson," *Globe-Gazette* (Mason City), June 5, 1962.

37 "Voice of America Will Give Band Festival World Coverage," *Globe-Gazette* (Mason City), June 7, 1962.

38 Each downtown merchant was assigned to dress its shop window in the "theme" of one of the states represented by a competing band. For the open house, the

stores stayed open until 9:00 P.M. on Band Festival Day. "Stores to Put on Festive Dress for Music Man Bands," *Globe-Gazette* (Mason City), March 1, 1962.

39 The Music Man Marching Band Competition Festival Program, Mason City, Iowa, June 19, 1962.

40 The band from Rockville, Illinois, was the winner.

41 Phil Currie, "75,000 Jam City for Band Festival/4-Hour Parade Is Led by Meredith Willson," *Globe-Gazette* (Mason City), June 19, 1962. Not surprisingly, Warner Bros. used the one hundred thousand figure in its promotional use of the event; the studio may have been, in fact, the source of that number.

42 "'Music Man' Festival Stops Mail Delivery," *Post-Advocate,* June 19, 1962; Carl Wright, "'They Stopped the Mails'/U.S. Newspapers Laud 'Music Man' Festival," *Globe-Gazette* (Mason City), June 25, 1962.

43 Frances Melrose, "'Music Man' to Premiere in Denver," *Rocky Mountain News,* June 3, 1962.

44 "'On the Air' with Hank Grant," *Hollywood Reporter,* July 25, 1962. Warner Records' two-page advertisement in *Billboard Music Week* for National "Music Man Day" boasts of "more than 700 radio stations throughout the U.S. light[ing] a belated firecracker for Meredith Willson's 'The Music Man.'" "Now! Join In and Celebrate National Music Man Day July 25th," *Billboard Music Week,* July 28, 1962. The two-page spread includes a "partial list" of radio stations, representing forty-five states, that were to participate in National Music Man Day.

45 *Variety Anniversary Issue,* January 9, 1963. The Internet Movie Database lists the film's domestic grosses as $14,953,846. http://www.imdb.com/title/tt0056262/business. Warner Bros. studio records indicate that the projected direct cost for *The Music Man* as of February 28, 1961, was $4.24 million. Production budget, *The Music Man,* February 28, 1961, *The Music Man* files, USC-WB Collection.

46 Friedman, Warner Bros. Studio press release, July 30, 1962, *The Music Man* files, USC-WB Collection.

47 In addition to the music scoring nomination, *The Music Man* was nominated for Best Picture; Best Sound; Best Art Direction–Set Direction, Color; Best Costume Design–Color; and Best Film Editing.

48 Shirley Jones placed third for the Laurel Award for Top Female Musical Performance.

49 "'Music Man' Pick of Month," *Hollywood Reporter,* July 5, 1962.

50 "'Music Man' Selected as Best Picture," *Citizen News,* February 8, 1963; "Catholic Mag's Choice," *Hollywood Reporter,* February 8, 1963.

51 Warner Bros. Studio press release, undated, *The Music Man* files, USC-WB Collection; emphasis added.

52 "For Phil Scheuer," Carl Combs, Warner Bros. Studio press release, May 5, 1961, USC-WB Collection; emphasis added.

53 "The Music Man," *Hollywood Reporter,* April 12, 1962; emphasis added.

54 "Melodies from American's Middle West," *Herald Examiners,* August 9, 1962; emphasis added.

55 "With 76 Trombones," *New York Mirror Magazine,* July 15, 1962.

56 George Bourke, "Family Will Enjoy Weekend Film Bill," *Miami Herald,* July 28, 1962.

57 Allen M. Widem, "Coast-to-Coast: 'The Music Man' Bright Screen Entertainment," *Hartford Examiner,* June 23, 1962.

58 The classroom showdown between Hill and the townspeople of River City occurs at night, but when the boys' band leaves the school, followed by the rest of the town, it is a bright, sunny day.

59 Although Hill claims Gary, Indiana, as his hometown, Paroo's discovery that the town was founded only in 1906 suggests that this claim of small-town roots is part of his confidence scheme.

60 Oates, *Meredith Willson,* 135.

61 Ibid.

62 Ibid.

63 Luvern J. Hansen, "Official Proposes Tourist Attraction," *Globe-Gazette* (Mason City), June 15, 1962.

64 Ibid.

65 The Conservatory of 1905, devoted to music education, houses the River City Barbershop Chorus, the Music City Chorus, and a summer band camp; it also includes a recording studio, a music library, and a number of practice rooms.

66 Reunion Hall is an events venue available for occasions such as weddings and parties.

67 As might be expected, Mrs. Paroo's Gift Shop sells *Music Man,* Meredith Willson, and Mason City memorabilia such as "Trombone" T-shirts, baseball caps, and baby clothes.

68 Whether deliberately or coincidentally, the River City Streetscape, although constructed inside the Music Man Square building rather than as a row of buildings on an actual city block, is otherwise nearly identical to that imagined in Hansen's original plan.

69 Music Man Square, Mason City, Iowa, http://www.themusicmansquare.org/streetscape.htm. This switch from imagery of "step[ping] into an actual motion picture" to feeling as if you'd "rented a video of the movie" reflects a curious melding of the actual and the mediated in a visitor's experience of the fictional River City and of the River City Streetscape; they are simultaneously something to physically enter and to watch on screen.

70 Roger Riley, Dwayne Baker, and Carlton S. Van Doren, "Movie Induced Tourism," *Annals of Tourism Research* 25 (1998): 919.

71 Ibid., 930–31.

72 Ibid., 932.

73 Ibid., 931.

74 Mira Engler, "Drive-Thru History: Theme Towns in Iowa," *Landscape* 32 (1993): 8.

75 Ibid.

76 Ibid., 17.

77 Ibid.

78 Ibid.

79 "The Music Man," *Hollywood Reporter*, April 12, 1962.

80 Fred Davis, *Yearning for Yesterday: A Sociology of Nostalgia* (New York: Free Press, 1979), 121.

81 The 1920 census recorded that, for the first time in the nation's history, the majority of Americans lived in urban rather than rural areas.

82 Paul Monaco, *Ribbons in Time: Movies and Society since 1945* (Bloomington: Indiana University Press, 1988).

83 Oates, *Meredith Willson*, 129.

84 Collectively, these performances were scheduled to run from May 28, 2007, to November 18, 2007. http://www.mtishows.com/show_home.asp?ID=000053.

85 Music Man Forum, Musicals.net, April 7, 2006, http://musicals.net/forums/viewtopic.php?t=38141&view=next.

86 Music Man Forum, Musicals.net, April 7, 2006, http://musicals.net/forums/viewtopic.php?t=38141&view=next.

87 Music Man Forum, Musicals.net, July 3, 2006, http://musicals.net/forums/viewtopic.php?t=38141&view=next.

88 Music Man Forum, Musicals.net, May 14, 2005, http://musicals.net/forums/viewtopic.php?t=38141&view=next.

89 *The West Wing* (NBC, 1999–2006).

90 "Marge vs. the Monorail," *The Simpsons* (Fox), Fourth Season, Episode 71 (aired January 14, 1993).

91 ABC aired the made-for-TV version of *The Music Man*, an episode of *The Wonderful World of Disney*, on February 16, 2003. Oates, *Meredith Willson*, 134.

92 "The Music Man Square History and Information," Mason City Foundation, undated.

93 When visiting Disneyland in summer 2005, I was accompanied by a thirty-something fellow graduate student. In her capacity as a resident advisor for an undergraduate dormitory, she had visited Disneyland often during the five years she had spent at the University of Southern California pursuing her doctorate. As I pointed out the various period-inspired details in Main Street, she told me I was educating her about both turn-of-the-century culture and Disney's exploitation and idealization of that culture. When we stopped to listen to a live barbershop quartet, she had never heard of the song they sang and did not know it was a period song, dating back to the turn of the century; furthermore, she had never consciously thought about the fact that the quartet was intended to represent any particular period in time. In fact, she had never paid any attention to how Main Street looked or what it contained; for her, it had always been "just that part of Disneyland you walk through to get to the rides."

7 | When the Set Becomes Permanent: The Spatial Reconfiguration of Hollywood North

AURORA WALLACE

At Rosco Digital Imaging's Toronto location, one of the many providers of back-drops of skyline scenes used in film and television productions, there are several scenic views of Manhattan available, including a financial district, an Upper East Side, and a view of the island from Brooklyn Heights, each under various lighting and seasonal conditions. They are rented out by the day to hang behind the false windows of soundstages to establish the location of the action so that any office or apartment can be placed in New York just by looking out the window. The backdrop industry is an unappreciated and largely unacknowledged service that helps to create verisimilitude for foreign-location productions. When it is done well, view-ers should not be aware that it has been done at all. In Toronto, the service is in great demand to accommodate the large number of projects set in New York that are filmed in Toronto, including *The Incredible Hulk* (Louis Leterrier, 2008), *The Perfect Man* (Mark Rosman, 2005), *New York Minute* (Dennie Gordon, 2004), *How to Lose a Guy in Ten Days* (Donald Petrie, 2003), *Eloise at the Plaza* (Kevin Lima, 2003), *Don't Say a Word* (Gary Fleder, 2001), and many more. But such rentals may soon become entirely redundant as the real view outside has come so closely to resemble New York itself.[1]

As digital technologies for film and television become increasingly sophisticated, green screens, computer-generated imaging, and digital actors can accommodate narrative sequences and story lines once thought impossible. Digital backdrops and archival footage have made the magic of film- and television-making capable of ever greater sleights of hand, allowing soundstage productions to appear as though they were filmed on location at multiple sites, without the actors, camera operators, or directors ever having to travel. Yet as the ongoing controversies sur-rounding American runaway productions demonstrate, real locations continue to matter a great deal to producers.[2] The fragmented assembly and effortless migrancy

of these productions are part of what Michael Storper has identified as the "post-Fordist industrialization" of the contemporary film industry. "Location shooting," he shows, "began as a direct *consequence* of vertical disintegration," allowing big studios to minimize their exposure to investment losses by distributing the risk among smaller independent producers and circumventing the labor rules that govern the physical space of the studio lot.[3] Shifting location shooting to other countries furthers not only these economic effects but aesthetic ones as well, defined by a kind of placelessness and geographic abstraction in filmed entertainment.

In film production, as in other industries, enhanced communication and transportation make moving labor to less expensive locales a budgetary imperative, but location shooting outside the Los Angeles basin has raised a number of very real economic and social considerations in the field of cultural production. Standard economic justifications for runaway production typically cite the considerable cost savings more than any desire to capture a sense of exotic locale. This is especially true of Canada, where Toronto, Montreal, and Vancouver compete for the title of "Hollywood North"[4] and all regularly stand in for both specific American cities and generic North American spaces. Despite the often-forbidding winter weather conditions, distance, and time zone shifts, the major cities of Canada support the film and television industries with highly trained crews and actors, a shared media culture and language, and an increasingly pliable built environment eager to conform to the requirements of production. Though policy makers applaud the flexibility of the "creative industries" in adapting to this growth industry, few have considered the impact that this outsourced production has had on the built environment of the city itself. In the recent maturation of Hollywood North, a new, generic architectural aesthetic well suited to the needs of the foreign-location shooting industry is emerging in Canadian urban space. The set, in other words, has become permanent.

Critics of runaway production assume the natural home for filmmaking to be Hollywood and production activity in other locations to be delinquent, suspect, and unfair. Alternate shooting locations are accused of stealing work from Los Angeles–based film crews, not unlike the way offshore workers in data entry and other information technology fields are seen as predatory. In both cases, it is the new location that is to blame rather than the companies that have engineered the outsourcing. In the location industry, blame could be shared by the Canadian government's introduction of the 1998 Production Services Tax Credit and the American producers who save money by taking advantage of it, but this does not prevent Canada from being cast as the villain.[5] This enmity was tellingly revealed in the title of a panel discussion at the 2007 SXSW film festival in Austin, Texas:

"Don't Blame Canada." Those seeking to curb runaway production assume that labor properly belongs in one place and not another and that quality can be used as the legitimating argument for its repatriation.[6] As such, the discourse of runaway production has invoked claims of inauthenticity, often using the terms *cheating, faking,* and *substitution,* all suggesting that location stand-ins are, by definition, inferior replacements for shooting places as themselves, akin to fudging an ingredient in a recipe.

Speaking to a New York audience on a local radio program, the director Spike Lee remarked disparagingly that "Miramax has taken more films to Toronto than any other studio. . . . The actors aren't as good, the crew isn't as good, and it doesn't look as good."[7] In Canada, it is precisely the look of the landscapes (in addition to the talent and existing infrastructure) that proponents tout as foremost among the reasons to shoot there. On both sides of the debate, one finds nationalistic rhetoric about the dangers that runaway productions pose to indigenous industries. Whereas Hollywood has long traded in the magic of make-believe, and soundstages have been built to emulate frontier towns, arid deserts, and European city streets, when other locations attempt the same charade, place becomes the sine qua non of the debate. In runaway locations, tactics of urban camouflage that remove signifying or iconic landmarks from view are understood to be necessary for more universal audience identification, but they are seen as a virtual erasure of local identity that threatens to undermine the value, and even self-worth, of the site being masked. Such place insecurity has been felt especially strongly in Toronto, where critics of U.S. production in Canada see it as yet another instance of American cultural hegemony expunging authentic Canadian experience. In Toronto, foreign-location shooting has meant that the features of the landscape specific to the city, including its red, white, and black streetcars with their overhead wires and tracks in the road; red Canada Post mailboxes; ATMs from Canadian banks; police cars; flags; and the iconic needle of the CN Tower have to be cropped out of scenes, replaced with their American equivalents, or digitally edited out in postproduction. In addition to these subtractions, location shooting in Toronto has often meant the temporary addition of details—garbage, graffiti, and other markers of urban detritus—to the landscape not normally found in a city lauded for its cleanliness. The dissonance between the real Toronto and its representation is one of the reasons that the Toronto Transit Commission maintains a dummy subway station below its real Bay Street station. Rather than continue to deface and clean an operational station, the substitute station underneath stays permanently derelict for the benefit of film crews without having to disrupt service.[8] It is in this context that one local newspaper's April Fools item resonated particularly well:

The latest of City Hall's designated neighborhoods kills two birds with one stone: it gives an instant identity to an anonymous place and gives producers a head start when the cameras start rolling on Anytown, U.S.A. In Hollywood North, the mailboxes are blue, the cabs are Checkers and the newspaper boxes offer The Washington Post. Garbage is collected only once a month and the Cyrillic scrawls of graffiti grace every building. Hulks of abandoned cars line the streets and the residents stay inside after dark, unless they're frequenting one of the bars along St. Clair that stay open until 3 A.M. The residents are overjoyed about their new identity. "It's the best thing that ever happened," says Denise Griffith of Vaughan Road. "Every time you turn a corner, it's like flicking the channel."[9]

The Toronto-based Web site Torontoist (itself an offshoot of New York's Gothamist) is typical of the ambivalent relationship the city has to its role in film. In its ongoing feature "Reel Toronto," Torontoist celebrates how much production takes place on Metropolitan city streets, criticizes imperfect attempts to do so, and decries how often these attempts are covered up:

> Toronto's extensive work on the silver screen reveals that, while we have the chameleonic ability to look like anywhere from New York City to Moscow, the disguise doesn't always hold up to scrutiny. Reel Toronto revels in digging up and displaying the films that attempt to mask, hide, or—in rare cases—proudly display our city.[10]

These three possible scenarios—masking, hiding, or proudly displaying—align well with Canada's complicated relationship with the United States. While the two countries are each other's largest trading partner, and friendly diplomatic relations and the North American Free Trade Agreement promote the fluidity of both people and goods over the border, the desire for a distinct national identity and international recognition in Canada keeps the location production dynamic from being entirely celebratory or free of friction.

With one-tenth the population of the United States, spread over thousands of miles of shared border, Canada continues to struggle for cultural expression against the dominant media industry immediately to the south. In 2007, a total of 629 film titles played in Canadian theaters, only 112 of which were Canadian films. But whereas these films represented 17 percent of the films shown, less than 1 percent of box office revenues came from English-language Canadian films, owing to their comparably limited theatrical release and length of time in theaters.[11] All the top

ten box office films in Canada were U.S. films, led by *Transformers* (Michael Bay, 2007), which earned over twenty-seven million Canadian dollars. By contrast, the top Canadian film (actually a Canada–United Kingdom coproduction) that year, *Eastern Promises* (David Cronenberg, 2007), earned only $2.9 million.[12] On television, Canadian dramas account for only 17 percent of all drama seen by Canadians, with American programs filling the entire list of the ten most popular television shows in the 2006–7 season, led by *CSI*.[13] By any measure, then, despite the efforts of Telefilm Canada and the Canadian Television Fund, the media landscape in Canada for filmed entertainment looked much as it did in the United States that year, with *CSI* (CBS), *American Idol* (FOX), and *Desperate Housewives* (ABC) dominating the small screen and blockbusters like *Spiderman 3* (Sam Raimi, 2007), *Harry Potter and the Order of the Phoenix* (David Yates, 2007), and *Shrek the Third* (Chris Miller, 2007) colonizing the big screen.

Seen against this backdrop, the nationalistic fervor surrounding foreign-location shooting is somewhat understandable. With such overwhelming competition from U.S. producers, it has been virtually impossible for Canadian-made cultural products to reach anything resembling equal access to its domestic market. Relegated to the status of an unacknowledged soundstage for the American industry, Canadians pay dearly for their privileged location status: they suffer the inconveniences of foreign film crews clogging up their streets with trailers and shutting down necessary amenities for the length of a shoot, they lose the tax revenue that would otherwise be collected because of the generous credits given to international productions, and the revenues from distribution and exhibition largely go back to the United States. Complicating this narrative, however, has been the urban growth in Toronto that makes it increasingly amenable to foreign-location shooting. Concurrent with the ebb and flow of U.S. production in Canada, Toronto has, in many ways, adopted the blueprint of the American and global cities that it pretends to be on film.

In reaction to the recent decline in foreign-location filming activity, the Toronto Film Board released its 2007 strategic plan for the "screen-based industry," titled *Bounce Back to Fast Forward*. A perfect storm of crises, including new technology platforms such as the iPod, cell phones, gaming, and IMAX; competition from other regions with state-of-the-art production facilities; and the rising value of the Canadian dollar, underpin the report.[14] Added to these challenges were the outbreak of SARS in Toronto in 2003, the increase in reality format television, a 25 percent decline in Ontario theater attendance, and the closing of the production arm of Canada's largest film and television company, Alliance Atlantis, in 2005.[15]

At the provincial level, the Ontario Media Development Corporation (OMDC)

has countered the downturn by boasting the province's ability and eagerness to stand in for a wide array of foreign locations:

> Toronto and Ontario have doubled on a regular basis for New York, Washington, Boston, Chicago and other U.S. locales as well as exotic sites such as London, Paris, Tehran, and Morocco. *Hairspray, Jumper, The Incredible Hulk, Chicago, Path to 9/11, Cinderella Man,* and many others were all shot in Ontario.[16]

In its 2008–9 production guide, the OMDC proudly exclaims, "We've got your look!":

> In Toronto, you'll find steel and glass skyscrapers, European streetscapes, industrial buildings, an Ivy League style university, inner city neighbourhoods, a pioneer village, several "Chinatowns," and even a castle! Thanks to the city's ethnic, architectural and cultural diversity, stories set in New York, Boston, Washington, Chicago, Florida, Vienna, Warsaw, Tokyo and Teheran have been convincingly shot in Toronto.[17]

As Mike Gasher has shown using a parallel example in British Columbia, the appeal to foreign producers is both aesthetic and economic. The British Columbian film commission likes to promote "the region's economic, topographical, climatic, architectural, and human resource attributes" as well as the "regional economic and industrial development which integrates the [British Columbian] audiovisual production community within a larger industry based in southern California."[18] In Toronto, an "Ivy League style university" and "inner city neighbourhoods" vie for pride of place with promises of a stable and reliable labor force, no-fee rentals on city property, hotel discounts, and "attractive tax incentives."[19] Acquiescence is assured at all levels, and proof of customer satisfaction abounds in filmmaker testimonials like those of Richard Donner, the director of *16 Blocks* (2006): "My crew in Toronto was without a doubt one of the best, if not the best crew I've ever worked with. The City of Toronto welcomed us with open arms; it's been a wonderful experience."[20]

The hospitality continues indoors at the many Toronto film studios in possession of ready-made New York settings. Toronto Film Studios features a "New York Style Apartment" that was "originally built as a replica of John Lennon's Dakota apartment"; a "New York Style Brownstone Townhouse," complete with "elegant lobby with chandelier, brass elevator doors, grand staircase and corridors"; and a "New York Style Police Precinct" with a squad room, captain's office, booking room, and holding

cells. Producers are assured that "there is no better New York style police station in Canada!"[21] At Fraser Avenue Studios, the squad room is explicitly "*NYPD Blue* style."

Beyond these prefabricated sets, a burgeoning location industry in Toronto commodifies locations with digital archives of camera-ready homes and streets. Houses, streets, and neighborhoods deemed as the most viable stand-ins for American locations are stored in the database for prospective location scouts, complete with availability and rates. Once a home is chosen for a shoot, its occupants agree on a daily dislocation fee and agree to let the production make any necessary changes. These can include redecoration, paint, and other alterations. At the end of the shoot, the owners can choose to leave their home in the altered condition or have it reverted back to its original state. In the real estate industry, such home staging is performed to make it easier for prospective buyers to picture themselves in a house by removing the personal identifying details, such as family photos, of its current owners and replacing well-worn furniture with more generic substitutes.[22] Home staging turns a place into a space and a home into a house; the city of Toronto has staged itself for the prospective film producer and chosen to keep the alterations intact.

These sets and studio facilities anticipate and encourage the production of New York–centered stories in Toronto, and its infrastructure has met with great success. Even the most iconic New Yorkers have had their movie of the week tales filmed in Toronto studios, including *Donald Trump: Unauthorized* (ABC, 2005), *Martha behind Bars* (CBS, 2005), and *America's Prince: The John F. Kennedy Jr. Story* (Fox, 2002). And where we might expect films and television programs in which place specificity is a central theme of the story to dictate the shooting location, Toronto's nonspecificity is perfectly suited to the task. Indeed, *Crown Heights* (Showtime, 2002), *Grey Gardens* (HBO, 2007), *Long Island Confidential* (Lifetime, 2007), *16 Blocks* (Warner Bros., 2005), *Knights of the South Bronx* (A&E, 2005), *Murder in the Hamptons* (Lifetime, 2005), *111 Gramercy Park* (ABC Pilot, 2003), *The Path to 9/11* (ABC, 2005), and the aforementioned *New York Minute* (Warner Bros., 2003), starring the Olsen twins, were all shot in Toronto.[23] The titles of these productions do some of the work of establishing place and all of that place's attendant meaning—*Murder in the Hamptons* rather than *Murder in Wealthy Beach Enclave*—so that viewers may be less inclined to recognize Lake Ontario as the body of water. Such fungible interpretations of place suggest that notions of authenticity can be easily retrofitted to serve budgetary rather than narrative requirements. In interviews following the release of David Cronenberg's *A History of Violence* (2005), the director mused that "it is a parable of art that, to be universal, you must be specific. Otherwise, you are just talking about an abstraction. So you have to talk about a

particular person and a particular place. Specificity is the essence of art." It was not lost on journalists that this comment was quickly undermined by Cronenberg's declaration that "here is a movie that is set inside of America with major American actors and not a foot of it was shot in America and the crew was Canadian, and I'm Canadian. It's kind of a strange amalgam of Canada and the U.S."[24]

Amid these playful experiments with place fluidity, there are real efforts at fixing place and film capital in Toronto. Despite claims that Toronto's best feature, as far as the film industry is concerned, is a kind of featurelessness, the city has constructed the largest studio space in North America to make it more desirable for blockbuster films to shoot there. In August 2008, Toronto Film Studios was annexed as part of the new Filmport development: three million square feet of space at the city's waterfront poised to lure major Hollywood productions to Toronto.[25] The sixty million dollar project is part of the city's campaign to revitalize Hollywood North by providing a grid of oversized warehouses and an empty space to be filled by the global screen industry on a valuable swath of downtown land.[26] Supported by the Comweb Group and the Rose Corporation, Filmport sits on land purchased by the Toronto Economic Development Corporation (TEDCO), formerly owned by Imperial Oil.[27] With the city of Toronto as its sole shareholder, TEDCO's mission is to extrapolate revenue from city-owned land and is thus a hybrid public–private developer whose master has not always been clear.[28] As part of a broad strategy of economic development masquerading as culture (or in the words of the OMDC, "Culture Is Our Business"), Filmport is promoted as more than a studio:

> As a community, Filmport will support a rich infrastructure of recreation, cultural and tourist amenities. Surrounded by parks and water, pulsating with business, refreshed by its cafés and bistros, explored by curious tourists and entertained by its cultural amenities, Filmport is bound to excite.[29]

Such verdant, utopian language recalls the promise of the Special Economic Zones so poignantly described by architect Keller Easterling.[30] A spatial artifact that is now a prominent feature of the global landscape driven by capital investment, by definition, the zone exists outside the regimes of local politics and geography. Designed to supersede national regulations on labor, taxation, and the environment, zones are artificial constellations of office parks, housing, communication, and transportation infrastructures that are built as ready-mades for the purpose of manufacturing and trade. Within their borders, a different set of rules applies, creating gated enclaves of single-purpose functionality. Above all, as Easterling writes, they are fictions that brook no contradiction. These zones, invented by

the United States for application in Puerto Rico, are now common in Singapore, Korea, China, Malaysia, and, more recently, in Russia and India and offer incentives for direct foreign investment without the trouble of negotiating with local governments. Filmport, as a major real estate investment in the heart of the city and paid for by the city, will not operate in such an independent manner, but its design clearly echoes the infrastructural flexibility of these global spaces with their gridlike interchangeability, just-in-time logistics, and imported labor. As a test case for a new model of economic development not unlike the maquiladoras along the U.S.–Mexico border, Filmport stands as a microcosm of the larger relationship between Toronto and the film industry. Operating on a "if you build it, they will come" principle, it demonstrates the city's willingness to have its development determined by Hollywood's needs. In an effort to encourage more film production in Toronto, the Ontario Film Commission sponsored a tour of the construction site for Los Angeles–based film executives, asked them plainly what they wanted, and then built it according to their specifications.[31] In January 2009, Mayor David Miller embarked on a trade mission to Los Angeles to promote the new studio space, while reminding Hollywood producers of Canada's favorable currency exchange and tax credits for foreign producers. In this appeal, it is not Toronto's preexisting structure, its lookalike-ability, that is being sold, but rather the promise of a tabula rasa to be filled as foreign film producers wish.

SPATIAL RECONFIGURATION

Beyond Filmport, other capital investment schemes have contributed to the global placelessness of Toronto's downtown core. Barbara Jenkins notes four building projects in Toronto—capital expansions to the Royal Ontario Museum, the Art Gallery of Ontario, the Four Seasons Center for the Performing Arts, and the Ontario College of Art and Design—that owe their existence to a renewed effort by the provincial and federal governments to increase spending in one of the few remaining growth areas of the economy.[32] These projects received less than half of their support from public sources, with the rest coming in the form of private fund-raising and ticket sales. Learning from, and hoping to emulate, the so-called Bilbao effect, whereby a previously overlooked or declining industrial site becomes a tourist destination through the purposeful reallocation of resources toward the cultural sector—with structures designed by celebrity architects—the city of Toronto has in mind an "Avenue of the Arts" in the downtown corridor to participate in what Jenkins calls the "symbolic power pageant for international cultural prestige."[33]

The capital investment noted by Jenkins, which involves focused spending on the arts to attract visitors using the protocols of global cultural tourism, produces

new "zones" strategically designed to concentrate building programs, people, and attention into an easily identifiable, walkable, and prescribed space. Unlike Bilbao, the specially designated Arts Zone embellishes extant museums and galleries in the downtown core with renovation and in-fill projects, but the branding of the avenue focuses attention within the zone for the purpose of art and consumption while casting the less photogenic parts of the city in shadow. The Avenue of the Arts is conveniently situated to take advantage of "Toronto's Fifth Avenue," the nickname given to Bloor Street in Yorkville for its proliferation of stores like Tiffany's, Chanel, Hermes, Cartier, Escada, Armani, Prada, and Gucci, among other global luxury brands. Culture is easily and purposefully conflated with consumerism, and as with all global tourist zones, high-end shopping is part of the formula that combines retail and leisure pursuits within designated areas to meet the needs of the short-term traveler's itinerary. The arts–culture zone, then, becomes one of the prime movers contributing to the increasingly homogenous commercial aesthetic that contributes to the interchangeability of these spaces around the world.

As Mike Davis writes in *Ecology of Fear,* "the contemporary American metropolis simulates or hallucinates itself in at least two senses": first by creating its "virtual double through the complex architecture of its information and media networks" and second through the kind of thematizing described earlier. These *tourist bubbles,* as he terms them, are a concretized social fantasy of urbanity at pains to keep the real city at a comfortable distance.[34] In California, simulations of film sets abound in theme parks and zoos, owing largely to the symbiotic relationship between the state and the entertainment industry. In Toronto, the simulation is at least third order: a simulation of a simulation. It is urban space reconstituted as a film set that has other film sets of urban spaces as its referent. Further blurring the distinctions between the city, its architecture, and its mediated representation is the new Festival Tower (Figure 7.1). The tower is ostensibly a condominium development built on top of the new headquarters for the Toronto International Film Festival and the Bell Lightbox Theater, yet, in marketing, the building itself is promoted as a film. The logo for the building is designed to look like a strip of film, and it is introduced as "The Directors Edition," as uncut versions of films and special collections are sometimes packaged. The director, in this case, is Ivan Reitman (*My Super Ex-Girlfriend, Six Days Seven Nights, Dave, Kindergarten Cop, Ghostbusters,* etc.), who, in partnership with the developer Daniels Corporation, is a "producer" of the building. The online portion of the campaign features a movie trailer of the building, with the soaring orchestral sound track of an epic. All other features of the structure are presented in the form of Academy Award categories, including Best Location. Full-page color print ads follow the design template of blockbuster

Figure 7.1. Newspaper ad for Festival Tower: Condominium as movie.

advertising, complete with reviewers' quotes: "This is real red carpet living in the heart of Toronto's Entertainment District—National Post."[35]

The conflation of media and architecture, film and city, continues beyond the site of Festival Tower in the Financial District, Chinatown, Little Italy, Soho, Koreatown, Chelsea Market, Midtown, and an underground PATH system. These are not film set signs; these features of the landscape are all permanent fixtures. These areas did not develop in response to the film industry but have been easily coopted by promoters of foreign-location shooting for their parallels with New York. Whether they are purposefully named after their Manhattan precursors, the imitation of New York in Toronto has long been a preoccupation of restaurant and hotel owners.[36] In Toronto, one finds a W, an Intercontinental, a Sheraton, and other global hotel chains but also smaller boutique hotels that recall their Manhattan doppelgangers such as 60 Thompson and the Gansevoort Hotel. These boutique hotels are part of the assemblage of developments intended to support and promote the film industry, which in turn supports and ultimately reshapes the city. As one Thompson promoter put it, "the hope is that the 102-room Thompson Toronto will be the Hollywood North outpost for the celebrities who frequent Thompson's six U.S. properties. The hotel could also add to the gentrification of the King St. W. area, which is rapidly becoming Toronto's version of New York's Soho neighbourhood."[37]

Such claims are common in marketing material for new hotel projects in Toronto, which often herald the New York–like qualities found in new developments like the Soho Metropolitan Hotel and the sixty-story Trump International Hotel and Tower, said to pay "homage to classic Manhattan skyscrapers" (Figure 7.2). Trump's Toronto venture is but one of many such homages to New York on Toronto streets, in which height supremacy, floor-to-ceiling windows, concierge service, and five-star amenities now dominate the market.[38] Amid this building frenzy, it does not seem at all incongruous that the new fifty-three-story Ritz-Carlton Hotel, designed by New York firm Kohn Pederson Fox, features a "Park Avenue" suite.

In 2007, the trade journal *National Real Estate Investor* featured Toronto as a city to watch, with "83 high-rise buildings under construction in Toronto that month—far more than Boston, San Francisco, Atlanta, Miami, and Chicago, and surpassed only by 124 buildings in New York."[39] In the same article, it was noted that "Toronto is to Canada what New York is to the U.S. It's the banking, investment, and real estate capital. The city is also a retail, education and cultural center as well as a transportation hub for road, rail and air travel. It offers a busy port handling 2.6 million metric tons annually."[40] Though such nods to New York are common, they conflict with the city's claim to be a world-class or global city and not simply Canada's *version* of New York. The new commercial towers mentioned

Figure 7.2. Trump International Hotel and Tower Toronto "pays homage to classic Manhattan skyscrapers."

in this report represent a building boom that will double the number of skyscrapers in the city. Among them are the Telus building, at twenty-six stories, whose green amenities, exterior skin, and silhouette are strongly reminiscent of Renzo Piano's New York Times tower, and the RBC Center by Kohn Pederson Fox, which, at forty-two stories, bears a striking resemblance to the firm's plan for the forty-two-story structure at 5 World Trade Center in New York. The Bay-Adelaide Center will consist of three structures at fifty-one, forty-nine, and forty-three stories, built by developer Brookfield Properties of the World Financial Center in New York.[41] Vying for tallest building in the city is One Bloor Street East, an eighty-story residential condo and boutique hotel with movie theaters at the corner of Yonge and Bloor, the intersection of two main city arteries. The global race for height supremacy now finds the tallest buildings in the world in the growing economies of Dubai and Kuala Lumpur, where iconic tall towers have marked these emergent skylines. In Toronto, by contrast, the new tall towers have held to more traditional forms that will undoubtedly make it easier for on-location filming to exclude the city's single most iconic feature, the CN Tower, in each frame and enhance its overall competitiveness relative to Vancouver and other desirable location sites in the southeastern United States and eastern Europe.

These skyscraper projects are buttressed by more modest residential developments with similar New York aspirations. At Bayview and Sheppard avenues, far

from the city's downtown core, the NY Towers project plays on the initials for "North York," while each building is named for New York icons, including the Waldorf, the Chrysler, the Rockefeller, and the Empire State buildings. According to the senior vice president of design and construction, they "did it to set the buildings apart. . . . Each building has a trademark. It gives people something they can identify with."[42] As part of the marketing strategy, buyers at the Rockefeller building were offered a free weekend in New York, complete with dinner for two at Rockefeller Center.[43] At the Gramercy Park condos in the northwest sector of the city, one finds "a tribute to the luxury condominium residences that have made New York famous."[44] The intention, according to the development company's president, "was [to] bring some of those wonderful Manhattan features to North York living."[45] The main feature of the development is a park that is restricted to residents, "taking inspiration from the iconic park side residences of Manhattan."[46] In Mississauga, west of the city, is the New Yorker; on Front Street East, one finds the New Times Square condominiums; and a development of towers and townhouses on Jarvis Street is called Radio City. One of the most extreme transformations of the landscape can be found in Manhattan, an eight-hundred-home subdivision in Unionville, Ontario, north of Toronto. In this Manhattan, streets like Forty-second Street, Lexington, Wall Street, Brooklyn Crescent, and Long Island Crescent are the ground on which housing models named the "Broadway" and the "Madison" are arranged.[47] Even those developments in Toronto not named for Manhattan landmarks are said to take their inspiration from the island: 77 Charles Street West is "reminiscent of some of the old-style condos in New York"; the Regency Yorkville Condos "will have a 1940s New York, art deco look"; and the Prince Arthur Condominium Mansions feature "a New York style doorman."[48] One Bedford Street was inspired by "New York's Fifth Avenue, where high-end retailers and estate residences sit across from parks and cultural institutions,"[49] while the Avenue "was designed to reflect the style and quality of New York's Park Avenue."[50]

Among the most coveted new forms in Toronto architecture, according to real estate professionals, are the loft and the brownstone. "New York style lofts" can be found at Gotham Lofts on King Street West, Soho Lofts on Eglinton, and Chelsea Lofts, with its signature "Gershwin Studio" on Davenport.[51] Madison Avenue Lofts are modeled on "an upscale, New York–style loft."[52] "Liberty Lofts" feature "a canopy over the main entrance that's styled like the Statue of Liberty's crown," and promotional materials "refer to the neighborhood around Sherbourne and Adelaide Sts. as Toronto's 'Lower East Side.'"[53] (On the "Upper East Side" is an insurance building conversion known as the Tribeca.[54]) At the Brownstones on Trillium Lane, "the design of the residences is reminiscent of traditional SoHo and

ARCHITECTURE

"We designed One St. Thomas to be the quintessential luxury residential building in Toronto. It has an aesthetic that recalls North America's grand urban apartment buildings of the 1920's and 1930's with a scale and sense of place that is entirely compatible and sensitive to the townhouses that once typified this neighbourhood."

ROBERT A. M. STERN, FAIA
SENIOR PARTNER OF ROBERT A. M. STERN ARCHITECTS,
NEW YORK, NEW YORK
DEAN OF THE YALE SHCOOL OF ARCHITECTURE

BACK

Figure 7.3. Robert A. M. Stern's One St. Thomas in Toronto.

Greenwich Village brownstones, which typically face a park or are hidden down laneways or in courtyards."[55] According to developer Sam Reese, "when you name a condo SoHo, it helps create a picture. People have ideas of what SoHo is like and that is the image we are trying to create."[56] To be sure, these New York resonances owe more to marketing strategy than to any real desire to replicate New York City, but for a municipality that laments its exploitation as an unacknowledged film set, and bemoans filmmakers' attempts to camouflage the real city, tapping into the image bank of New York neighborhoods to "create a picture" speaks directly to the construction (and destruction) of place through media image.

The Manhattanization of the city is further accomplished by the importation of internationally renowned architects like Robert A. M. Stern, whose One St. Thomas residential development "looks backward to the luxury apartment blocks put up, circa 1930, on New York's Park Avenue"[57] (Figure 7.3). Daniel Liebeskind is building the "L" atop the Sony Performance Center because Toronto, "like New York, has vibrancy and a cosmopolitan population, but it also has the excitement of being a brand-new city."[58] Santiago Calatrava built the Atrium at BCE Place and Frank Gehry the addition to the Art Gallery of Ontario. These projects can easily be read as a sign of a flourishing economy, the commodification of place that inevitably follows global capital. But in Toronto, the form that has followed success as a world city is tethered to another specific place. Toronto achieves its world city status through its association with New York, a preestablished and

widely recognized world city. By restricting its design template to New York's, it is instead a shadow city, one that is promoted (by American Airlines and others in the travel industry) as a place to experience New York for less money. Visitors can see so-called Broadway style–theater like *Jersey Boys, Dirty Dancing, A Chorus Line, Grease,* and *Legally Blonde* on a budget. Insofar as Toronto has a brand identity, then, its brand is a newer, cleaner, cheaper New York.

RETOOLING FILMCITY

The markers of cosmopolitanism that one finds in Toronto are not false; the vibrant entertainment industry, like its architecture, takes advantage of a preexisting and hospitable cultural environment. But neither do they happen without directed policy support. In Telefilm's report "Bounce Back," it is urged that

> Toronto must retool, becoming the place where a unique combination of artistic, computational and networking excellence is channeled by strong financial services into a globally competitive screen-based industry and the English-speaking world's foremost location to practice the screen arts of the digital age.
>
> Toronto must use its planning tools and incentives to develop infrastructure and lure productions.
>
> Toronto should market itself worldwide as the best location for purpose built, state-of-the-next-art studios able to accommodate $100+ million productions. The attributes of our diverse pool of trained professionals, specialists and experts, combined with graduates from eight major universities and community colleges, create a City of vibrancy and livability that is unmatched by any other Creative City.

The language of Telefilm Canada and the recently announced and decidedly analogous City of Toronto Plan are synchronous by design. Two new corporations, Invest Toronto and Build Toronto, put into effect in 2009, will take over from and replace TEDCO (the corporation that engineered the aforementioned Filmport), with a view to splitting up the functions of real estate development and foreign investment. Build Toronto's mission is to

> unlock value in under-utilized and surplus City real estate by developing properties to stimulate desirable job creation and regenerate neighbour-hoods, consistent with the City's broader economic, social and environ-

mental goals. While the majority of the City's real estate, valued at $18 billion, is used to deliver municipal programs, the City will be aggressively looking to maximize development potential.

In the context of foreign-location shooting, the mandates and goals of the film industry and the city are largely indistinguishable—a conflation that exemplifies well George Yudice's notion of the "expediency of culture." Justifying investment in the arts on the basis of its return on economic investment; treating culture as a resource to be managed, administered, and evaluated; and deputizing the arts to fulfill roles previously performed by the state are all a part of the new agenda for cultural relevancy, utility, and applicability.[59] Following the announcement of the two new oversight bodies, Toronto mayor David Miller, chairing both of the corporations otherwise staffed by business leaders, declared that "the basic principle underlying our approach today . . . is, first of all, let government do what it does best, and let business do what it does best."[60] To the degree that culture in Toronto implicates the screen industry, and the screen industry continues to be controlled by the United States, the local government has adopted a laissez-faire approach to its development as a private real estate enterprise. As Nicholas Garnham has shown, in Britain, the discursive shift from "cultural industries" to "creative industries" paralleled the shift from public spending to public investment, in which returns on those investments became paramount and "recipients had to show measurable outputs against pre-defined targets."[61]

From an economic development perspective, the desire to buttress the film and television industry in Toronto by providing the necessary material resources to international producers meets with little dispute. As with other attempts to lure foreign investment, it is seen as both necessary and desirable. From a cultural perspective, however, foreign-location shooting is understood as a complex set of negotiations and compromises in which local identity comes under threat, markers of place are vulnerable to erosion, and distinguishing features of the landscape can disappear from view. The anxiety surrounding this disappearance, however, is diluted by these accommodating political and economic incentives. As Serra Tinic shows using the example of coproductions,

> the extent to which cultural specificity is lost in an IJV [international joint venture] is largely dependent on the countries involved in the production partnership. . . . Canada tends to be a preferred partner because of the North American style and sensibility that is brought to the product. Here

the emphasis is on developing a North American style without producing a completely American story. In other words, foreign producers see their Canadian partners willing to negotiate on cultural points to the extent that both countries are able to maintain a semblance of references to their specific national contexts even when following a generically American story formula.[62]

Given that story formulas are "generically American," and the grammar of film and television has been determined by Hollywood, the result has been a slippage between generic stories and generic spaces. The lack of place specificity has been a refrain that undergirds many recent attempts at rebranding the city of Toronto, without which, it is feared, the city will lose any distinctive claim in the increasingly competitive global market for tourism. As marketing professor Alan Middleton put it, "if we don't get our act together, we'll become 'invisible' to the world within 15 years."[63]

Visibility here is a double-edged sword. Despite the fact that global audiences have had a great deal of exposure to Toronto on screen, the city remains largely invisible. The 2008 release of the film *Max Payne* is a case in point. The film, which stars Mark Wahlberg as the title character in a remake of a video game, is based on the story of a New York cop who has to enter a dangerous, noir-ish criminal under-world to exact revenge for the murder of his family. Set in a gritty, postapocalyptic landscape beset by crime, desperation, and sci-fi demons, Toronto is an unlikely loca-tion for the production. Twentieth Century Fox's press kit for the film explains that

> Max's world is dark and stylized New York City, light years from the Big Apple usually presented on screen. "It's a New York minus a layer of reality," says [producer] Julie Yorn. The filmmakers conceived much of the city's look early in pre-production. The decaying New York skyline and cityscapes would be dominant and omnipresent. "[Director] John [Moore] referred to our New York as the 'Ghost City,'" recalls visual effects supervisor Everett Burrell. "In Max's world, the city has been so overrun by crime and drugs that it's kind of dying from the top-down."[64]

Of course, the New York presented here *is* some distance from the Big Apple, and the layer of reality missing is precisely the actual New York location. The video game aesthetic dictates that backgrounds are, by convention, not necessarily dependably referential, and digital postproduction is expected, but the landscape

bears no resemblance to the friendly cosmopolitan city boasted by residents and civic leaders in Toronto. As the *Philadelphia Inquirer* described it,

> [Payne's] New York (a transformed Toronto) is a hellhole of back alleys, not boulevards; of deserted subway platforms, not teeming sidewalks; a place where ashy snow drifts down like endless regrets.[65]

There are at least two crucial issues at play here in the representation and reconfiguration of Toronto as New York. One is the tension working between the economic desire to host foreign-location shooting and the inevitable erasure that ensues. But the second involves the local versus the global reception of the representation. As John Durham Peters puts it,

> Part of what it means to live in a modern society is to depend on representations of that society. Modern men and women see proximate fragments with their own eyes and global totalities through the diverse media of social description. Our vision of the social world is bifocal. Institutions of the global constitute totalities that we could otherwise experience only in pieces. . . . The irony is that the general becomes clear through representation, whereas the immediate is subject to the fragmenting effects of our limited experience.[66]

Seen bifocally, Toronto's representation in *Max Payne* becomes a more real or truer version of the city by virtue of being seen at a distance. Toronto is made coherent from the outside, through its filmic representation of something other than it is. If visibility is a concern for Toronto, then arguably, the city is rendered less visible through these representations than if none had been made at all. As the city develops in accordance with the dictates of film and television scriptwriting, it also becomes less able to take advantage of its malleability as a characteristic of its location, by narrowing the parameters of what can be filmed there to those productions attempting to emulate New York. If the city's malleability is its best-selling feature, and flexibility is the aim of the new creative industry, then the plan is a risky one. The specificity of place that makes it easily stand in as "anyplace USA" has become too specifically New York.

Given the economic incentives in place to keep film and television production work in the United States, the permanent set in Toronto now suffers from its own success. As Rhona Silverstone, the Toronto film commissioner, recently reported,

"we used to do a lot of Toronto for New York, but now it's just going to New York." There was even some speculation that *Scott Pilgrim vs. the World*, a story set in Toronto, would shoot New York for Toronto.[67] As it happened, *Scott Pilgrim* did shoot in Toronto, and the finished product fairly revels in its use of locations playing themselves. Close observers will, of course, note that as Scott does battle with Ramona's ex-boyfriend, Lucas Lee, a shallow American film star, the set is staged in front of Casa Loma, the castle so frequently lauded in promotional materials for choosing Toronto as a foreign-shooting location. Yet in front of the castle hangs a screen of New York's skyline prominently featuring the Empire State Building. The fight scene delights in the visual joke, as the action moves repeatedly beyond the frame of the backdrop to reveal the real city behind it. Scott's query, "They shoot movies in Toronto?" further emphasizes the insider wink to the audience that followed the complicated production schedule that threatened to take the project to New York and anyone else with a passing familiarity with Hollywood North.

At the 2008 Toronto International Film Festival, representatives from the New York Mayor's Office for Film, Theater, and Broadcasting were on hand to promote a small group of films that all had one thing in common: they could all sport a "Made in NY" logo. The "Made in NY" incentive program, inaugurated in 2005, is designed to showcase a suite of incentives for filming television and film in New York and includes tax credits, free permits, and receptions at international festivals like those in Toronto. There was a time when such a campaign would have been thought at best unnecessary and at worst xenophobic, but New York is now in a battle for control over its representation with Toronto, a city most eager to masquerade as the Big Apple to lure film projects north of the border. Yet, like Halloween makeup that won't wash off, the trace of the disguise remains, and its permanence makes it difficult for the city to go as something else in the future.

NOTES

1 http://www.roscodigital.com/.

2 The term *runaway* is historically a pejorative term for foreign-location shooting. In the 1950s, Hollywood unions the International Alliance of Theatrical Stage Employees and the Screen Actors Guild urged members not to sign on to productions with foreign locations to support the local industry. At that time, the targets of the boycotts were mainly in Mexico and Europe.

3 Michael Storper, "The Transition to Flexible Specialisation in the US Film Industry: External Economies, the Division of Labour, and the Crossing of Industrial Divides," *Cambridge Journal of Economics* 13, no. 2 (1989): 285.

4 Ben Goldsmith and Tom O'Regan, *The Film Studio: Film Production in the Global Economy* (Lanham, Md.: Rowman and Littlefield), 157.

5 See Center for Entertainment Industry Data and Research, *The Global Success of Production Tax Incentives and the Migration of Feature Film Production from the U.S. to the World Year 2005 Production Report* (Encino, Calif.: Center for Entertainment Industry Data and Research, 2006).

6 On these debates, see Ted Magder and Jonathan Burston, "Whose Hollywood? Changing Forms and Relations inside the North American Entertainment Economy," in *Continental Order? Integrating North America for Cybercapitalism*, ed. Vincent Mosco and Dan Schiller, 207–34 (New York: Rowman and Littlefield, 2001).

7 Leonard Lopate, New York and Company, WNYC, January 25, 2003. The show was broadcast in front of a live audience, who applauded approvingly Lee's commitment to shooting on location in New York.

8 Theresa Ebden, "A Gold Mine Hidden beneath the Tracks," *Globe and Mail*, May 8, 2005, R20.

9 "On the Morning of April 1, You'll Wake Up and Find the CN Tower Up for Grabs, Hollywood North with a Home at Last . . . ," *Globe and Mail*, March 25, 1988, 10.

10 http://www.torontoist.com/tags/reeltoronto/.

11 Canadian Film and Television Production Association, *2008 Profile: An Economic Report on the Canadian Film and Television Production Industry* (Ottawa: Canadian Film and Television Production Association, 2008), 58, 70.

12 Ibid., 71.

13 Ibid., 56–57.

14 Toronto Film Board, *Bounce Back to Fast Forward* (Toronto, Ont.: Toronto Film Board, 2007), 2.

15 Ibid., 9.

16 Ontario Media Development Corporation, *Ontario Production Guide 2008/9: Facilities and Services for the Film/Television and Commercial Industry in Toronto and Ontario, Canada* (Toronto, Ont.: Ontario Media Development Corporation, 2008–9), 2.

17 Ibid., 1.

18 Mike Gasher, "The Audiovisual Locations Industry in Canada: Considering British Columbia as Hollywood North," *Canadian Journal of Communication* 20, no. 2 (1995), http://www.cjc-online.ca/index.php/journal/article/view/868/774.

19 http://www.omdc.on.ca/Page3675.aspx.

20 http://you-belong-here.com/.

21 http://www.torontofilmstudios.com/.

22 See the International Association of Home Staging Professionals at http://www.stagedhomes.com/.

23 "City of Toronto Economic Development Toronto Film and Television Office List of Productions Shot in Toronto Representing Other Cities 2001–2007," http://www.toronto.ca/tfto/pdf/locations_repo1-07.pdf.

24 Bruce Kirkland, "History Lesson: David Cronenberg Was Just the Right Man to Helm Adaptation of *A History of Violence*," *Toronto Sun*, September 4, 2005, S14.

25 Jennie Punter, "Build It and They'll Come," *Variety*, August 25–31, 2008, 18.

26 The development of a permanent infrastructure for film is reminiscent of Jacques Tati's "Tativille" set built for his film *Playtime* (1967), whose generic architecture was meant as an indictment of modernism yet was built in the hope that other films might someday shoot there. See Stuart Klawans, *Film Follies: The Cinema Out of Order* (London: Cassell, 1999).

27 Jamie Komarnicki, "Can a Mega-studio Lure Hollywood Back North?" *Globe and Mail*, August 21, 2008, A10.

28 Elana Safronsky, "Backroom Player Is Ready for Its Close-up," *Globe and Mail*, August 19, 2008, B7.

29 Filmport brochure, 1.

30 Keller Easterling, *Enduring Innocence: Global Architecture and Its Political Masquerades* (Cambridge, Mass.: MIT Press, 2005).

31 Punter, "Build It and They'll Come," 18.

32 Barbara Jenkins, "Toronto's Cultural Renaissance," *Canadian Journal of Communication* 30 (2005): 169–86.

33 Ibid., 170.

34 Mike Davis, *Ecology of Fear: Los Angeles and the Imagination of Disaster* (New York: Metropolitan Books, 1998), 392.

35 http://www.festivaltower.com/.

36 See Sarah Matheson, "Projecting Placelessness: Industrial Television and the 'Authentic' Canadian City," in *Contracting Out Hollywood: Runaway Productions and Foreign Location Shootings*, ed. Greg Elmer and Mike Gasher (Lanham, Md.: Rowman and Littlefield, 2005), 125.

37 Tony Wong, "Ultra Chic US Hotel to Debut in Canada," *Toronto Star*, October 4, 2007, B1.

38 Other notable developments include the Aura at Yonge and Gerrard, at seventy-five stories; the Shangri-La, at sixty-five stories; and the two Four Seasons towers of fifty-five and twenty-six stories.

39 *National Real Estate Investor*, July 2007.

40 Ibid.

41 Stephen Weir, "Lofty Plans; Luxury Hotel-Condo Being Built on Five-and-Dime Lot Presents Some Logistical Problems . . . and Some Interesting Solutions," *Toronto Star,* May 31, 2008, CO8.

42 W. D. Lighthall, "Creating a Roof That Stands Out," *Toronto Star,* July 9, 2005, P01.

43 Michael B. Davie, "Weekend in New York for North York Buyers," *Toronto Star,* September 13, 2003, PO6.

44 http://www.freecondoguide.com/toronto_investment_properties/gramercypark.php.

45 "Manhattan Inspiration in North York," *Toronto Star,* December 1, 2007, CO07.

46 Sydnia Yu, "Taking a Cue from Manhattan," *Globe and Mail,* October 26, 2007, G10.

47 Karen O'Reilly, "Manhattan in Unionville," *Globe and Mail,* September 29, 1984, H5.

48 Sydnia Yu, "Mansion 'in the Sky' Tops Stylish Building," *Globe and Mail,* March 28, 2008, G16; Sydnia Yu, "Little to Upgrade in High-End Yorkville Suites," *Globe and Mail,* July 20, 2007, G6; http://www.theprincearthur.ca/.

49 Sydnia Yu, "One Bedford: A Location That Few Can Rival," *Globe and Mail,* July 14, 2006, G8.

50 Sydnia Yu, "Exclusive Residence Targets Downsizing Baby Boomers," *Globe and Mail,* November 25, 2005, G11.

51 Diane Tierney, "Chelsea Site Attracts a Young Crowd," *Globe and Mail,* April 4, 2003, G16.

52 Sydnia Yu, "Conversion of an Old Toronto Hydro Building Sparks Interest," *Globe and Mail,* September 16, 2005, G18.

53 Shree Paradkar, "For Those Who Like Living on the Edge," *Toronto Star,* October 16, 1999, CO01.

54 Tracy LeMay, "Tales from Condo Hell: Buying a Condominium Should Fulfill a Dream. But for Many, It's Been the Start of a Never-ending Saga," *National Post,* April 8, 2000, C7.

55 Sydnia Yu, "New York Brownstones Inspire Townhouses," *Globe and Mail,* April 28, 2006, G11.

56 Samantha Grice, "A New York State of Mind Gets Developers Excited: Worldly Inspiration: What's in a Name? Plenty, If You Can Sell Condos with It," *National Post,* February 14, 2004, TO4.

57 John Bentley Mays, "A New Modernist Muscles In," *Globe and Mail,* October 10, 2008, G2.

58 Martin Knelman, "Too Tall an Order for T.O.? Daniel Liebeskind Is Perplexed by the Reaction to His Towering Design for the Hummingbird Centre but Battles over Vision Are Nothing New for the Architect behind the World Trade Center's Rebirth," *Toronto Star,* September 29, 2005, A03.

59 See George Eudice, *The Expediency of Culture: Uses of Culture in the Global Era* (Durham, N.C.: Duke University Press, 2003).

60 Jeff Gray and Jennifer Lewington, "Mayor Unveils New Development Plan,"
 Globe and Mail, September 30, 2008, A15.

61 Nicholas Garnham, "From Cultural to Creative Industries," *International Journal
 of Cultural Policy* 11, no. 1 (2005): 15–29.

62 Serra Tinic, *On Location: Canada's Television Industry in a Global Market* (Toronto,
 Ont.: University of Toronto Press, 2005), 114.

63 Alan Middleton, "Toronto Needs to Be Less Swiss," *Toronto Star,* November 4,
 2006, A17.

64 Twentieth Century Fox, *Max Payne* press kit, 2008.

65 David Hiltbrand, "*Max Payne* a Stylish Pulp Fiction," *Philadelphia Inquirer,* Oc-
 tober 17, 2008, W07.

66 John Durham Peters, "Seeing Bi-focally," in *Culture, Power, Place: Explorations
 in Critical Anthropology,* ed. Akhil Gupta and James Ferguson (Durham, N.C.:
 Duke University Press, 1997), 79.

67 Peter Kuitenbrouwer, "Filmport Arrives with a Flourish, but without Work,"
 National Post, August 19, 2008, http://network.nationalpost.com/np/blogs/
 toronto/archive/2008/08/19/filmport-arrives-with-a-flourish-but-without-work.
 aspx.

8 | The Last Place on Earth?
Allegories of Deplacialization
in Dennis Hopper's *The Last Movie*

ARA OSTERWEIL

> Peru is an epic fantasyland. Imagine scenery on the scale of an Indiana Jones or Lara Croft flick, with forgotten temples entangled in jungle vines, cobwebbed imperial tombs baking in the desert sun and ancient bejeweled treasures beyond reckoning. Wild rivers that rage, pumas that prowl in the night and hallucinogenic shaman rituals that are centuries old—and it's not just a movie here, it's real life.
>
> —*Lonely Planet Peru*

In 1969, Dennis Hopper's independently produced *Easy Rider* captured the counterculture's pulse beyond the wildest dreams of the studios. Exploiting the techniques that had defined underground cinema in New York for the previous decade, *Easy Rider* represented the countercultural lifestyle as a perceptual euphoria that was simultaneously antiestablishment and accessible to the mainstream. As Jack Kerouac had famously described it a generation earlier, freedom in *Easy Rider* meant being "on the road," where loose women, fast bikes, and most memorably, a psychedelic LSD trip updated the frontier myth for a new generation. But as the apocalyptic end of the film suggested, freedom was also the end of the road. Rebellion may have been ecstatic, but *Easy Rider*'s hippie outlaws paid the ultimate price for their attempt to live on the outskirts of the dominant order.

Riding the unprecedented success of *Easy Rider,* Dennis Hopper set out to make *The Last Movie,* a film he had originally intended as his first but hadn't believed would find an audience. Self-styled as the young Orson Welles—a comparison Hopper himself made in interviews in the documentary *The American Dreamer*[1]—Hopper gained absolute personal control over all aspects of production for his second feature. Granted access to a whopping $850,000 budget (far less

than most Hollywood films but more than twice what *Easy Rider* had cost) and industrial means of production from Universal Pictures,[2] the mercurial director had managed to convince the studios—if not the actual counterculture—that his impression on the youth audience was akin to the Midas touch.

The inspiration for his second feature occurred to Hopper during the filming of the John Wayne western *The Sons of Katie Elder* (Henry Hathaway, 1965) in Durango, Mexico. Confronted with the enormous contrast between the archetypal artifice of the production and the impoverished reality of the local community, Hopper wondered what would happen when the Hollywood movie cast and crew departed and the indigenous people were left living among the detritus of Western sets and other movie production paraphernalia.[3] What, in other words, was the afterlife of Hollywood mise-en-scène for the indigenous populations who were compelled to incorporate Hollywood's waste products into their daily lives?

Whereas the ill-fated protagonists of *Easy Rider* had sought to fulfill their romantic desire for self-determination within America's borders, the Ulyssean antihero of *The Last Movie* went to South America in search of the financial success that had eluded him in the States (Figure 8.1). Playing capitalist industry man rather than romantic outlaw, Dennis Hopper's character in *The Last Movie* sought not an untouched wilderness but an untouched market. Yet, instead of discovering a population eager to serve as the faceless, red backdrop to the heroic antics of a gang of cowboy cronies, the protagonist of *The Last Movie* discovered an indigenous community ready to resist foreign domination. If the end of *Easy Rider* suggested that the cherished dream of freedom could not be sustained when confronted with the violent racism of the Deep South, then *The Last Movie* refused to accommodate the outsourcing of this dream to a land south of the border. Perhaps unconsciously, *The Last Movie* demonstrated that the capitalist desire for an unregulated market and the hippie desire for an unregulated social body were two sides of the same fraught ideological game.

Yet *The Last Movie* didn't merely move beyond the geographic location of the United States; rather the film turned the cameras around on America—both literally and figuratively—to reflect on the ideological presumptions that defined Hollywood, alternative cinema, and Hopper's own evolving posture from Method-trained actor to avant-garde outlaw. Though the film failed miserably with audiences of its time, in the nearly forty years since its debut, it has been recognized, by critics such as David James and J. Hoberman, as one of the most provocative, prescient metafilms to emerge from the period. Though this essay hopes to further the revaluation of Hopper's fairly unsung masterpiece, it also attempts to "re-place" an analysis of the film in its actual setting of Chincheros, in the hope of restoring the vital

Figure 8.1. Dennis Hopper casts an imperial gaze over the Peruvian landscape in *The Last Movie*. A "camera" fabricated by the local cargo cult suggests that the natives are getting restless. Courtesy of the Academy of Motion Pictures Arts and Sciences.

context of place to the film's complex critique of the American culture industry.

As this essay shall argue, *The Last Movie* makes visible the violent forms of cultural colonialism that Hollywood films practice in their attempt to disavow, conceal, and eradicate the ambiguities of local cultures and places where they are often filmed and to which they are often exported. In doing so, it allied itself—however unwittingly—with the emerging Third Cinema practices of Latin America and Africa. And yet, as a capitalist-financed *über*-production of the first world that is merely set in the third world—rather than being a genuine collaboration between the developed and developing worlds—*The Last Movie* was itself the kind of film it so astutely critiqued.

PLACING *THE LAST MOVIE*

Like *Easy Rider,* Hopper's second directorial effort was interested in demythification and disillusionment and the ways in which naive fantasies of space crumble under the deeply ingrained tensions of place. By moving beyond the nation's borders, *The Last Movie* gestured beyond America's fraught political landscape, in which every

corner seemed to contain a gun-toting reactionary ready to stamp out the dreams of Hopper's generation.[4] As David James, J. Hoberman, and other critics have noted, *The Last Movie* was a far more radical picture than *Easy Rider,* in matters of both style and content.[5] Superficially exploiting the experimental palette without actually undermining Hollywood's conventional narrative structure of subversion and containment, *Easy Rider* had utilized avant-garde film techniques exclusively to depict the expanded awareness of drug-induced perception. Borrowing from Bertolt Brecht, *The Last Movie* deconstructed the very language of storytelling and filmic presentation with its self-conscious inclusion of disorienting flashbacks, flash-forwards, superimposed titles, missing frames, projectionist cue marks, outtakes, and repetitions. Yet these techniques of distanciation were not unleashed merely in the service of an art house self-reflexivity that had already become de rigueur by the late 1960s; rather they were used to critique, among other things, Hollywood's invidious strategies of what I, following philosopher Edward S. Casey, would like to call *deplacialization* or "the systematic destruction of regional landscapes that served as the concrete settings for local culture."[6]

The Last Movie both dramatizes and critiques the intertwined strategies of deplacialization and cultural colonization that define Hollywood films shot on location in the third world. Yet, through my reading of the film's quixotic production history, I shall demonstrate that despite its bold critique, the production of *The Last Movie* paradoxically reduplicated the very colonialist practices that the film interrogates at the narrative level. By investigating this central paradox, I hope to read *The Last Movie* as an object lesson par excellence in the complex relationship between movie-made fantasies of space and the real-world practices of place.

Unlike Hopper's directorial debut, *The Last Movie* was not just a vision of transgression and punishment but an assault on the very culture industry to which Hopper was both a privileged insider and self-fashioned outsider. Though Hopper's on-screen persona was again summarily executed at the end of the film, this time, it was not done at the hands of shotgun-toting rednecks, as in *Easy Rider,* but by anticolonial insurgents seeking self-determination by any means necessary. If Hopper had flattered himself by playing a romantic rebel in *Easy Rider,* in *The Last Movie,* he depicted himself as indistinguishable from the patriarchal, colonialist, capitalist establishment, despite his character's alternative sexual mores and post-beat sensibility.

Given *Easy Rider*'s success,[7] *The Last Movie* was the most eagerly anticipated picture of 1971. To whet the public's appetite, there were cover stories in *Esquire, Rolling Stone,* and *Life* as well as pieces detailing the film's scandalous production in the *New York Times, Look,* and *Playboy.* Yet its arrival was delayed after an agonizing

postproduction during which Hopper took a year and a half (three times as long as was standard) to edit the film in a house he had purchased in Taos, New Mexico,[8] rather than at Universal Studios, where his notoriously undisciplined style could have been kept under closer watch. Once Hopper delivered his unruly final cut, studio executives threatened to withdraw the film if he didn't agree to a more conventional final edit. He refused. In spite of Universal's disapproval, *The Last Movie* won the Critics' Prize at the Venice Film Festival. When it finally opened in New York, it broke the single-day box office record at the RKO Fifty-ninth Street theater, the site of *Easy Rider's* celebrated engagement. But despite these auspicious beginnings, the film was lambasted and ridiculed by nearly every reviewer in the country and, as promised, was withdrawn by its distributor within two weeks. The experience ended Hopper's career behind the camera for over a decade, rendering the filmmaker's own professional death the final, extratextual death in the film's palimpsest of mortality.

Despite its commercial failure and critical denunciation, *The Last Movie* remains the most explicit critique of the relationship between the generic mythology of Western space and the nongeneric reality of third world place that Hollywood has ever produced. In his landmark philosophical study *The Fate of Place,* Edward Casey distinguishes between *space* and *place* by describing space as a void that can be filled, or as an "endless extensiveness" that is characterized by a deliberate sense of "spread-outness."[9] But if space is characterized by its emptiness, and its infinite potential to accommodate nonindigenous fantasies of unlimited exploration, then place is characterized by its dense multiplicity, its rich and diverse specificity, and a concreteness that is only legible to local populations. Already full of their own meanings, features, practices, and customs, places are not empty voids to be filled. Indeed, there is hardly a surplus of *room* in place because someone already lives there.

Whereas space "fails to locate things or events" other than by abstractly pinpointing positions on a geometric or cartographic grid, place situates things in "regions whose most complete expression is neither geometric or cartographic."[10] Indeed, the defining characteristics of place cannot be gleaned from a two-dimensional or even a topographical map. Not only are the essential textures of place only visible from the ground but the secrets of place can only be experienced through the cultural immersion of the corporeal, historical body in a particular regional landscape. Lacking the specific attributes that make place the authentic setting for real, live, material bodies, space becomes not only vacant but also vacuous.

Yet, despite its vacuity, space is not neutral, for even the supposed *emptiness* of space is itself an ideological construction determined to disguise the eradication

of place, people, and culture that occurs through colonization. Casey himself implicates the Western concept of spatiality by arguing that it was the very notion of "infinite space" that provided a philosophical cornerstone for the West's insatiable quest toward expansion and the concomitant violence this quest entailed.

If, as Casey argues, place has been evacuated and subsumed by the triumph of a violent spatial logic, then in the last century, Hollywood has served as an agent of this deplacialization through its monopoly of global markets and its manufacture of universalizing, essentializing tropes of anthropologic otherness. As many scholars of third world cinema have demonstrated, the global distribution of American films has been detrimental to the development and maintenance of vital national cinema traditions. Yet deplacialization precedes global distribution and the subsequent devastation of local cinema traditions that occurs because of the flooding of national markets with American exports. For as this essay shall demonstrate, deplacialization can also occur at the level of film production, when particular places are transformed into sites for location shooting.

HOW THE WEST WAS WON

By fabricating place out of the abstract contours of a soundstage or studio set, or by instrumentalizing one place to serve the representational function of another, Hollywood routinely effaces the "localness" of location. The implications of this practice are multifold. Saturating particular locations with mythic meaning entails the evacuation of the specific, local meanings that are contested and negotiated by inhabitants. Using the particular to stand in for the universal paradoxically often renders the particular location and its inhabitants mute. Silenced by its compulsive figuration as mythic trope, places become unable to speak their own history. When Chincheros, Peru, becomes rewritten as Lamas, New Mexico, as it does in *The Last Movie,* both places disappear.

This forced disappearance is perhaps most overt and conspicuous in the western, that quintessentially American, racist genre which *The Last Movie* both deconstructs and to which it pays homage. For despite its claims toward the infinite, open space of the frontier, and its concomitant manufacture of nonspecific geographies in the clichéd form of Old West saloon towns, Indian settlements, and rugged desert landscapes, the western is defined by the tensions between place and space, tensions that reverberate through the history of American expansion and genocide. As Casey points out, the Native Americans' struggle against settlers and conquistadors was inextricable from their attempt to preserve a homeland replete with the nuances of history, identity, and character that do not survive displacement.[11] This struggle is rendered impotent in Hollywood's mythical, racist version of the

conflict between cowboys and Indians as well as in Hollywood's transformation of places—with their particular historical and cultural resonances—into "sites."

Casey's notion of "site" provides an extremely helpful way of understanding the implications of Hollywood's transformation of regional places into sites for location shooting. Casey defines *site* as "the leveled-down, emptied-out, planiform residuum of place and space eviscerated of their actual and virtual powers and forced to fit the requirements of institutions that demand certain very particular forms of building."[12] Unlike the notion of "site specificity" that has dominated sculpture and installation practices since the 1970s,[13] and in which the environmental features of a particular place are self-consciously incorporated into the creation of the artwork, Hollywood routinely disavows and disguises the particular locations it transforms into production sites. By formatting the particularities of specific locations to better serve as backdrops for the Manichean fictions of the dominant order that are compulsively repeated in the foreground of the frame, Hollywood evacuates actual places of their textures and histories. There is perhaps no better example of this than the manufactured western landscape. One must only recall all of the John Ford westerns that claim the iconic Monument Valley as their backdrop[14] to recognize that most westerns attempt to repress the difference-of-place on which *The Last Movie* insists.

Yet, as the unsightly markers of midcentury industrial sprawl began to encroach on the frontier mythologized by directors like John Ford, westerns of the late period were increasingly outsourced to nonnative locations. Rather than signifying their own regional specificity, however, foreign landscapes continue to be made to stand in for a generic, fictive sign of mythic proportions. Whereas late Hollywood westerns like *The Sons of Katie Elder* attempted to disguise this substitution, and the spaghetti westerns of Sergio Leone—many of which were shot in Tabernas, Spain—subtly utilized their geographic displacement to sever their ties to classical realism (without calling into question the ideological basis that supported that realism), *The Last Movie* explicitly foregrounded its own displacement and site specificity to ground its critique in the anticolonial struggles of the third world.

Rather than attempting to transform its third world location into a site that reinscribed rather than resisted the dominant ideology of the West, *The Last Movie* asserted the radical difference-of-place that has been violently erased by the dominance of American economic and political paradigms. By situating its conflict within a particular regional landscape inhabited by indigenous people with specific local customs, *The Last Movie* revealed the ways in which the realities of place undermine the mythic tropes of expansion, conquest, and freedom to which they are often subjected in the genre's classic iteration. By acknowledging the

specificity of place through the inclusion of documentary footage of Peru, where the film was shot, *The Last Movie* critiqued the instrumentalization of the supposed authenticity of local culture for Hollywood's fundamentally imperialist project. Yet, through its attempt to reveal the contradictions between place and site that inform Hollywood, *The Last Movie* also unwittingly revealed its own inextricability from these contested discourses.

IMAGINARY SIGNIFIERS?

As an artist, Dennis Hopper was uniquely positioned to forge a powerful, self-reflexive critique of Hollywood. Hollywood movie star, fashion photographer, art world insider, pop art collector, unconventional filmmaker, upwardly mobile husband,[15] and drug-addled wacko, Hopper was a genuine anomaly, one of the sole common denominators between "Hollywood expertise and recalcitrance."[16] An accomplished actor since childhood, Hopper had achieved a kind of notoriety by appearing alongside James Dean in films such as *Rebel without a Cause* (Nicholas Ray, 1955) and *Giant* (George Stevens, 1956), and yet, Hopper was equally at home with the most radical avant-garde figures of the art, film, and music worlds. Hopping from gallery to gallery in New York in the late 1950s, the young Method actor came of age as an artist in the moments before abstract expressionism yielded to pop. He soon became a friend of Warhol's and often visited the lofts of Jasper Johns, Roy Lichtenstein, and Allen Ginsberg. A regular at jazz clubs, he knew Thelonius Monk and Miles Davis. Toting his still camera around like a midwestern tourist, Hopper immersed himself in the experimental art scene that was flourishing downtown. When he finally was able to fulfill his lifelong dream to direct, all these appropriated influences would be visible, from the editing styles of experimental directors Bruce Conner and Gregory Markopoulos to the expressionist use of light and color to the Warholian obsession with celebrity and surface. Yet it was only in *The Last Movie* that Hopper managed to integrate fully what he had learned from the avant-garde into feature-length filmmaking.

The Last Movie begins with the ill-fated production of a Samuel Fuller western, which is being shot on location in the remote village of Chincheros, Peru. In a probable reference to Fuller's recent film *Shark!* (1969), a pre-*Jaws* adventure thriller in which a Mexican stuntman was killed during production,[17] the actor playing Billy the Kid (Dean Stockwell) is accidentally killed in a stunt that goes awry. Soon after, the cast and crew evacuate, leaving behind a dilapidated western set and a disillusioned cowboy stuntman named "Kansas" (played by Dennis Hopper), who stays behind in the hope of developing a location for future film productions. In the meantime, he plans to build a Malibu-style retreat and ski lodge (even though

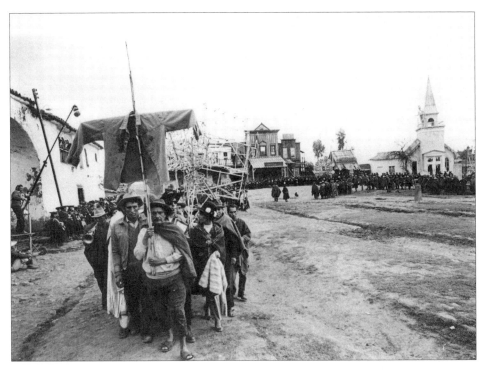

Figure 8.2. The locals march through Chincheros sporting their homemade movie equipment. Dismissing the distinction between real and illusory movie violence, the indigenous crew intends to sacrifice Kansas as recompense for the exploitation they have endured. Courtesy of the Academy of Motion Picture Arts and Sciences.

it never snows) in the film's heavenly setting. A *nobody* on the set, Kansas yearns to be a *somebody* when it is evacuated. He attempts to realize these ambitions by exploiting the developing world and its people. Not merely the story of Kansas, this is also the story of the actor–director who played him.

As Kansas soon discovers, the "Indians" don't turn out to be as gullible as they seem in the movies, for even after the official production of the Fuller western concludes, the natives refuse to grant it narrative closure. Enticed by their glimpse of Hollywood glamour, they have already begun to shoot their own film on the abandoned set. Emerging from the encounter between tribal ingenuity and the technological opulence of foreign invaders, theirs is a true cargo cult, complete with magical thinking, religious rituals, and the imitation of nonnative manufactured goods. With make-believe equipment constructed out of wicker and bamboo, the indigenous crew sets out to re-create the Fuller western scene by scene (Figure 8.2). Undeterred that they have no film, and that none of their scenes can actually be recorded with their counterfeit equipment, they approach the Fuller film as a sacred text that must be perfectly reproduced. Modeling the Fuller production (or the Hopper production?), there is even a despotic director (Jorge Montoro), whose

irrational commands seem more appropriate to a military junta than an entertainment unit. There is, however, one crucial difference between the Fuller film and its indigenous imitation, which is known to the local community as *La Ultima Pelicula*. Like many of the puppet dictatorships set up by the United States, the crew turns against the imperial regime that first enabled it to do their dirty work. To Kansas's horror, the local population insists on shooting the actual slaughter of the gringo stuntman. Deeming their sacrifice the ultimate sign of white male obsolescence, the native crew renames Kansas "El Muerte."[18]

Promoted from stuntman to star, Kansas has finally obtained the role of a lifetime. Unfortunately for him, his big break is also a death sentence. In a strange inversion of Hollywood's own repetition compulsion, the natives compel Kansas to endlessly reenact the Hollywood production that was their undoing. This eternal return seems an attempt to manage the trauma of foreign invasion—once by the Spanish in 1533 and once by the Americans in 1970, as Alix Jeffry of the *New York Times* so glibly describes it. But in their long history of anticolonial struggle, the Peruvians haven't made such predictable or neurotic victims. Once again, they prove formidable, tireless resisters to Western colonialists. Through filming *La Ultima Pelicula,* the Peruvians attempt to repossess what has been, literally and metaphorically, stolen from them. As David James writes, the Peruvians have "symbolically reclaimed the landscape stolen in the past by white imperialism in North America. Their appropriation functions as a symbolic liberation from imperialism, just as their possession of cinema, of the Western, is a rejection of the type of Exploitation symbolized by the Fuller production."[19]

Or is it? Kansas may be forced, against his will, to stand in for the entire power structure of Hollywood and to pay, with his own life, for the sins of Tinseltown's global imperialism. But does this sacrifice truly effect liberation for the local population? Like a nuclear reactor, the Hollywood set continues to poison the Peruvians with dreams of greed and violence even after its original cast and crew have abandoned it. Its existence indelibly tarnishes the peasant community, who can neither continue to live as before nor acquire the equipment and commodities they would require to modernize. Their only option is to rebel against the foreign intruder—which they do. But this, too, offers no real solution because they model their revolt on the autocratic model of authority that they have witnessed.

Disavowing the radical impetus behind their seizure of Hollywood's detritus, Kansas initially assumes that the natives lack the media sophistication to distinguish real violence from movie violence. In one particularly compelling early scene, he attempts to demystify filmmaking conventions for the group of "savages," who are senselessly beating each other in imitation of the departed cast.

Only when Kansas's demonstration of fake punches fails to divert the crew back to Hollywood-style chicanery does it becomes obvious that the Peruvians intend their production as an act of political resistance and recompense. By failing to distinguish activism from adulation, Kansas succumbs to the stereotypical notions of indigenous ignorance and primitivism that are the hallmark of the very genre Hopper is striving to dismantle.

By assuming that the native population cannot discern the language of cinema—and its basis in imaginary signification—Kansas fails to recognize the cultural sophistication of the Peruvians' radical praxis. For by presuming that the locals are unable to distinguish real violence from movie theatrics, Kansas assumes that the indigenous population cannot navigate the complex relationship between signifiers and signifieds—or representations and the real-world objects and relations they reference. Like the European conquerors of Peru, who didn't recognize the linguistic capacity of the Andean man and, in doing so, falsely assumed his cultural inferiority, Kansas's attempt to communicate is doomed to failure because of his own myopic vision of the Other's capacity for language and legitimate culture. As *The Last Movie* demonstrates, it is Western man, in fact, who proves to have trouble distinguishing the so-called real from the imaginary—who has trouble navigating signs. Though Kansas assumes that natives can't tell the difference between the real and the imaginary, it is actually he who cannot make this distinction. Why else would he consider the demolition of the artificial set—which he undertakes midway through the film—adequate recompense for the exploitation of the land and its native people?

Kansas's very name provides an interesting allegory for the layers of signification—both real and imaginary—that structure *The Last Movie*. Simultaneously referencing Hopper's own midwestern birthplace and Dorothy's mythologized origins in *The Wizard of Oz,* the name "Kansas" links Hopper's character to both America at large and Kansas in particular. Wedged in the heartland, Kansas represents the stuff of outlaw dreams and Depression-era poverty—both associations movie made. Wyatt Earp was appointed marshal of Dodge City, Hopper's hometown, in 1867; gunfighter cum lawman Wild Bill Hickok served as deputy marshal nearby. At the beginning of the Civil War, "Bleeding Kansas" was a battleground between pro-slavery settlers, Free-staters, and abolitionists, led, most notably, by John Brown. Torn at the core between oppression and liberty, Kansas became part of the Union in 1861 but soon became the site of one of the largest acts of domestic terrorism in history when confederate bushwhacker William Quantrill slaughtered nearly two hundred people in Lawrence. Longtime victim of rural exodus, Kansas is at once the place from which you want to get away and the place to which you can never return. It is, after all, a long way from Hollywood.

The name "Kansas" encapsulates Hopper's own geographical trajectory from midwestern farm to the cultural capitals of New York and Los Angeles, where he made his name in both the East Coast avant-garde and West Coast dream factory. It serves as neat shorthand not just for the traces of Hopper's biography but also for an active nostalgia for the particularities of place that have "been lost in a worldwide monoculture based on American economic and political paradigms."[20] There is, indeed, "no *place* like home," to quote Dorothy's famous incantation. For without place, home no longer exists, except as an abstract, idealized sign.

In the late capitalist world in which *The Last Movie* takes place, however, nobody can tell the difference. Constantly mistaking the filmic or theatrical for the authentic, and vice versa, Americans in *The Last Movie* are ill equipped to understand or meaningfully respond to the insurrection of the Peruvian population. As Dennis Hopper has suggested, by chasing the American dream of capital and conquest, Kansas has failed to understand the material relation between aesthetics and politics:

> [Kansas is] Mr. Middle America. He dreams of big cars, swimming pools, gorgeous girls. . . . But the Indians . . . see the lousy Western for what it really was, a tragic legend of greed and violence in which everybody died at the end. So they build a camera out of junk and reenact the movie as a religious rite.[21]

Kansas is certainly a flawed character. Nevertheless, *The Last Movie* insists that his ignorance is not a unique trait but rather is endemic to America's collective unconscious, which has been exported to remote parts of the world, along with American products. Kansas's friend Neville Robey (Don Gordon) is a perfect example of the punch-drunk American, so intoxicated by Hollywood's rags-to-riches schemes that he has traveled to the proverbial end of the earth in search of a pot of gold. An expatriate convinced that he is going to strike it rich from a mine nestled in the Andes, Robey has modeled himself after every flimsy trope of classical adventure films. As to be expected, Robey doesn't have the slightest idea how to find the precious metal in the rough. Insisting that gold in the earth must look exactly like the ring on his finger, Robey repudiates the labor that transforms the natural resource into the commodity. Stubbornly protesting that "Walter Huston didn't do it that way!" (in *The Treasure of the Sierra Madre*, directed by John Huston in 1948), Robey can't distinguish the performer from the role he plays. Interestingly, neither can *The Last Movie*.

Neville Robey is not the only white person who mistakes the imaginary signifier for the mark of authenticity. In the midst of the violent chaos that ensues as a

result of the native production, a white traveler attempts to take a photograph of Maria (Stella Garcia), Kansas's glamorous Peruvian girlfriend. Dressed in traditional Andean costume solely for her role in the film, the cosmopolitan Maria is mistaken for the quintessential mountain villager and is asked to pose accordingly, in deference to what the tourist considers genuine Peruvian archaism. But Maria has given up the fraught identity of primitive outsider for the equally problematic role of exotic mistress. She refuses to stand in for the white man's fantasy of aboriginal Otherness, choosing instead the highly constructed image of the femme fatale. Flirting conspicuously for the camera, Maria repeatedly lifts her skirt and attempts to show off her feminine assets—to the tourist's dismay. Like Robey, the tourist has not only mistaken a movie set for reality but clings tenaciously to his own movie-made notions of how Peruvians should look and behave. This charged moment in the film parodies both the diegetic and extradiegetic audience's expectations for third world minstrelsy, with red paint substituting for black on the faces of performers and an Andean village in the place of the proverbial watermelon patch.

Like many vacationers who still visit the Peruvian interior in search of rediscovering the ancient wonders of the Incan world, the occidental tourist expects the indigenous population of the late twentieth century to behave like ghosts from the distant past. But unlike many Peruvian villagers, who, as contemporary guidebooks warn the wary traveler, continue to dress in traditional apparel only to be photographed for a fee by Western tourists, Maria refuses to play the antiquated role that the white man has assigned her. Maria may worship totems, but they are totems firmly situated in the contemporary world: throughout the film, she repeatedly demands refrigerators, swimming pools, and other modern conveniences from Kansas. Though Kansas takes these commodities for granted in his own life, he is dismayed by Maria's sudden desire for them. Like the tourist, Kansas wants Maria to remain a picturesque relic of the past, a taxidermic display of uncivilized (wo)man who forcibly bears witness to the greater authenticity of her own primitive culture.[22]

Presupposing the colonialist myth that places developed nations outside of time, while insisting that developing nations are determined by the parameters of their specific locality and the teleological narratives of modernity, the tourist demands that the marks of timeless, native authenticity be made visible. Presumably deprived of his own regionality by the massive industrialization that has transformed the local places of his native land into identical spaces of strip malls, chain stores, and sprawling suburbs, the Western tourist wants to be assured that real places still exist—somewhere. Yet despite that the Western tourist expects the inhabitants of the third world to be able to put on primitive, authentic faces for the camera at any

moment, he also expects third world locations to be mutable enough to accommodate whatever fantasy he implants on them. Expected to offer an authentic testimony of place, third world inhabitants are nevertheless made to speak in different tongues.[23]

And yet, for Hopper, the self-conscious ignorance of the tourist was itself a more authentic position for a Westerner than the pretension to know about a culture about which one is clearly ignorant. In an interview with Tony Crawley in 1977,[24] Hopper—ever suspicious of the opposition between illusion and reality—claims to prefer the ignorant tourist's approach to one that naively presumes the authenticity of the Other. Speaking of the difficulty of making a film in another country, Hopper admits that he would *only* make a film in another country from the explicit point of view of a tourist. Rejecting the idea that it is *ever* possible to authentically document a foreign place on camera, Hopper nonetheless insists that it is possible to make a movie outside the United States "if you don't pretend you know all about the country. If you come as a tourist, it can work." And yet, Hopper's suggestion that an American filmmaker working in a transnational context should embrace rather than correct her own ignorance can also be read as the Stetson-clad director's own attempt to deflect and nullify a critique of his own controversial practice. For as the following discussion of the film's production history shall demonstrate, playing the Ugly American with impunity does not render the position any less problematic.

ON LOCATION WITH THE UGLY AMERICAN

Though Peru was in the grips of a military dictatorship when Hopper decided to film there, the stunning nation below the equator must have nevertheless appealed to the director as an idyllic alternative to his divided homeland, where he had been marginalized by the industry and spit on by his countrymen.[25] Although Hopper had originally wanted to shoot in Mexico, he was rerouted after Mexican officials demanded censors on the set to monitor the representation of "Indians."[26] After visiting the ruins at Machu Picchu, one of the last archaeological wonders "discovered" in modern times, Hopper was struck by the Peruvian landscape. Ironically, however, it was not the place itself but an idealized simulacra that caught his eye: an image in the office of a travel agency of a small "village of Indian farmers, a church on a big square, adobe huts [and] the peaks of the Andes in the distance." As Hopper recalled, "Chincheros was perfect! Every Sunday about twenty-five hundred people came to a big market; otherwise it's nothing but a hamlet with Indian farmers, shepherds, llamas, a rural area with striking scenery."[27] Despite its lack of electricity, it was, as Hopper told the *New York Times* in 1970, "a paradise."[28] In his praise of the locale's impoverished, picturesque authenticity, Hopper neglected to

mention the growing drug trade that would prove so amenable to him and his crew.

Located thirty kilometers north of the city of Cuzco (approximately forty-five minutes by car) and four thousand miles, or fourteen thousand feet, above sea level, Chincheros is a small town made up of twelve indigenous communities that maintain the *ayllu,* or tribal system. Surrounded by the Andes Mountains, Chincheros is strategically placed at the intersection of three roads that connect Cuzco, Yucay, and Pumamarca. Originally established as a resting place for Inca emperor Túpac Yupanqui, the village was designed as a court residence in the middle of a rural environment. Fittingly, in 1480, the Incas ordered the construction of temples, baths, cultivation terraces, and a royal palace.

Known for its esteemed agriculture and weaving industries, Chincheros has become a popular tourist destination because of its proximity to the famed site of Machu Picchu. It is also one of the few locales in the region that has preserved its Incan architecture and urban design—to the delight of first world tourists. Indeed, many of the town's main attractions—including the remains of the Incan palace, the colonial church erected on stone foundations, its impeccable cultivation terraces, and a colorful Sunday fair—can be seen in Hopper's film.

Chincheros, Peru, may have seemed an unlikely destination after Kansas, Hollywood, and New York, but Hopper may have seen it as the logical next step in a career made of confounding, often contradictory choices. Hopper's uncanny knack for being where it was happening made South America, land of Marxist foment and martyred revolutionaries, an appealing setting on which to stage his own fantasies of persecution. Though his early friendship with Dean and his first marriage into the wealthy Hayward family rendered Hopper a privileged insider, he continued to assert himself as a symbolic outsider and political rebel. A master of appropriation, Hopper moved from the margins to the mainstream and back again.

Though it is unclear whether Hopper was familiar with the particular history of cinema in Peru, which has been defined by the conflicts generated between the disparities of rural and urban experience and indigenous production and foreign competition,[29] it is clear that the director had considered the implications of outsourcing Hollywood fantasy production from his experiences working on *The Sons of Katie Elder.* Like the history of cinema in Peru that it unconsciously allegorizes, *The Last Movie* is torn between documentary and fiction, between a notion of an indigenous cinema founded on violent resistance to colonization and the hegemony of Western mythmaking. Though the documentary footage of Chincheros references the real or authentic indigenous communities that are systematically destroyed by the global expansion of Hollywood, the film's production failed to live up to its ostensible ideological goals.

Taking into account the time period in which it was made, in which anticolonial ideologies of self-determination were both in the air and on screen, it is no surprise that *The Last Movie* attempts to restore the particularities of Peruvian places at the expense of Hollywood mythmaking. Made in 1971, the same year that Fernando Solanas and Octavio Getino conceived of a politicized guerrilla cinema in Argentina, the film merged first world cinema practices with the ideological urgency of what Solanas and Getino named "Third Cinema." Their equation of cameras and guns was crucial to the transformation of both filmmaking and film viewing into anticolonial modes of political praxis.[30] Furthermore, the eighteen-month occupation of Alcatraz by a coalition of Native American tribes beginning in 1969, as well as the numerous civil rights riots in cities throughout America and the emergence of Black Power rhetoric, broached the idea that anticolonialism could function as a useful paradigm for understanding not only the political struggles abroad but the racial relations at home.

Like many contemporaneous works of Third Cinema, including *The Battle of Algiers* (Gillo Pontecorvo, Algeria, 1966), *Blood of the Condor* (Jorge Sanjinos, Bolivia, 1969), and *How Tasty Was My Little Frenchman* (Nelson Pereira dos Santos, Brazil, 1971), *The Last Movie* asserts the ability of indigenous communities to resist foreign intrusion. But if native resistance is staged at the film's narrative level, it was not maintained at the level of production. For despite the deconstructive impetus of the text, and its obvious allusions to Third Cinema practices, its production history revives the notion of the Western conquistador as heroic figure. Though the director may have fashioned himself a countercultural outlaw, Hopper's methods of production maintained the age-old division between cowboys and Indians. While *The Last Movie* celebrated indigenous insurgence in its fictional story, its production was riddled with anxieties about native disobedience.

Although the crisis of indigenous self-actualization that *The Last Movie* allegorizes can be firmly situated in the anticolonial struggles of the 1960s, many of these anxieties that animate *The Last Movie* date back to the earliest days of cinema. In a 1915 article titled "The Dangers of Employing Redskins as Movie Actors," film critic Ernest Alfred Dench warned of the likelihood of actual "Red Indians" employed by Hollywood getting violently carried away in their attempt to "play themselves" as the movie industry imagined them. Whereas Dench originally assumed that casting actual Native Americans in the roles of Indians—rather than white actors in redface, as was, and remains, customary—would help civilize them, he fretted that their involvement in the emerging dream factory had had the reverse effect, affording them the opportunity to "[re]live their savage days."[31] Dench explains, "They put their heart and soul in the work, especially in battles with whites"; he

further writes, "It is necessary to have armed guards watch over their movements for the least sign of treachery. . . . Once a white player was seriously wounded when the Indians indulged in a bit too much realism with their clubs and tomahawks."[32]

Although Dench refused to recognize the political impetus implicit in the acts of sabotage he cites, Dennis Hopper was more attuned to the revolutionary potential of the Native appropriation of Western media. Nevertheless, *The Last Movie* does not dispense with the stereotype of the rapacious savage or the white savior. Pauline Kael recognized this in her review of the film in the *New Yorker* in 1971:

> The most embarrassing thing about [Hopper's] Christ bit is not that he has cast himself in the role, but that he has so little visual interest in any-one other than himself. The Peruvians in the film are an undifferentiated mass of stupid people; not a face stands out in the crowd scenes except Hopper's—the others are just part of the picturesque background to his suffering.[33]

Hopper may have conceived of the film as a blow to Hollywood, but his avowed inspirations for the film seem lifted from the script of an Indiana Jones film, the first of which was released ten years after the dreams of *The Last Movie* had been cast into oblivion. On many occasions, Hopper has insisted that the film was influenced by the Gnostic "Gospel According to St. Thomas," which was first discovered in 1945 in a ruined temple near Nag Hammadi, Upper Egypt,[34] and first published as a photographic edition in 1956. Thomas's Gospel purports to be the sayings of Jesus as recorded by his "twin" Didymos Judas Thomas, for whom Hopper renames the village church. Hopper may have parodied the delusional character of Neville Robey for his naive belief in buried treasure, but the director himself was similarly fixated on turning this mythical caché into movie gold.

If Kansas refused to acknowledge the native Other's capacity to understand the symbolic relations of legitimate culture or language, Hopper didn't even try. Hopper's refusal to provide a place for the voices of Peruvian dissent is both a self-conscious device—as witnessed in the director's omission of any subtitles that would translate the language spoken by the Peruvians—and a failure of the political dimension of the project. For while *The Last Movie* claims to speak in the name of the South American struggle for self-definition, it deprives the actual Peruvians involved in the production of their voice.

There are many accounts of the difficulties Hopper encountered during production, the excesses to which he and his crew were prone, and his hostile reception by Peruvian authorities. Hopper's biographer Elena Rodriguez suggests these

conflicts rather overdramatically when she writes, "Peru had painfully learned to live with earthquakes, jungles, icy mountains, cannibalistic Indians, and deadly snakes. But Dennis Hopper was an entirely new peril."[35] Recycling every tired cliché of the Western director as conquistador, Rodriguez constructs Hopper as a larger-than-life figure with mythic powers of destruction and seduction and the indigenous population as "cannibalistic Indians" who serve as foil to modernization.

As Rodriguez recounts, the military government was in an uproar over the incoming crew even before Hopper arrived in Lima. By the time Hopper's thirty-eight-person cast and crew were drunk and stoned on their plane, the Central Intelligence Agency had already been put on alert to greet this unwelcome entourage of hippies, groupies, and druggies. Diplomatic relations didn't improve once Hopper was settled. The director's inaugural pronouncements celebrating marijuana and homosexuality in the newspaper *La Prensa* didn't help, considering the epidemic drug trade in the nation and the taboo of same-sex relations. Within a day of the article's release, the Roman Catholic Church was fuming. To make matters worse, the military junta led by General Juan Velasco Alvarado (1968–75) denounced the article and discussed a decree that would repeal the freedom of the press, a threat that was later accomplished in 1974. For the self-styled rebel without a cause, this encounter with realpolitik served as a badge of honor; Hopper boasted about it to the *New York Times* when he said, "Censorship was put in this country because of me."[36]

Once established, Hopper and his crew took full and conspicuous advantage of the availability of cocaine and other narcotics at discounted local prices. The hotels where the cast and crew stayed were chaotic: Peter Fonda carried a gun to protect himself, hippies shrieked through the night as a result of bad LSD trips, and Sylvia Miles, "the bleached-blonde prostitute in *Midnight Cowboy*," mistook a military general for a bellboy and ordered him to carry her bags upstairs.[37] Agents of the local generals were put on set to observe, report on, and control the abuses that occurred, but they seemed unable to do much about anything. Groupies wandered from room to room and reportedly slept with "anyone who would give them a bed for the night." Their post–Summer of Love sexuality was an affront to local customs, as was their willingness to score drugs for Peru's latest conquistador. As it turned out, the Peruvians weren't the ones who had trouble distinguishing reality from the movies; in perhaps the worst offense, reported by *Life* magazine, a young lady was chained to a porch post and a fire was lit at her feet in drug-induced homage to Joan of Arc.[38]

Local tensions between the two reigning forces of the community, the Communist Party and the Roman Catholic Church, were exacerbated during Hopper's

production. By selling community property to the American crew, a priest was accused by a Communist leader of exploiting local resources for capitalist gain. Hopper "graciously" resolved this fracas by playing the *über*-capitalist and paying twice as much for the desired goods. Yet in exchange for placating the Communist leaders, Hopper "suggested" that the local roads be fixed so that his crew would have better access. As Rodriguez reports,

> The next day a quickly organized crew of Indians went to work on it, filling in the holes and getting rid of rocks that had tumbled onto the track. Hundreds of Indians lined the road as Dennis drove a tour of inspection. It was perfect. Hopper was so moved that he cried.[39]

Unfortunately, Hopper's tears of gratitude at this display of subjugation did not translate into reciprocity or mutual respect. According to Joseph Spielberg, an American then studying and teaching anthropology at the University of Cuzco, daily radio editorials lambasted the film company for their disrespect of local customs and their insensitivity to the problems of the people. Protests focused on Hopper's exploitation of the area and its inhabitants: natural settings had been used without payment, and the crew had interfered with the performance of religious rituals. Sheep were slaughtered in imitation of local customs, and pieces of the butchered animals were handed out as payment for work.[40]

When asked by *New York Times* reporter Alix Jeffry what portion of the film's budget was going to the villagers, producer Paul Lewis insisted, "We've given them everything we have." Unfortunately, the description of "everything" that followed sounds a bit too much like the civilizing mission of the white man's burden: "We've given them tools and we're going to teach them how to use them. We're giving them medical aid, clothing, and the lumber from the set. But . . . everyone is hassling in the village as to who gets what . . . just as they do in the film."[41] Medical aid from a crew who couldn't get over their diarrhea and altitude sickness the entire time they were there? Not likely. Lumber from the set? In other words, Hopper's crew would abandon it after production, just like the "fictional" Samuel Fuller Western. Certainly the less than one dollar a day paid to local workers couldn't have helped much when an earthquake rocked the central mountain areas a few weeks later, killing more than seventy thousand people.

Indeed, all on-site accounts suggest that Hopper's respect for the local community was minimal. As photographer and designer Cecil Beaton recalls from his meeting with Hopper in the Peruvian inlands, there had been a feud about a local bell tower that Hopper wanted to pull down for the purposes of filming—an

act that was protested by the local population. Luckily for the director, who had a magical way of mastering special effects, the bell reportedly fell down "of its own accord" soon after Hopper's demands.[42]

Followed everywhere by a horde of tripped out, long-haired groupies, the cultish Hopper considered himself a revolutionary. But stomping around Peru with a local girl on his arm, boasting of drug use and group sex, and wearing his cowboy boots and Stetson hat, Hopper may have looked more like the Ugly American to local audiences. The "Duke" may have considered Hopper a pinko outlaw,[43] but local campesinos whose interests were actually being represented for the first time by Alvarado's leftist government wouldn't have considered the gringo director—playing the tired game of cowboys and Indians on and off the set—a revolutionary figure. Ironically, it was only after Hopper left the "colonels and their uptight country"[44] that Peruvian cinema came of age, under the regime of General Velasco, who guaranteed compulsory exhibition for Peruvian-produced shorts and encouraged the development of a new feature-length Peruvian cinema.[45]

CLOSE ENCOUNTERS OF THE THIRD WORLD

Dennis Hopper was neither the first nor the last Western filmmaker to exploit the Peruvian landscape as an ideal landscape for imperial adventures. Not only does Peru have a relatively large résumé in American cinema as both actual location and symbolic site, but its contemplation by American audiences has been thoroughly mediated—if not created—by on-screen representations. The cold war–era Charlton Heston vehicle *Secret of the Incas* (Jerry Hopper, 1954) charted an adventurer's search for hidden treasure in the Peruvian jungle and was the first American film to exploit the wonders of Machu Picchu, the sublime Incan city rediscovered by Yale archaeologist Hiram Bingham in 1911. Made by Paramount the same year that Hopper was filming *Rebel* for Warner Bros. with James Dean, and the explicit archetype for the later Indiana Jones films, *The Secret of the Incas* was the first Hollywood studio film to shoot on location in Cuzco and Machu Picchu. It was also the first mainstream film to introduce the wonders of the Incan world to cold war audiences. In one of the many instances where cinema has opened up the unknown, developing world to moviegoers who then "calmly and adventurously go traveling" in the midst of the world's "far-flung ruins and debris,"[46] the film caused a surge of American tourism to Peru in the years following its release.

Indeed, the jungles of Peru have a particularly cinematic history that came to fruition in the decades that witnessed the international development of so-called New cinemas. At least two documentaries about Chincheros were released in the 1960s in a wave of documentary filmmaking that came to be known as the Cuzco

School: *Vidas de los Campesinos de Chincheros,* directed by Manuel Chambi in 1961, and *Chinchero,* directed by Alberto Carlos Blat in 1968. Originally committed to the documentation of everyday aspects of Andean life, the Cuzco School became increasingly socially conscious, intent on critiquing rural exploitation and "revindicating" the indigenous by focusing on their customs and lifestyles.[47] As Chambi himself stated in 1974,

> I should point out that in my first works I thought more about cinema, now I think more about the reality of my country and I am not obsessed with the formal beauty of cinema.[48]

The indigenist tradition of the Cuzco School rejected the European model of auteurism as a pretentious, inappropriate export that was unsuited to the conditions of filmmaking in Peru.[49] That didn't stop self-styled European auteurs from mining the Peruvian landscape for its astonishing beauty. Following the release of *The Last Movie,* Werner Herzog, legendary enfant terrible of the New German Cinema movement, gave Peru its most iconic treatment for art house audiences with the release of his landmark film *Aguirre, the Wrath of God* (*Aguirre, der Zorn Gottes,* 1972).[50] Here the Peruvian jungle and its wild savages furnished the mise-en-scène, motivation, and foil for a Nietzschean conflict between man and nature.

Unfortunately, the representation of Peru both ushered in the so-called New Hollywood and signaled its demise. Shot on location by a maverick, reportedly crazed director who had been given total creative autonomy and an appreciable budget, *The Last Movie* represented a legitimate alternative to the Old Hollywood system of bloated sets, old-fashioned soundstages, and opulent production values. Yet if *The Last Movie* indicated that creative autonomy, a neorealist-influenced shooting style (with natural light, handheld equipment, and the inclusion of nonprofessional performers), and avant-garde postproduction techniques were possible as never before under the rubric of the decaying studio system, the debacle of its reception also informed the beginning of the end of Hollywood risk taking. After the so-called Hopper fiasco in Peru, studio executives at Universal and elsewhere were loathe to take the financial risks of giving nonconformist directors the kind of freedom Hopper had needed to make his early films. Rather than serving merely as an amusing footnote in the excesses of the counterculture, Hopper's very placed encounter with Peruvian culture had became a moment of definitional crisis in the organization of labor and capital in the New Hollywood.

As Peter Biskind describes in *Easy Riders, Raging Bulls,* his classic exposé of the birth and death of New Hollywood,

the failure of *The Last Movie* was also a blow to the kinds of films people like Hopper and [Jack] Nicholson hoped to make. In fact, [producer Ned] Tanen's whole slate suffered, particularly in light of other New Hollywood pictures that flopped.[51]

As *The Last Movie*'s failure at the box office suggested, audiences were not as ready as Hopper hoped for a more provocative, more politicized cinema practice. As Hopper himself observed, "what they really wanted was 1940-opiate kind of movies where they didn't have to do a whole lot of thinking—what Spielberg and Lucas came up with."[52]

Though *The Last Movie*'s attempt to document Peruvian authenticity was ideologically flawed, Hopper at least made an attempt to interrogate, and reflect on, his own cultural biases. Hopper may have been a rebel without a genuine or rigorous political cause, but the type of American cinema that followed his efforts lacked any connection with the rebellions of the 1960s. Spielberg's trip to Peru in *Raiders of the Lost Ark* (produced by George Lucas, 1981) is an apt eulogy to a revolutionary decade of American cinema that was already in its death throes just moments after its birth. Though set in the jungles of Peru, a mere stone's throw away from where *The Last Movie* had actually been shot, the South American scenes in the first film in the immensely lucrative Indiana Jones franchise were shot mostly on sets in England and on location in Hawaii. The idea for the setting came not from any interest in the indigenous cultures of Peru but from Lucas's and Spielberg's overlapping vacations in Hawaii, after the exhausting success of *Star Wars* (Lucas, 1977) and *Close Encounters of the Third Kind* (Spielberg, 1977).

If *The Last Movie* was influenced, however obliquely, by the anticolonial movements of the 1960s and the extraordinary films that documented these struggles, *Raiders* was suffused with a self-conscious nostalgia for the pre-lapsarian days of colonialism, chronicled by Hollywood adventure serials of the 1930s and 1940s. Though they take place on overlapping—if imaginary—geographic territories, *Raiders* is as far from *The Last Movie*'s critique of Hollywood's illusion machine as possible. Bereft of even a single frame of actual Peruvian landscape, *Raiders* celebrates the politically regressive genre it both emulated and reinvented. One of the highest grossing movies ever made, *Raiders* was as socially progressive as *Gunga Din* (George Stevens, 1939).

Though the most recent film in the series, *Indiana Jones and the Kingdom of the Crystal Skull* (Steven Spielberg, 2008), returned its protagonist to the mythical land of Peru, again in search of hidden treasure, it again never actually brought

its crew there to film; rather many of the Peruvian scenes in *Crystal Skull* were filmed in Universal studios, on locations in Hawaii, and in the neighboring country of Argentina, where the famed site of Iguazu Falls was made to stand in for the Peruvian jungle. Furthermore, as many Peruvian bloggers have protested,[53] the latest Indiana Jones film is replete with the kind of embarrassing geographic errors and offensive cultural oversights that are the unsung hallmark of the genre. Many of these errors are predictable enough: there is Mexican music playing in a supposedly Peruvian marketplace, Mayan-looking architecture is made to stand in for Incan ruins, and the Mexican revolutionary Pancho Villa is credited with teaching the colonialist Indiana Jones Quechua, an indigenous language from the Andean region of South America.[54]

THE LAST PLACE ON EARTH

At the levels of both its narrative and its production, *The Last Movie* takes place within overlapping paradigms of cultural imperialism and Western expansion. Through its figuration of the exploitative relationship between the generic myth of Western space and the nongeneric reality of third world place, the film critiqued the cannibalization of particular places, and the local cultures they generate, by American global capitalism. As the victims of cultural imperialism transformed into agents of cultural resistance in *The Last Movie,* place returned with a vengeance. The film challenged the hegemony of the generic space of the Western as a ready-made set that could be implanted on any impoverished third world place to set the stage for an eternal, preordained showdown between cowboys and Indians.

In Hopper's film, the reemergence of particular details about place threatens to rupture the fictional concept of Western space. Heralding the return of the repressed, the documentary footage of Peruvian life in *The Last Movie* intrudes on the already deconstructive fiction that is at the heart of the film. And yet, by compelling the Peruvian everyday to signify the very authenticity that Hollywood productions so conspicuously lack, *The Last Movie* maintained the binary oppositions—between civilized and uncivilized, cultured and savage, symbolic and real—that have defined the encounters between first and third world cultures in the Western imagination.

Dennis Hopper's *The Last Movie* did not affect the death of cinema, as its title claimed, though it did have the unfortunate effect of helping to eradicate some of the industry's more rebellious streaks. In the end, it was the Bleeding Kansan Dennis Hopper who was destroyed by the endeavor, while Hollywood persevered. For while *The Last Movie* executes Hopper's screen surrogate Kansas while preserving

Hopper as director, film history failed to make such forgiving distinctions. As the historical reception of the film attests, *The Last Movie* was the death of Dennis Hopper as a significant auteur.

A sublime, grandly conceived eulogy for Hollywood, *The Last Movie* is perhaps more remarkable as a eulogy for place, which has been the ultimate victim of globalization. As Hopper's version of an authentic non-Western community untouched by Western technology has been thoroughly eradicated by the global expansion of a Coca-Cola America of strip malls and chain stores, it seems that even the proverbial last place on earth no longer exists. Every place is, by definition, the last place on earth.

NOTES

1 See the documentary *The American Dreamer* (1971), directed by L. M. Kit Carson and Lawrence Schiller. This behind-the-scenes portrait of the eccentric director was shot in Taos while Hopper was in postproduction for *The Last Movie*.

2 *The Last Movie* was the first film signed by production head Ned Tanen for Universal Picture's new youth unit. The fiasco of its production and commercial failure was such a devastating blow to the new unit that it quickly ended Tanen's ability to produce truly unconventional films. For a fuller account, see Peter Biskind, "The Moviegoer," in *Easy Riders, Raging Bulls: How the Sex-Drugs-and-Rock 'n' Roll Generation Saved Hollywood*, 110–40 (New York: Simon and Schuster, 1998).

3 J. Hoberman, *Dennis Hopper: From Method to Madness* (Minneapolis, Minn.: Walker Art Center, 1988).

4 After the assassination of John and Robert Kennedy and Dr. Martin Luther King Jr., whom Hopper had photographed on the five-day march from Selma to Montgomery, Alabama, Hopper became convinced that America was hell-bent on destroying itself, or at least its most hopeful sons.

5 The experience of showing *Easy Rider* to students had transformed Hopper's expectations of what American audiences desired and could accept. As he recalled in an interview with *Playboy* magazine in 1990, "I wanted to do it [*The Last Movie*] as my first film and I didn't. So I went right into it afterward, because I'd gone around the universities with *Easy Rider* and everybody said, 'We want to see new kinds of film, new kinds of film, new kinds of film.' So I said, 'Oh, boy, have I got one for you.'" "20 Questions," *Playboy*, March 1990, 140–44.

6 Edward S. Casey, *The Fate of Place: A Philosophical Introduction* (Berkeley: University of California Press, 1998), xii.

7 Made for less than four hundred thousand dollars and produced by the independent company BBS, *Easy Rider* made over forty million dollars and was immediately revered as a generational statement.

8 Hopper purchased the adobe mansion that had belonged to patron of the arts

Mabel Dodge Luhan and in which D. H. Lawrence, one of her most famous beneficiaries and one of Hopper's idols, had spent time during the last year of his life.

9 Casey, *Fate of Place*, 201.

10 Ibid.

11 Ibid., xii.

12 As Casey, *Fate of Place*, 183, points out, Michel Foucault's critique of institutionalized surveillance in *Discipline and Punish* was founded on an analysis of site, in the sense of both an architectural plan and the disciplinary regime that it enables and maintains.

13 The term *site specificity* came into currency into the 1970s through artists such as Robert Irwin, Lloyd Hamral, and Athena Tacha, as well as critics such as Lucy Lippard. Unlike so-called pop art, to which it is practically and conceptually opposed, site-specific work attempts to integrate public sculpture and location into the culture and texture of the surrounding area through an environmentally oriented approach. Whether site specificity actually achieves its utopian goals of integration and preservation is debatable.

14 As has been often described, John Ford used the dramatic natural formations of Monument Valley, situated on the border of southern Utah and northern Arizona in the Navajo territory, as the backdrop for the defeat of various, mythical tribes by American settlers in various contested territories in the United States. Monument Valley is visible in John Ford westerns such as *Stagecoach* (1939), *My Darling Clementine* (1946), *Fort Apache* (1948), *She Wore a Yellow Ribbon* (1949), *The Searchers* (1956), and *How the West Was Won* (1962).

15 After Hopper's first marriage to heiress–actress Brooke Hayward (daughter of producer Leland Hayward and actress Margaret Sullavan), dissolved in 1969, he married Michelle Phillips, singer from the Mamas and the Papas. The marriage lasted scarcely a week.

16 David James, *Allegories of Cinema: American Film in the Sixties* (Princeton, N.J.: Princeton University Press, 1989), 302.

17 The death of the stuntman was later used to advertise the film, a decision that Fuller apparently found offensive. After having constant clashes with the producer, Fuller was denied final cut. He considered the edited version of the film so butchered that he tried and failed to remove his name from the production.

18 This moniker is shared—albeit in translation—by Georges Bataille's *Le Mort* (1967) and Jim Jarmusch's *Dead Man* (1995).

19 James, *Allegories of Cinema*, 301.

20 Casey, *Fate of Place*, xiii.

21 Dennis Hopper, quoted in Biskind, *Easy Riders, Raging Bulls*, 124.

22 See Fatimah Tobing Rony's essay "Taxidermy and Romantic Ethnography: Robert Flaherty's Nanook of the North," in *The Third Eye: Race, Cinema, and Ethnographic Spectacle*, 99–128 (Durham, N.C.: Duke University Press, 1996), for an extended discussion of the taxidermic fetishization of non-Western cultures.

23 To cite one of many possible examples, the celebrated film *Black Orpheus* (1958),

shot on location in Brazil by French director Marcel Camus, romanticized the poverty of the favelas, exploited and distorted local customs, and redesigned the local geography to create a fantastic, idealized landscape for the pleasure of foreign eyes. Winner of both the Palme D'Or at Cannes and the Best Foreign Film Oscar in 1959, *Black Orpheus* continues to be mistaken by Western critics for a Brazilian production. As Bob Stam notes in *Tropical Multiculturalism: A Comparative History of Race in Brazilian Cinema and Culture* (Durham, N.C.: Duke University Press, 1997), 166, "for many non-Brazilians, the phrase 'Brazilian Cinema' instantly elicits the memory of what was in fact a French film," thus obscuring Brazil's own extraordinarily complex and diverse national cinema as well as the culture that produced it.

24 Tony Crawley, "The Ego Trip That Became 'The Last Movie,'" *Films Illustrated*, March 1978, 253–56.

25 As Elena Rodriguez describes in her biography *Dennis Hopper: A Madness to His Method* (New York: St. Martin's, 1988), Hopper had been harassed on the march from Selma to Montgomery, where he and others who looked like him were spat on and called "long-haired, nigger-loving" Communists (51). This was also his experience during the making of *Easy Rider*, in which he and costar Peter Fonda were verbally taunted for being "Commies," "queers," and insufficiently masculine (60).

26 Or so Hopper claims in a quotation included in Rodriguez, *Dennis Hopper*: "They thought that we'd show too much reality about their poverty" (70). Though this claim flatters Hopper's own notion of himself at the time as a political activist, it is not necessarily supported by his stereotypical depiction of the "grotesquely obsequious Mexican" drug connection and the "fraternal pre–Cheech and Chong befuddlement of the pot scenes" in *Easy Rider*. Hoberman, *Dennis Hopper*, 15.

27 Dennis Hopper, quoted in Rodriguez, *Dennis Hopper*, 70–71.

28 Dennis Hopper, quoted in Alix Jeffry, "A Giant Ego Trip for Dennis Hopper?," *New York Times*, May 10, 1970, 14.

29 For a brief history of Peruvian cinema in English, see John King, "Andean Images: Bolivia, Ecuador, Peru," in *New Latin American Cinema*, vol. 2 of *Studies of National Cinemas*, ed. Michael T. Martin, 483–50 (Detroit, Mich.: Wayne State University Press, 1997); Jeffrey Middent, *Writing National Cinema: Film Journals and Film Culture in Peru* (Hanover, N.H.: Dartmouth University Press, 2009); and Zoila Mendoza, *Creating Our Own: Folklore, Performance, and Identity in Cuzco, Peru* (Durham, N.C.: Duke University Press, 2008).

30 *The Last Movie* also came immediately in the wake of Brazilian Cinema Novo, in which the 1920s Brazilian modernist notion of cannibalism as a gesture of political defiance was reevaluated and revitalized as a metaphor and methodology of cultural production. Significantly, 1971 was also the release year of Nelson Pereira dos Santos's film *How Tasty Was My Little Frenchman*, in which a French settler in the service of French Huguenots is captured by the cannibalist tribe of Tupinamba and sentenced to death.

31 Ernest Alfred Dench, "The Dangers of Employing Redskins as Movie Actors," in *Making the Movies* (New York: Macmillan, 1915), 92.

32 Ibid., 93.

33 Pauline Kael, "The Current Cinema: Movies in Movies," *New Yorker,* October 9, 1971, 145–57.

34 Mikita Brottman, "The Last Movie," in *Dennis Hopper: Movie Top Ten,* ed. Jack Hunter (London: Creation Books International, 1999), 56.

35 Rodriguez, *Dennis Hopper,* 69.

36 Dennis Hopper, quoted in Jeffrey, "Giant Ego Trip," 14.

37 Brad Darrach, "The Easy Rider in the Andes Runs Wild," *Life,* June 19, 1970, 54.

38 Ibid.

39 Rodriguez, *Dennis Hopper,* 70.

40 Jeffrey, "Giant Ego Trip," 14.

41 Lewis, quoted in ibid.

42 Cecil Beaton and Hugh Vickers, *The Unexpurgated Beaton: The Cecil Beaton Diaries* (London: Orion, 2003), 49.

43 Biskind, *Easy Riders, Raging Bulls,* 123.

44 Quoted in Rodriguez, *Dennis Hopper,* 70.

45 King, "Andean Images," 495.

46 Quote is from Walter Benjamin's seminal essay "The Work of Art in the Age of Mechanical Reproduction," in *Illuminations,* ed. Hannah Arendt, trans. Harry Zohn (New York: Schocken, 1968), 236.

47 King, "Andean Images," 496.

48 Ibid.

49 Ibid., 497.

50 Herzog later returned to film *Fitzcarraldo* (1982) in Peru.

51 Biskind, *Easy Riders, Raging Bulls,* 136.

52 Quoted in ibid., 135.

53 See http://globalvoicesonline.org/2008/06/13/45377/ for a good assortment of these comments. Spanish-language readers are also encouraged to look at http://www.cinencuentro.com/2008/05/29/indiana-jones-y-el-reino-de-las-mentiras-del-peru/, which translates into "Indiana Jones and the King of Lies about Peru."

54 Perhaps the most eloquent criticism was from Ronald Vega, a Peruvian national living in Bolivia, who runs the blog Voz Urgente: "Someone could say films are fiction, and as such, are under no obligation to be strictly linked to the history of the stories they tell. But, that doesn't lessen the interesting fact that these discussions are carried out in certain parts of the world, where they construct a clearly intentional image about persons in certain 'other' parts of the world. But beyond these clear disconnects presented in the film, there is a background issue. The de-legitimization of the historic and ancestral knowledge produced in this part of the world. . . . But, the Andean-Amazonian man, belonging to those American cultures who due to the lack of writing (which he did have, but incomprehensible to the minds of the colonizer), and in the case of the Quechua & Aymara peoples were condemned to historic postponement. Those men were not considered capable of creating, of constructing their own culture, their own knowledge. That is why in the film and in many other texts produced by the

West, the construction of all that knowledge is related with beings from other worlds, extraterrestrials, that way denying the recognition of the wisdom of the American cultures, the same ones that were destroyed during the colonization process." See translated excerpts from Vega's blog "From Indiana Jones and the King of Lies about Peru" on Global Voices. See also Juan Arellano in "Peru: Pointing Out Errors in the New Indiana Jones Movie," http://globalvoicesonline. org/2008/06/13/45377/.

PART III | Geopolitical Displacements

9 | The Nonplace of Argento: *The Bird with the Crystal Plumage* and Roman Urban History

MICHAEL SIEGEL

FACES IN THE WINDOW

Early in his debut film *L'uccello dalle piume di cristallo* (*The Bird with the Crystal Plumage*; 1970), Dario Argento presents the following scene: Sam Dalmas (Tony Musante), an American writer living in Rome, while out for an uneventful night-time walk on an empty street in the modern Flaminio district, witnesses a struggle between a man and a woman through the double glass doors of a brightly lit contemporary art gallery. Sam's concern builds, and as soon as he sees a knife, he begins to walk across the street, heroically, if mindlessly, drawn toward the luminous space. After a passing car brushes him and knocks him over in his rapt distraction, Sam continues toward the box of light, eventually rushing through the front door into the glass bubble that forms the gallery's vestibule. Once there, he finds the inner door locked. A low-angle reverse shot from inside the gallery that almost perfectly aligns the camera's frame with the iron frame surrounding the huge panes of sliding plate glass then reveals that Sam is trapped—vertically and horizontally by the double framing of the vestibule and camera and in depth by two large glass walls. Suddenly, the front door through which Sam had entered slides closed, and his imprisonment is complete: he is enclosed in the diffuse light-space of the vestibule, able neither to enter the gallery to stop the crime nor to flee the scene, and thereby forced to observe a horrific murder unfold from a transparent jail cell. As he gestures wildly in fear, terror, and sympathy for the suffering victim, as he silently screams for the attention of passersby and pleads for the writhing, bleeding woman to persist, Argento forces us to watch Sam watch the terrifying scene unfold through multiple layers of crystal-clear glass.

The most striking visual element of this scene is without question the double, transparent walls of glass that trap Sam in the gallery's entryway (Figure 9.1).

Argento goes to great lengths to foreground them and to exploit the wide spectrum of possibilities inherent in the architectural material of glass here. This scene emphasizes the transparency of glass, its subtle reflectivity, and its visual property of collapsing multiple planes of depth onto one surface. At the same time, however, Argento's camera also highlights the materiality of glass, that is, its ability to demarcate and segment space by obstructing the passage of sound and bodies. The gallery sequence calls attention to the ways in which glass as a building material paradoxically allows for both the distinct, physical separation and the blurred, optical interpenetration of space. In this scene, glass delineates the spaces of the street, the vestibule, and the gallery interior as architectonically separate, as an opaque wall would. At the same time, however, it links these spaces visually. In doing so, it produces a transparent cell that immobilizes Sam as an observed, observing subject.

In one of the few book-length studies of Argento available in English, Maitland McDonagh analyzes the gallery scene in *The Bird with the Crystal Plumage* as one of Argento's many self-reflexive references to cinematic spectatorship:

> Like the movie viewer who sits in a darkened theatre and watches glowing two-dimensional images flicker before his eyes, Sam Dalmas walks along a nighttime street, enveloped in his own cloak of darkness. His attention is engaged first by the light, the light emanating from the art gallery whose glass-paned façade allows it to spill onto the street. Through the glass, framed by the metal strips that define the doors, Dalmas can see figures, flattened and remote. This moving image is tantalizingly incomplete; Dalmas crosses the street to get a better look. It seems that he is about to lose his status as surrogate voyeur . . . that he is about to become part of whatever event is taking place within. But that's not what happens. Dalmas passes through the first set of glass doors and is trapped: he has been made doubly a spectator. The inner doors keep him separated from the woman bleeding within the gallery while the outer doors set him apart from the action on the street, the action of which he was a part only seconds before.[1]

This reading of Sam as a stand-in for the cinematic spectator is validated by similar references to looking and spectacle througout Argento's career. As McDonagh is careful to point out, however, the comparison between Sam and the cinematic spectator—especially, it is implied, the immobilized, fixed, disembodied, voyeuristic, and "all-seeing" one posited by apparatus theory—can only be taken so far.[2] The version of spectatorship that this scene articulates is rendered more complex by

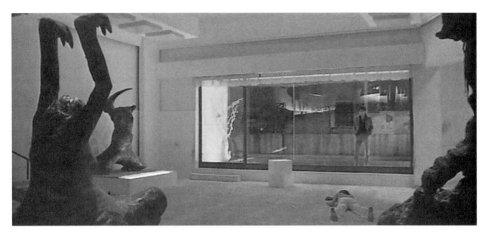

Figure 9.1. Helpless, immobilized, and trapped, Sam Dalmas is forced to watch a violent crime unfold from inside the glass vestibule of a modern art gallery.

two factors. First, even if he is trapped within a relatively circumscribed space and is unable to interact with the spectacle of Monica's suffering, Sam is anything but disembodied here. On the contrary, his body—his wild gesticulations and nervous shuffling—forms a spectacle in its own right. Second, that Sam's act of looking is itself spectacularized means that the terms of vision are not unidirectional. Sam is not the "pure, all-seeing, and invisible subject" of apparatus theory;[3] on the contrary, every bit as much as Sam is the observer here, he is also the observed—first by Monica, later by the passerby, eventually by Inspector Morrosini, and always by the camera and the spectator. Clearly Sam is caught up in a different scopic regime than that of the keyhole.

The scopic regime in which Sam finds himself is, rather, that of the modern, bureaucratic–corporate metropolis, that theorized by the Frankfurt School, Henri Lefebvre, Fredric Jameson, and Paul Virilio, among many others. But this film is not about metropolitan specularity per se; rather it is rooted in the specificities of one particular city at one particular moment, namely, the Rome of late capitalism. There is no doubt that *The Bird with the Crystal Plumage*, like many other Argento films, persistently foregrounds space, architecture, and location, sometimes at the expense of classic cinematic spatiotemporal organizational devices like narrative causality, diegetic integrity, and character. What must be accounted for, however, is the great extent to which the film engages, both spatially and narratively, with the particularly *Roman* social and architectural context that forms its diegesis.

The figure of Sam is not, therefore, a stand-in for a transhistorical spectating subject; rather his various modalities of looking—ranging from the curious to the investigative to the self-protective—motivate an urban exploration of Rome that is

quite historically concrete. *The Bird with the Crystal Plumage* uses the structure of detective fiction (with the foreigner Sam as a literal witness) to conduct a thorough interrogation not of any individual suspect (fittingly, the identity of the killer turns out to be almost irrelevant in the end) but rather of the city itself.

This is revealed, on one hand, in the film's cataloging of elements of Rome's urban space via location shooting. For example, there is a clear emphasis placed on the city's doors, windows, and thresholds and the borders between spaces throughout the film. Such elements are frequently used as two-dimensional, geometric framing devices that call attention to the flat, compositional qualities of the image. Argento, for example, employs the same technique for nearly all of *The Bird with the Crystal Plumage*'s establishing shots—a simultaneous tilt-up and zoom-in from a camera positioned at street level to a second- or third-floor window (beyond which the subsequent scene ostensibly takes place). If the traditional role of an establishing shot is to help make diegetic space legible by, on one hand, rooting a scene to a particular place within a film's imaginary geography and, on the other, laying out the spatial dynamics of a larger space in preparation for the use of closer shots in analytical editing, then these establishing shots fail doubly. First, because of the employment of obvious visual rhymes and repetitions, these shots take on an autoreferential quality that disrupts their function as simple markers of place. Second, they do not provide an anchor for the film's geography. Rather, restricted as they are to representing minor, tangential features of the banal, modern Roman apartment buildings that serve as the locations of scenes that happen in interior spaces, they begin instead to call attention to certain repeated features in the actual built environment of the city. More than simply allowing diegetic space to take hold by indicating the parameters and properties of the film's narrative space, these shots take on the function of calling attention to various types of architectural thresholds (especially doors and windows) in modern Rome. Spatial orientation, in other words, is evacuated from these establishing shots in favor of an analysis of urban and architectural phenomena.

In addition, given the modern urban planning history of Rome, *The Bird with the Crystal Plumage*'s location choices are highly complex and problematic. Among these are the late-nineteenth and early-twentieth-century gridded neighborhoods of Flaminio and Salario, the fascist-era EUR district (Esposizione Universale di Roma) and Via Leonida Bissolati (formerly Via XXIII Marzo), and the newly constructed Fiumicino Airport. Each of these locations represents and embodies an attempt on the part of the city and/or national government to control or direct the course of Rome's immense and disorderly twentieth-century growth in one way or another. In both its elaboration of its own narrative space and its location choices,

The Bird with the Crystal Plumage represents a highly symptomatic attempt—that is, one filled with unresolved assertions and tensions rather than a single, clearly articulated argument—to grapple with Rome's complex modern urban history.

ARGENTO'S THIRD ROME

Roman urban historians commonly distinguish three phases in the city's planning history, all of which coexist and overlap in today's city: the First, the Second, and the Third Romes. The concepts of the First and Second Romes refer to the ancient and papal cities, respectively. The Third Rome is the modern capital city ushered in by the process of Italian unification (known as Risorgimento).[4] The period of the Third Rome (1870 through the present) has witnessed the most intense social, political, cultural, economic, and spatial upheaval in the shortest amount of time, mainly because of the unification government's decision to build the Third Rome inside the old city's walls instead of constructing a new, modern city outside the old city's walls. As Spiro Kostof has put it, for Rome, the unification and the decision to construct the modern city within the boundaries of old

> meant the rude awakening of a picturesque, backward, but immensely prestigious town of some 230,000 people, through the influx of a massive government apparatus, a new middle class of bureaucrats, bankers, and speculators; and working class people drawn to the capital of the young Kingdom by the promise of special opportunity. It meant housing facilities for tens of thousands, accommodation for government offices, new roads, and public services. It meant, beyond all this, the fashioning of a national image—the iconography of unity.[5]

Rome was meant to become the physical manifestation of the superior ideals of the new liberal democracy over the old clerical aristocracy. The result was an historic center peppered with monumental civic buildings, crisscrossed by large avenues, and surrounded by new, gridded residential districts. Not surprisingly given the new nation's lack of financial, material, and technological resources, urban reform was piecemeal, incomplete, and poorly regulated. This massive project of building the Third Rome could therefore only take place, as Robert C. Fried has noted, "through ad hoc conventions between the city and private developers and through ad hoc measures of public improvement, without benefit of, or hindrance from, an overall design."[6]

Urban historian Mario Sanfilippo has argued that one can distinguish separate periods within the planning history of the Third Rome.[7] The first, lasting from 1870

until 1945, was the most "centralized, bureaucratic" period of planning. Four of the five locations chosen for *The Bird with the Crystal Plumage*—Flaminio, Salario, EUR, and Via Bissolati—were the results of this early, highly disruptive moment in the planning of the Third Rome. This was a period of relatively controlled, if alarmingly massive, expansion that saw the city's population increase from roughly 230,000 in 1870 to 1.6 million in 1944.[8] Among the stated goals of this extremely controversial period of planning was to fill any urban voids left within the city center by centuries of chaotic, organic growth; to urbanize the rural areas within the walls; and to quickly build new neighborhoods immediately outside the walls and deeper into the periphery to accommodate the influx of new residents and manage the future growth of the city. This moment therefore saw the construction of new axial boulevards, the widening of existing streets into thoroughfares, the erection of dozens of new governmental buildings and excessively ornamental monuments, and the development of highly organized pockets of predominately residential urban space on the edges of the historic center. Because the material imperatives were hastiness and convenience and the ideological imperatives were rationality and equality (political—and spatial—ideals meant to contradict centuries of Catholic domination), the city's planners opted to import the grid model provided by the *piemontese* city of Turin, the birthplace of the Risorgimento movement and Italy's first capital. The effects on the city were palpable and sudden. As Insolera has put it, "the city being born at this time seemed to want to be *piemontese* and Haussmannian," with its new clusters of grids and axial boulevards directly opposed to the "dark and unhygienic alleys of old Rome."[9] The use of the grid as a structuring pattern of streets and buildings was meant not only to sanitize Rome's past but also to dictate its future by preventing sprawl and rampant speculation. Ironically, however, because of a free-market ideology and poor enforcement of building codes, these were to become the very defining features of the landscape of twentieth-century Rome.

The overall effect of this period was therefore a slowly unfolding and ever incomplete attempt to rationalize Roman urban space. The purest expression of this was the fascist regime's Master Plan of 1931, a blatant attempt to institute in the traditionally opaque urban environment of historic Rome what Anthony Vidler has referred to as "modernist transparency."[10] In typically bombastic language, during the ceremony introducing the Master Plan, Mussolini himself extolled the virtues of wide, Haussmannian boulevards:

> You will cut the streets of Rome out from the foolish contamination [of medieval and Renaissance Rome], but you will also give the most modern

means of circulation to the new towns that will spring up in a ring around the ancient city. You will construct an axis that will be the widest in the world and that will bring the fury of the sea all the way from a resurrected Ostia directly to the heart of the city where it will master [*veglia*] the unknown.[11]

In addition to attempting to achieve Mussolini's goal of *grandezza*, or "grandeur," and neoclassicist aesthetic cleanliness ("in 5 years, Rome must appear vast, ordered, and powerful like it was in the time of the first empire," "you will continue to liberate the trunk of the great oak of the Eternal City from all that encumbers it,"[12] etc.), one of the important concepts behind the Master Plan of 1931 was the attempted codification and resectioning of Rome's urban space. The plan's intent to "regulate [*disciplinare*] the future growth of the city" found its graphic representation in its map's neat and color-coded classifications of neighborhood use, building typology, demography, and class. In practice, however, the massive demolitions called for by the Master Plan created a series of "voids" and "urban deserts" in the historic center.[13]

Sanfilippo's second phase (1945–70) encompasses the years of postwar reconstruction funded largely by American Marshall Plan money, the subsequent economic miracle, and the beginnings of the turbulent Sessantotto (Italy's decade-long, extended version of France's May 68). This period saw the rapid increase of *edilizia abusiva*, the illegal building outside the city walls and immediate periphery, and beyond the control of the still effective Master Plan of 1931, that produced, among other atrocities, the infamous *borgate*. During this period, residents began to spread rapidly into the newly constructed periphery, and the basis of central Rome's economy transformed from artisanal production and familial exchange into more anonymous service-sector activities (especially those involving tourism and foreign investment). During this period, the EUR district, the location of the dramatic first shots of *The Bird with the Crystal Plumage*, was transformed from a fascist showpiece cum veritable ghost town into a trendy residential district and center of international finance capital, where new apartment buildings, banks, shopping centers, and corporate headquarters sprang up with shocking suddenness.

The 1950s and 1960s would mark the end of a century of hegemony in Roman planning of gridded residential pockets, axial boulevards, and demographic segmentation as means of geographic "discipline" and its replacement with a new spatiality of dispersal, transport, and individual motorization.[14] The concept of "bureaucratic, consolidated" city space that had itself been so ambivalently received at its advent precisely because of the ways in which it displaced the Renaissance and medieval spatiality that had defined Rome for centuries before Risorgimento

was, by the 1960s, being eclipsed in turn by an increasingly abstract, centrifugal concept of city space, one that conceived of the city as a mobile, concentric network rather than a series of discrete parts. As Insolera has observed,

> In the twenty years between 1951 and 1971 . . . almost four-fifths of the historic center's previous residents moved into the city's periphery. After 1970, this same phenomenon extended to the circular "oil stain" of neighborhoods beyond the city walls: just as these neighborhoods were formed between 1870 and 1960 to house the population of the growing city, now they were being transformed into offices whose patterns of dispersal formed yet another "oil stain."[15]

Many post-Risorgimento residential neighborhoods whose grids and demographic organization by class were thought of only a generation earlier as destroying the organic social and urban fabric of old Rome, in other words, were themselves slated for major changes, many transforming from predominantly residential zones into commercial or finance districts. Some, like Flaminio and Salario, were to become conduits of automobile transit and trucking leading into the city center from the new belt of freeways around Rome (the Gra, or Grande Raccordo Annulare, begun in 1951 and completed in 1970). In Sanfilippo's third phase (1971 through the present, a period beyond the scope of this chapter), the city would fragment and disperse even further.

The story of the Third Rome is, in other words, one of unchecked sprawl and dissolution, countered at various points by improvisatory measures to contain and discipline this growth through typically modernist urban structures such as axial boulevards and street grids. The organic unity of the ancient and papal center was replaced by a loosely functional, hierarchical city, forced to cater to the needs of a flailing monarchic republic and then to those of an imperfect totalitarianism. This city was in turn replaced by a polycentric urban agglomeration that developed at the whim of a fickle and highly exploitative free market. The story of the Third Rome is also, therefore, one of decentralization and deregulation at the level of governmental control over the expansion of the city. The unlawful and dangerous mode of *edilizia abusiva*, the result of countless decisions to yield to the free market, became increasingly dominant with time. If, by 1870, Rome was already arguably Europe's most historically and urbanistically complex capital city, by 1970, it had become an indecipherable urban palimpsest—an ever more diffuse, centrifugal city overlying a poorly organized, bureaucratic city; resting on a medieval, Renaissance, and baroque holy city; covering, in turn, an ancient, imperial city.

ROME, (IL)LEGIBLE CITY

This complex history and its sociospatial implications haunt every one of Argento's Roman films. In its narrative, mise-en-scène, and location choices, his debut, *The Bird with the Crystal Plumage,* represents an attempt to grapple with this intricate urban history. In particular, the film confronts the highly complex and ever-changing relationship between the urban space of Rome and governmental and institutional authority. For at the same time that Rome's urban fabric expanded into ever new, unregulatable, and unrepresentable forms, just as rapidly and haphazardly, the Italian state was developing new modes of social control. In addition to being a period of intensive urban expansion, the 1960s and 1970s were also a time of extreme political activism and violence in Italian society from both left- and right-wing terrorist groups.[16] The most dramatic response on the part of the government was the advent of several new *leggi speciali* passed in a state of emergency that vastly expanded state authority, allowing for the application of both brute force and surveillance to its citizens in ways unseen since fascism.[17]

This moment also saw the restructuring of the Italian secret service, originally founded by Mussolini. In 1965, Mussolini's infamous Servizio Informazioni Militare, which had been effectively dormant since the fall of the regime, was resurrected, renamed the Serivizio Informazioni Difesa (SID), and charged once again with preventative surveillance and police intervention on the home front. Not only did SID—having never been purged, only renamed—therefore represent the continued, institutional presence of fascism in Italian society but it would also become a central part of the disturbing collusion of this period between governmental institutions and neofascist groups. Beginning with the December 12, 1969, bombing of Milan's Banca Nazionale dell'Agricoltura that killed sixteen people, a series of terrorist acts committed by right-wing groups was falsely attributed to leftist anarchists by high-ranking members of the carabinieri, SID, and the Ministry of the Interior. These government officials were later proven to have close ties to neofascism. The idea behind this *strategia della tensione* was simple: a widespread desire for a new authoritarian, neofascist dictatorship would naturally emerge from the fear and panic created by supposedly leftist terrorism. Although the emergence of this new government never took place, the *strategia della tensione* did effectively urge the Italian state toward the Right. The neofascist Movimento Sociale Italiano–Destra Nazionale, for example, saw great gains in the 1972 parliamentary elections, doubling right-wing percentages. It was this right-heavy parliament that was responsible, beginning in November 1974, for passing the *leggi speciali* that so significantly increased the presence of state power in everyday life.

Although many of these legal changes took place later, Argento—who had strong leftist ties going back even beyond his *Paese sera* days—had already begun to examine the changing nature of power in Italian society in his 1970's *The Bird with the Crystal Plumage*. The plot of the film is quite simple by Argento's normally convoluted standards. Sam Dalmas, an American writer living in Rome with his girlfriend, Julia, witnesses an attempted murder at an art gallery. It turns out to be the most recent in a string of attacks on young women, of which this particular victim, Monica Ranieri, the wife of the gallery's owner, Alberto, is the first survivor. With his passport confiscated by the police, Sam decides to investigate the attacks on his own. Throughout the course of his search, Sam and Julia receive threatening calls from the killer. The sound of a rare bird in the background of one of the calls leads to the zoo, directly across the street from the Ranieri's apartment. When Sam and the police corner Alberto, he falls from a window and, with his dying words, confesses to the crimes. Unconvinced, feeling lingering doubts about his memory of the event, and worried by the sudden disappearance of Julia and his friend Carlo, Sam continues to investigate. He learns that the killer is Monica, who experienced a psychotic episode after seeing a painting of a rape. Once Sam discovers that she has murdered Carlo and kidnapped Julia as well, his memory of the attack is restored, including the detail that the knife was in Monica's hands, not in the hands of the man with whom she was struggling (who, it turns out, was Alberto). Sam is rescued by the police just seconds before Monica kills him, and he and Julia return to the United States.

Using this relatively simple story line, *The Bird with the Crystal Plumage* not only examines the new roles of institutional authority and state power in Italian society but figures this problematic as a question of space by producing a dystopic fantasy of a highly structured and surveilled Rome. This can be seen both in the film's location choices and in its mise-en-scène. Argento, for example, chose to shoot in locations closely associated with specific regimes (the grids of the modernist–monarchic Flaminio and Salario, the fascist-era axial intervention of Via Bissolati, and the monumentality cum late capitalist business and leisure area of EUR). The film activates the traces of historical power entombed within these locations by staging in them a murder mystery narrative that hinges on new policing technologies of archiving and profiling. As for the film's mise-en-scène, it crystallizes many of these issues in the trope of glass, the only material that segments and separates individual spaces from one another, binds these separate spaces optically, and, as in the gallery sequence, places subjects and their immobilized bodies on display. Despite touching on these many different parts of Rome, the film constructs a carceral and panoptic cinematic city for the most part—a painstakingly delineated,

rationalized, legibile Rome, completely transparent to the gaze of power, in which new structures of control have become dominant even at the level of space.

According to Edward Dimendberg, for a film to construct a panoptic cinematic city, it would have to include "an emphasis upon ordering the city and endowing it with a visual unity."[18] Dimendberg points, for example, to the "synoptic visual images of skylines, panoramas, and aerial views" in American film noir that "exemplify the spatial concentration and enclosure of the 'disciplinary societies.'"[19] The urban-scale establishing shots that Dimendberg considers requisite for a panoptic critique of city space are almost completely absent from this film (and from Argento's work as a whole). Argento's ordering of the city operates at a more embedded, microscopic level. *The Bird with the Crystal Plumage* examines the individual's (in this case, mostly Sam's) experience of Rome at two levels, which, together, are able to suggest a visual unity for the city despite the absence of any synoptic representation. The first level is architectonic—that of individual spaces and their particular variations of the segmentation–transparency dialectic that is so explicitly foregrounded in the gallery sequence. The second level, which comes into focus in the film's location choices, is urban—that of the neighborhood and street as units of planned city space, developed by distinct regimes to produce specific, disciplinary effects on the sprawling built environment of modern Rome. The locations of this film are, not coincidentally, those neighborhoods most closely associated with surveillance and order either through the presence of a rationalist, gridded street layout or through a historical association with a specific regime (monarchic, fascist, or international capitalistic). Via these two levels, the Rome of *The Bird with the Crystal Plumage* appears as a citywide, serial form of enclosed, transparent spatiality—something like a repetitive agglomeration of clear cells.

For the location of both Sam and Julia's home and the art gallery, Argento chose the *quartiere* Flaminio. Built in the 1910s and 1920s, the Flaminio is one of the city's quintessential gridded, *piemontese* neighborhoods. Because of the topographical position of the Flaminio—it is hemmed in by the hills of the Parioli and the Villa Borghese to the east and northeast, the curving Tiber to the west and northwest, and the Porta del Popolo and historic center to the south—few, if any, concrete changes were made to its gridded streets during postwar planning. The grid and its scheme of visibility (organized vistas, uniform buildings, etc.) represented in the film by Flaminio were to become the dominant features of Rome's urban landscape by the end of World War II. However, when the Flaminio was constructed in the 1910s, its pattern would still have been radically foreign and disruptive to the city's traditional fabric (that inside the walls in the historic center). Furthermore, if, by the end of World War II, neighborhoods like the Flaminio

would have defined a relatively new (and still controversial) norm for Rome, by the time of *The Bird with the Crystal Plumage* in 1970, this style of urbanism was already being eclipsed by the motorization, dispersal, and sprawl of the 1950s and 1960s. The Flaminio, therefore, is a chunk of urban *legibility* sandwiched between two radically different forms of urban *illegibility*—the ancient and organic within the walls and the postmodern and centrifugal further into the periphery. The glass box of the gallery sequence, in its presentation of visuality—that is, its relations of visibility, segmentation, and entrapment—is, in this sense, a remarkably apt figuration of the Flaminio as an urban–geographic site. The repetition of the glass box as a visual motif—in modern and postmodern buildings, in the ornithology museum where the eponymous bird is discovered, and in the overall emphasis on windows throughout the film—functions to disseminate this particular visuality throughout much of the mise-en-scène of the film and, by extension, its version of the city as a whole.

The one shot in this film that resembles anything like a synoptic overview of Roman space, far from endowing the city with a visual unity, actually functions to depict this complex dialectic of illegibility–opacity and legibility–transparency on an urban scale. After Alberto Ranieri's death, Sam begins his search for Carlo, Julia, and Monica at the top of a wide pedestrian stairwell in the northern part of the Flaminio. A panorama ensues of the entire district that begins as an extreme high-angle shot of Sam, then floats up and toward the south to reveal a sweeping view of the Tiber, the axial spine of Via Flaminia, and the parallel Lungotevere Flaminio as they head directly into the historic center (Figure 9.2). The uniformly spaced buildings of the foreground, all in a tightly organized chute between the Tiber and the western edge of the Villa Borghese, emphasize the geographic clarity of the modernist Flaminio, which is therefore made to contrast sharply with the disorderly array of churches and monuments in the shot's background just beyond the Porta del Popolo and in the city center. The synoptic shot sets up a binary between the organic and opaque inside the walls and the rationalist and transparent outside the walls.[20]

This shot reminds us that earlier, when Sam and Julia were chased by Alberto's hit man, the city center had indeed been represented as opaque. This chase scene begins in the tight alleys of the historic center, where Sam and Julia wisely run into a street where the hit man's car cannot fit. A foot chase begins when the hit man, now brandishing a silenced revolver and wearing a yellow jacket, emerges from the car. Argento emphasizes the heavy building materials of the historic center in the first part of this sequence. Sam hides Julia first in an arched, brick alleyway and then behind a metal door under the arch. He runs past fences and

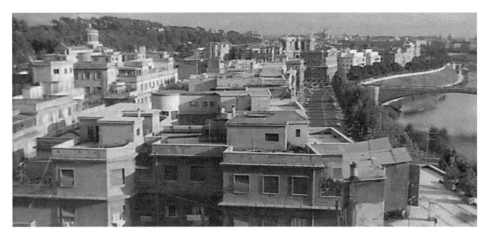

Figure 9.2. A synoptic overview taken from the northern part of the Flaminio looking south toward the *centro storico* that emphasizes Rome's unique urban dialectic of legibility and illegibility.

gates made of wood and corrugated metal and through a bus depot and climbs crumbling, concrete walls. Close-ups and Foley sound of both Sam's and the hit man's feet on cobblestones and gravel, and of the hit man's stray bullets on dense, solid brick, suggest just how materially different this place is from the Flaminio, where the emphasis is, as in the gallery sequence and panorama shot, squarely on transparency and legibility. Jump cuts and violations of the axis of action combine with the free jazz score and low key lighting to provide a further sense of confusion and spatial indecipherability to the scene.

As if to further emphasize the differences in visuality between the ancient city and modernist planning interventions, when Sam finally emerges onto a busy street to take safety in the urban crowd, he suddenly finds himself chasing the hit man on the modern Via Leonida Bissolati, a wide axis proposed by the Master Plan of 1931 as Via XXIII Marzo (to commemorate the anniversary of fascism) and originally intended to facilitate the circulation of automobile traffic around Piazza della Repubblica, Piazza Barberini, and the new, gridded streets of the Ludovisi neighborhood. Once demolitions were complete and the street was built, it was lined with massive brick and concrete office and apartment buildings, all of which, in typical 1930s fascist style, featured large first-floor windows. Via Bissolati's modernist buildings were, during the economic boom, converted into car dealerships, home appliance stores, and travel agencies. In addition to choosing such an historically loaded street, Argento also chooses a striking camera movement—a straight left-to-right track—for this sequence that once again highlights the jolting difference in visuality between opaque, premodern Rome, where the chase begins, and this modernist, transparent street. The camera's track articulates the shape,

rare for Rome and practically nonexistent before Risorgimento, of the fascist-era street—that is, a completely continuous straight line. Its very trajectory is made possible, in other words, only by a certain strand of Risorgimento and fascist thinking on Roman urban modernity; its path is a cinematic–spatial elaboration of urban clarity and legibility.

THERE IS NO "THERE" THERE: POSTMODERNITY AND THE NONIMAGE OF ROME

In a film that is so much about what is seen and not seen, it is equally important to note what the synoptic shot of the Flaminio does not show. For behind the camera, in the northern parts of the Flaminio and across the Tiber, a brand-new city had recently emerged around the new athletic and housing facilities and public infrastructure hastily built in preparation for the 1960 Summer Olympics. This new city bore the marks, above all, of engineer–architect Pier Luigi Nervi. Nervi worked prodigiously in Flaminio between 1956 and 1960, most notably on the design of the Palazzetto dello Sport in northern Flaminio, on the renovation of the Stadio Flaminio, and on the construction of the huge Corso di Francia viaduct connecting Flaminio to the northern suburbs. Nervi's work left indelible marks throughout Rome that exemplify a form of architecture emerging at this time, much of which featured very alien materials to Rome's traditional landscape such as reinforced concrete and narrow-pane glass. The very placement of the camera in this overview shot, by, in effect, turning its back on and eliding this emergent Rome, therefore suggests yet another level of illegibility. Only this time, it is not the illegibility of the visible, as in the gallery sequence, or of the opaque, as in the ancient city center, but rather that of the invisible-because-as-yet-unrepresentable.

Immediately following the opening credits of *The Bird with the Crystal Plumage*, there is a rapid, right-to-left tracking shot of a young woman (who turns out to be the first victim, Sandra Roversi) briskly walking on Piazzale dell'Industria in EUR toward a bus stop, directly in front of an office building designed by Luigi Moretti and V. Balio Morpugo and built in 1965 (Figure 9.3).[21] The loosely brutalist building's serial repetition, featuring narrow slivers of plate glass sandwiched between huge concrete and steel beams, starkly contrasts with the limpidity of the art gallery's double glass entryway that appears in the very next scene. The incongruity of these two locations, along with the images of quotidian life on Piazzale dell'Industria, endows this building with an odd urban–historical temporality: it is made to appear at one and the same time, paradoxically, as an emblem of a radically new strand of postwar architecture but one that has already become so pervasive as to have established itself as the newly unnoticeable backdrop of everyday

Figure 9.3. Sandra Roversi, the film's first victim, walks in front of the new headquarters of Credito Italiano on Piazzale dell'Industria, exemplary of the radically new backdrop of everyday life in 1960s Rome.

Roman life.[22] Clearly we are not among the familiar landmarks, monuments, and tortuous romances of the picture-postcard First and Second Romes, nor are we in the tightly organized and transparent gridded neighborhoods of the modernist Third Rome; rather we are, without question, in another phase of Roman urban development, one in which anonymous buildings outfitted with generic signifiers of institutional and global economic and cultural authority dominate. We are in a Rome in which urban dwellers wander from nonsite to nonsite, a city that has yet to establish a self-image.

In this sense, while *The Bird with the Crystal Plumage* introduces a decidedly urban–cinematic critique of Rome (around transparency, opacity, and segmentation, and via both its settings and locations and its mise-en-scène), it also points to the emergent and as yet unrepresentable urban forms encroaching on the city throughout the 1960s. Fredric Jameson has famously drawn on urban theory (specifically the work of the planner Kevin Lynch) to argue that the socioeconomic relations of late capitalism are, like a poorly designed city, not directly mappable and representable and that such an incapacity is "as crippling to political experience as the analogous incapacity to map spatially is for urban experience."[23] The peripheral Rome chosen for the opening of *The Bird with the Crystal Plumage* is a perfect embodiment of such "an alienated city . . . a space in which people are unable to map (in their minds) either their own positions or the urban totality in which they find themselves."[24] To the extent, therefore, that these new buildings speak at all, they speak in the empty spatial language of the 1960s and 1970s Rome of motorization, dispersal, and centrifugality. They stand in not only for such markers of postmodernity as the highway, the airport, the suburban shopping

center, and the office park but also for what Edward Dimendberg has called, in the context of postwar American urban transformation, "the geographic ubiquity and impersonality of the large corporation and the more opaque social and economic relations developing in its wake."[25]

The film's final scene is as striking as its first, and together, I'd like to argue, these bookends suggest a form of illegibility that does not just attempt to figure Rome's urban space but also effects a metatheoretical engagement with geopolitical space and mass media more generally. For in these sequences, the film touches on the same form of illegibility that the overview shot of Flaminio does through elision—that is, it raises questions not just around urban morphology and history but around representation itself. The opening scene, as we have seen, situates these questions at the level of architecture and location. The closing scene, however, makes this critique at the more powerful, more immediate level of filmic discourse.

Once the case is finally closed, the police call on a psychiatrist, Professor Renaldi, to give what will turn out to be—in an obvious reference to *Psycho*—an entirely inadequate explanation of Monica's motives for the murders. Significantly, he does so in the form of a television address. While Renaldi's explanation continues as a voice-off, Argento closes his film with an almost incoherent series of jump cuts depicting jetliners of various companies taxiing on the runways at the newly constructed international airport at Fiumicino. In the midst of these jump cuts is a shot of Julia in the first-class cabin of an airplane and then, a few jump cuts later, Sam coming to meet her. With its protagonists finally reunited and en route to their home country, the film cuts to its final shot: a TWA jet taking off behind rolling credits, with the sound of Sam repeating one of his very first lines in the film: "I can hear him saying it now: Go to Italy. It's a peaceful country. Nothing ever happens there."

That no single shot stays on the screen for more than a few frames gives the overall impression of a kind of dissolution of the filmic text.[26] In addition, the relation between the doctor's poor representation of the case, the sudden irruption into the film of the medium of television, Sam's repeated voice-over, and the images and sounds of 747s is never made clear. There is nothing in the film to motivate this scene's schizophrenic disarray of signifiers. It is as though the long-haul jetliners and the almost instantaneous capacity that they signify to connect the local to the global both economically and geographically exceed the spatiotemporal capacities of cinema.

But despite this assault on representation, it important to note that this moment, like so many others in the film, retains a powerfully historical subtext. At the time that Argento shot *The Bird with the Crystal Plumage*, the location of this sequence,

Rome's new international airport in the town of Fiumicino, was still quite new. Originally constructed to facilitate the influx of athletes, press, fans, and delegates for the Olympics, the Rome–Fiumicino International Airport opened to the public on January 15, 1961. Just as the Olympics themselves functioned as a kind of coming-out party for Italy into the sphere of global capitalism (and therefore as an affirmation of the ultimate success of reconstruction and the economic miracle), the addition of an international airport to the extended urban fabric of Rome represented not just a quantitatively new level of urban dispersal but a qualitatively new modality of space and time altogether—that of globalized simultaneity. The airport in which this film so confoundingly closes was, in other words, the very centerpiece of an emergent, post-Olympiad—indeed, postmodern—Rome.

Paul Virilio has argued that what defines a city precisely as contemporary in postmodernity is the diminished importance of physical boundaries—such as, for example, those so carefully elaborated throughout much of *The Bird with the Crystal Plumage*. Such boundaries have been eroded by the new experiences of time and space produced by ever-advancing technologies of transport and telecommunications:

> If the metropolis is still a place, a geographic site, it no longer has anything to do with the classical oppositions of city/country nor center/periphery. . . . While the suburbs contributed to this dissolution, in fact the intramural–extramural opposition collapsed with the transport revolutions and the development of communication and telecommunication technologies. . . . In effect, we are witnessing a paradoxical moment in which the opacity of building materials is reduced to zero. . . . Deprived of objective boundaries, the architectonic element begins to drift and float in an electronic ether, devoid of spatial dimensions, but inscribed in the singular temporality of an instantaneous diffusion.[27]

One can imagine, at this point, a rereading via Virilio's argument of both the dialectic of transparency, opacity, and segmentation staged throughout *The Bird with the Crystal Plumage* and the issues of representation raised by its opening and closing sequences. In such a reading, it is not just the limits—internal and external—of Rome but also those of urban representation itself that are glimpsed by the film. The means of representation for contemporary cities, this would suggest, can no longer be those of a modernity predicated on capturing the fleeting moment (such as photography) or the continuous unfolding of time (such as cinema); rather cities, synchronized, as they were becoming, at this historical moment into a globalized

economic system and shared time and space through means such as the airplane, imply new technologies of representation whose currency would need to be immediate dissemination and real time.

It is the combination of this new version of transparency—literally a fully mediatized model of immediacy—along with the opaque social and economic relations of late capitalism that Argento's film ultimately installs and traces in the Roman landscape. *The Bird with the Crystal Plumage* traverses various locations and modalities of space in its examination of the changing roles of institutional authority and state power in Italian society. It figures these as spatial questions by presenting a fantasy of a policed and urbanistically regulated Rome. It ends, however, with a series of images that point directly to their own limits and suggest that the cinema may be inadequate to the new global spatiotemporality and the new social relations implied by the jetliner, the quintessentially postmodern means of transit.

This film pries open—and leaves open—a series of questions about the future of the city in the face of the new spatialities, temporalities, and power structures of a postmodernity that was really beginning to take root in Rome at this time. But it also, in the end, hints at the emergence of new forms of media and therefore new forms of urban representation. Indeed, as Virilio suggests, there is one form of mass media that, precisely because of its innate displacements, may be adequate as a figuration of this new urban nonplace, namely, television, whose literal voice gives this closing scene its only, very tenuous semblance of unification. "The cathode-ray window," Virilio writes, "brings each viewer the light of another day and the presence of the antipodal place. If space is that which keeps everything from occupying the same place, this abrupt confinement brings absolutely everything precisely to that 'place,' that location that has no location."[28] Television—the medium par excellence of Virilio's "instantaneous diffusion"—and the jetliner descend on the film in its very final moments to disrupt any ability that *The Bird with the Crystal Plumage* had painstakingly attained to occupy the very complex place that is Rome. Not only Rome, therefore, but also urban cinema itself appears at the end of the film to be precisely a location that has no location.

NOTES

1 Maitland McDonagh, *Broken Mirrors/Broken Minds: The Dark Dreams of Dario Argento* (Minneapolis: University of Minnesota Press, 2010), 49–50.

2 *Apparatus theory* loosely refers to a current in 1970s film theory that deployed semiotics, structuralist Marxism, and Lacanian psychoanalysis to posit a form of cinematic spectatorial identification that was textual and technological in nature. Apparatus theory tended to argue that the very mechanics of cinematic representation were self-effacing and therefore ideological. The goal of classical cinema, in this theory, is interpellative: narrative films generally are to suppress the source of their cinematic enunciation and, in turn, force the viewer unconsciously to identify as this source. Apparatus theory further claims that classical films structure spectatorship around a unidirectional system of voyeuristic pleasure in which the viewing subject experiences a combination of disembodiment and psychic regression and an illusion of all-seeing, all-knowing transcendence. This model of spectatorship was subsequently discounted as too passive, too apt to attribute monolithic authority to the text itself, and unable to account for empirical acts of viewing by individuals of a variety of socially articulated subject positions. Founding texts include Christian Metz, *The Imaginary Signifier: Psychoanalysis and the Cinema*, trans. Celia Britton and Annwyl Williams (Bloomington: Indiana University Press, 1982); Jean-Louis Baudry, "Ideological Effects of the Basic Cinematographic Apparatus," in *Narrative, Apparatus, Ideology*, ed. Philip Rosen, 286–98 (New York: Columbia University Press, 1986); Baudry, "The Apparatus: Metapsychological Approaches to the Impression of Reality in Cinema," in Rosen, *Narrative, Apparatus, Ideology*, 299–318; and Laura Mulvey, "Visual Pleasure and Narrative Cinema," in Rosen, *Narrative, Apparatus, Ideology*, 198–209.

3 Metz, *Imaginary Signifier*, 97.

4 The historical information on Roman urban planning in this piece comes from a number of sources. The main ones are Antonio Cederna, *Mussolini Urbanista: Lo sventramento di Roma negli anni del consenso* (Rome: Laterza, 1980); Robert C. Fried, *Planning the Eternal City: Roman Politics and Planning since World War II* (New Haven, Conn.: Yale University Press, 1973); Italo Insolera, *Roma moderna: Un secolo di storia urbanistica* (Turin, Italy: Einaudi, 1962); Spiro Kostof, *The Third Rome, 1870–1950: Traffic and Glory* (Berkeley, Calif.: University Art Museum, 1973); Borden W. Painter Jr., *Mussolini's Rome: Rebuilding the Eternal City* (New York: Palgrave Macmillan, 2005); and Mario Sanfilippo, *La costruzione di una capitale: Roma, 1870–1911* (Milan, Italy: Amilcare Pizzi, 1992).

5 Kostof, *Third Rome*, 10.

6 Fried, *Planning the Eternal City*, 23.

7 Sanfilippo, *La costruzione di una capitale*, 10.

8 Fried, *Planning the Eternal City*, 21.

9 Ibid., 36.

10 Cf. Anthony Vidler, *The Architectural Uncanny: Essays in the Modern Unhomely* (Cambridge, Mass.: MIT Press, 1992), and Vidler, *Warped Space: Art, Architecture, and Anxiety in Modern Culture* (Cambridge, Mass.: MIT Press, 2000).

11 Governatorato di Roma, *Piano regolatore di Roma, 1931, Anno IX* (Milan, Italy: Treves, Trreccani, Tumminelli, 1931). I have translated the Italian word *veglia* here as "master" to call attention to the issue of power and domination in this phrase. *Veglia* is the root of the Italian word for "surveillance" *(sorveglianza)*.

12 Ibid.

13 Insolera, *Roma moderna*, 135–36.

14 Cf. the essays about the debates preceding the 1967 Master Plan in "Roma: verso le ultime fase del piano," *Urbanistica* 40 (March 1964): 11–92.

15 Insolera, *Roma moderna*, 319.

16 Historical information in this section is drawn from Paul Ginsborg, *A History of Contemporary Italy: Society and Politics, 1943–1988* (New York: Penguin Books, 1990).

17 These laws drastically limited civil liberties for Italians by lengthening precharge detention for suspects of terrorism to up to an astonishing eight years; extending the legality of the use of lethal force on the part of the police and immunity rights for those who did use it; and drastically reducing constitutional limits both on search and seizure and various forms of surveillance and eavesdropping, including over telephone lines, mail, and in public space. See Ginsborg, *A History of Contemporary Italy*.

18 Edward Dimendberg, *Film Noir and the Spaces of Modernity* (Cambridge, Mass.: Harvard University Press, 2004), 83.

19 Ibid.

20 Such a binary is, indeed, problematized by the fact that just south of the city walls from the Flaminio is the most organized section of the ancient city, that planned by the interventions of Pope Pius IV and structured around the Via del Corso, of which Via Flaminia is an extramural continuation. I thank John David Rhodes for this observation.

21 Today, the building houses the headquarters of the Credito Italiano bank.

22 It is similar to a number of concrete, steel, and glass architectural interventions constructed in Rome between the late 1950s and mid-1960s. They include buildings such as Adalberto Libera, Leo Calini, and Eugenio Montuori's 1958 office complex on Via Torino (the first building in Rome to use the curtain wall); the 1959 Sede Acea on Piazzale Ostiense, Carlo Chiarini's 1960 commercial and residential complex on Via Merulana, which featured enormous plate glass picture windows on each of its first two stories; Massimo Castellazzi, Tullio Dell'Anese, and Annibale Vitellozzi's Biblioteca Nazionale Centrale di Roma, begun in 1965 after significant public debate about the merits of its international-style design (and not completed until 1975); Gaetano Rapisardi's 1959 housing and commercial unit adjacent to the church of San Giovanni Bosco in the Centocelle district; and perhaps most famously, the Monte Mario Hilton, constructed in 1963. See Gaia

Remiddi, Antonella Greco, Antonella Bonvita, and Paola Ferri, eds., *Il Moderno attraverso Roma: 200 architetture scelte* (Rome: Croma Quaderni, 2000), 2, 113, 115, 130.

23 Fredric Jameson, *Postmodernism, or the Cultural Logic of Late Capitalism* (Durham, N.C.: Duke University Press, 1991), 416.

24 Ibid., 51.

25 Dimendberg, *Film Noir and the Spaces of Modernity*, 4.

26 There are thirty-one shots in just below two minutes of screen time. Removing the fifty-seven seconds of the final, credits shot, this makes for a rapid-fire pace of just less than one shot per second for about a minute.

27 Paul Virilio, *The Lost Dimension*, trans. Daniel Moshenberg (New York: Semiotext(e), 1991), 12.

28 Ibid., 17–18.

10 | The Placement of Shadows: What's Inside William Kentridge's *Black Box/Chambre Noire?*

FRANCES GUERIN

> Something about shadows makes us very conscious of the activity
> of seeing.
>
> —William Kentridge

In the relatively small, but critically substantial, work on William Kentridge's films, installations, theatrical sets, drawings, and sculptures, the emphasis has often been on questions of process, movement, ephemerality, and transformation. Critics have focused on Kentridge's signature transformations of darkness into light, charcoal-and-ink drawings into cinema, dreams and illusions into reality, and in all cases, vice versa. The ineffability of Kentridge's signature shadows—figures sketched in charcoal, pencil, pastels, ink, and any other medium that can be erased, diluted, or reworked—are typically understood to encapsulate the evasions and infinite transformation of history, politics, and memory.[1] Scholars such as Tom Gunning have also written on the deceptions and illusions of vision brought to the fore in Kentridge's preoccupation with technologies and techniques of visual reproduction such as the stereoscope, stop-motion photography, and the cinema.[2]

In this essay, I extend and complicate such conceptualizations of the signature ephemerality of Kentridge's work. Specifically, I argue that intransigence, concretion, and elements of permanence are always the sturdy foundation of much of his work. Many of Kentridge's films, drawings, and installations are motivated by a colonialism that he demonstrates to be deeply entrenched in the historical, cultural, and political landscapes that surround the work. Though Kentridge is committed to the representation of colonialism in South Africa, there is also a more universal discourse on colonialism that pervades his works. Here I analyze *Black Box/Chambre Noire* (2005), an installation commissioned by the Deutsche Guggenheim in Berlin, in this light.

Kentridge's work has appeared internationally for at least the last two decades,

and over this time, the form and media have remained constant. This work, such as *Felix in Exile* (1994), *Ubu Tells the Truth* (1996–97), and *The Deluge* (1990), has been acknowledged for its obvious address to contemporary South Africa. These films tell of economic recession, the Truth and Reconciliation Commission hearings, and other legacies of apartheid. As Dan Cameron notes, there is often an interrogation of the historical and cultural relationship between Europe and South Africa.[3] The works are usually exhibited internationally and therefore seen predominantly by non–South African viewers, viewers outside the purview of South African colonization.[4]

In contrast, *Black Box/Chambre Noire* reaches beyond the borders and shores of South Africa. Its engagement with German colonialism and the fabric of contemporary German history means that as Western, or non–South African, viewers we are no longer objective observers to the representation of colonialism. Rather, we become participants in the history of German colonization of southwest Africa in the late nineteenth century as told by *Black Box/Chambre Noire*. More profoundly, our involvement with the installation's complex discourses of twentieth-century colonialism, and its relevance to contemporary Germany's identity, is enabled by the placement of *Black Box/Chambre Noire* in the Deutsche Guggenheim, in the heart of reunited post-Wall Berlin. Thus I examine *Black Box/Chambre Noire* for the centrality of placement to its politics. Though the ephemeral might be the obvious constant in Kentridge's films, sculptures, and installations, such ephemerality is always in the service of its opposite. *Black Box/Chambre Noire* might be composed of fleeting, impermanent images, of images under erasure; however, its subject matter, the depiction of political injustice and personal violence in the name of historical vision, are not so ephemeral. They are consistently reinforced if we attend to the placement of the installation in the Deutsche Guggenheim, on Unter den Linden, Berlin, 2005.

Taking my cue from the historical as well as the geographical contexts of the installation's exhibition, within my analysis, *placement* casts more conventional notions of site specificity in a new light. In her genealogy of site-specific art, Miwon Kwon notes that the relationship between site and artwork has changed significantly since the 1960s' and 1970s' attachment to place, ground, or actual location.[5] Beginning in the late 1970s and into the 1980s, *site* came to be understood as the cultural framework for the institutions of art.[6] In the 1990s, *site* became "a *discursively* determined site that is delineated as a field of knowledge, intellectual exchange, or cultural debate."[7] Kwon notes that historically, the specifics of the relationships between site and art were the basis of their political and ideological vanguardism. Though Kwon is careful to note the consequences of transporting site-specific works—namely,

the loss of a critical edge—she also discusses different ways that site-specific works can be moved without losing their political and ideological impact. *Black Box/ Chambre Noire,* I would argue, offers one such unique negotiation between site and artwork, between site specificity and the transience of a transportable installation.

Black Box/Chambre Noire stands out as unique because its connection to place is neither literal nor solely discursive; rather, its connectedness to place—what I call its *placement*—is historically, culturally, geographically determined. This placement is particularly provocative to a viewer who is knowledgeable of the cultural and geographical history of the site of the work: the Deutsche Guggenheim in Berlin. Ultimately, as I go on to discuss, placement is defined by the visitor's experience of *Black Box/Chambre Noire.* That is to say, all of the components of the work's placement cohere in an experience of the installation as a memorial to a series of specific incidents of colonialism in Germany and southwest Africa, in the past and in the present. In Kentridge's miniature theater, with its accompanying drawings and sketches on the surrounding walls, ephemerality and ineffability are always in tension with the immutability of placement in his work. Moreover, the conflict between the two is vital to the communication of a violent colonialism, the memory of which might be under erasure, but is never wiped away.

The privilege I give to placement as the foundation of analysis can lead to a new level of historical awareness for the viewer of Kentridge's work. In Berlin, *Black Box/Chambre Noire* potentially triggers a process of taking responsibility for historical injustices as they are represented, a responsibility that begins with the viewer's presence at the installation and, through this presence, her implication in its story. One of Kentridge's primary concerns is to keep the continuing turmoil of South Africa's history and politics, and its international repercussions, in the public imagination.[8] He does this through making connections between Europe and South Africa, or between apartheid as the legacy of colonialism, derelict mining landscapes outside Johannesburg, and the city's mythical appearance as an Edenic paradise. I foreground another connection: that between Kentridge's installation and its placement as a driving force in a new viewer consciousness. Through the emphasis on exhibition at one specific site—the Deutsche Guggenheim, Berlin—we come to see that *Black Box/Chambre Noire* enables audiences to remember, and to witness various historical events. Thus the placement of the *Black Box/Chambre Noire* installation in Berlin in 2005 potentially leads viewers to an awareness of their unavoidable implication in the work's historical and political urgency. Viewers are bequeathed the responsibility of keeping the memory of genocide alive in the twentieth century.

Lastly, Kentridge's *Black Box/Chambre Noire* reflects on the way that the walls

of the museum, its place, its history, and its location, all weigh on the way we read exhibitions in general. Again, this characteristic of site-specific art results from a notion of the site as an institutional space—not only the museum and gallery space but also the discursive space of the art world. When artworks do not specifically draw attention to this aspect of production, we comfortably ignore the location and the role of the museum in its meaning.[9] And yet, as I demonstrate, the location can be critical to accepting responsibility for involvement in the disturbing and politically urgent events represented. Kentridge's work does not draw attention to or even lend itself to critical reflection on the museum as institution; rather the interrogation of this level of meaning is made possible by two facts: (1) *Black Box/Chambre Noire* was specifically commissioned by the Deutsche Guggenheim in Berlin and (2) the events represented in and by the piece can be interpreted to engage with the history of the city and culture outside the exhibition. Thus the installation offers a unique opportunity to consider how place infuses the meaning of a work, even when the work does not directly point to that place.

THE INSTALLATION

Through the insubstantial images of shadows on screens, animated figures, and sculptured bodies, *Black Box/Chambre Noire* tells the story of the German massacre of the Herero people at the beginning of the twentieth century (1904–7). Europe began its colonization of Africa in the late nineteenth century. The history of colonization represented in *Black Box/Chambre Noire* began in Berlin in 1884–85 with the Conference of Berlin. It was there that Europe cut up Africa, dividing it among the various European powers. In 1884, German traders moved in, and missionaries were drawn to southwest Africa by the promise of economic and agricultural prosperity.[10] However, to colonize the southwest, they needed support from imperial powers. Troops were sent in, and the ensuing battles resulted in the deaths of 70 percent of the two hundred thousand Herero population. Although the Herero people fought back in 1904—killing 150 German settlers—the occupying forces were too powerful for the locals. The massacre is now acknowledged as the first genocide of the twentieth century.[11] Herero survivors of the massacres were put in concentration camps, where they were worked to death as slave laborers or died from malnutrition.[12] And once dead, their skulls were sent back to Germany to be measured in an attempt to prove the supposed superiority of the Aryan skull, a practice that the Nazis would resuscitate less than forty years later. With the installation of *Black Box/Chambre Noire* in the Deutsche Guggenheim, Kentridge brings the rarely acknowledged, horrendous genocide to post-Wall, reunited Berlin, to a Germany that still has other genocides on its mind.[13]

Figure 10.1. Installation shot, William Kentridge, *Black Box/Chambre Noire*, at the Deutsche Guggenheim, 2005. Commissioned by the Deutsche Bank, in consultation with the Solomon R. Guggenheim Foundation for Deutsche Guggenheim. Copyright 2005, William Kentridge. Photograph by Mathias Schormann.

Black Box/Chambre Noire (Figure 10.1) was conceived as a maquette for a production of *The Magic Flute*. It is, at one and the same time, a miniature theater, a sculpture, a projection site, and an installation work that also includes a twenty-three-minute loop film. Seven mechanical figures act out a theatrical drama that tells of the Herero massacre: a megaphone man who carries a sign bearing the word *trauerarbeit*;[14] a paper Herero woman with a gauze headdress; a mechanical running man who is in fact a cutout piece of paper; an anthropomorphized device that measures skulls and maps; an exploding skull and a second Herero woman whose body is formed by a German postal scale from 1905; and the occasional appearance of a coffee pot. The visual narration that takes place through the synthesis of the on-stage "puppets" and projected drawings—which are constantly being erased and superimposed and which fade in and out—is accompanied by a score that weaves together traditional Namibian box music, Herero laments and praise songs, and fragments of a performance of Sarastro's aria from *The Magic Flute* (Figure 10.2). The evil Sarastro sings ironic and provocative words: "In these holy halls, there is no vengeance taken." The recording of *The Magic Flute* is taken from a performance in Berlin in 1937, and when we hear the rapturous applause of the audience, knowing the plan for vengeance and extermination that would

be hatched by those on their way to power in 1937 Germany, Sarastro's aria takes on a whole new layer of meaning.[15] Similarly, in its juxtaposition with the traditional African music, it complicates the realities of Germany as colonizer in the twentieth century.

Black Box/Chambre Noire was commissioned by the Solomon R. Guggenheim Foundation for the Berlin gallery's ongoing exhibition series in the intimate space on Unter den Linden. Even though *Black Box/Chambre Noire* is portable and, indeed, was reinstalled in Sweden and South Africa, among other places, and the same films projected in the miniature theater were subsequently reprojected for *The Magic Flute* in Brussels, Lille, and Tel Aviv, *Black Box/Chambre Noire* was, in its original form, site specific,[16] which is to say, it was made for this gallery in this city in Germany. The work was conceived on the grounds of a geographical location, a location whose history and identity have, however, been conceptually, culturally, and politically unstable. Indeed, the future architecture and urban design of Berlin, together with its role in reunited Europe, remains uncertain. As I did not visit it at other locations, I can only speculate on how the work was received in other countries. Nevertheless, given its placement in Berlin, we can assume that a new set of meanings will be created in the new spaces and places. In turn, the mutability of its potential meanings will accentuate both the aforementioned frailty and ephemerality of Kentridge's work and the uncertainty of Berlin's physical and historical future.

PLACES

The Deutsche Guggenheim is a small, cramped space on the ground floor of Berlin's very own Deutsche Bank on Unter den Linden. The Deutsche Bank was established as a specialist bank for foreign trade in 1870—the kind of trade that led to Germany's interest in Africa in the first place. Today, the bank is a global financial institution that, like all such establishments, prioritizes making money. In 1998, the bank was found to have financed the construction of the Auschwitz death camps, it serviced the accounts of the SS, and it loaned money to finance the construction of the IG Farben chemical plant adjacent to Auschwitz, the one that manufactured Zyklon B.[17] And in keeping with these activities, as the biggest bank in Germany in the first half of the twentieth century, the Deutsche Bank knowingly purchased the gold confiscated from Jewish victims of the Holocaust.[18] The history of this institution in which Kentridge's exhibition is housed certainly weighed on my mind as I reflected on the significance of this work about an earlier, forgotten genocide. The images, puppet figures, and music of *Black Box/Chambre Noire* may be ambiguous and in a constant state of disappearance, but the narrative

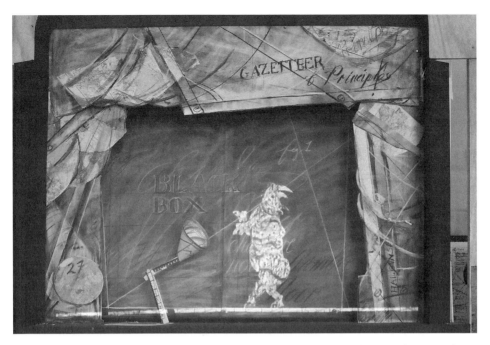

Figure 10.2. Installation shot, William Kentridge, *Black Box/Chambre Noire*, at the Deutsche Guggenheim, 2005. Commissioned by the Deutsche Bank, in consultation with the Solomon R. Guggenheim Foundation for Deutsche Guggenheim. Copyright 2005, William Kentridge. Photograph by Mathias Schormann.

told by these images is unyielding in its ultimate indictment of the history to which it can be seen to belong: a history of German violence.

The installation's inhabitation of the spaces and places it simultaneously complicates is so typical of the paradox that pervades Kentridge's work in general. As Cameron notes, "his work is grounded in a desire to reflect altered (yet still recognizable) European models back towards their point of origin, while simultaneously applying those same models to the contradictions of the society in which he lives."[19] In other Kentridge pieces, the immersion in historically and culturally dominant—European—representational forms articulates a protest of the very same domination. However, in *Black Box/Chambre Noire* in the Deutsche Guggenheim, in Berlin, the quandary is reflected in the placement as it is, in turn, realized in the mind of the spectator.

The Solomon R. Guggenheim Foundation, with its home in New York and branches in Venice, Bilbao, Berlin, Las Vegas, and since 2011, Abu Dhabi, is a colonizer of contemporary art par excellence. Thus this aspect of the placement of *Black Box/Chambre Noire* reminds us of the Guggenheim's tendency to bestow value on the work of commissioned artists or on existing works from international collections. The Guggenheim's main achievement in the twentieth century has been to erect more museums, to showcase the art of well-known artists. The Deutsche

Guggenheim is more restrained in its curatorial choices than its Madison Avenue parent. With exhibitions by Yves Klein, Gerhard Richter, Mark Rothko, James Turrell, a number of other revered male artists, and a few reputable female artists such as Kara Walker and Rachel Whiteread, the artists and their work exhibited here have secured their place within the mainstream international art world. Kentridge is indeed one among them. His work fits perfectly with the demands for established, respected art that is guaranteed to draw an audience.[20] The Deutsche Guggenheim is not a place where one comes to see emerging artists. For all its educational connections and proclamations, the Guggenheim is not an institution interested in the service of the public and social development. The Guggenheim is a corporate business organization first and foremost. It is in the business of determining the value of art and even, of late, what constitutes art with exhibitions such as the motorcycle show and fashion designer shows at the Madison Avenue headquarters.[21] Though these exhibitions were conceived for their anticipated revenue, the influence of an art institution such as the Guggenheim is so significant that it has the power to set new trends in art and cultural values. Thus the two powerful institutions of the Deutsche Bank and the Solomon R. Guggenheim Foundation join hands in this "unique joint venture" that, despite the apparent distance between art and economics, is ultimately focused on common goals: financial wealth and cultural dominance. And we will remember that the building itself was constructed in 1920, not so long after the Herero were colonized and massacred by the Germans. Like most buildings in this historic part of Berlin, the building has a palimpsestic history. The red sandstone building with its neobaroque facade was originally owned by Disconto-Gesellschaft (which merged with the Deutsche Bank in 1929), was sold to the German Reich in 1933, and in 1949, was used by the Free German Association of Unions of the German Democratic Republic. As the museum's mission statement proudly informs, the Deutsche Bank reacquired its former commercial domiciles following the fall of the Berlin Wall in 1990.[22] The Deutsche Bank's reacquisition and the Guggenheim's taking up residence in this same building are the latest pronouncement of cultural dominance in a cityscape where such power dynamics have been constantly under erasure.

Unter den Linden was once the grandest street in Berlin. In the seventeenth and eighteenth centuries, it was built as the central east–west axis of the city, designed to connect the Imperial Palace to the gates of the city on the way to the Tiergarten. And though it sat on the walled periphery of East Berlin for twenty-eight years during the cold war, today the boulevard has been restored to its imperial glory, just as Friedrich Wilhelm intended it. The years of the Communist regime have been all but effaced. Thus Unter den Linden is lined with the undulating history

of this great city, minus the twenty-eight years of Communist rule. While many other locations in Berlin remain under construction, its uncertain relationship to the many pasts of Berlin, its "current state of becoming" made manifest in the indecisions of its urban development, Unter den Linden was one of the first locations to be regenerated in the post-Wall years.[23] Again, like the Deutsche Guggenheim, this street has been forcefully reclaimed by the rich and powerful, in this case, Western capitalism. And yet, like the Museum at 13–15 Unter den Linden, it is a street where the traces of the past still haunt its vision in the present. Sites of monarchical glory—the Brandenburg Gate, the Zeughaus, the Lustgarten—once key historical sites, are now symbolic of past eras. In addition, bourgeois life continues to thrive inside the walls of Humboldt University, the operas, and the State Library, all of which are found on the majestic boulevard. These sites are unique in the palimpsest of Berlin because they all maintained their identity through two world wars, the cold war, and reunification. Then there are those sites that remember the traumatic historical events of World War II and the Nazi regime, such as Bebelplatz—where the books were burned in 1933—sites that are obligatory stops on a stroll down Unter den Linden today. The political struggles of the cold war have been razed, but their memory still colors the facades of the buildings: the former Russian embassy is now the Adlon Hotel, as it was in Berlin's glorious monarchical past. The American Embassy has taken up residence on Pariser Platz, in a prime location on Unter den Linden behind the Brandenburg Gate, the one-time entrance to the city. Despite vociferous public outrage, the Palast der Republik, seat of the East German parliament, began to be torn down in 2006. To add insult to injury, the imperial Stadtschloss will now be rebuilt on the site of the Palast der Republik at the River Spree end of Unter den Linden. Unter den Linden is once again the thoroughfare between East and West and the link between all the glorious moments of German history. While the not so glorious have been wiped away, their effacement can only ever be temporary given the social and cultural climate of wanting and needing to remember the past in the present. Unter den Linden is a street in which the past is made present and along which we move from one Germany to the next and on to another in the space of a few steps. It is exemplary of Berlin, as Huyssen would have it—the urban palimpsest in which traces of past, present, and future, East and West, history and memory continue to redefine its ambivalent heterogeneity.[24]

With this knowledge of the history of Unter den Linden, it is difficult not to see *Black Box/Chambre Noire* as another display that sits on this fragmented historical path. As such, the installation becomes integrated into the élan of postreunification Berlin. The discerning visitor will see the lessons of *Black Box/Chambre Noire*

being reflected onto the street outside its windows, the work's ephemerality adding yet another, previously forgotten layer to the already heterogeneous cityscape of Berlin. *Black Box/Chambre Noire*'s commitment to retelling the violence and senselessness of German colonization, in sound and images, becomes another aspect of twentieth-century German history. The placement of the installation adds a further layer of complexity to the West's takeover and subsequent attempted erasure of the East, the desire for a (nevertheless unrealized) forgetting of twenty-eight years of walled occupation, and all the other historical traces along Unter den Linden. Thus, if we foreground its placement, the integration of *Black Box/Chambre Noire* into its location in the Deutsche Bank, on Unter den Linden, juxtaposes the violent colonization of Namibia with the economic and architectural annexation of contemporary German and, by extension, Western cultural values and institutions. Indeed, numerous other acts of appropriation and assertions of power—Wilhelmine, Nazi, Allied forces, and capitalism—now sit side by side with the injustice, intolerance, and greed that motivated the Germans to enter Namibia a century ago. Kentridge's images in Berlin thus become projected onto this history and remind us of the past that might otherwise be hidden in the name of regeneration and cultural expansion, and so the spatial and geographical placement of *Black Box/Chambre Noire*'s Berlin installation transforms the events represented into a highly political and historical work.

Once inside the exhibition, the projections and accompanying drawings of skulls, measuring instruments and technology, and rulers overlaid with lists, details, writing, and scientific measurements of the world continue to bring the viewer face-to-face with her responsibility. The projected images of rationalization form the background to a drama of mechanized figures and instruments for measuring, and together, the objects and images speak to the imbrication of South African history with that of the historically manipulated narrative of Germany both inside and outside the museum's walls. First and foremost, the measuring instruments and documents of instrumental rationality gone awry will remind viewers of racial cleansing and studies of phrenology designed to prove the superiority of the Nazis. Thus the Nazi's activities as they were asserting themselves in World War II, only one generation after the Herero massacre, resonate in Kentridge's work.

Kentridge demonstrates infinite connections between the massacre of the Herero and the Nazi Holocaust thirty to forty years later. For a contemporary viewer, the more recent events of World War II are everywhere visible in the depictions of maps, measuring devices, forms of quantification, and murder by lynching, all in which human life is instrumentally rationalizable. While visitors not familiar with the layers of history on Unter den Linden might not see connections and

continuities between the undulating history of Berlin and the colonization of Namibia, the resonances with the Nazi genocide are unmistakable to all as they are represented in Kentridge's images. The cutting up of Africa into pieces and handing it out to European powers is strongly reminiscent of the redrawing of Europe's geographical borders into the promise of Germania. In Kentridge's work, we also see ledgers detailing share prices, lists of workers, and a death list dividing the dead according to the cause of death: disease, hunger, thirst, and so on. We have seen this all before in the representation of more recent crimes. These representations recall, in all too vivid a form, the Nazi obsession with lists, names, the quantification and thus dehumanization of bodies, and the rationalization of the most heinous of crimes. When we view *Black Box/Chambre Noire* within these walls, in this institution, on the ground floor of this bank, we are placed in the middle of the history that Kentridge summons. The physical location not only articulates this history as one that stretches unevenly all the way back to the nineteenth century but implicates our present in the historical links between horrific moments in German history. And given the vividness of the carefully constructed history of Germany outside on the street of Unter den Linden, the narrative can be understood to contribute its historical claims to the contemporary landscape of twenty-first-century Berlin. Thus, though *Black Box/Chambre Noire* is, on one level, quietly gracious, the experience of the work, in the context of its historical and geographical placement, encourages a challenge to the forces and narratives of power and cultural capital that nevertheless enable it at every level. In addition, through drawing attention to other histories and places, the work animates in the viewer a process of remembering and witnessing violent histories, histories it represents and to which it belongs.

Within these particular walls, colonization, racial eugenics, and massacre are understood to reach backward into European history in a way not often acknowledged. Thus the specific geographical place of the exhibition becomes the foundation of an historical trajectory of genocide that might otherwise go unremarked. And if there are precedents for exertions of such power and violence as we saw in World War II, isn't their recurrence, then, a possibility in the present and future? Similarly, the retrieval of the colonization of southwest Africa and its subsequent juxtaposition with contemporary Berlin throws into relief the reminder that history is often written and problematically rewritten for the convenience of those who would rather forget the injustices committed along the way. More important, rather than forgetting the biases and injuries of power, rather than repeating the historical amnesia that surrounded the Herero genocide for many years, it is our responsibility to recognize and keep active in memory what is otherwise hidden

behind the illusions and deceptions of representation. If it draws attention to the heterogeneous cityscape of Berlin beyond its walls, *Black Box/Chambre Noire* reminds us that the debates about how and what to remember of Germany's past are far from resolved.

HISTORICAL PLACEMENT

On their manifest level, the images and sounds of *Black Box/Chambre Noire* represent the intersection of two historical trajectories: first, the work focuses on the intersection of fin de siècle Germany's violent colonization of southwest Africa and the resultant massacre of the Herero population; second, it focuses on the history of visual and aural representation, particularly as it was explored by the international avant-garde in Germany in the early decades of the twentieth century. Kentridge's debt to the aesthetic and forms of the history of European art is not new to *Black Box/Chambre Noire*. The politically radical work of figures such as Vladimir Tatlin and Max Beckmann—and, in the cinema, Sergei Eisenstein and Jean Cocteau—permeates Kentridge's films and installations. Kentridge sees himself as part of a history of "heroic attempts at connecting the world with art."[25] Again, by emphasizing the fixity of place and location—Berlin, Germany, and Namibia, South Africa—the significance of these intersecting histories works to entice the viewer into the reality of these histories.

In *Black Box/Chambre Noire,* we see lynched corpses, a rearing rhinoceros, and uniformed men waving their sabers in pursuit of unarmed and naked bodies, all in silhouette. These hastily drawn images under constant threat of erasure are projected on the back of the miniature theater set. The vegetation, the oil rigs, and the headdresses of female figures are markers of where these events take place—they are metonymic signifiers of South Africa—and the continual superimposition of texts in German reveals the identity of the colonizer. A charcoal spiral woven over a map of the streets of Johannesburg, with whited-out areas relabeled "*Wüste*" (desert) and "*wenig Vegetation*" (little vegetation), makes clear the dynamics of colonialism at stake in such an image. German words are imposed onto the map of Johannesburg, and thus the spaces and places of South Africa are rewritten and redefined by Germany. Furthermore, the sound track's overlay of popular Namibian music with Mozart's *Magic Flute*—a Western symbol of all that is cultured and privileged—leaves no doubt in the visitor's mind as to the cultural and historical collision at stake in *Black Box/Chambre Noire*. Namibian culture is drowned out by the authority of Western opera, and the South African landscape is simultaneously rewritten by the authoritative German language.

At exactly the same time that Germany was moving into southwest Africa, some

of the twentieth century's most exciting experiments in visual modernism were being celebrated on and around Unter den Linden. As if in response to this artistic vibrancy of the same era that saw the violent colonization of southwest Africa, Kentridge embraces and deploys the kaleidoscope of aesthetic forms and genres that were being developed simultaneously. Though there is no cause-and-effect relationship between the development of German modernism and the demise of the Herero population, the juxtaposition of the two in the visual and aural representations of *Black Box/Chambre Noire* stirs up accusations of cold-blooded arrogance, pride, and inhumanness in the mind of an audience aware of this history. The installation's association with this rich cultural product, and thus the memory of the intense creativity of German modernism, is not guaranteed by the sounds and images of *Black Box/Chambre Noire*; rather, the associations come alive as a result of the installation's placement in Berlin, Germany, 2005.

To reiterate, Kentridge includes mechanical figures in a miniature theater, both of which are set in motion by animated film images and culled photographs projected onto the background. At the same time that German armed forces were massacring the Herero people, variety shows in Berlin celebrated the burgeoning of second-wave industrialization by putting mechanized objects, figures, and media (such as the cinema) on the stage.[26] We are invited to walk around the miniature theater, to examine it from all angles and to scrutinize the accompanying sketches and drawings on the wall. Thus *Black Box/Chambre Noire* is also a sculptural installation that references dramaturgical trends contemporaneous with the slaying of the Herero people. New forms of theatrical staging that emphasized the direct involvement of the audience in the performance were flourishing in Berlin at the turn of the century. As the exhibition catalog notes, Kentridge references a history of representation that stretches as far back as the invention of the camera obscura (the *chambre noire*) all the way up to that of another black box: the flight data recorder that represents the final moments in the cockpit before the airplane disaster.[27] The influences of the black box and Mozart's *The Magic Flute* are the most obvious. Critics of this exhibition do not mention the references to other forms of visual representation, but the mélange of forms in *Black Box/Chambre Noire* as we experience it in Berlin also takes us back to the visual experiments in art, theater, and film; on the vaudeville stage; and in architecture and typography from fin de siècle Germany up until the time of World War II. In addition to provoking associations between the events depicted and the carefree life of art and the mind in Berlin at the same time, these aesthetic references have a reverse effect: they provide a sense of the work's placement in twentieth-century Germany.

Many of the exciting developments taking place at this time in Germany were

being carried out in establishments along and around the Unter den Linden, in movie theaters and revue halls, on the streets, and in the buildings around the corner along Friedrichstrasse and, not far away, along Kurfürstendamm. For example, Kentridge's silhouettes in motion created both through stop-action photographic images projected onto the miniature theater set and through the use of the mechanical figures remind us of the painstakingly detailed animation films of Lotte Reiniger. Reiniger was a pioneer among film animators, and her contributions to the films of Paul Wegener, Arthur Robison, and Walther Ruttmann, as well as her own feature-length fantasy films, drew on the ancient Chinese art of silhouette puppetry for their fantastic narratives.[28] It is not only Reiniger's work itself that is recalled as we experience Kentridge's shadows but that of her oriental influences as well. The silhouettes of the mechanical figures act out violent or melodramatic scenes and thus remind us of Reiniger's illusions and fantasies, her empty shadows designed to entertain an audience with the wonder of mechanized motion. Reiniger's zeal to entertain audiences often overwhelmed the rest of the film. Despite the sophisticated and innovative types of animation, the stories were fantasies and fairy tales lacking moral profundity. Thus, in films such as *The Adventures of Prince Achmed* (1926), a version of *The Book of One Thousand and One Nights,* we are mesmerized by the processes of animation and storytelling, paying little attention to the familiar story of the sorcerer winning the hand of the princess. Viewers familiar with Reiniger's shadow plays will be prompted to reflect on the process of representation and the painful reality of the history it represents in *Black Box/Chambre Noire.* It is unclear, and ultimately not relevant, whether this connection is Kentridge's conscious intention. What matters is that viewers familiar with the rich cultural history of Unter den Linden, and of Berlin more generally, will inevitably make links to German cultural history as it pervades their experience of *Black Box/Chambre Noire.* As a result, they may begin to question at what cost all this artistic experimentation was taking place.

In Germany, this moment of great innovation saw the cinema develop and mature within the larger visual and cultural landscape. There existed a healthy and productive cross-pollination between the techniques used in film and those of the theater of Max Reinhardt, for example. Reiniger also worked in and was inspired by Reinhardt's work.[29] This cross-pollination with theater is everywhere in *Black Box/Chambre Noire.* Indeed, the piece's tendency to cross between theater, film, and installation, all the time incorporating elements of opera, animation, and politics, is typical of the multigeneric arena in which artistic expression was explored in the first two decades of twentieth-century Germany. The acknowledgment of these historical interrelationships discloses a more political significance

to the multimedia of technological representations in *Black Box/Chambre Noire.* The placement of the work in a city with this history of artistic experimentation allows the visitor to create connections that open up to new, suggestive insights. Namely, the violence and destruction of colonization is made even more painful because we recognize that it is forgotten, eclipsed by the privileged memory of all these exciting developments in the arts.

The connections between *Black Box/Chambre Noire* and turn-of-the-century German art and culture expand the temporal and geographical boundaries of Kentridge's installation. The work spills over into past centuries, to other countries and continents, and infuses the miniature theater set with a political power that is not otherwise visually or textually present. When we see the work as anchored within a geographical space, and recognize its placement, it accrues a political agency. Though site specificity is more usually recognized when a work is in direct, often polemical, conversation with the museum or the literal space—usually public—of its exhibition, for *Black Box/Chambre Noire,* site specificity or placement comes alive in the knowing viewer's mind. Like all works of witnessing and memory, this is a political process that is dependent on the presence of the spectator for its full meaning. In this case, the experience of Kentridge's multimedia installation in Berlin encourages us to see the privilege of art within the political landscape of the early decades of the twentieth century.

In addition to Reiniger's shadow plays, the experiments in light and magic of Richter and Ruttmann and the introduction of the mechanical onto a stage of political unrest recall the multimedia dramaturgical innovations of Erwin Piscator. Like Piscator and Reinhardt before him, Kentridge challenges the lines between stage and auditorium, between history and representation, in the interests of inciting political awareness.[30] In the early 1930s, when Piscator staged his controversial plays, Berlin was a city of great unrest. The proletariat was losing its voice in the political landscape, left-wing leaders were being murdered, and the presence of the National Socialist Party was becoming ever more evident. Piscator was one of a handful of dramaturges who protested the growing dominance of the political Right. Multimedia theatrical events were his preferred language for protest. For example, Piscator included documentary films that functioned to extend the space of the theater into that of the filmic events. Accordingly, his representations embraced and spoke to the everyday world beyond the stage. For Kentridge, a range of forms and technologies are also used to represent a history that is tainted with anxiety, uncertainty, and confusion. Perhaps more important, Kentridge reaches for an array of media to extend the illusory discourse into the reality of contemporary history. In the same way that Piscator's representation of protest on the 1920s and

1930s Berlin stage bled into the reality of the proletariat in the audience, our experience of *Black Box/Chambre Noire* bleeds into our own bourgeois reality. Thus we identify easily with projected images of German newspapers, the megaphone man with the *Trauerarbeit* sign around his neck, shadow figures drilling for oil, acting on a stage that spills over onto the walls of the gallery of privilege in which we sit. The stories told by these multimedia forms have everything to do with our lives in 2005 Europe. This recognition is what encourages a placement of *Black Box/Chambre Noire*'s concerns into the historical narratives taking place all around it.

Another of the black boxes referenced in the title of the work is that of the single theatrical performance space in which there is no clear division between actors and audience. By removing the conventional separation between stage and audience (as Reinhardt and, later, Piscator did),[31] we are invited to become more intimately involved with the drama: we become implicated in the action on stage when it bleeds over into our own reality. This implication is then interwoven with the responsibility that *Black Box/Chambre Noire* offers us to remember and mourn the tragic consequences of the twentieth century's genocides. And it is an implication, we will recall, that is founded on the fact that the piece is installed in a gallery on Unter den Linden, in Berlin, Germany, in a place with a long history of representational exploration.

Around the corner, on Friedrichstraße, movie palaces and variety theaters were filled with audiences nightly. Unter den Linden, with its operas and theaters and the university has, since 1871, been home to some of the most avant-garde experiments in the arts. Similarly, at the turn of the century, the shop windows along Friedrichstraße were entertainment in and of themselves, as people strolled along and enjoyed displays of the latest technological inventions, including the projection of films. We are reminded specifically of these and even earlier exhibitions of cinematic technologies by the stop-motion animation, the fades in and out, the photographs in serial representation, the lantern-slide spectacle of exotic images of Africa as they appear and disappear in *Black Box/Chambre Noire*.[32] All the forms and artistic technologies that Kentridge uses in *Black Box/Chambre Noire* were in their nascent stages in turn-of-the-century Berlin, indeed, all over Europe, at the same time that the Herero people were being massacred. And all of them, like the performances of Kentridge's installations, blurred the lines between different realities; the past, the present, and the future; and impossibly distant geographical locations.

The fine arts in fin de siècle Germany also saw collage take the center stage of modernist experimentation. The use of paper cutouts, newspapers, photographs, typography, and objects stuck onto the representational plane—images and objects

that equally reference events outside the frame as well as creating an overall coherence from the collision of parts—is familiar from the canvases of Kurt Schwitters, Hannah Höch, and later, John Heartfield. All these various works inspire *Black Box/Chambre Noire*. Again, while Kentridge may not directly reference these ancestors of German art, when we see drawings of maps of Africa superimposed on cuttings from German newspapers in an artwork installed in the center of Berlin, it is inevitable that we will recall German exponents of similar techniques. These memories are particularly forceful because we stand inside the Deutsche Guggenheim on Unter den Linden. It is difficult to deny the immediacy and impact of geographical location on the experience of *Black Box/Chambre Noire*. This reading would not, or is less likely to, occur to the viewer in Sweden, Tel Aviv, or South Africa. It is a reading that is dependent on its German context, and it is a reading that is, to some extent, dependent on the kind of visitor that is attracted to the Deutsche Guggenheim in the first place: learned, historically and politically aware. It is a reading that casts placement, and the experience of place, as key to the work's understanding.

In Berlin, the shimmering, transient images and ideas of Kentridge's multimedia work are placed in an historical narrative of genocide. And the ramification of their placement in Germany is that these events are not finished, distant events that took place in a forgotten past. They are no longer events to which we have no connection. They are ongoing, and their ramifications are felt all over the globe, today. Our connection to the events and their modes of representation means that the installation can be appropriated in processes of witnessing genocides other than that of the Herero people at the beginning of the twentieth century, processes of witnessing that are central to the continued memory and understanding of what ultimately remains inexplicable.[33] Thus, when situated within the walls of the Deutsche Guggenheim, on Unter den Linden, in Berlin, our responsibility to the trauma, guilt, and the memory of the violence that generated them is what might be located inside the *Black Box/Chambre Noire*.

HISTORY OF REPRESENTATION/REPRESENTATIONS OF HISTORY

My focus on the placement of *Black Box/Chambre Noire* leads to an understanding of the work's extension of the way we see and know history, in particular, German history. As Gunning has said of other Kentridge works, and as Kentridge himself has said of this one, the most manifest level of the installation reveals its concern with constructions of the image, as a representation of the history of seeing, and, by extension, how both must be looked on with skepticism.[34] This discourse is made salient in *Black Box/Chambre Noire* by the explicit reference in

the title to the camera obscura in its earliest days, as the *chamber noire*. The camera obscura, with its images in reversal and distortions in size, and the theater, with its shadows under erasure, objects and humans at the mercy of electric lights, are not to be trusted, or at least, their reality is not to be taken for granted. Similarly, as Maria-Christina Villaseñor points out, the black box of the flight data recorder that mixes voices and information while doing battle with interference can put forward a deceptive reality.[35] And yet, we continue to look to each of these forms of representation for the truth, the truth of what happened in history. Thus, in *Black Box/Chambre Noire,* the history of representation, especially where it concerns the reproduction of images and sounds, encourages reflection on epistemology, especially the possibility of knowing history. In this case, the specificity of the placement as a result of the site specificity of *Black Box/Chambre Noire* encourages us to see and know the uneven history of different forms of postwar Germany, from the massacre of the Hereros in Africa to the reenvisioning of the streets of East Berlin ninety years later.

Like the flight data recorder, the black box of history keeps a record of all the atrocities simultaneous with their occurrence, and yet it is sometimes impossible to learn what lies behind these representations, to decipher their signals, to see inside the box. All we can know for certain is that our physical and historical implication in the work, and by extension, the stories it tells, heralds our responsibility to remember the atrocities and injustices even as we are encouraged to forget them. The significance of the piece ricochets outward so that the depicted and alluded to violence, oppression, derealization of geographical and cultural identity, and displacement of whole populations have an impact far beyond that of the immediate stories on exhibition. At least in the moment of viewing the installation, the colonial histories depicted in *Black Box/Chambre Noire* are added to, and thus comment on, the conglomeration of histories that already vie for attention on the streets of Unter den Linden.

NOTES

The research for and writing of this essay was supported by a Marie Curie Intra-European Fellowship from the European Commission's Seventh Framework Programme.

1 See Carolyn Christov Bakargiev and Jane Taylor, eds., *William Kentridge* (Milan, Italy: Skira, 2004); Susan Stewart, "A Messenger," *Parkett* 63 (2001): 82–89; and Roselee Goldberg and William Kentridge, "Live Cinema and Life in South Africa: A Telephone Conversation in Chicago, October 21, 2001," *Parkett* 63

(2001): 96–103. See also the contributions to the catalog accompanying *Black Box/Chambre Noire*: *William Kentridge: Black Box/Chambre Noire* (New York: Solomon R. Guggenheim Foundation, 2005), published in conjunction with the installation *Black Box/Chambre Noire*.

2 See Tom Gunning, "Doubled Vision: Peering through Kentridge's 'Stereoscope,'" *Parkett* 63 (2001): 66–73. The one exception to this trend in Kentridge criticism is Rosalind Krauss's piece on *The Rock*. See Rosalind Krauss, "'The Rock,' William Kentridge's Drawings for Projection," *October* 92 (2000): 3–35.

3 See Dan Cameron, "A Procession of the Dispossessed," in *William Kentridge,* ed. Dan Cameron, Carolyn Christov-Bakargiev, and J. M. Coetzee (London: Phaidon, 1991), 40.

4 Dan Cameron, e.g., makes this point that most viewers do not share Kentridge's experiences of South Africa and the reality of the periods of apartheid and post-apartheid, in particular. Ibid., 38.

5 Robert Smithson's land art and Hans Haacke's installations would be good examples of this kind of early site-specific art.

6 Here Daniel Buren, Michael Asher, and Hans Haacke have again conceived of work in this vein.

7 Miwon Kwon, *One Place after Another: Site-Specific Art and Locational Identity* (Cambridge, Mass.: MIT Press, 2004), 26. Kwon cites Mark Dion's installations, such as *New York Bureau of Tropical Conservation* (1992), among others as typical of contemporary site-specific art.

8 Cameron, "Procession of the Dispossessed," 49.

9 The institutional critique is best seen in the work of, e.g., Hans Haacke, Michael Asher, or Fred Wilson, all of whom have produced work that directly critiques the museum and its practices of institutionalization. In a well-known example, Hans Haacke criticized Philip Morris company's sponsorship of a 1989–90 exhibition about cubism at the MoMA in *Cowboy with Cigarette,* which turned Picasso's *Man with a Hat* (1912–13) into a cigarette advertisement. See Benjamin Buchloh, "Conceptual Art 1962–1969: From the Aesthetics of Administration to the Critique of Institutions," *October* 55 (1999): 105–43. Richard Serra's *Tilted Arc* (1981) is a powerful example of site-specific art, in which the sculptural installation both critiques and redefines the public location. More recent examples of art that draw direct attention to the walls of the museum and its influence on meaning are the works of Steve McQueen, where we walk into and onto the image.

10 It is sometimes said that Germans came to southwest Africa to mine diamonds and copper.

11 Dan Stone, "White Men with Low Moral Standards? German Anthropology and the Herero Genocide," in *Colonialism and Genocide,* ed. A. Dirk Moses and Dan Stone, 181–94 (New York: Routledge, 2001). See also Jon Bridgman and Leslie J. Worley, "Genocide of the Hereros," in *A Century of Genocide: Critical Essays and Eyewitness Accounts,* ed. Samuel Totten, William Parsons, and Israel Charny, 15–52 (New York: Routledge, 2004).

12 The continuities between the genocides of Germany's Second and Third Reichs are explored in Benjamin Madley, "From Africa to Auschwitz: How German Southwest Africa Incubated Ideas and Methods Adopted and Developed by the Nazis in Eastern Europe," *European History Quarterly* 35, no. 3 (2005): 429–64. Madley argues that the German experience in Africa was in fact a precursor to the genocides of World War II.

13 The literature on genocide commonly places it within the frame of modernity and the ideological forces of modernity in the twentieth century. In addition to the two anthologies cited in note 11, see the essays collected in Robert Gellately and Ben Kiernan, eds., *The Specter of Genocide: Mass Murder in Historical Perspective* (Cambridge: Cambridge University Press, 2003).

14 *Trauerarbeit,* literally, "the work of mourning," is a term that has become a latchkey in postwar discussions of how to mourn the German past. However, the term is in fact more dated. It was brought into contemporary intellectual circles by Walter Benjamin's work on German aesthetic production and the roots of German tragedy in the baroque period. See his *The Origin of German Tragic Drama,* trans. John Osborne (London: Verso, 1998).

15 Philip Miller composed the music for *Black Box/Chambre Noire.*

16 The exhibition was in the Malmö Konsthall from May 31 to August 19, 2007. *Black Box/Chambre Noire* was presented at the Johannesburg Art Gallery in early 2006 and at Museum der Moderne, Salzburg, from July 26 to August 10. April 2006 saw the opening of the exhibition of Kentridge's installation piece *Preparing the Flute* and associated drawings at the Marian Goodman Gallery in Paris. *Die Zauberflöte* has been performed at Opera de Lille, at the Israeli Opera in Tel Aviv, in Naples in 2006, and in Johannesburg and Cape Town in 2007. For full details, see http://www.mariangoodman.com/.

17 Harold James, *The Nazi Dictatorship and the Deutsche Bank* (Cambridge: Cambridge University Press, 2004).

18 See Harold James, *The Deutsche Bank and the Nazi Economic War against the Jews: The Expropriation of Jewish-Owned Property* (Cambridge: Cambridge University Press, 2001).

19 Cameron, "Procession of the Dispossessed," 42.

20 This is also another significant difference between *Black Box/Chambre Noire* and other site-specific work, which sets out to be confrontational and is characteristically in a mode of conscious dissent toward the institutional discourses that house it.

21 In 2001, the Guggenheim exhibited the clothing designs of Giorgio Armani; see http://pastexhibitions.guggenheim.org/armani/index.html. In 1998, the Art of the Motorcycle exhibition was apparently one of the museum's most successful shows.

22 "Information Folder," Deutsche Guggenheim; see http://www.deutsche-guggenheim-berlin.de/e/.

23 See Andreas Huyssen, *Present Pasts: Urban Palimpsests and the Politics of Memory* (Stanford, Calif.: Stanford University Press, 2003), esp. chapters 2–4; quotation is from p. 54.

24 Andreas Huyssen, "After the War: Berlin as Palimpsest," in Huyssen, *Present Pasts,* 72–84.

25 Carolyn Christov-Bakargiev in conversation with William Kentridge, in Cameron et al., *William Kentridge,* 33.

26 See Ernst Gunther, *Geschichte des Varietés* (Berlin: Henschelverlag, 1981).

27 Maria-Christina Villaseñor discusses the three different black boxes referenced in Kentridge's work in "Constructions of a Black Box: Three Acts with Prologue," in *William Kentridge: Black Box/Chambre Noire,* 77–103.

28 See Lotte Reiniger, *Shadow Theaters and Shadow Films* (London: Batford, 1970). See also Frances Guerin and Anke Mebold, "Lotte Reiniger," in *Women Film Pioneers Sourcebook,* vol. 2, ed. Jane Gaines and Monica Dall'Asta (Champaign: University of Illinois Press, forthcoming).

29 Ibid. Like Reinhardt, Reiniger was interested in the manipulation of light and other media for the expression of emotion and as a narrational tool.

30 On Piscator and his use of film to extend the conceptual space of the theater, see Frances Guerin, "The Electrification of Life, Cinema, and Art," in *A Culture of Light: Cinema and Technology in 1920s Germany,* 30–38 (Minneapolis: University of Minnesota Press, 2005).

31 Ibid.

32 Magic lantern slides commonly depicted the exact same exotic Africa as we see in *Black Box/Chambre Noire.* Other of Kentridge's work directly converses with the early cinema and cinematic forms, e.g., in 2003, the Baltic Art Center in Sweden staged his exhibition William Kentridge, Journey to the Moon and Seven Fragments for Georges Méliès. Also see Guido Convents, "Film and German Colonial Propaganda for the Black African Territories to 1918," in *Before Caligari: German Cinema, 1895–1920,* ed. Paolo Cherchi Usai and Lorenzo Codelli, 58–77 (Pordenone, Italy: Le Giornate del Cinema Muto/Edizioni Biblioteca dell'Immagine, 1990).

33 For a conceptualization of the role of images as agents in processes of witnessing traumatic historical events, see Frances Guerin and Roger Hallas, Introduction to *The Image and the Witness: Trauma, Memory, and Visual Culture* (London: Wallflower Press, 2007). An exhibition on the 1904 massacre of the Hereros ran concurrently with *Black Box/Chambre Noire* at the Deutsches Historisches Museum across the street from the Guggenheim. The Deutsches Historisches Museum, like the Deutsche Bank, is an institution housed in a building with an implication in Berlin's and Germany's checkered history. The museum is situated in the old Zeughaus, or arsenal, the oldest structure on Unter den Linden, originally built as a storehouse for heavy weaponry during the reign of Frederick III and turned into a military museum in 1875.

34 Kentridge says this in the catalog essay "Black Box: Between the Lens and the Eyepiece," in *William Kentridge: Black Box/Chambre Noire,* 47–51.

35 Maria-Christina Villaseñor, "Black Box #3: Flight-Data Recorder," in *William Kentridge: Black Box/Chambre Noire,* n.p.

11 | Into the "Imaginary" and "Real" Place: Stan Douglas's Site-Specific Film and Video Projection

JI-HOON KIM

FILM AND VIDEO PROJECTION IN THE GALLERY AND THE ENGAGEMENT WITH PLACE

In the terrain of contemporary art, the projection of film and video in the gallery is a popular means of combining an image, a viewing subject, and a space. The term *projection* refers to the transfer of images—those made of light but not identical to it in their final figuration—onto the surfaces that embody them. This "travel of luminous images"[1] is inherently indissociable from the apparatus and the space-time situation in which the viewer perceives them. In this sense, the concept of projection offers us the rendering of two places simultaneously; first, we are invited to an "imaginary" place carried and framed by the luminous images that adhere to the material and technical constitution of its apparatus (natural or electric light equipment and film or video projector), and second, this journey literally takes place in the "real" place through which the images travel with the operation of the apparatus.

The now pervasive use of projection in gallery-based exhibition and the concomitant burgeoning of time-based moving images in this mode of exhibition date back to the inception of film and video installation during the 1960s and early 1970s by a number of artists and experimental filmmakers who called into question relationships between those two—imaginary and real—places. Their variegated experiments were driven by two different yet often overlapping intentions. On one hand, some filmmakers, such as Michael Snow, Paul Sharits, and Anthony McCall, forged nonnormative modes of projection to elicit the inseparability of the two, distancing themselves from the theatrical format that is still dominant in our experience of moving images. In the institutionalized theatrical mode of projection, the apparatus of theatrical projection remains invisible, its images fixed onto a single screen and separated from the auditorium wherein viewers

255

are obliged to maintain their immobility. As much discussed in the discourses of apparatus theory, this formation is understood as inducing viewers to identify with the images and thereby to be little concerned with the material conditions of the space framing them, including the screen, the auditorium, the light of projection, and so forth.[2] Seen in this light, the real place in the dominant mode of cinematic projection serves to enhance the illusory power of the imaginary place contained in the images as its existence is neutralized. By contrast, nonnormative forms of film projection installed within the walls of the gallery—split or multiple screens, and mobile projection via rotating equipments—provided multiple or decentralized perspectives, while, at the same time, they exposed to viewers their apparatus. In this way, they turned the viewers' attention not simply to images on the screen (the imaginary place) but "to the surrounding space, and to the physical mechanisms and properties of the moving image"[3]—the real place. The interconnectedness of those two places, too, was explored by many video artists of the time: Peter Campus, Bruce Nauman, and Dan Graham, to name just a few. Their works were not strictly projective in the sense that they utilized the video monitor instead of the projector, but the artists assumed that installing it within the various physical positions and settings of the gallery could furnish viewers with the opportunity to contemplate a perceptual process of domesticated spectatorship triggered by televisual devices.[4]

On the other hand, many of the practitioners' attempts to devise alternative modes of projection in the gallery aimed at transforming both the exhibition space and its relation to the artwork and the audience. While the institutionalized art exhibition has been tied to regulating its gallery space as the *white cube,* a framing device that functions to exalt an object to the status of artwork through isolating it from its real surroundings,[5] film and video installation promises a transformation of the exhibition place through the experience of projected images. Unlike the evenness or clarity of the light that illuminates the artwork in the traditional museum, the darkened setting of film and video installation introduces a lack of visibility into the exhibition space, thus turning the white cube into the black box.[6] This condition engenders the viewers' somatic and affective involvement in projected pictures. Despite its fascinating and sometimes hallucinatory power, however, projection in the gallery more or less allows viewers to keep their distance from the image (and its imaginary and immaterial place), for their physical and psychic engagement is inextricably linked to their self-consciousness of the materiality of the real place, an environment that is conditioned technically (the formation of the apparatus), spatially (the deployment of the apparatus within the exhibition place), and temporally (the time of viewing).

The gallery space penetrated or inhabited by the projected image, then, allows for a refreshed understanding of the concept of site specificity, one that differs from the understanding of this practice when it was first initiated in the 1960s. Site-specific art initially aspired to foreground the physical presence of a geographical space or material location and the viewers' own physical embodiment and spatial situatedness, focusing on "establishing an inextricable, indivisible relationship between the work and its site."[7] In so doing, the artwork, encompassing various forms or activities, such as provisional installations, public events, and performances, was deemed to be both an integral part of a specific spatiotemporal situation—one most often assumed to be both contingent and ephemeral—and an interruption of and intrusion into it. In particular, the use of media such as photography, film, video, and the computer network has increasingly been key to the artwork's engagement with site specificity so that the exhibition site itself has more and more come to be understood "as a venue . . . that allows seemingly different discourses to cross and influence each other."[8] In this sense, various artistic approaches to film and video installation inside the black box are understood to render the gallery space an arena for the overlapping, even competing, material, sociocultural, and discursive claims of locations—a media laboratory for the juncture between the imaginary and real place." To put it another way, I would argue that the gallery, in this condition, fits usefully into what is meant by the term *MediaSpace*. For Nick Couldry and Anna McCarthy, MediaSpace is a dialectical concept that encompasses "both the kinds of spaces created by media, and the effects that existing spatial arrangements have on media forms as they materialize in everyday life."[9] In this sense, the term suggests that our experience of film and video installations becomes increasingly bound up with media technologies crossing the boundary between the virtual and the material, or between the represented space and the site, as part of the surrounding structure framing them.

When gallery projection began to become more widely diffused in the early 1990s, it involved the material and spatial reformulation of moving image media whereby film and video, hitherto respectively distinct in terms of medium specificity, entered into a new circuit of dynamic and fluid exchange. And yet, as technological progress in shooting and projection matured, including the emergence of high-definition video cameras and the innovation of digital devices for storage and display, the power of moving image installation to destabilize the specificity of artistic media began to be enfeebled. What is lost in this shift is the more nuanced possibility for visitors to interact with the mediated space as constructed and the exhibition site as culturally encoded. Positioning the viewer in a stable relation to the image, wherein its mediated structure remains not overtly visible, this naturalized

projection within the black box brings about two boomerang effects. First, as many artists have begun to adapt the most normative form of narrative cinema, and as the format of single-channel projection has been folded into the dimly lit space, the black box environment has become less distinguishable from the traditional cinema setting, wherein the relationship between its apparatus, its viewers, and its surroundings (the real place) is not problematized. This naturalized projection, in turn, has tended to reconfirm the viewer's understanding of profilmic space (the imaginary place) as unmediated and waiting to be consumed. Second, the growing accommodation of moving images by today's museums, regardless of medium (film, video, or digital media), reinforces the ideology of the white cube that promotes the aura of uniqueness and transcendence and a concomitant spectatorship of contemplation. As Liz Kotz has remarked, "high-tech formats of modern display culture merge awkwardly with older forms of connoisseurship associated with unique object."[10]

Canadian artist Stan Douglas is important in the context of this deadlock, inasmuch as he postulates his art of film and video installation as "works that are materially realized, using projection as a material with extension in space"—"as opposed to making an art gallery into a cinema."[11] Since the 1980s, he has consistently interrogated the properties of film and video and has made viewers aware of how they could be transformed and redeployed inside the black box as the real place. In doing so, he has intended to lay bare relations of his projected images, their apparatus, and the imaginary places they represent. These places are, in fact, historically and geographically specific locations that he has explored in detail. Douglas's multidimensional intervention in places—both imaginary and real—suggests the fruitfulness of an analysis of his practices within the prism of site specificity: not simply in terms of how the notion of site specificity applies to his body of work but, more significantly, in terms of how it asks us to understand the necessity for us to think about site specificity in relation to media.

STAN DOUGLAS'S ART OF PROJECTION AS INTERVENTIONS IN SITE SPECIFICITY

Douglas's corpus of projection work does not so much take on a physical location per se; rather it constructs the site as what Miwon Kwon calls the *discursive vector*, a term that underscores the notion that site specificity itself has been changed. Kwon uses this term to argue that the early definition of the site that emphasized the physical realities of place is now out of sync with "the prevalent description of contemporary life as a network of unanchored flows," which increasingly requires a new understanding of it as "ungrounded, fluid, and virtual." Kwon's insight

does more than call into question site specificity's presumption of the authentic-
ity, fixity, and actuality of a location. More significantly, Kwon's emphasis on the
"network of unanchored flows" suggests that the textual and cultural production
of the location plays a constitutive part in shaping and shifting its meaning. Con-
temporary site-specific work may directly tell us something about a place and the
people living there, but it is also able to blur the boundary between the local and
the global, to mix factual observations with fictions and imagined reenactments,
or to challenge the notion of the place's history as chronologically linear. In any
case, the conjuring up of the site as the discursive vector is aligned with "the
possibilities for the production of multiple identities, allegiances, and meanings,
based . . . on the non-rational convergences forged by chance encounters and cir-
cumstances."[12] For this reason, contemporary site-specific art practices are required
to penetrate not simply the historical and geographical conditions of a place but
the chain of various representational artifacts influenced by and simultaneously
affecting those conditions.

Douglas's understanding of the site as the discursive vector is obvious as he
assumes it as an intertextual network of different materials such as literary texts,
documents, films, television shows, and so on. His materials touch on or allude
to particular locations, but all of them do not need to be directly associated with
it; that is, he often shapes the meaning of a place from a material that directly
relates to it, and then assimilates the material to another that serves to extend
that meaning. For instance, Douglas's conception of *Le Détroit* (2000; two-track
16mm film projection) was first made possible by his reading of Marie Hamlin's
anthology *Legends of Le Détroit* (1883), a collection of thirty-one tales that were
concerned with the history of Detroit from its inception as a French colonial city in
the seventeenth century. Douglas was interested in these tales because they were
understood to blend historical documents of the colonial repression against its
native inhabitants with fictional stories about them—something like ghost tales.
He then further associated the tales with Shirley Jackson's novel *The Haunting
of Hill House* (1959). In this story, a female protagonist (named Eleanor) agrees
to reside in an isolated house as part of a scientific experiment trafficking in the
existence of the supernatural. Unlike the rest of the three other inhabitants, she is
so possessed by the house that she experiences strange things, supposedly evidence
of haunting, which they do not. Another version of the ghost story, this novel is
adapted by Douglas's work wherein a young black woman (whose name is also
Eleanor) inspects a deserted house in Herman Gardens, a now-abandoned housing
project in Detroit. Here Douglas's exploration of the text about Detroit's history
and his appropriation of Jackson's novel as an equivalent of his imagined city are

combined with his study of the dramatic change in the city's urban condition. "As city centers were emptied, suburbs became accessible by new highways and rail service and the old city centers became the homes of the working class in such housing projects," Douglas explains. "Detroit is a very severe example of this."[13]

More significantly, Douglas's strategies of extracting and transforming the components of literary and cultural texts about a place are predicated on an assumption that they structure the ways in which one understands the place's specificity. It is here that his site-specific awareness intervenes in the real and imaginary places created by the media and in the media per se simultaneously. For instance, *Suspiria* (2003; Figure 11.1), commissioned by and exhibited at Documenta 11 in Kassel, extracts 256 truncated segments from the Brothers' Grimm *Fairy Tales*. The reenacted segments center around a group of characters that serve as social and economic allegorical types of nineteenth-century social life—the innkeeper, the giant, the poor traveler, the long-suffering servant, and so on. They act out a series of episodes that revolve around payment and debt, greed and exploitation. The setting of these episodes is intertwined with the location of the work. Douglas chose a construction that has characterized Kassel's appearance up to this day, the Oktogon, a seventy-one-meter-high monument crowned by a gigantic statue of Hercules.[14] Its labyrinthine corridors allowed Douglas to invoke *Fairy Tales,* particularly the Gothic characters and stories that might trouble the Oktogon's monumental appearance and instead call forth supernatural and uncanny sensations.[15] He then installed within the corridors four black-and-white video surveillance cameras whose pan-and-tilt movements are controlled by computer. A software algorithm synthesized a random sequence of the black-and-white images captured by the cameras in real time with a DVD playback of prerecorded color shots of *Fairy Tales.* Because the running time of each image track is different, this system generated a variety of permutations of the episodes. As a result, viewers were able to observe how the real place of the site—the Hercules Oktogon—was occupied by the operation of the media that made its meaning ungrounded and fluid. The Oktogon came to be understood as something other than an historical relic marked by its physical location and was instead turned into a locus of the imagined characters that embodied the contradictions and conflicts of nineteenth-century European capitalism such as poverty, exploitation, and the magical power of capital to invest commodities with surplus value.[16]

Douglas's historical consciousness of media plays a pivotal role in both interventions—into the real and imaginary places and into the media *as such.* His art of projection has involved the material and technical components of film and video that have become outdated as they have been overwhelmed by new media.

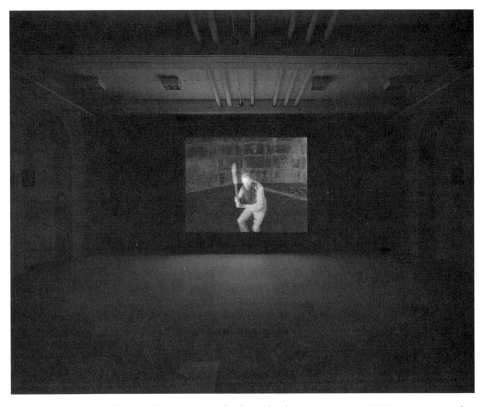

Figure 11.1. Stan Douglas, *Suspiria* (2003), single-channel video projection, six DVDs, computer, color, sound, variable dimensions. Installation view, Winnipeg Art Gallery, Manitoba, Canada. Courtesy of the artist and David Zwirner.

Reflecting on and revealing those components, he can be understood as an artist who seeks to "reinvent the medium"—to borrow Rosalind Krauss's critical phrase. Krauss argues that a technological medium is given a new life through its loss of dominance, through the very process through which it becomes obsolete. It is reinvented by artists who conceive of it as "a set of conventions . . . out of which to develop a form of expressiveness that can be both projective and mnemonic."[17] Krauss's notion of reinventing the medium fits well into Douglas's film and video installation, for this work is concerned with how the deconstruction and transformation of its technologies, in the guise of their obsolescence, defies the logic of technological progression, in which the historicity of media is prone to be forgotten. For instance, he has explored the technological mechanism of the analogue NTSC video—its visual impression consisting of the combination of two scan lines—by interweaving two different but interrelated voices of an English and a Spanish colonizer talking about a terrifying moment at Nootka Sound in Canada (*Nu•tka•*, 1996) or by making characters' figures and faces oversaturated *(Suspiria)*.

This sort of superimposition formally corresponds to his fabrication of projecting two films onto a single screen, as is the case with *Le Détroit* and *Inconsolable Memories* (2005).[18] These experiments are mnemonic as they are thematically linked to the motif of the undead through the figures of the specter or the double. What is more, the return of the undead is also projective insofar as he continues to embrace contemporary media. He testifies to this point by combining filmic images with video projection often driven by his creative application of computer-based systems.

Both mnemonic and projective, Douglas's various approaches to film and video are intent on emphasizing the repercussions of history in varying degrees, which call on the viewer to recognize the exhibition place as highly mediated by the afterlife of old technologies and the mutation of new ones as well. This encounter is, too, the moment at which the viewer is able to regard the meaning of a geographical site as under constant construction. By drawing the viewer's attention to the way in which the trace of a specific historical event still overshadows the site even when it has passed, Douglas's installation work signals that we live in the "residue of" the event and that its potential is "not yet spent."[19] In what follows, I will examine *Der Sandmann* (1995) and *Win, Place, or Show* (1998), two pieces that are very different in format and style but that engage the historical specificity of location and the place of viewing in significant ways.

DOUBLED MEDIASCAPE: *DER SANDMANN*

As neatly summarized by Scott Watson, *Der Sandmann* is "a kind of panoramic cinema that depicts . . . the play of historical processes that both build and destroy an imaginary *Schrebergärten* [garden allotment]"[20] in Germany. The allotments were named after Moritz Schreber, an educationist, who argued that major cities of the German federation should prepare garden plots for rural workers who had left their hometowns and had been forced to provide their labor power for industrialization. Excavating this historical context, Douglas imaginatively elaborated this historical material with further references that would build into the narrative tropes of this piece. First, Douglas hinted at the fact that Moritz Schreber's son, Daniel Paul, is most famous for Sigmund Freud's account of his nervous disorders as a theory of paranoia. Moritz Schreber thought that the garden plots could serve to alleviate harmful psychological effects of industrialization on children, but he also experimented with the correction of children's posture with obsessive thoroughness, a pursuit that seemingly caused his son's mental collapse. Douglas develops the Freudian connection and its themes of repression, estrangement, and fear and links them to E. T. A. Hoffman's *Der Sandman* (1817), a short story

central to Freud's theorization of his notion of the uncanny *(Der Unheimlich)* in 1919. Foregrounding a male figure named Nathanael, who returns to the *Schrebergarten* in Potsdam where he resided in his childhood, Douglas's *Der Sandmann* begins with an exchange of three letters culled from the opening of Hoffman's tale. Narrated by Nathanael (who is on-screen) and his friends Lothar and Klara (who remain off-screen throughout the piece), the three letters address Nathanael's psychic disorientation caused by a mysterious old man he has seen in the garden. The man triggers the recurrence of their memories about the old man they used to see as children, whom they believed to be the Sandman. Here one does not fail to observe that Nathanael is disturbed by the traumatic return of the repressed. The *Schrebergarten* is viewed as a place occupying Nathanael's past and present, and the Sandman embodies a continual confluence of what he sees and what he remembers.

The meanings of the *Schrebergarten* and its subjects (both Nathanael and the Sandman) cannot be fully explained without examining Douglas's cathexis of this historical site and his imaginary reconstruction of it during production. First, in the Ufa film studio at Potsdam-Babelsberg, he created a garden set that was imagined as a Postdam garden of the past. After having performed this bit of reconstruction, a new reverberation of the garden's social and economic situation of the present day after the fall of the Berlin Wall occurred to him: "Douglas discovered another transformation underway in the local use of property. The arrival of real estate specu-lation and development in Potsdam also impinged on the small, private gardens allotted to Potsdam apartment dwellers."[21] This connection led him to construct a second garden, looking as if it were under construction today. Whereas the first (old) garden's foliage and cabbages are reminiscent of the detritus of gardening, the second (new) one contains tire racks in the mud, blocks, and cement, all sug-gesting that it is a construction site. But overall, they look similar in that they were shot on black-and-white film; they share an atmosphere of thin trees, fog, and broken barbed wire; and they feature the same garden shed interior, where tools, ladders, and other equipment are stored. In this way, the two gardens are able to represent the past and present of the same historical site.

Yet it is eventually a sophisticated combination of shooting and projection that makes complicated their relations—and, by extension, the articulations of Nathanael and the Sandman. The two gardens were shot with a motion-control camera that made one continuous, 360 degree pan. The two takes, one of the old garden and the other of its contemporary counterpart, were then duplicated and combined with a pair of projectors, each occupying different sides of the same

screen. Thus only half of each projector's image is thrown into the right and left of the screen, with its other half blocked out (Figure 11.2). This device successfully produces a *temporal wipe* effect. As Douglas himself writes, "as the camera passes the set, the old garden is wiped away by the new one and, later, the new is wiped away by the old; without resolution, endlessly."[22] This effect is indeed made possible by the fact that this shooting–projection system leaves a seam running vertically through the center of the screen space, a nodal point where the left and the right, the old and the new, continuously affect each other at the levels of both form and subject matter. More precisely, in their synchronization with the continuous pan, both sides are interrelated with far more complexity than would initially seem to be the case. The seam appears obliquely at first sight, thus the screen space looks slightly divided into two halves. As the pan sweeps broadly, however, it emerges as a more visible boundary into which images on one side of the screen fall, vanishing for a moment before they reappear on the other side. The issue of the boundary is particularly crucial in two key scenes from the piece. In the first scene, viewers see Nathanael read the first letter in the two sets of the garden shed sharing the same objects such as desks, ladders, and tools. In the second, the Sandman wanders about the foggy garden while working—arranging the bushes of its trees and trying to pump water. The two scenes exemplify Douglas's idea of a *temporal polyphony,* by which viewers are able to have two things happening at two different time periods and "perceive those things simultaneously."[23] In this structure, the past and the future of the same site relay on the circular loop. More precisely, they catch up with each other up to the point where one constantly reshapes the other, and vice versa.

The subjectivities of Nathanael and the Sandman are placed within this repetition of inscription and erasure. Aided by the looped mechanism of projection, the Sandman does not cease to reappear as he disappears into the seam between the two projected images. This pattern is linked to Nathanael's psyche, provided that the Sandman is seen after he reads his letter. In this sense, the Sandman is seen as a projection of something unavoidable to him, evocative of a sense of fatefulness that has captured his past and present alike. But what is remarkable is that Nathanael himself is no less a sort of double than the Sandman, an entity that crosses the boundary between the garden of his childhood and its present-day shape. This is obvious in the interior scene, where he is seen as continuously split across the vertical seam, which generates the effect of his voice-over being out of sync with his appearance, which in turn suggests that his mental condition is troubled by the indeterminacy of the relationship between the past and the present. Is it the

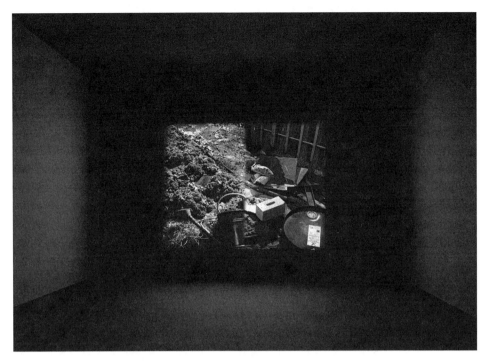

Figure 11.2. Stan Douglas, *Der Sandmann* (1995), two-track 16mm film projection, black and white, sound, nine minutes. Installation view, Hauser and Wirth, St. Gallen, Switzerland. Courtesy of the artist and David Zwirner.

case that Nathanael's memory of the Sandman in his childhood is displaced by his return to the *Schrebergarden*? Or is his witnessing of the man in the present garden the hallucinatory return of the traumatic encounter with the Sandman? The answer to these questions remains ambiguous, inasmuch as Nathanael's identity is in a constant state of precariousness and confusion. It is interesting to read those characteristics of Nathanael and the Sandman against the grain of the historical context of the *Schrebergarten*. Douglas was interested that this sort of allotment garden had been a means of feeding the general population and maintaining class division since the modernization of Germany—from the Weimar Republic and its depression era to the Third Reich and on into the postwar period of divided Germany. Given this history, the Sandman, reappearing in the ruin of the once-prosperous garden and continuing to work for something whose achievement is eternally delayed, is allegorized as the spectral, eternal recurrence of the working class. As he speaks of the "imperfect past" of the garden allotments as part of "the specters of a recurrent, repeatedly foundering modernity,"[24] Nathanael's ineluctable anxiety about the Sandman symbolizes an identity crisis of the bourgeois class. It is here that the "imagined" gardens made of the "discursive vectors" of

the nineteenth century in Germany—the historical documents on the Schreber family and Hoffman's tale—allude to the *Schrebergarten* as the real place whose uses are determined by the network of economic, industrial, and social powers. This piece, then, is, as Douglas explains, an intervention in "a specific [cultural] territory, which in turn has its own history—a history marked by the omitted, suppressed, and hidden."[25]

The divergence of the two halves becomes spatial as well as temporal. Thus the seam, in a sense, invokes "the gaps and fissures in time and space that inhere in cinema"—those preoccupied by film theory and avant-garde film practice. However, its disturbing impact on the piece's representation of the site is not confined to, as Carol Clover argues, the incarnation of "a wound . . . that never lets us forget that this is a film."[26] More than demystifying filmic illusion, the seam brings the viewer back to the materiality of filmic media that is allegorized by the piece's thematic and formal doubleness of the past and present. As with the unfolding of cinematic space, a shot is required to wipe out its preceding shot on the screen space during its linear progression driven by the projector. Douglas translates this technical convention of cinema into a reworking of its media technologies—an elaborate and idiosyncratic combination of the camera work and the looped projector. He does so by dealing with the filmed sequence of the scenes like two separate tracks and condensing them into the two-channel projection in such a way that is not bound to the theatrical projection of film.

Der Sandmann's complex doubling draws the viewer's attention to the projection of an imaginary site *as such,* a mediated and thus concrete event within the real place where the work is at play. To illuminate this point, it is helpful to briefly compare this work with Michael Snow's *Two Sides to Every Story* (1974), a piece that makes use of two films projected from opposite sides of the room in a continuous loop. Shot by two fixed cameras, the piece offers footage of a woman who makes a series of movements as she walks between the two shooting cameras. In this way, the images (the woman as doubled), their recording mechanism, and the mode of projection are inseparable from one another, as is the case with *Der Sandmann*. The only difference is that, unlike Douglas's projection of two films onto the single screen in the same direction, Snow compels viewers to compare the two films by moving from one side to the other of the single screen (suspended in the middle of the gallery) onto which the films are projected. Thus the relationship between the screen and the viewer in *Der Sandmann* would seem to be less physical than in *Two Sides to Every Story.* Nonetheless, the viewer's fixed position does not help him find a determining relation between the two images, which continue to blur

their boundaries. In this sense, Douglas as much decentralizes the single cinematic viewpoint as Snow does, but in a method of projection different than Snow's. The interplay between Douglas's two projectors is revealed to the viewer not by their sheer presence, as is the case with *Two Sides to Every Story*, but by the inspection of the relations between the two images. It is here that the gallery place is, like the *Schrebergarten*, haunted by the "new" recurrence of the filmic projection as the "old" media technique.

PERPETUAL RECOMBINATION: *WIN, PLACE, OR SHOW*

From the late 1990s onward, Douglas has produced recombinant works that redeploy narrative units—scenes, dialogues, sound tracks, visual cues, and so forth—taken from other existing materials such as film, television, and literary, cultural, or historical texts. As in his previous works, Douglas uses these materials to create new artifacts that offer a means of meditating on the places they represent and on which they rest. His methodological achievement in doing so, then, resides in the fact that he introduces a putatively infinite number of combinations of the constitutive elements of each piece. He first films a series of sequences, then dissects them into smaller units—sound track and image track or individual scenes, for instance—and redistributes them into two or more channels that are connected to different playback devices. Each of these devices has a different temporality and duration, and thus their synchronized operations produce different combinations of those units from loop to loop.

This recombinant narrative is inspired by his application of the computer to select certain elements such as characters, situations, rules, and story paths. Yet he challenges the popular belief in hypermedia narrative's mutable freedom, in which the viewer or player is offered what is actually a controlled set of actions, paths, and closures.[27] Instead of hierarchical and centralized control, each of Douglas's recombinant artifacts is predicated on contingency (in the sense that its elements are combined) and partial perspectives (in the sense that each viewer comprehends its spatiotemporal construct), while turning the viewer's attention to its technological system. In so doing, Douglas assumes that our understanding of a place in our engagement with the media-produced narrative depends as much on its temporal parameters as on spatial ones. As those temporal parameters are subject to randomness, difference, recurrence, and endlessness, his recombinant narrative defies the notion that events happening in a fictional—imaginary and diegetic—place unfold in a chronological order. Characters in this sort of narrative are depicted as stripped of the power of controlling those events: their conflicts

remain unresolved and repeated *(Suspiria)*, or a main character's perception of her world is unfixed in the continual drifting between her consciousness and memory *(Inconsolable Memories)*. These circumstances, by extension, suggest that a character is uprooted from the place in which she dwells. For any change in the time and space of the events turns out to be made in the narrative's extradiegetic dimension: the automated media system that governs the combination of them. The decentralization of the characters accordingly anticipates a decentralized viewer whose "construction of subjectivity is an open-ended process."[28]

Win, Place, or Show takes as a starting point a widespread mode of postwar urban transformation in North America: the process by which outdated houses and buildings have been demolished and replaced with new public housing aimed at accommodating lower-class communities.[29] Douglas draws attention to a campaign against urban blight in Vancouver, which took place in 1950, when the city launched a redevelopment plan for its poorest neighborhood, Strathcona. In this work, he reconstructs a one-bedroom apartment in one of the planned, but never built, dormitories for retired and employed seasonal workers. Within this space, two workers take part in an antagonistic conversation that follows bouts of physical violence committed against each other. Their verbal frictions are heightened by the work's six-minute looping structure as well as by the setting's monotonous and cramped interior. The interior is modeled after the Vancouver-produced CBS TV drama series *The Clients* (1968), a show about officers investigating parolees recently released from prison. With twelve separate camera angles, Douglas employs certain visual tropes that are closer to the rules of cinematic realism than to the conventions of television drama such as the use of long takes and the absence of master shots. He then transfers the filmed scenes to four DVD players connected to a synchronous starter and an interval switcher, two technical devices that vary the combination of the looped material.[30] The result is an almost infinite and random expansion of their montages (to more than twenty thousand hours for 204,203 variations), which subjects the viewer to the varying but repetitive chain of the two protagonists' conflict. Owing to the changing combinations within the same setting, this conflict is represented as always fissured and unending. The viewer slowly recognizes a connection between the two characters' conflict and the space in which it takes place. As Douglas states, "no two people can see the same sequence of events that lead to this fight that will never be resolved. However, this conflict which never happened in fact takes place in a realm of fantasy that still determines the occlusion of space to this day."[31]

Douglas's site-specific inquiry in *Win, Place, or Show* questions the modernist ideal of a seamlessly harmonious relationship between dwelling place and inhabitants

as well as the aftermath of this ideal. While researching the housing project in Vancouver, he participated in a seminar held in Chicago at the Museum of Contemporary Art in 1998, where he studied a similar project. There he came to the conclusion that "modernity ended after the Second World War when a lot of the social content included in the Modernist movement, [including the modernist architecture], was taken out of it on the cultural and political scenes."[32] What he means by the "social content" is the imperative of modernist architecture in the early twentieth century to provide the urban working class with the mass-produced dwellings that were presupposed to be the most convenient and natural home for this subject.[33] In developing *Win, Place, or Show,* Douglas kept in mind his impression that this "social content" had been emptied out of the newly designed civic space in the postwar North America, even though a number of housing projects (including those in Chicago and Vancouver) were modeled after modernist architectural forms.[34] This impression was manifested in the set construction for the unrealized apartment. The set duplicated a few characteristics of modernist housing such as the minimal number of furnishings (a television, a radio, a drawer, two wooden armchairs, a table and two steel chairs, and a mattress), the exclusion of decoration, and chromatic restraint in the painting of interiors. As Anthony Vidler remarks, the overemphasis on functionality in modernist urban architecture, coupled with the elimination of other redundant elements, was originally grounded in the conception of the building as a "'machine for living in,' with the implication that a smoothly running machine, tailored to the body's needs, was modernity's answer to the proportional and spatial analogies of humanism."[35] Douglas's imagination of the unrealized housing plan criticizes this conception by infusing a kind of inhuman and claustrophobic atmosphere into the set. Because of its confined space and its lack of anything that makes the two protagonists feel at home, the apartment looks like a merely temporary accommodation for the two residents' minimal rest after a working day—its comforts consisting of little more than watching TV or listening to radio. In this sense, their verbal and physical antagonism can be read as symptomatic of the apartment's impossible attempt to satisfy the bodily and sensual demands or desires of its inhabitants. The discordance between the original intent of the apartment and the protagonists' neurotic state of mind amplifies the sense of the unhomely that Vidler describes as "the precarious relationship between psychological and physical home."[36]

In both formal and structural senses, *Win, Place, or Show* exemplifies a transition from Douglas's synthetic works to his later recombinant narrative experiments. As he did in *Der Sandmann,* Douglas explores and reveals the spatial gaps that inhere in the construction of cinematic narrative space. This time, the method of

maintaining spatial continuity—shared by both feature film and television show—is his object of research. Instead of sustaining spatiotemporal continuity by orienting an action shot from different angles within the same side of the frame, so that the viewer can identify with the imaginary coherence of diegetic space, Douglas creates a series of shots that are in and of themselves separated. Sometimes there is a series of two shots—for instance, shots of the two protagonists fighting—viewed from the same side but from two adjacent positions, creating an impression that "each character exists within his cinematic space and then crosses into the other character's space."[37] Douglas exerts further variations on two different camera angles to the extent that dialogue is sometimes divided into close-up shots, each occupying two opposite sides of the imaginary 180 degree line—overtly transgressing the conventions of continuity editing.

Undoubtedly, these shots are combined with the two-channel video projection format, evocative of the seam in *Der Sandmann,* and thus they echo Douglas's ongoing fascination with the double that coexists in front of the viewer but is inherently divided into two screens (Figure 11.3). And yet, what the spectator witnesses is not the continual division of the past and the present of the same place, as in *Der Sandmann,* but the fragmentation and overlapping of a single spatiotemporal construct. Unlike the continuous 360 degree pan in *Der Sandmann,* the fixation of camera position in *Win, Place, or Show* invests itself in realistically capturing the confined staging of the scene. This representational strategy is aided by the work's projection onto two adjacent surfaces. Providing about 2.66:1 aspect ratio of its size, this multiplication of the screen's surface provides the viewer with an all-encompassing view that evokes the widescreen. Viewers' optical mastery over the diegetic space is, however, perpetually disturbed and eroded by the persistence of the gap in the middle of the screen, thereby finally leading them to recognize its instability. Like Nathanael and the Sandman, the two protagonists appear at the edge of one image on some occasions and disappear into the gap on others. Viewers bridge the perpetually emerging interstice of the apartment interior, but the work's form enforces the sense that the two characters are caught in the web of mutual friction, each of them doubled continually. As Hans D. Christ observes, in this way, "the 'totalitarian' spatial concept . . . is transferred, not into the structure of a historical performance, but rather into a claustrophobic, fragmented, disastrously inexorable constant, within which the action abides by the dictates of the space."[38] But more than this effect, the combination of shooting and projection, as in the case of *Der Sandmann,* functions to destabilize the piece's narrative space and the convention of continuity that renders it unmediated and seamless. The work compels viewers to consider how the piece's site specificity is mediated by

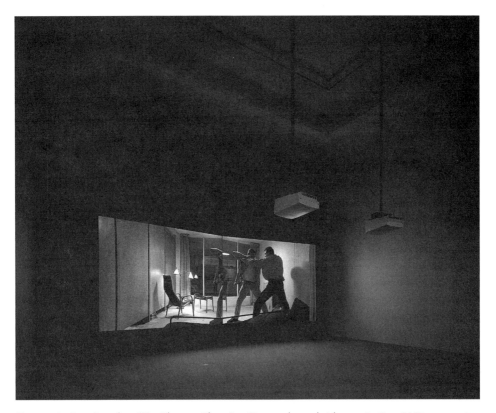

Figure 11.3. Stan Douglas, *Win, Place, or Show* (1998), two-channel video projection, DVDs, computer, color, sound, approximately twenty thousand hours for 204,023 variations, with an average duration of six minutes each. Installation view, Vancouver Art Gallery, British Columbia, Canada. Courtesy of the artist and David Zwirner.

a couple of key "discursive vectors" that represent the historical and social conditions of Vancouver. These discursive vectors are, first, Douglas's own cinematic construction of fictional working-class urban housing and, second, *The Clients,* to which he refers in his research on the redevelopment plans of the 1950s.

Thus what makes *Win, Place, or Show* distinct from *Der Sandmann* in terms of the troubling of the relation between the imaginary (the depicted place) and the real site (the exhibition space as well as Vancouver itself) lies in its time frame within which viewers contemplate the art of the moving image inside the gallery wall. More than deconstructing the convention of cinematic narrative space and exposing the operation of media via the projection of images onto the screen, as *Der Sandmann* does, this piece makes it impossible for viewers to obtain the whole and coherent picture of the site represented by it. They will not be able to endure the time taken by the putatively infinite number of permutations during their limited visit to the installation site. Instead, they may watch as many different versions of the work's sequence as possible, but what they see will be contingent on the

moment they enter the installation and the duration of viewing to which they are willing or capable of submitting themselves. Accordingly, visitors' experiences of the work will differ from one another's. In this sense, a recombinant work like *Win, Place, or Show* makes contingent the temporal condition of the exhibition place that influences our perception of the artwork. The implication of this contingency can be understood in reference to art critic Boris Groys's argument about how the incorporation of moving image installations into the museum reconfigures the relations between viewer and artwork as well as the temporality of the viewing–visiting experience. In a traditional museum displaying static artworks such as paintings and sculptures, the amount of time spent observing an artwork is at the viewers' disposal. Because the duration of moving image installations is ultimately out of viewers' control, such installations, according to Groys, rob viewers of their autonomy—that is, their freedom to make an aesthetic judgment in an undetermined time of contemplation. Viewers then realize that they cannot decide where these works begin or conclude, thus whether they "stay put or . . . keep moving . . . [their] choice will always amount to a poor compromise—which will later need to be repeatedly revised."[39]

Seen in this light, Douglas's recombinant works challenge the myth of viewers' total control over the artwork (as it is experienced in the traditional museum) by tremendously enlarging the works' time frame, by making their beginnings and endings look arbitrary, and by throwing their deployment of events into a state of uncertainty. This means that viewers themselves are produced by the artworks as decentralized and inconclusive subjects. However, this is also the case with the exhibition place *as such* in terms of Groys's further comment on the effect of installing the art of the moving image within the gallery walls: "The museum visitor now suddenly finds himself back in a situation similar to life outside the museum, returned to that familiar place we all know as somewhere where we constantly miss out on anything of importance."[40] Douglas's strategies of introducing uncertainty deconstruct the aura of eternity and transcendence as it is promoted in the white cube of the traditional museum and thereby draw viewers' attention to the two material forms constituting his work of art: the form of cinematic narrative and the form of computer-based random algorithm, both mediating our everyday life and our understanding of time and place.

Douglas's body of work exemplifies the degree to which the art of projection contributes to expanding the horizon of site specificity by interlacing multiple—historical, geographical, observational, and textual—layers that influence the meaning of a site and by channeling them into the reworking of the forms and techniques shaping his projected images. Articulating the site as doubled, erased,

inscribed, or temporally indeterminable, the images give viewers the opportunity to perceive their surroundings as part of MediaSpace—as the material space conditioned by the constitution of media. Therein opens the very possibility that the art of the moving image inside the black box sheds a new light on the meaning of both imaginary and real place as historically conditioned and subject to chance.

NOTES

1 Dominique Païni, "Should We Put an End to Projection?," trans. Rosalind Krauss, *October* 110 (Fall 2004): 24.

2 On the apparatus theory, see, e.g., Jean-Louis Baudry, "Ideological Effects of the Basic Cinematographic Apparatus," in *Narrative, Apparatus, Ideology: A Film Theory Reader,* ed. Philip Rosen, 286–98 (New York: Columbia University Press, 1986); Baudry, "The Apparatus: Metapsychological Apparatus to the Impression of Reality in Cinema," in Rosen, *Narrative, Apparatus, Ideology,* 299–318; Christian Metz, *The Imaginary Signifier: Psychoanalysis and the Cinema,* trans. Ben Brewster (Bloomington: Indiana University Press, 1982).

3 Chrissie Iles, "Between the Still and Moving Image," in *Into the Light: The Projected Image in American Art 1964–1977,* ed. Chrissie Iles (New York: Whitney Museum of American Art, 2001), 33.

4 For a brief but illuminating overview of this tendency, see Chrissie Iles, "Video and Film Space," in *Space, Site, Intervention: Situating Installation Art,* ed. Erika Suderburg, 252–62 (Minneapolis: University of Minnesota Press, 2000).

5 See Brian O'Doherty, *Inside the White Cube: The Ideology of the Gallery Space,* exp. ed. (Berkeley: University of California Press, 2000).

6 The term *black box* is indebted to Ursula Frohne. See her "Dissolution of the Frame: Immersion Participation in Video Installations," in *Art and The Moving Image: A Critical Reader,* ed. Tanya Leighton, 355–70 (London: Tate, 2008).

7 Miwon Kwon, "One Place after Another: Notes on Site Specificity," in Suderburg, *Space, Site, Intervention,* 39.

8 Gregor Stemmrich, "White Cube, Black Box, and Grey Areas: Venues and Values," in Leighton, *Art and the Moving Image,* 441.

9 Nick Couldry and Anna McCarthy, "Introduction: Orientation—Mapping MediaSpace," in *MediaSpace: Place, Scale, and Culture in a Media Age,* ed. Nick Couldry and Anna McCarthy (New York: Routledge, 2004), 2. In a similar vein, Arjun Appadurai has coined *mediascape,* a term that refers both to "the distribution of the electronic capabilities to produce and disseminate information" and to "the images of the world created by these media." Apparadurai, "Disjuncture and Difference in the Global Cultural Economy," *Theory, Culture and Society* 7, nos. 2–3 (1990): 298–99.

10 Liz Kotz, "Video Projection: The Space between Spaces," in Leighton, *Art and the Moving Image,* 380.

11 Stan Douglas and Christopher Eamon, "Regarding Shadows: Stan Douglas and Christopher Eamon in Conversation," in *Beyond Cinema: The Art of Projection, Films, Videos, and Installations from 1963 to 2005,* ed. Joachim Jäger, Gabriele Knapstein, and Anette Hüsch (Ostfildern, Germany: Hatje Cantz, 2006), 18.

12 Kwon, "One Place after Another," 46, 56–57.

13 Kathryn Hixson, "An Interview with Stan Douglas," *New Art Examiner,* December 2000–January 2001, 24–25.

14 For the exhibition at Documenta 11, the work was ensconced in a dark room with two arched doors on its opposite side, which reminded the viewer of the entrance into an isolated space within the Oktogon.

15 Douglas comments on the decision to choose this place: "We know from the face of the now-obsolete thousand deutschmark note that Kassel was home to the Brothers Grimm. . . . The brothers' folklore and philology was ultimately pedagogical, intended to instruct a bourgeois subject." Douglas, "*Suspiria:* Project Description," in *Stan Douglas, Past Imperfect: Works 1986–2007,* ed. Hans D. Christ and Iris Dressler (Ostfindern, Germany: Hatje Cantz, 2008), 206.

16 Douglas here combines the segments from *Fairy Tales* with literary allusions culled from Karl Marx's *Das Kapital.*

17 Rosalind Krauss, "Reinventing the Medium," *Critical Inquiry* 25, no. 2 (1999): 296. In fact, her notion of "reinventing the medium" has some shortcomings that make it difficult for it to be comprehensively applied to understanding how various film and video installation works engage with the reconstruction of cinematic image and apparatus in their explorations and applications of media technologies and conventions. For this point, see my "The Post-medium Condition and the Explosion of Cinema," *Screen* 50, no. 1 (2009): 114–23.

18 In this sense, I agree with Sven Lütticken's remark that "just as film haunts many of his video works, video haunts the film." *Stan Douglas: Inconsolable Memories* (Vancouver, B.C.: Joslyn Art Museum, Vancouver, and Morris and Helen Belkin Art Gallery, University of British Columbia, 2005), 126. As with *Inconsolable Memories,* a complex adaptation of Tomás Guttièrrez Alea's 1968 film *Memorias del subdesarrollo [Memories of Underdevelopment],* Douglas experiments with the syncopation effect between two image tracks by means of two intermeshing 16mm reels. Both loops in this piece have their own self-sustained alternations of black-and-white film sequences and blank-film parts, different in length—one is a five-part loop with 28:15 minutes, whereas the other is a three-part loop with 15:57 minutes. Douglas projects both uneven loops onto a single screen simultaneously so that their ordering is made into fifteen permutations that one can endure in just less than eighty-five minutes.

19 "Diana Thater in Conversation with Stan Douglas," in *Stan Douglas,* ed. Diana Thater, Scott Watson, and Carol Clover (London: Phaidon Press, 1998), 29.

20 Scott Watson, "Against the Habitual," in Thater et al., *Stan Douglas,* 33.

21 Ibid.

22 Stan Douglas, "*Der Sandmann:* Project Description," in Thater, *Stan Douglas,* 128.

23 Robert Storr, "Stan Douglas: L'Aliénation et La Proximité," *Art Press*, no. 262 (2000): 7.

24 Iris Dressler, "Specters of Douglas," in Christ and Dressler, *Stan Douglas, Past Imperfect*, 10. Her essay delivers a fascinating and wide-ranging analysis of Douglas's oeuvre in terms of an assumption that his use of narrative and media can be viewed in line with Jacques Derrida's *Specters of Marx*.

25 Reinhard Braun, "Iris into Black: Stan Douglas," in Christ and Dressler, *Stan Douglas, Past Imperfect*, 149.

26 Carol Clover, "*Der Sandmann*," in Thater, *Stan Douglas*, 76–77.

27 This point is what he manifested in an interview: "It's like the inverse equivalent of a CD-Rom, which gives the illusion of freedom, in some ways, whereas this gives the illusion of mutability, of transformation. After a while you realize there's a very strict structure which maintains the order of everything. It's a locked narrative loop which doesn't really change." Daniel Jewesbury, "Neither/ Or, in Conversation with Stan Douglas," *Art Monthly* 4, no. 243 (2001): 3.

28 Daniel Birnbaum, *Chronology* (New York: Lukas and Sternberg, 2005), 20. See also George E. Lewis, "Stan Douglas's *Suspiria*: Genealogies of Recombinant Narrativity," in Christ and Dressler, *Stan Douglas, Past Imperfect*, 43–60.

29 Along with this new housing plan, which propelled the decentralization and deconcentration of the previous high-density urban environments, the postwar urban transformation in North America included the construction of downtown complexes of several office buildings. For a guiding account of this city planning, see Edmund P. Fowler, *Building Cities That Work* (Quebec City, Quebec: McGill-Queen's University Press, 1992), 3–14.

30 For a detailed description of how the work is installed, see Hans D. Christ, "Stan Douglas, *Win, Place, or Show*," in *Present Continuous Past(s): Media Art, Strategies of Representation, Mediation, and Dissemination*, ed. Ursula Frohne, Mona Schieren, and Jean-Francois Guiton, 124–31 (New York: Springer, 2005).

31 Stan Douglas, "Project Description: *Win, Place, or Show*," in Christ and Dressler, *Stan Douglas, Past Imperfect*, 202.

32 Hixson, "Interview with Stan Douglas," 24.

33 For the formal development of the modernist architecture, see Sigfried Giedion, *Space, Time, Architecture: The Growth of a New Tradition*, 5th ed. (Cambridge, Mass.: Harvard University Press, 1967). Also, for the landmark evaluation of its utopian aspiration, see Manfredo Tafuri, *Architecture and Utopia: Design and Capitalist Development*, trans. Barbara L. LaPenta (Cambridge, Mass.: MIT Press, 1979).

34 "The architectural idiom of most of these projects was a variety of modernism so removed from the utopian ambitions of its prewar models that 'truth to materials' became cost-cutting as a means to achieve the lowest possible, and the motto 'form follows function' came to describe monolithic multi-dwelling towers which would symbolize social problems they had." Douglas, "Project Description: *Win, Place, or Show*," 200.

35 Anthony Vidler, *The Architectural Uncanny: Essays on the Modern Unhomely*

(Cambridge, Mass.: MIT Press, 1994), 128. The phrase comes, famously, from Le Corbusier.

36 Ibid., xi.

37 George Wagner, "Historical Evasions," in *Stan Douglas,* curated by Daina Augatis (Vancouver, B.C.: Vancouver Art Gallery, 1999), 89.

38 Hans D. Christ, "At the Right Place: The Films of Stan Douglas in the Museum," in Christ and Dressler, *Stan Douglas, Past Imperfect,* 181.

39 Boris Groys, "On the Aesthetics of Video Installations," in *Stan Douglas: Le Détroit,* ed. Peter Pakesch (Basel, Switzerland: Kunsthalle Basel, 2001).

40 Ibid.

12 | Doing *Away with Words*: Synaesthetic Dislocations in Okinawa and Hong Kong

ROSALIND GALT

Across his work as a cinematographer, photographer, and director, Christopher Doyle's images seem to work against claims on materiality. His color-saturated cinematography for directors like Zhang Yimou, Pen-ek Ratanaruang, and Wong Kar-wai is more decorative than realist, and its abstracted style often focuses attention on the composed surface of the screen rather than its profilmic depth.[1] Thus Doyle seems at first glance to be oddly matched with a project based on the material significance of cinematic location. Yet, if we examine Doyle's own background, the question of location takes on what looks like a defining influence. A white Australian, Doyle has worked almost exclusively in Asia, and he commonly goes by the Chinese name "Du Ke-feng." Self-described as "an Asian with a skin disease," Doyle's rewriting of his own ethnic identity suggests that place holds both a mutability and a determining importance in the location of his own practice.[2] Indeed, Doyle himself sees place as central to his aesthetics. Discussing his approach to narrative, he says that "why this story happens is because it happens *here*."[3]

Thus Doyle presents something of a conundrum: an image maker who is frequently discussed in terms of his transnational biography but whose work is just as often read as asocial formalism. Moreover, he's best known as a director of photography—part of a creative team rather than a singular film author. To analyze "Christopher Doyle" as an author figure is to decenter the terms of a film's own place of origin, opening out different possibilities for designating where it comes from. This relatively unusual situation of attributing a degree of authorial status to a cinematographer adds to the transnational quality of Doyle's reputation because not only is he an immigrant in Asia but his stardom emerges out of a series of collaborations with Asian directors. In certain industrial, critical, and fan circles, Doyle is famous for his visual style, and this brand is closely linked to the resurgence of East and Southeast Asian art cinemas in the 1980s and 1990s.[4]

277

Thus the apparently purely formal account of Doyle (the director of photography with a strong visual signature but no directorial vision) runs in close parallel to his geographically defined histories (Asian New Wave, artist biography). In this chapter, I aim to bring these discourses together, situating Doyle's aesthetics in terms of their material locations and engagement with geopolitical space. I focus on Doyle's directorial debut *Away with Words* (1999), a film that stages these questions of transnational location both narratively and in their formal dialogue with the profilmic.

The film is almost entirely set in two locations: Hong Kong and Taketomi Island in Okinawa, Japan. For the most part, Hong Kong constitutes the narrative present, where our directionless protagonist Asano has jumped ship and found himself in a dive bar owned by Kevin, a drunken ex-pat Englishman. Kevin lets Asano stay with him, and joined by Kevin's Singaporean friend Susie, the two men drift around the city's gay bars, noodle shops, and garment factories. The narrative is attenuated, and time spent in Hong Kong is heavily overlaid with Asano's dreamy memories of his childhood in Okinawa. Taketomi is part of the remote Yaeyama Islands in the far south of Okinawa, and these flashback and fantasy sequences focus on the white coral roads, traditional houses, and beaches characteristic of Taketomi. The two locations are clear opposites, with the hyped-up consumerism and seedy glamour of Hong Kong contrasting with the peaceful, premodern landscapes of Taketomi. Hong Kong as world city and filmmaking center is also a highly recognizable location, representationally codified, with each late-night noodle shop or sign-filled street evoking a history of cinematic reference. Taketomi's beach roads, by contrast, might be anywhere as far as most spectators are concerned. On the very margins of Japan, Taketomi is at once a highly specific location and one that resists the use of conventional national landmarks to identify place.

The contrast between these two places grounds the film's narrative of geopolitical displacement. Hong Kong is a real place to Asano but one in which he is alienated and cannot feel at home. (The same can be said for Kevin and Susie, as all the main characters are immigrants.) Taketomi, meanwhile, is Asano's home, but it is a place that exists largely in memory. The film's formal strategies chart these subjective relationships. Hong Kong is represented in a more realist manner, but from the start, it is defined as not-home. From the opening sequence of the beach in Taketomi, we cut to Asano arriving in Victoria Harbor. This precredit section uses a landmark view of Hong Kong to orient the spectator but also to emphasize the difference between the tiny beach and the huge harbor. As the film continues, we see few such long-range perspectives of the city, instead spending much of our time inside Kevin's bar or in the police station. Exteriors are limited in perspective

and composition so that we never really get to think of Hong Kong as a clichéd and familiar place. Defamiliarization codes Asano's sense of foreignness. But the heart of the film is its construction of Taketomi, which is highly aestheticized, formally and narratively complex, and yet with an insistent return to the same beach road location. Characters appear there out of narrative time and place, and a series of camera and lighting effects are used to trouble any sense of unmediated reality. Yet this beach and road in Taketomi draw the spectator in, promising, if not answers, then at the very least truth. One thing is clear: this place matters (Figures 12.1 and 12.2).

In the apparent mismatch between the film's abstract aestheticized images and its concern for Taketomi as a profilmic place, a geopolitical style emerges. *Away with Words* takes location as its expressive material, avoiding common markers of authenticity or denotative realism in favor of an aesthetics, in Susan Buck-Morss's sense of the word.[5] Buck-Morss returns aesthetics to the entire domain of experience, pointing out that "the original field of aesthetics is not art but reality—corporeal, material nature. . . . It is a form of cognition, achieved through taste, touch, hearing, seeing, smell—the whole corporeal sensorium. The terminae of all of these—nose, eyes, ears, mouth, some of the most sensitive areas of skin—are located at the surface of the body, the mediating boundary between inner and outer."[6] In *Away with Words*, Doyle's images of Taketomi propose exactly this kind of relationship to the object world, using the surface of the screen to elaborate an intense, if oblique, sensation of place. Colors, materials, and forms make constant demands, emphasizing their ontological specificity at the same moment that they exceed or displace their denotative meanings. And all the senses are mixed: the figure that best describes Doyle's engagement with place is synaesthesia.

This first half of this chapter will explore synaesthesia as the means by which Doyle articulates place. It is important to understand how place is expressed in *Away with Words* before we can recognize the significance of specific locations, not least because synaesthesia as a representational mode is not a random choice but is itself bound up with the histories of both cinema and East Asian aesthetics. In the chapter's second half, I will turn to the film's narration of Okinawa (and, to a lesser degree, Hong Kong) to consider why these places need to be imagined synaesthetically and, more broadly, how these places matter. Taketomi becomes a set of material signifiers, offering meaning in the form of sensory experience: taste, smell, and touch as well as sound and image. Places speak in an intimate aesthetic that closely links sensory experience with the geopolitical. The sensory material of place is more important here than written or spoken language. In the opening credits, the painted words of the title dissolve in water, words washed

Figure 12.1. Taketomi's distinctive beach roads frame Asano repeatedly in *Away with Words*. Christopher Doyle, 1999.

Figure 12.2. The image is aestheticized and decomposed but always readable as this same place.

away literally and visually so that the sensory experience of being in a (watery) place can take over. *Away with Words* works to develop the expressivity of sensory perception, the aesthetic and synaesthetic, as a way to tell stories. The reason this story happens is because it happens *here,* and the material nature of here is the stuff of storytelling. For Doyle, it is the experiential sense of place that allows us to do away with words.

PEACOCK FEATHER : SOFA

As a psychological condition, *synaesthesia* is narrowly defined as occurring "when an individual who receives a stimulus in one sense modality simultaneously experiences a sensation in another."[7] In the literature of aesthetics, it has often been expanded to encompass evocations of sound or taste in writing or of color in music. Synaesthesia is a slippery idea: the medical definition, while intriguing, is experienced only by a tiny percentage of the population, whereas the rhetorical figure spreads out so far as to include any sensory metaphor. (Common examples are a *loud shirt* or *bitter cold*.) Moreover, the idea of correspondences among the senses has historically attracted a dubious mysticism. As E. H. Gombrich says, "this is dangerous ground, a favorite haunt of cranks and madmen, and yet I think it is ground that must be traversed. . . . What is called synaesthesia, the splashing over of impressions from one sense modality to another, is a fact to which all languages testify."[8]

This is a figure, then, around which we should tread lightly. So why is synaesthesia apt for thinking about Christopher Doyle's screen images? First, Doyle's cinematography has been directly associated with the expression of meaning through sensory impressions. Wong Kar-wai describes him thus: "Chris Doyle is like a jazz musician. We don't discuss the light, we don't discuss the camera angles. . . . For him, he needs to know the rhythm and color of the film. The color is not actually the color red or blue, it's his feelings toward the film."[9] Here framing signifies sound and colors evoke emotion. Doyle's visual style self-consciously deploys a synaesthetic process of meaning-production, and thus, by interrogating this process, we can get at the stakes of surfaces, color, and abstract composition in the construction of his images.

Second, this process is foregrounded in *Away with Words* because Asano is a synaesthetic. For him, every experience triggers layers of memory. The film opens with Asano in voice-over describing his sensory world: "Thirteen is blanket, one is matchstick, three is orange." Asano's speech immediately makes a claim on a particular semiotic mode of synaesthesia. He doesn't simply hear colors or taste sounds; rather he swaps numbers for objects. Words become things, and abstract

signifiers take on material form. This problem of language structures the narrative of *Away with Words*: Asano is a Japanese man alone in Hong Kong, while Kevin is a white Englishman. Neither speaks Cantonese well, and so the main language of the film is one that both its protagonists translate badly. Signifiers unmoor from their proper referents, and memories, images, and places float and recombine promiscuously. The splashing of impressions is all that allows communication to occur at all.

This sensory splashing has not been universally appreciated. Though *Away with Words* played extensively at film festivals, particularly queer-oriented ones, it was not critically lauded. Peter Brunette, for instance, dismisses it as "almost unwatchable."[10] This difficulty might speak to the tendency of synaesthetic rhetoric to suggest eccentricity, a detaching of rationality and clarity of thought. Certainly no one has ever accused Doyle of aesthetic restraint. But *Away with Words* is not simply incoherent; rather synaesthesia centers a discourse that links the surface of the screen, the problem of language, and the geopolitics of dislocation. Doyle has defined cinematography in terms of "how a color suggests a certain emotion," and he locates this rhetoric in relation to Chinese medicine, cosmetics, and alchemy.[11] Not surprisingly, one of the main sources of synaesthetic representation in the film is color. The narrative is framed by two sequences on the beach at Taketomi, the remote Okinawan island where Asano grew up. He connects the experience of water to a peacock feather and brings a piece of wood painted with a peacock pattern with him from Taketomi to Hong Kong. In turn, the peacock feather comes to signify the sofa in Kevin's club, which is a similar shade of royal blue. The patterned wood is a souvenir of home, even though Asano is the last person in the world to need to carry an object to help his memory. It works, not as a prosthetic memory for someone who might otherwise forget, but as a material signifier, a synaesthetic object of exchange. Blue articulates the sensation of being in water to the safety of Kevin's sofa, and so Okinawa becomes Hong Kong.

Instances of this color logic proliferate throughout the film. In voice-over, Asano says he likes Kevin because of the colors Kevin uses when he talks. In a point-of-view shot, he experiences the ringing of a doorbell via flashing neon lights on the ceiling. Critics have often pointed to this feature of Doyle's style. Stephen Teo, writing on *Happy Together*, argues that "Doyle's cinematography reflects the subjectivity of his characters and their psychic energy. Color is the principal means of expression: the chroma is heightened; gold turns into an aggressive orange and red; there is bright yellow; the blue is hallucinatory like the light we see on recovering from an anaesthetic after an operation. Doyle uses color in a Fauvist manner, basing it on feeling, choosing color to fit sensation rather than

reality."[12] Teo's turn to art history to explain Doyle's colors speaks to synaesthesia's mixing of media and also points to its importance in the literature of modernity.

The most productive example of this criticism for cinema is Eisenstein's writing on synaesthesia. In "Synchronization of Senses," Eisenstein contextualizes sense-transfers in film within a broad history of aesthetics. In addition to glossing philosophical accounts such as Schlegel's, he draws on the ways that synaesthesia has been mobilized in other art forms, from eighteenth-century ocular music through Rimbaud's color sonnet "Voyelles" to visual artists like El Greco and Whistler. This history of synaesthesia is echoed in a critical literature that traces the emergence of aesthetic synaesthesia in romanticism, a fad for music–color apparatuses in the late nineteenth century, and a series of modernist sensory experiments that include Mondrian's *Broadway Boogie-woogie* and Messiaen's color-music.[13]

For Eisenstein, this aesthetic history opens complex possibilities for sound–image relations, and the figure undergirds his ongoing development of the concept of montage in *Alexander Nevsky* and *Ivan the Terrible*. For my purposes, though, I want to limit my focus to three qualities that his analysis emphasizes. The first is history: though many theorists have insisted on universal schemas (e.g., Schlegel claimed that the letter *I* corresponded to blue, love, and sincerity), Eisenstein debunks synaesthesia's mysticism and uncovers the social and political anecdotes that construct each association. Thus red signified revolution in the Soviet context but meant the exact opposite when it was taken up by aristocrats in revolutionary France.[14] The point is perhaps obvious, but it reminds us that an analysis of sensory qualities is not formalist but might be quite materialist in orientation.

His second addition is cinematic specificity. Eisenstein elaborates not only sound–image relations but the significance of sense-transfer to theories of film in general. Thus he writes:

> But that is all very well for Disney in the medium of the animated cartoon: just you try and make a real pair of trousers produce a trembling, shivering line—a physically non-existent line—which can separate the shape of a leg from its background, or sing to the tune played on a saxophone, etc. So what can be done when filming real things? The only available resource is the changing interplay of graphic shapes within the shot and in montage, the contrast of textures, and the play of light on shapes and textures.[15]

Synaesthesia, for Eisenstein, is not simply one aesthetic option among many for cinema, as it would be for poetry or music, but is a central concern for a multisensory medium. Moreover, he suggests that the challenge for filmmakers is

negotiating not only the relationships among senses but the relationship between senses and real things. Again, synaesthesia demands a relationship between film and the profilmic, accessing foundational questions of representation and reality.

Last, it seems suggestive that Eisenstein repeatedly locates the inspiration for his cinematic synaesthesia in the visual and linguistic cultures of Japan. Just as his work on montage draws on the ideogram, so his analysis of synaesthesia is grounded in the techniques of transfer and materiality in Kabuki theater. In "The Unexpected," he writes, "In place of *accompaniment,* it is the naked method of *transfer* that flashes in the Kabuki theater. Transferring the basic affective aim of one material to another, from one category of 'provocation' to another." Eisenstein concludes that this structure of aesthetic transfer penetrates "all aspects of the Japanese world-view."[16] Eisenstein's synaesthesia, then, might be closely matched to Doyle's practice, which also deploys East Asian aesthetics in the service of a nominally Western cinema. Doyle is fond of citing the difference between Eastern and Western notions of composition as well as Chinese color theories. The synaesthetic nature of Japanese culture could well be another influence, but a less essentializing move is to consider the material transfer of nationalities and artistic identities that Doyle performs. Mixing white and Asian names and locations, Doyle's biography and aesthetic practice embody the process of sense-transfer that Eisenstein describes in Kabuki.

This cultural displacement explains the film's close articulation of sense-transfers to language and location. Asano's synaesthetic connections are structured by a series of flashbacks from the narrative present in Hong Kong to his childhood in Taketomi. Hong Kong is experienced through Japanese memories, but whether visual, auditory, or linguistic, the work of translation is imperfect at best. In one flashback, we cut from a recurrent memory of the beach road in Taketomi to an intertitle listing equivalences written in Japanese and English: shark = bus stop, shrimp = wooden stick, turnip = school bus, red snapper = bathtub, peacock feather = sofa. Most of the connections seem nonsensical, but the spectator does know how peacock feather equals sofa. Soon after this scene, Asano tells Kevin that shrimp for him tastes like wood, belatedly explaining shrimp = wooden stick.

These idiosyncratic equations stage a personal experience of synaesthesia, but it is not only Asano who has language problems. Kevin's Cantonese is so bad that every time he gives a taxi driver his address, he ends up at the police station. In Buck-Morss's terms, if Asano is a synaesthetic who registers the excesses of modern experience across the surface of his body, then Kevin figures the equally modern response of anaesthetics, numbing himself with alcohol to the point

where he cannot experience much at all. Kevin's friend Susie attempts to mediate these extremes but is ultimately ineffective. In a scene where she tries to befriend Asano, her voice-over is in Cantonese, his in Japanese. While the spectator watches the film with a unifying subtitling language, it is clear that the characters cannot communicate. Although the spectator is in a privileged position here, she is never allowed a natural relationship to language. Even a Japanese, Cantonese, and English speaker would be displaced from the cryptic intertitles that express Asano and Kevin's semiotic disjunctures. Thus *Away with Words* deploys synaesthesia to articulate both a particular experience of cultural displacement and the imbrication of cinematic signification with geographically located language systems. Distributed via the film festival circuit, *Away with Words* depends on the transferability of global art film aesthetics. At the same time, its textual system disintegrates this comfortable universality, constructing language, image, and objects as intertwined sources of cultural friction.

OKINAWA : HONG KONG

In *Away with Words,* synaesthesia connects sensory displacement in the text with larger geopolitical displacements. As we have seen, the film moves between two very different locations: Hong Kong and Taketomi Island. Hong Kong is figured in the film as an involuted warren of dive bars and alleys, whereas Taketomi is conjured as the abstracted and color-saturated beach of Asano's memory. What these places share is a lack of coherent national identity: in fact, their juxtaposition sites a precise mapping of twentieth-century geopolitical dislocation. Hong Kong has long signified the cosmopolitan; a multilinguistic hub of colonial global traffic, whose cinematic image has recently refracted the spaces of postcoloniality and the identity crises of Chinese capitalism. Taketomi, on the very edge of Japan, is as ancient as Hong Kong is modern. The home of the indigenous Ryukyu culture, Taketomi also names a modern history of Asian geopolitics. The islands have been Chinese and Japanese, as well as American, occupied, and their strategic importance has produced a different kind of transnational influence on their beleaguered native cultures.

It might place too much weight on Doyle's own transnational identity to insist on a connection, but his first feature film nonetheless enters intimately into a location that, like him, eludes nationality. It is significant that this is not Doyle's own story: it is a foreign one, refusing easy autobiographical interpretation, and yet, like synaesthesia, it performs a transfer, displacing experiences of attachment and transnational belonging to another place. And Okinawa is not just any other

place but somewhere historically defined by its simultaneous national marginality and regional centrality.

Okinawa is first of all marginal to Japan. Geographically distant from the main islands and nominally independent for much of their history, the islands of Okinawa were only incorporated into the Japanese state in 1879. Julia Yonetani posits the nineteenth-century understanding of the islands as neither *gaichi* (outside Japan) nor *naichi* (inside Japan).[17] This ambivalent state continued in the twentieth century, enabling the easy transfer of Okinawa to the United States after World War II. Okinawa was categorized as already not a part of Japan, and the Potsdam Declaration of 1945 stated that "Japanese sovereignty shall be limited to the islands of Honshu, Hokkaido, Kyushu, Shikoku and such minor islands as we determine."[18] Despite their importance in the war, the Ryukyu Islands were not important enough to be named in the peace treaty. When Okinawa was excluded from the 1947 Japanese Constitution, the population became effectively stateless. It was only in 1972 that Okinawa reverted to Japan and became a prefecture,[19] and Nishitani Osamu describes the continuation of this sense of Okinawa as a borderland: "Okinawa is part of Japan but at the same time it is not. In every sense. Geographically, historically, culturally—Okinawa remains the 'internalized Other' to Japan."[20] A displaced relationship to national identity, then, grounds Okinawan identity.

Moreover, Taketomi is marginal even within the geography and history of Okinawa. The name "Okinawa" is often used for the entire island group and is the official name of the prefecture, but the name derives from and can refer to the main island of the group. (It is for this reason of inclusivity that many institutions have returned to the older name "Ryukyu.") The Yaeyama Islands are called *Saki-shima,* or "outer islands," and have long been perceived even within Okinawa as remote and perhaps backward. In his 1958 history of Okinawa, George H. Kerr writes, "A melancholy sense of isolation and a longing for recognition at the capital permeates the songs, dances, and folk tales of *Saki-shima*."[21] Moreover, if Yaeyama is at the remote edges of Okinawa, Taketomi is a tiny island in that already small group. Kerr does not count it as a "settlement of consequence," and many maps of Okinawa don't even show Taketomi. As Okinawa is to Japan, so Yaeyama is to Okinawa, and Taketomi to Yaeyama. Asano's beach is not just any threshold but the very edge of Japanese nationhood, nested in its marginality.

But the other side of Okinawa's marginality is its centrality as a crossing point in the Pacific, valued by each great power in the region. Of course, its military value is well remembered in the context of World War II, where the Battle of Okinawa was the only land battle on inhabited Japanese soil.[22] The postwar U.S.

Figure 12.3. Taketomi as geopolitical threshhold.

occupation took advantage of the islands' strategic position close to China, Japan, Taiwan, and Korea. But well before the last century, the Ryukyu Islands juggled Chinese and Japanese influence, their position overdetermining their political and cultural independence. And there is a longer history of transnational exchange: Kerr traces a prehistory of ethnic mixing and global transits crossing Okinawa, including Chinese, Malay, Manchurian, and Ainu peoples.[23] The cultural history of the Ryukyus is diverse and international, opening (like Hong Kong) out onto Asia. We can also think of this centrality in ecological terms. Gavan McCormack tells us that Okinawa has developed a rich and unique ecosystem such that it contains up to forty-five times more species than the Japanese mainland and is sometimes known as the Japanese Galápagos.[24] The transnationality of the islands comes from their physical location, and hence it is not only part of political history but natural history, too. The star-sand beach that Asano remembers is virtually unique to Taketomi, a tiny figuration of geographical specificity on a global scale.

Thus *Away with Words* takes as its most significant location a place richly freighted with both transnational histories and displaced identities. Repeated rapid tracks along the white coral road to the beach figure a marginal yet open geopolitical space. Asano's memories place him in a virtual tunnel, an enclosed, intimate place that nevertheless leads to a threshold, opening out to the ocean (Figure 12.3). Taketomi is tiny, just a path, but that path leads us to the transnational space of the Pacific. The film's narrative continues this figural trajectory, as

Asano travels from Okinawa to Hong Kong, Tokyo, and China. The beach opens expansively onto the world, but wherever he goes, Asano's memories of that very particular place center his vision. Moreover, these memories insist on a traditional landscape. McCormack reminds us that global geopolitics in Okinawa is in no way separate from the ecology of the islands: "Militarized, and turned into the key to the U.S. chain of East Asian garrisons, Okinawa now faces a choice between being incorporated in the nation-state-centered regional and global order as a hyper-peripheral, hyper-dependent backwater to be despoiled by the slash-and-burn of rampant development (ran-kaihatsu) or, alternatively, becoming a base for the creation of the 21st century's new, decentralized, sustainable and naturally balanced order."[25] Taketomi's traditional pathways literally ground contemporary battles over Okinawa's identity.

Underlying contemporary accounts of Okinawa's marginality and centrality is its traumatic history: the islands lost up to one-third of their population during the war, and though much destruction was caused by American bombardment, many Okinawans were shot by the Japanese army that was meant to be protecting them. Still today, one-fifth of Okinawan land is owned by the American military and thus unavailable to the local population.[26] So in the most brutally direct terms, location here is about land and the ways that violent political histories are written into the contemporary landscape. Though Doyle is an outsider to Okinawa, *Away with Words* is in dialogue with recent Okinawan films and literature, which have often foregrounded histories of trauma. Experimental filmmaker Takamine Go, for example, narrates the stories that his parents told about a landscape covered in corpses after the Battle of Okinawa. He writes, "When I'm looking at the landscape I'm not an outside observer. I wanted to try to capture the smell of death in the landscape with my 8mm camera. Of course, 8mm film is a visual medium, but I wanted to absorb the smell by looking."[27] For both filmmakers, the apparently innocent landscape can speak of history, but only in a synaesthetic process of sensory transfer.

Michael Molasky argues that whereas contemporary Japanese literature often poses binary U.S.–Japanese relations, Okinawan literature constructs multinational and multilinguistic tensions.[28] His prime example is *The Cocktail Party* by Ōshiro Tatsuhiro, which sets Japan, the United States, China, and Okinawa in relation via protagonists who speak these four languages. He reads the novel, in which an Okinawan girl is raped by an American, as a Jamesonian national allegory of occupation. *Away with Words* offers a less overtly political narrative, but in its multilinguistic and international staging of Okinawa's place in the world, it similarly refuses to conceive of Okinawa solely in relation to Japan. The thematic issues

that it raises—those of language, emigration, and memory—are equally weighted ones in the Okinawan historical imaginary. The issue of language, for example, has been a site of contestation and violence in successive political regimes. In the early twentieth century, Japan attempted to suppress forcibly the native Okinawan languages, whereas during the occupation, American forces tried to persuade Okinawans that they were not Japanese.[29] Thus refusing to speak Japanese was a (dangerous) act of resistance until 1945, but speaking it became so in the postwar era. Asano's mistrust of language links the aesthetics of synaesthesia to the corporeal politics of Okinawan culture. Likewise, mass emigration is a major social and economic issue in modern Okinawan history. Overpopulation and economic underdevelopment forced generations of young people to migrate to Japan's urban centers, to the Americas, or elsewhere in Asia.[30] After World War II, the problem multiplied as so much land was destroyed or expropriated by the American military. Asano's trajectory from Taketomi to Hong Kong to Tokyo, then, evokes a traumatic Okinawan history of emigration, loss of self, and memory of home.

For *Away with Words,* located objects articulate the experience of displacement. As a child, Asano recites airplane schedules, but as an adult, he is reminded of home in everything: shark, blue, shrimp. Asano sees Taketomi in abstract memories, a constant iteration of houses, road, and beach that never quite takes him back. Toward the end of the film, the Cibo Matto song "Sugar Water" reminds him of an attempt to re-create Taketomi in the city, at a fake indoor beach in a mall. He tries to create one space out of the experience of another, but this cannot work. Like the penguins and polar bears that are cut into the sequence, he is trapped in the wrong kind of water. Sliding down a flume, Asano searches for the experience of the coral road tunnel that opens onto the ocean, but the managed sensation of the water park is an inadequate replacement. As the sequence continues, the image degrades, becoming unfocused and layered with abstract shapes. Color, surface, and music become dominant, speaking Asano's distance from the image of Taketomi.

Hong Kong forms an alienated space for each of the displaced protagonists: Susie's independent lifestyle and queer social circle have separated her from her family, while Kevin is constantly having run-ins with the police. Kevin and Susie are exiles, ex-pats, outsiders, and their Hong Kong queers any idea of the local. As Susie says to Asano in a language he can't understand, "I miss my home, too." In both Taketomi and Hong Kong, the real things of which Eisenstein speaks are places, but places that can never be experienced as national or even transnational. Instead, these shards of place are both fragmentary and material, intense evocations of objects that embody a system of dislocated locations.

DOING *AWAY WITH WORDS*

This chapter began to think place from the formal qualities of the image, gradually approaching its material referent. As we get closer to Asano's Proustian beach, we home in on the specificity of Taketomi: why this island, this beach? As the examples of Takamine Go and Ōshiro Tatsuhiro demonstrate, Okinawa Island is more easily incorporated into a national allegory or used to evoke the specters of World War II. But Taketomi does not easily articulate this exact historical trauma, even though the impact of the Battle of Okinawa and American occupation hit hard on the entire prefecture. Asano's story is an Okinawan story of emigration and displacement, but it is grounded in a very local sense of belonging, an intense investment in this place in particular. If we consider Taketomi's location within Okinawan politics, its natural landscape, traditional built environment, and sheer distance from the main islands evoke a discourse of primitivism that has shaped both the island's history and its present spaces. Taketomi bespeaks a concept of Okinawa as a primitive, quasi-colonial outpost, object of the Japanese imperial gaze and now of a globalized tourist gaze. That could-be-anywhere tropical beach in fact embodies a very particular intersection of global politics and image culture.

In the early twentieth century, Okinawa's semi-Japanese status led to the region being treated similarly to Japan's colonies. Like Korea and Taiwan, Okinawa was often viewed in public discourse as backward and premodern, and as with the colonial regime of vision in Europe, this disparaging discourse was married to an intense visual fascination. Alan Christy describes the 1903 Fifth Industrial Exhibition in Osaka, which exhibited a "House of Peoples," showing a Japanese man with a whip and a selection of "primitive" peoples, including Koreans, Taiwanese, and Okinawans.[31] Moreover, Christy finds that even writers who included Okinawa as part of Japan felt that to travel south in the islands was to travel into the past. Yanagita Kunio recounts a 1924 trip in which he describes Oita Prefecture (already in the south of the country) in terms of the present, but by the time he reaches Yaeyama, he focuses entirely on the past. "Time itself has collapsed for the people in the Yaeyama islands so that they are just beginning to forget what we forgot long ago."[32] To look at Taketomi is to invoke this primitivist history. Asano's inability to forget is not, it seems, a random cognitive trait but the precise characteristic ascribed to the Yaeyamans by Japan's colonial gaze.

The contemporary correlative of the House of Peoples is the rise of the tourist

industry in Yaeyama from the 1970s onward, in which the outer islands are presented as an exotic destination for the Japanese market. Around the reversion to Japan, mainland businesses bought much land on the smaller islands, creating, in some places, the kind of unchecked overdevelopment that McCormack critiques. The exoticizing gaze of tourism is, of course, linked to a cinematic investment in images of exotic others and beautiful locations. Mika Ko has identified a quasi-orientalist gaze in Japan's contemporary cultural interest in the region, an "Okinawa boom" in which images of Okinawa feed a desire for an exoticizing multiculturalism.[33] Aaron Gerow links these trends, charting a postreversion growth in tourism-themed films, in which Okinawa provides the utopian space in which mainland Japanese characters can find themselves.[34]

The recent history of Taketomi both extends and complicates this unidirectional primitivizing gaze. In response to destructive development, local government passed the Taketomi Island Charter in 1986, effectively turning the island into a historic preservation area. Only traditional one-story structures can be built, and the island has preserved its historic environment, including coral roads, shrines *(on),* and transportation by water buffalo cart. In some respects, this kind of heritage tourism enables contemporary forms of primitivism. To take an example of this kind of language, the Hirata tour company's publicity materials promise, "A short ten minute ferry ride will take you back to the past on Taketomi Island."[35] Clearly the tourist economy deploys this fantasy of time travel to a premodern culture. However, Taketomi's preservation model doesn't simply create a faux experience of history but combines environmental protection with an effort to sustain local culture and to nourish counterhistories. Philip Rosen has outlined the relationship between tourist sites and cinema in contemporary preservation culture, and in Taketomi, we find an iteration of heritage culture whose response to the exoticizing gaze is its investment in the historical materiality of place.[36]

This response, I would argue, is written into the image-language of *Away with Words.* Its images of *on* and red-tiled houses as well as the coral roads and wild beach invoke not only a familiar Western trope of tropical tourism but also the Japanese quasi-colonial clichés about Yaeyama. Doyle cites the cliché extensively, although he also counters it briefly by showing Asano's family home as impoverished. For the most part, though, like Taketomi itself (or rather its people, collectively), the film takes on the clichéd signifiers of place, insisting on the weight and political potential of their material histories. Unlike the films that Gerow discusses, *Away with Words* centers on an Okinawan protagonist, and his subjectivity focalizes our

view of Taketomi. In his childhood memories, Asano takes milk to an *on* by the beach, watched carefully by some of the island's feral cats. In another flashback, children play on the roof of their building. But there is no touristic long shot across the island, no sweeping track past folkloric details. Instead, the signifiers remain enclosed in Asano's subjective memory, flourishing in their own ecosystem but not wholly available to the outsider. Ethnographer Arne Røkkum has written that the Ryukyu language works only in concrete terms so that "images, substances, and movements draw on an experience from within a bounded island ambience."[37] Doyle's technique of synaesthesia performs a similar work, preserving the specificity of Taketomi's place and experience.

For Eisenstein, synaesthesia is necessary for a cinematic engagement with representation in modernity. *Away with Words* explores this aesthetic claim in terms of postmodernity. However, the film's fragmentary style is not simply a postmodern refusal of meaning; rather Taketomi and Hong Kong form opposing versions of contemporary spatial experience. Hong Kong is frenetic, diasporic, and forgetful, embodying the influential urban models of Fredric Jameson and David Harvey as well as echoing, in the impossibility of belonging in place or time, Ackbar Abbas's account of the colony's prehandover melancholia.[38] Taketomi, meanwhile, is a heritage site, preserved and displayed in postmodernism's nostalgia economy. These are categories often critiqued as inauthentic, but here both spaces promise utopia—Hong Kong as a queer, exilic space of possibility and Taketomi as a sublime memory of communication. Both are places where synaesthetic language can make sense, offering practically the same escape from the structures (and strictures) of modernity.

In the film's final scene, the camera once more tracks down the coral road toward the beach. Wistful and enveloping music plays, creating a privatized enunciative space. We return to the framing shot of the peacock painting floating in the water, but this time, we can read the image (Figure 12.4). In the end, the spectator is enfolded fully into Asano's sensory experience. More important, in elaborating a synaesthetic language, *Away with Words* gathers those aesthetic elements usually dismissed as superficial—cinematography, music, and so on—along with the material histories of place into its signifying system. Rejecting conventional materialist claims on the aesthetic, the film insists on the political potential of cinematic spectacle, visual saturation, and the sensory. History and memory are merged in synaesthesia, and Taketomi's sensory material becomes the film's most insistent means of expression. Conjuring trajectories of transnational experience that are peripheral, even traumatic, *Away with Words* proposes other ways to experience place and history. Indeed, we might find in its articulation of

Figure 12.4. The synaesthetic image in place and time.

displacement through the cinematic sensorium a modality uniquely attuned to the contemporary experience of global dislocation. Intimately drawn from the local, Doyle's synaesthetic transfers simultaneously speak to the pressures of transnational mobility. Thus, in Christopher Doyle's style, we may read counterhistories of globalization. His splashy sensorium speaks of the falsities of postmodern space, but it also imagines its truth.

NOTES

1 E.g., *Hero* (Zhang, 2002), *In the Mood for Love* (Wong, 2000), and *Last Life in the Universe* (Ratanaruang, 2003), also starring Asano Tadanobu.

2 Christopher Doyle in Matthew Ross, "The Wild Man," *Filmmaker: The Magazine of Independent Film*, Fall 2005, http://www.filmmakermagazine.com/fall2005/features/wild_man.php.

3 Christopher Doyle interviewed on *The Culture Show* (BBC, 2005).

4 Doyle first worked with Edward Yang on *That Day, on the Beach* in 1983. His first collaboration with Wong Kar-wai was *Days of Being Wild* in 1990. More recently, he has worked on Thai and South Korean films as well as on some high-profile Western projects.

5 Susan Buck-Morss, "Aesthetics and Anaesthetics: Walter Benjamin's Artwork Essay Reconsidered," *October* 62 (Fall 1992): 3–41.

6 Ibid., 6.

7 Greta Berman, "Synaesthesia and the Arts," *Leonardo* 32, no. 1 (1999): 15–22.

8 E. H. Gombrich, *Art and Illusion: A Study in the Psychology of Pictorial Representation* (New York: Phaidon, 1977), 366.

9 Wong Kar-wai, quoted in Peter Brunette, *Wong Kar-wai* (Urbana: University of Illinois Press, 2005), 131.

10 Ibid., 16.

11 *The Culture Show* (2005).

12 Stephen Teo, *Wong Kar-wai* (London: BFI, 2005), 110.

13 Sergei Eisenstein, "Synchronization of Senses," in *The Film Sense*, trans. Jay Leyda (New York: Harcourt, 1947), 69–109.

14 Sergei Eisenstein, "Color and Meaning," in Leyda, *Film Sense*, 143.

15 Sergei Eisenstein, *Eisenstein*, vol. 2, *Towards a Theory of Montage*, ed. Michael Glenny and Richard Taylor, trans. Michael Glenny (London: BFI, 1994), 255.

16 Sergei Eisenstein, "The Unexpected," in *Film Form: Essays in Film Theory*, trans. Jay Leyda (New York: Harcourt, 1949), 21, 24.

17 Julia Yonetani, "Ambiguous Traces and the Politics of Sameness: Placing Okinawa in Meiji Japan," *Japanese Studies* 20, no. 1 (2000): 15–31.

18 http://www.international.ucla.edu/eas/documents/potsdam.htm.

19 We might compare the position of Okinawa with that of Hong Kong: both caught between world powers of East and West and both reverting to Asian rule in the latter part of the twentieth century.

20 Nishitani Osamu, "A Documentary of the Future," trans. Yoshikawa Chikako, in *Yamagata International Documentary Film Festival Catalog* (Yamagata, 2003), 4.

21 George H. Kerr, *Okinawa: The History of an Island People* (Tokyo: Tuttle, 1958), 116.

22 For an example of recent revisionist writing on Okinawa in the context of World War II, see Ota Masahide, *The Battle of Okinawa: The Typhoon of Steel and Bombs* (Tokyo: Kume, 1988).

23 Kerr, *Okinawa,* 21–22.

24 Gavan McCormack, "Okinawan Dilemmas: Coral Islands or Concrete Islands," in *Okinawa: Cold War Island,* ed. Chalmers Johnson (Cardiff, Calif.: Japan Policy Research Institute, 1999), 262–63.

25 Ibid., 287.

26 Over one thousand Okinawans were executed by the Japanese Army for using their own language. For an overview of this history, see Matthew Allen, *Identity and Resistance in Okinawa* (Lanham, Md.: Rowman and Littlefield, 2002), 4–35.

27 Takamine Go, interview by Nakazato Isao, "Documentarists of Japan #20: Takamine Go," in *Yamagata International Documentary Film Festival DocBox,* http://www.yidff.jp/docbox/22/box22-1-1-e.html.

28 Michael S. Molasky, *The American Occupation of Japan and Okinawa: Literature and Memory* (London: Routledge, 1999).

29 Steve Rabson, "Assimilation Policy in Okinawa: Promotion, Resistance, and 'Reconstruction,'" in Johnson, *Okinawa,* 145.

30 Kerr, *Okinawa,* 438; Allen, *Identity and Resistance,* 7.

31 Alan S. Christy, "The Making of Imperial Subjects in Okinawa," in *Formations of Colonial Modernity in East Asia,* ed. Tani E. Barlow (Durham, N.C.: Duke University Press, 1997), 141.

32 Ibid., 152; his translation. Original in Yanagita Kunio, *Yanagita Kunio zenshu,* vol. 1 (Tokyo: Chikunama Shobo, 1989), 402.

33 Mika Ko, "Takamine Go: A Possible Okinawan Cinema," *Inter-Asia Cultural Studies* 7, no. 1 (2006): 156–70.

34 Aaron Gerow, "From the National Gaze to Multiple Gazes: Representations of Okinawa in Recent Japanese Cinema," in *Islands of Discontent: Okinawan Responses for Japanese and American Power,* ed. Laura Hein and Mark Selden (New York: Rowman and Littlefield, 2003), 273–307. ·

35 http://www.hirata-group.co.jp/english/islands/taketomi/index.html (accessed June 1, 2009).

36 Philip Rosen, *Change Mummified: Cinema, Historicity, Theory* (Minneapolis: University of Minnesota Press, 2001).

37 Arne Røkkum, *Nature, Ritual, and Society in Japan's Ryukyu Islands* (London: Routledge, 2006), 67.

38 Fredric Jameson, *Postmodernism: or, the Cultural Logic of Late Capitalism* (New York: Verso, 1992); David Harvey, *The Condition of Postmodernity: An Enquiry into the Origins of Cultural Change* (London: Blackwell, 1991); Ackbar Abbas, *Hong Kong: Culture and the Politics of Disappearance* (Minneapolis: University of Minnesota Press, 1997).

PART IV | (Not) Being There

13 | Moving through Images

BRIAN PRICE

This essay takes up as a theoretical problem a use of cinema with which we are all familiar and about which one rarely speaks, namely, moving—not what happens when an image moves but when we do. It is a question concerning the use we make of images of a place that we do not yet know in its livable potential, neither in its ontic facticity—that which will be there ahead of me, with me, or after me—nor as mood. We have no idea of the possible relations between what is already there—what is already, enduringly, and ontically present—and the mood that might be said to exist ahead of my arrival. It is that which will either dominate me (if I am unlucky or unsuited to it as a place) or what I overcome as a being capable of forcing a relation that is constitutive of other and less predictable moods, of an altogether new way of living and an understanding of my relation to what is already there. It is what I look for if I am worried or excited about the place I am going to go but do not yet know. I look to the image for comfort and confirmation, for the recognition of something familiar, despite knowing that the very thing that makes me look is the absence of the familiar, of something that corresponds to what I already know or that can be translated in the terms of that something else. I want place to be located in and by the image like a genre—as something familiar, relatable in its familiarity, but different enough to sustain both my interest and what may become of my particularity, which can only be shown by way of what recurs or overlaps. To satisfy my worry, then, I need the image to be an imperfect analogy of that place, knowing that neither a photograph nor a fictional film is going to provide an identical relation that also indicates mood—what I might feel like there, given what I know about myself and what I know about what appears before me. I merely need images to be handy. My question, then, concerns the way in which we use images to understand a place we do not yet know, but any answer to that question will likewise pertain to a larger ontological problem of how images participate in being, how we might be said to be-with-images, especially as those images present to us a place to which we are about to go and that will affect our being in a particular way.

USE AND WORRY

I became aware of this use of moving images on receiving an offer for a tenure-track job at Oklahoma State University. I had never been to Oklahoma and had very little notion of what it would be like to live there. I was short on images; it was short on images. And almost everyone I encounter who now comes to Oklahoma does so for the first time. During her keynote address at the 2007 World Picture Conference at Oklahoma State University, for instance, Joan Copjec wryly confessed that that was her first time in Oklahoma and that until that moment, she had always thought that Oklahoma was spelled with an exclamation point. The point of the joke is obscured, now, by the problem of writing. If I had spelled it out as the title of the film—*Oklahoma!*—the joke would be much harder to comprehend or appear as redundant. The joke had to be heard if the exclamation point was going to appear as a signifier of place established by film. The name is already too familiar as a place on film to notice what the film has done to the popular imagination of the state—to notice how the exclamation point goes unnoticed even while it does its work. Since no one ever goes there, the image of place retains its sense of place largely as one that will not be confirmed or looked to for its geographical handiness.

Having accepted the offer, and after a brief glance at the terrain of Stillwater, I was heedful and concerned. I needed the job, but the place was short on trees and grass, buildings and traffic. What I feared was the potential for generalized emptiness. Coming from Chicago, Stillwater seemed uninhabited and uninhabitable. There was no bookstore, not even a Starbucks—not a single commercial reminder of what a place looked like if it was going to attain the status of place. When I lived in New York in the 1990s, I used to remark on the ways in which sitcoms like *Friends* depicted the city and its living spaces, only then to watch the city take on the character of its representation. This was a matter of high seriousness and the source of laments about the end of New York as we knew it—the subject of jokes we could make to our students at New York University who came there to live that image, even though they wanted to be recognized by us now as both a part of that place and as laughing along. And yet, looking around Stillwater, I would have been comforted by some signs that are familiar because they are everywhere, signifiers of an everywhere that can be place, even though *everywhere* suggests a relation to space more than it does to place.

We take recourse to images when we feel that there is too much place, when place overwhelms us in its unfamiliarity—when we are altogether whelmed.

Returning to Chicago, I took recourse to images, largely because I also had to present this place to my spouse as the where to which we might arrive. I needed

to be able to communicate something about it as place to assuage any concerns she might have, to be able to point to the signs of an unhappiness that might await us there, even though I know that unhappiness is neither immanent nor universal but rather something external to me. When we moved from New York to Michigan, we were surprised at how well we were able to adapt—working, as we then were, on an assumption that Ann Arbor was countrylike and small. To be countrylike, I supposed, one has to experience a sense of placial deprivation, insofar as deprivation is understood as an antonym of urban density. Stillwater, however, seemed like a tougher challenge, largely because I perceived myself to be lacking the means to describe what I had seen there. It was especially worrisome knowing that Stillwater made Ann Arbor look much more like New York, despite that most residents of Ann Arbor would no doubt be baffled that it bears any resemblance to New York at all. So we watched *Twister* (1996), an American action film about a couple in the middle of a separation—one a weatherman, the other a tornado chaser—who are forced to contend with, and find a way to measure, a series of devastating tornadoes. The film is set in Oklahoma, and a measure of its success is that whenever anyone asked me if I had taken the job, their response to my yes was almost always, "They have serious tornadoes down there."

We were not watching *Twister* as a document of place, a modern instance of Dorothea Lange's photographs, nor were we skeptical about the distance between representation and reality; rather I was hoping that something could be partially known, glimpsed at an angle: a sense of ambience, the texture of land, a fractional sense of its architecture. I wanted to calibrate the image to what I saw only fleetingly and while worrying. I wanted to be able to see with and through the image, to look past the things that were easy to recognize as what an American action film generalizes about every place it records and toward what might just happen to be in the frame. The remainder is what I perceived to be instructive—that which could be seen in the image but did not solely belong there. The character of remainder that I am proposing here is not that which is in excess of the image and the story it tells but what remains even once the image and its fictional narrative end. It is what endures. In this sense, we needed to be able to imagine *with* and around what mostly appears in the image, knowing well that the image has neither the power of decision nor eternal verity. We can only think *with* it.

A recourse to images in the face of a move to come, then, raises two central questions about place and its relation to images: what will a place do with me? What will I do *with* and *in* this place? I need an image to help me worry less, and to worry less, I need only a horizon of possibilities. Put this way, it is also clear that what is narrated as occurring in a place and because of place does matter,

but only as a possible way of being situated. It is no surprise that I also started reading Meghan Daum's fictionalized account of her move from New York to Nebraska, which she undertook to escape a seemingly insurmountable debt acquired as a result of a sense of what it meant to live properly in New York. In *The Quality of Life Report,* Daum writes the life of a young New Yorker who has moved to Prairie City, a signifier based not on an indexical relation to a real place but on the everywhere that is nowhere in the Great Plains.[1] As I read about "Lucinda's" experience in this small midwestern town full of barn dances, meth labs, intrusive neighbors, and people entirely unlike me, I imagined place *with* the novel insofar as I could imagine how I might feel if these things were to happen to me—not how I would feel if I were to respond as Lucinda did but how I would feel as if I were in her place but not her. To be in place is to be situated somewhere physically and psychologically or to occupy a place in someone's imagination. Place is neither wholly physical nor entirely imaginative. To be in her place is not to imagine myself as Lucinda but to be in her place as me (in whatever state of singular plurality *I* may be) and in a place with people, customs, and land arranged in a series of possible situations. I am not reading for plot but in spite of it—plot as a series of situations, the connective logic of which will matter very little to me. What I know of as *me* in the instance of reading I know relationally and contingently as what recurs across a series of different encounters, even if the character of recurrence does not imply a discursive hardening. In a relational understanding, something recurs but does not do so identically or infinitely. Every place complicates the being of the one that recurs. Or as we say of someone experiencing emotional duress, *he's in a bad place.* And if our friend is in a bad place, our first advice is that she extricate herself from a particular location. Place and mood can be very difficult to separate.

BEING-THERE

The difficulty of separating place and mood is an ontological problem—one that understands being as inextricably bound to place, even if that link guarantees nothing about what will come of the what and the who that are linked. If I turn to images in a moment of worry, I do so because I believe that the place depicted will affect the being that I am in certain ways; indeed, I believe that place is constitutive of being. The place to come will collide with the place I am now and know well enough, especially as I know it in relation to what came before. The living effect of a relational knowing lingers with me in a state of superimposition without definition. It will generate something more, yet change the way other places are now understood and participate in the ongoing being that I continue to be.

The ontological problem that place presents is, perhaps, best understood with respect to Heidegger's influential theory of being, or *Dasein*. *Dasein* is neither the subject nor mere body. *Dasein,* especially as developed in *Being and Time,* refers to the spatiotemporally unique being that I am—to a being that comes to being by way of its discovery and use of what is at hand. For Heidegger, the clarity of *Dasein*—what is distinctive about *Dasein,* about the particular being that we are— also comes by way of being thrown and being-with-others. To be is to be thrown; it is to emerge in a world that is without essence and that is already happening before our arrival. One of the ways in which we understand *Dasein,* then, has to do, for Heidegger, with the way in which *Dasein* removes itself from the "they," or from a state of being-with-others in a uniform fashion. The particularity of *Dasein* comes by way of its retreat from *Mitdasein,* or being-with-others, a collective space of indistinction.

However, as Jeff Malpas argues, *Dasein* is also more than mere *sein,* or being. *Dasein* is a there being, a being there, or a being determined by place, by a there: *da.* Whatever we say of our being will have to be said of place. What this makes clear about Heidegger's theory of being is that

> existence, we might say, is its [*Dasein*] "there," and in being such, it is not something separate from the there, the place, the world, in which it finds itself. The basis for Heidegger's "factical" conception of the relation between existence and the world would seem, initially, to be phenomenological: when we look to the character of experience . . . what first confronts us, in the sense of being ontologically primary, is not a sense of our own existence in some detached or abstracted form, nor of being presented with a field of "sensory" evidence, but rather our being already involved with things in such a way that we do not even think of them as separate from us nor us from them, and in which things are encountered as already a part of a meaningful whole. We thus find ourselves first of all enmeshed in a world, and so in a set of relationships, and it is only subsequent to this that we begin to separate out a sense of ourselves and a sense of things as they are apart from us.[2]

This is precisely how Heidegger imagines that we begin to discover the world as an unfixed totality defined by objects and their uses, by their handiness. Handiness will give us a sense of place, and being is always—as Malpas suggests—*there*-being, placial being.

The handiness or what is at hand gives us access to a larger relational structure

in which a network of associations begins to show itself as a series of useful things. We discover who we are by the place we inhabit, which can only be understood by what we use. However, what we use—or what is at hand even before we make use of it—does not reveal ourselves to ourselves; it is not a tool or representation that points us back to the who we have always already even before the recognition of our own *ipseity*; rather, we come into existence as we find what is at hand. Use and recognition are temporally entwined in the open constitution of being.

One of Heidegger's most famous examples of the handiness of useful things that reveals place has to do with the way in which we experience a room, especially as we understand *room* as the discovered relation of objects assembled or associated there. "These 'things' never show themselves initially by themselves, in order then to fill out a room as a sum of real things. What we encounter as nearest to us, although we do not grasp it thematically, is the room, not as what is 'between the four walls' in a geometrical, spatial sense, but rather as material for living."[3] To say that we do not grasp a room thematically "in order to fill a room out" is to define place as something that cannot come to us in advance, whether as essence, discourse, or *eidos*. By contrast, space is geometrical and can be understood thematically, without respect to what one finds there. It is calculable in advance as a matter of extension. Place can only be disclosed by handiness, by the relation we detect and establish in our use of things, in our experience of their handiness. And if the room is an assemblage of material for living, it is also a totality: "A totality of useful things is always already discovered before the individual useful thing."[4] Following a critique of space that is made in terms of its relation to extension, we can only assume that for Heidegger, this totality that precedes our discovery of "room" is not closed; rather we begin to make sense of the usefulness of the thing only after we have perceived its relation to other things—once we have begun to puzzle out possible associations. Place comes into focus as a totality revealed to us by the handiness of what is at hand, but only contingently, especially as the totality comprises our own movements in space and from our use and interaction with what is at hand. A more geometrical conception of space—by contrast—is what will recur as space despite the disorder introduced by any of our own movements. Place is the specificity of being, a world and a being constituted simultaneously in the unique spatiotemporal trajectory of *Dasein*.

One way of understanding the persistence of the geometrical conception of space over place in this instance would be to offer a skeptical reading of the Situationist practice of the *dérive*. The Situationist practice of the *dérive*—articulated in the late 1950s—involved the construction of alternative maps of cities, which were also an itinerary for a group of walkers who will experience an ambience that

comes from the movement through areas of the city that are guided not by the logic of official urban planning but by an itinerary set in advance that will nevertheless produce a psychogeographical ambiance predicated on a successive experience of place that defies the logic established by urban planners. Or As Guy Debord put it:

> The lessons drawn from *dérives* enable us to draft the first surveys of the psychogeographical articulations of a modern city. Beyond the discovery of unities of ambience, of their main components and their spatial localization, one comes to perceive their principal axes of passage, their exits and their defenses. . . . One measures the distances that actually separate two regions of a city, distances that may have little relation with the physical distance between them.[5]

The alternative movement through space is what activates in negative terms the mood of a place and thus who I am, even if who I am is constituted in this moment by an awareness of my own alterity to what appears. Mood, here, is as an effect of social planning and political repression, triggering movements through space that defy the geometrical logic of the map, insofar as the map promotes a logic of urban space that it also made possible for an earlier and now well-sedimented form of social organization. The work of the *dérive* was to lead to "the constant diminution of these border regions, up to the point of their complete suppression."[6] The persistence of movements that are individualized will both reveal the generalized psychic effects intended by that structure, which are otherwise meant to be experienced simply as normal, natural, or unnoticeable, and overcome them in time and by way of repetition. However, to overcome the cartographic structure and its earthbound referent presumes the repetition of a new structure in its place—a route guaranteed in advance of any movement that will now follow and will do so precisely because it has proven effective as a structure. The alternative route thus becomes a structured method for avoiding the very problem of structure. In so doing, a dialectical conception of place (the singularity of the *dérive*) and space (that which is geometrically stable) gives way to a conception of place as stable precisely, and paradoxically, for the sake of avoiding the repetition of movements that are structured in such a way that the ontological force of geometric extension never truly appears—only the place itself that is both created and guaranteed by that structure. A dialectical conception of space and place can only ever generalize the particular in the advent of an overcoming—whether in the overcoming of the general or the becoming general of the particular that remains opposed to the general to which it has been previously opposed. What remains particularized can

only do so as something other to a structure, or unrecorded as one, even where it is recorded precisely for its singularity—no matter how liberating or pleasing repetition may be. Thus we are left with an intensification of the distinction between *Dasein* and *Mitdasein*: one either produces and inhabits for oneself an unshareable place or else risks the perpetuation of structure and geometrical extension by enhanced means, the price of which is extreme solitude or diminished being. Neither option, however, understands representation as something neutral, let alone beneficial, to being.

One conception of space is geometrical, the other curvilinear, but the effect of each is the same. Ontologically speaking, as guided movements through place, being will become indistinct, shared, and calculable. There are problems with this formulation to be sure, and I will address them ahead, but for now, it is worth considering the way this alignment suggests something particular about the distinction Heidegger will draw between *Dasein* and *Mitdasein,* which he will also come to describe as *they*-being, and precisely owing to our contact with the techniques and products of modernity and mass production. For instance:

> In utilizing public transportation, in the use of information services such as the newspaper, every other is like the next. This being-with-one-another dissolves one's own Dasein completely into the kind of being of "the others" in such a way that the others, as distinguishable and explicit, disappear more and more. In this inconspicuousness and unascertainability, the they unfolds its true dictatorship. We enjoy ourselves and have fun the way *they* enjoy themselves. We read, see, and judge literature and art the way *they* see and judge. But we also withdraw from the "great mass" the way *they* withdraw, we find "shocking" what *they* find shocking.[7]

There are a number of problems with this formulation, particularly the ways in which Heidegger articulates a theory of modernity and mass culture as the ground of a false unity—the technologies of the popular and the populace that can be said to organize the social in a homogenous fashion. This is not a view I wish to uphold. Standardized representations or routes of passage participate in our being, but they do not determine it, nor do they guarantee a uniform response across perceivers or beings. But for our purposes here, the example should make clear that for Heidegger, *Dasein* is a singularity and cannot be defined by what it shares with others, only by how it differentiates itself from the *they.* What should be clear is that for Heidegger, representation itself is something to which our being can only be figured or realized in opposition and something to which we must extricate

ourselves for the sake of *Dasein*. Thus representation is understood as conceptually distinct from, and unrelated to, place. Being with others, as an instance of they, is to be with others whose being has been negated in its singularity by technologies of mass culture. Our opinion—or that which should constitute our singularity in response to what we all share as an event or as news—is useless to *Dasein* insofar as technologies of mass culture produce a uniformity of judgment and experience, or are said to. In other words, owing to *Twister,* we all believe that Oklahoma is flat and that devastating tornadoes lurk behind every windmill. This is why *being-with-one-another* is hyphenated. The hyphen admits of no spacing, of that which makes difference visible and possible. The hyphen is a collapse of the many into a one. If the many is a one, then there is also no *Dasein*—no singular instance of being.

It is nevertheless important to note that *Mitdasein*—as Heidegger here conceives it—is not the end of being altogether; rather, in his view, being-with-others is merely reduced or inauthentic being. To be inauthentically, however—which is what one would presumably be at the moment in which we share *Twister*—is not the same as nonbeing:

> What we called the inauthenticity of Dasein may now be defined more precisely through the interpretation of falling prey. But inauthentic and non-authentic by no means signify "not really," as if Dasein utterly lost its being in this kind of being. Inauthenticity does not mean anything like no-longer-being-in-the-world, but rather it constitutes precisely a distinctive kind of being-in-the-world which is completely taken in by the world and the *Mitda-sein* of the others in the they.[8]

For Heidegger *Dasein* is a question of authenticity, but not purity—which I would take to be a mode of being that can only retain its authenticity if it avoids contact with others altogether, especially as that contact is facilitated by the varied forms of mass culture. We can still be in the world, Heidegger says, but only in a state of collective indistinction. So long as we remain there, we will not know ourselves apart from the moment of being-with-others.

Heidegger's distinction is tempting to dismiss, predicated as it is on a conception of being as something that can only be defined singularly and at the moment in which *Dasein* appears in the moment of its withdrawal from others. The *they* is a moment of inauthentic consensus, and with consensus, there will be no *Dasein,* even if there will be some being. If we understand how the *they* is constituted by modernity and mass culture, we should also be in a place to see how the distinction between *Dasein* and *Mitdasein* also follows from a distinction between city

and country. To be most fully is to be alone, and the best chance of being alone is to be in the country, in places short on mass transit and public spectacles (in Heidegger's view). *Dasein*, then, is the urbanite gone country, much like Daum's Lucinda discovering the inauthenticity of her desire to be someone who lives in a city in a particular way. To be with others as beings in a city is to live particularity as quotation—to disappear within the very quotation that is being summoned to define us in our shared particularity—especially as being in a city has been produced discursively, whether by lore or HBO. However, in naming the town in which Lucinda is situated "Prairie City," Daum's fictionalized account of her move to Nebraska works against the haunting specificity of the unfamiliar place to come. "Prairie City" is an empty signifier meant to collect and stand in for every rural place. As such, "country," too, becomes a form of quotation: something to which I relate, but can only do so by saying what has already been said, by admitting that my being—even in the country—is being-with-others or being-by-way-of-another. What came before will be what becomes of me. In this sense, then, the distinction between city and country implied by the move from *Mitdasein* to *Dasein* is itself troubled by representation.

However, as Jeff Malpas has suggested, it would be too simple—too problematic—to understand space and place in Heidegger in the strictly antithetical terms of extension and location. Arguing that space does not merely precede place—indeed, that location does more than figure as the ground or end of extension—Malpas suggests that space and place "ramify into a number of difference aspects." What he reminds us of most forcefully are the many ways in which they are intertwined:

> We thus see how the proper dimensionality that belongs to space, and that is evident in the way space stands "between" things, thereby enabling them to stand in relation to another, is transformed into the space that allows for multiple "places," as well as into the space of the distance or the "interval" that is subject to quantifiable determination. Yet is equally clear that these are all modifications or transformations of space as such. The space that is quantifiably determinable, the space of *spatium* and *extensio*, is itself a space that emerges from out of the single, complex opening of a space that is the happening of place in the gathering of the world in and through the thing. Just as the gathering of world that occurs in the Event is a gathering of elements that make up world (of the things that are evident in the world, and of the thing as such), so we can see in the way place opens into space, into places and spaces, into extension and location, the

way in which place and space themselves comprise a certain gathering and opening of what is proper to them—a gathering and an opening of a multiplicity of aspects.[9]

Space is also what appears between things. If spacing makes things legible, and we come to being by way of our interaction with things and the relation we simultaneously detect and produce, then—and as *extensio*—space can only proceed from one of many possible aspects. As extension, space follows—as Malpas suggests—from location, which is irreducibly owed to the gathering of world that could be anywhere, the totality of which is defined by the contingent path of my movement, by what I myself gather. If spacing makes things legible, and *any* being possible, which is to say, resistant to any alignment with a fixed totality that precedes and absorbs me in a paradoxical act of self-definition, then place, as location, can only be the predicate to a model of extension "founded" on the very contingency of being itself.

One might argue that any notion of extension predicated on the planned singularity of a movement through place is just as susceptible to reification as the *dérive* that becomes both map and the guarantor of movement as quotation. If place is being—and being is *there*-being—then what distinguishes the *dérive* from the bus-ride, particularly as both are predicted on a repetition by others? It is not *Dasein* that will only repeat the course; it is not simply an alternative structure that I keep to myself and for myself. Rather *they* will repeat the course, insofar as "they" is a "we" that becomes one in the process of following along in precisely the same manner as the one and many that came before, even if I do not become a "they" at exactly the same time as the others with whom I share this moment of being-in-indistinction. Space may very well precede place as that which indicates a thing in its distinction, thus bringing *Dasein* into existence as we discover the relatedness of what is at hand, but it does not guarantee—strictly by virtue of being a predicate to place—that the place established will not become reified, that space and place will lose their distinction.

The concept of spacing does not guarantee infinite difference, even if spacing is essential to difference—as it is for a poststructural poeisis. This is the joke I perceive Francois Truffaut to be making in *The 400 Blows* (1959) when Antoine discovers "himself" while reading Balzac and goes onto plagiarize Balzac as the story of his own life. When confronted with his teacher's charge of plagiarism, Doinel is dumbstruck: he found himself in Balzac, but what was found there is the impossibility of the self—being as quotation. What is understood as uniquely me is merely the text of another. Thus, if we can say that space and place are

intertwined, then we can also say that the predication of place by spacing is what allows for the lived conflation of location and extension, which—in Heidegger's terms—can only be understood as they-being, or inauthentic life. Just as Debords's *dérive* awaits "me," or brings me to myself as every other, Balzac's text effects a terrifying epiphany: I recognize myself most completely when I am least present.

If I prefer the *dérive* to the *Michelin,* in other words, will my preference also constitute my singularity? Or is my preference merely a mistake of *ipseity,* my pleasure in movement nothing more than the reactivation of what lies sedimented there? How will I know the difference, if difference is the genesis of structure? If I now follow a *dérive,* won't I be doing so simply to have an authentic experience of Debord's travels?

Heidegger would have had to answer in the negative, despite his concerns about mass culture. Our emulation of the *dérive* might produce they-being, insofar as everyone who reproduces the *dérive* will be reproduced by it in turn, but they-being is only what I am calling being-in-indistinction. They-being does not imply the eradication of being, for Heidegger; it is something against which *Dasein* will be realized. When we tour a Situationist *dérive,* we might be doing nothing more than participating in they-being, but we will only do so for *some time.* We are not inhabited fully and forever by Debord any more than Heidegger's train passenger loses being merely by being with others in a calculated and repeated configuration of space and time. At worst, in Heidegger's logic, we will be in inauthenticity only as long as it takes us to move through a planned itinerary or for a film to end. We might extend the time of our inauthenticity insofar as we share our opinions about what we saw, but we will not do so without end, nor will the talking be carried on by all and expire at the same time.

But this is a weak solution. The spacing of the contingently produced place—or there-being—is repeatable but only for some time, and only potentially so. One can walk slower; one can walk faster. When one looks out the window, what one sees is that there are the standardized movements framed by the window of the bus and the stops and starts determined by the segmentations of the route. How I respond to what I see will be characterized by the contingency of the being that I am before arriving there. If I have spent my life in Alaska and find myself now for the first time in New York, the view of Central Park that I see as I head south down the street will likely be very different from the one of the person who sits next to me and was born and raised in Queens. To believe otherwise, we would have to accept that both our perceptions and perceptual habits reside in the thing itself, that our encounter with an object will be one in which its character—indeed, its mood—is irrevocably impressed on me. If I move to New York and repeat the

same journey every day and at the same time, I might come to share a particular way of thinking about what I see with the one who rides beside me, but the chances of that person being the same in every instance are slight. And even if it is possible, it is equally unlikely that we will share the same space at all times without end. What they-being might describe—at best—is a shared sensibility, a limited compossibility of beings whose being includes other coordinates, other things that other spacings make evident for me alone and that will recursively modify some aspect, tone, or distinction of what it is that we shared for some time. If being is contingent and relational, its distinction—what it is that prevents they-being from becoming an irrevocably reduced being from the time of its inauguration to the moment of my death—is owed to a relational turning that my movements in time guarantee.

MOVING WITH IMAGES

If we can say that being is *there-being,* and that the place we occupy at any given moment is fundamental to the being that I am both becoming and continue to be, even as my being is marked by a turning that time and movement inexactly promise—and even in the moments of supposed they-being—then how will we come to understand images of place and the use we make of them? Why is this a question of moving with images? If place is being, then why should it be important to regard an image of place as anything other than reified being?

To regard the moving image as an origin of false consciousness, we would have to confer on it the status of a totality that allows, in Heidegger's terms, the existence and handiness of the thing at hand to come into focus. If we come to being by way of our discovery of the usefulness of what is at hand, and the moving image is understood as that which makes things legible, then being will become they-being in the worst possible way. The moving image, in this scenario, becomes a totalizing force of origination in which the being of all who experience it will come to be in precisely the same ways, since what we can discover of our world— of the place that gives us being—will have been standardized by the image itself, by what it asks all of us to notice. But as my preceding discussion of the *dérive* should make clear, the time of they-being—of our being together in a moment of representation or standardized movement—precludes this as a possibility, even if we attribute this kind of power to the moving image. For the moving image to organize place in a totalizing and uniform fashion, we would have to watch the same thing for the same time, and always the same thing through all of our time, even though none of us will ever share time perfectly and consistently.

Even if we were to confer on the moving image the ontological force of a totality,

each instance of the moving image would indicate the contingent character of that totality in every instance, no less than the totality that brings place to be for *Dasein*. As a totality that brings things into focus and relation, each moving image could only ever do so in different ways. If the moving image organizes our perception of place, and thus *there-being*, each film could only be understood as *yet another* way of perceiving place—one that may share a topographical sensibility with another film, that is, a tendency to organize place in similar terms by way of shot selection and setting, but never identically. Our general and legalized opposition to plagiarism precludes it. Even though genres of moving image productions thrive on such similarities, they all require some spacing, some difference to appear and to be recognized as related but legally distinct.

If there can be said to be an essential characteristic of the moving image, unlike linguistic forms of expression, the moving image is incapable of identical repetition. Even if we decide that Michael Haneke's remake of *Funny Games* (2008) is shot for shot—even if we think that the structure is identical—the actors that appear there cannot be identical to the ones who appeared before, even if the ones who appeared before appear again. Even if Arno Frish and Frank Giering, who appeared as Paul and Peter in the original version from 1997, were not replaced ten years later by Michael Pitt and Brady Corbet, owing to the inescapable fact of time and aging, they would not appear the same, despite appearing in what seems to be an identical structure. As a totality that works to bring things into focus and relation, the film could only do so with some perceivable difference. And it is a difference that might change what comes into focus for those of us who—owing to a totality we call *a* film—perceive things relationally. Supposing that a moving image makes an indelible mark on us and controls what we will find at hand outside the image—we would have to admit that the later film, and even with the same actors, would alter our perceptions ever so slightly: where once I became aware of teenage sociopaths in the Austrian countryside (1997), I may now cast a worrisome glance at white males in their late twenties who wear all white in the Hamptons (2007). My opinion will change because what I can notice, which will determine who I will be in all my indistinction, will have been altered by a change in the totality that makes things legible for me and for all who see with and through this particular totality, assuming we recognize the moving image as a totality that makes things legible by a standardized logic of spacing. However, if the moving image owes its distinctiveness as a medium to its inability to reproduce something identically, then the promise of they-being that this film makes by virtue of its status as a totality that will inform our perception, and thus our being, will be largely ineffective as a promise. The film will be very little use

to us, as we wonder about the place we are about to go, which appears to us in advance of arrival in moving images. It may give us a sense of place, but only an inexact one.

There is a better explanation. We might turn to an image in a moment of worry about what a place will make of me, but our gratification will be of another sort altogether. In "Uncanny Landscape," Jean-Luc Nancy makes the following remark about the country and the unique sense of place it provides, one that suggests quite strongly our relation to images of place:

> The country is first of all the space of a land considered from a certain corner or angle, a corner delimited by some natural or cultural feature . . . : a row of trees or a road, a river or a ridge, a pass, a glacial constriction, a formation of alluvial deposits, a passing herd or an armed horde, an encampment. But first a corner: something that depends on a geometry as yet without ideality or analysis, the laying out of at least two axes of reference and thus of an opening separated by whatever angle they create, more or less wide or narrow, only exceptionally at an angle.[10]

More or less wide or narrow, a passing herd: this is the language of contingency. What is expressed here in terms of contingency are the spatial markers that become the impermanent ground of place, despite that what we call the "country" is a place denied to the fixed spatial markers of the city, places situated by fixed and interlocking points. This is why Nancy describes the country as a "cadaster without any administration."[11] It is so precisely because it is place founded on contingency, positively unrelated to a necessarily closed domain—as would be the city or even the garden. Even if the garden exceeds visibility, as does the country—insofar as one can see through the place articulated *as* country out toward a space that is as yet indefinite—the garden still belongs to "the order of the courtyard: the house and its outbuildings open, but it does not open onto anything."[12] Even if the garden stretches out beyond the reach of my vision, its vanishing point is nevertheless calculable in the terms of the home to which it belongs and by which it is defined spatially. The country, then, is a place determined by points that are not yet fixed or a place whose spacings can only be indeterminate since they remain unmoored from any fixed and geometrically conceivable space nearby. The beyond-vision of the country—its vanishing point—is not determined by the corner that defines in contingent terms the point of origination for the place we discover *as* country. The corner, like Heidegger's contingent totality that helps us to discover the handiness of what is at hand, is approachable from some other corner that will orient our

being—a constellation of things made visible by spacing—in a different way. The vanishing point is not the space of the necessarily unseeable site of All that appears and what appears in a fixed and essential way. It is an infinite promise that things can be any other way than they are now. What appears open, remains open.

Isn't this what the moving image has to offer us as we worry about place? If I have lived in Guthrie, Oklahoma, for the last fifteen years and am in the process of preparing for a move to New York, and I watch ten films set in New York, what will I see? What I will see is the city articulated according to the logic of the country, as a place that can be any other way than it is now. If each film is proof that a city can never be filmed the same way twice, then what these films present to me is an example of the contingency of being that spacing makes both possible and most apparent. And what we shall say of place we shall also say of being. This would be just as true if I had lived in New York for ten years and was preparing myself to move to Oklahoma. What every film or television show shows is the organization of place by a particular corner that is not fixed and yet brings a spatial logic into existence that makes things visible in turn. The only thing that another film can promise—even if it tries to imitate in exact terms the films that came before—is that there are different ways of being in place. If I have watched more than one film, I have had the opportunity to understand that a conception of being as immutable, consistent, and sealed shut before my appearance here in an unshareable *ipseity* is as improbable as the idea that images will eradicate *Dasein* and consign us forever to they-being.

Rather the comfort of the moving image and the image of place it makes and shows to us as *a* place we might go to, as *a* place I may be—but only insofar as the places I have been before become yet another spatial coordinate of the there-being that only I can be in time—is comforting precisely because of the *Angst* that it also provokes. As Heidegger saw it, *Angst* is both a rare experience and to be distinguished from fear:

> *Angst* individuates Dasein to its ownmost being-in-the world which, as understanding, projects itself essentially upon possibilities. Thus along with that for which it is anxious, *Angst* discloses Dasein as being-possible, and indeed as what can be individualized in individuation of its own accord.[13]

Disclosed in the experience of *Angst* is the existential awareness of not being home in the world, which is a way of recognizing that we are fully in and of the world—that our being is *there-being*—but only contingently so. If place is being, and place can begin anywhere, the experience of *Angst* is a recognition of "the nothing

and nowhere" that comes to us when "everyday familiarity collapses."[14] Everyday familiarity is they-being. Even though we come to the nothing and nowhere of *Angst* by way of the failure of they-being, it is the nothing and nowhere that can also produce fear, which Heidegger defines as a "tranquilized, familiar being-in-the-world."[15] "Fear is *Angst* which has fallen prey to the 'world.' It is inauthentic and concealed from itself as such."[16] The nothing and nowhere that comes to us by way of *Angst* allows us to project and embrace the pure possibilities of being as we can countenance the nothing and nowhere that a genuine understanding of the world as contingent actually discloses to us. Nowhere makes anywhere possible, just as the country is describable from any possible corner since *corner* is never articulated by a geometrical expression of space. By contrast, fear of the nothing and nowhere that makes one fall prey to the world is—according to Heidegger's logic—what happens when we experience a sense of publicness with mass culture. They-being, in these terms, is a shared world of tranquility and distraction, distraction from the fact of the nothing and nowhere—which, if properly and fearlessly grasped in the moment of *Angst*—is also what "discloses Dasein as '*solus ipse*.'"[17]

However, if we understand the moving image as fundamentally incapable of producing an identity between beings, or between an image and the being making use of that image in a moment of worry, then fear cannot be understood strictly in terms of what it takes from being. I come to images in moments of worry and fear, especially when I am about to move to a place that I do not yet know, but the image is incapable of doing exactly what I desire, especially if what I desire is a projection of what is guaranteed to become of me when I arrive at the place that I am now looking at as an image—if, that is, I am seeing something certain that will not be described as possible. Even if tranquilized being-in-the-world is what I am after, the moving image will always fail me because it is incapable of identity within repetition and because it can only last for some time. I will have to look at something else, too, and will likely do so if I believe a film to have failed me in my search for tranquilized being. If I look at something else, I do so in fear—particularly if we understand fear as an expression of the avoidance of the nothing and nowhere that makes being possible. However, the fear that leads me to the moving image is what will bring me to *Angst,* and it does so because it cannot produce an identity in repetition, despite my desire to be tranquilized, and precisely because it can only last for some time. If I watch a series of moving images of the place where I am about to go, what I become aware of is the nothing and nowhere that each image is both reminder and expression of. What the moving image gives to my being—as there-being—is a continual reminder of the possibility of being that

is owed to the nowhere and nothing in which we find ourselves daily. The moving image provokes *Angst* by virtue of a repetition fueled by worry and is "satisfied" by the promise of the countless number of them that exist—countless because they are made every day and by many, and sometimes about the same "place" that cannot be exactly the same. Place can be shared, but only imperfectly, and only for some time. *Angst* is the dawning of what is purely possible *and* a normative experience of spectatorship.

NOTES

1 Meghan Daum, *The Quality of Life Report* (New York: Penguin Books, 2003).

2 Jeff Malpas, *Heidegger's Topology: Being, Place, World* (Cambridge, Mass.: MIT Press, 2006), 52.

3 Martin Heidegger, *Being and Time,* trans. Joan Stambaugh (Albany: State University of New York Press, 1996), 64.

4 Ibid.

5 Guy Debord, "The Theory of the *Dérive*," in *Situationist International Anthology,* ed. and trans. Ken Knabb (Berkeley, Calif.: Bureau of Public Secrets, 1981), 53.

6 Ibid.

7 Heidegger, *Being and Time,* 118.

8 Ibid., 164.

9 Malpas, *Heidegger's Topology,* 254–55.

10 In Jean-Luc Nancy, *The Ground of the Image,* trans. Jeff Fort (New York: Fordham University Press, 2005), 51.

11 Ibid.

12 Ibid., 52.

13 Heidegger, *Being and Time,* 176.

14 Ibid.

15 Ibid., 177.

16 Ibid.

17 Ibid., 176.

14 | Living Dead Spaces: The Desire for the Local in the Films of George Romero

HUGH S. MANON

> They're after the place. They don't know why.
>
> —Peter (Ken Foree) in *Dawn of the Dead*

This essay theorizes the structure and function of localness in cinema, examining the split viewership that results when films embrace marginal, relatively unknown real spaces as a backdrop for fictional narrative. Drawing on Jacques Lacan's discussion of anamorphosis, especially the idea that spectatorial engagement depends on the inscrutable copresence of the other's desire—an oblique field in which the beholder does not reside—I argue that an excess of localness in cinema can appear as an incongruous smear on the face of the text, a site of disjuncture at which perspective reveals its own multiplicity. Although isolated traces of the local may be recognized as familiar by insiders ("Hey, I know where that place is!") or produce an impression of gritty realism for outsiders, both these responses affirm the viewer's experience as one of plenitude, a comfortable identification with the reality that the film presents—satisfaction, in other words, but not desire per se. However, when localness abounds in a given film—when one senses that there is too much *there* there—these two mutually exclusive paths to satisfaction come into conflict, each confronting the other's itinerary. The result is an anamorphotic blot in the field of vision, a desire-inspiring blockage that neither a local nor a nonlocal audience can easily reconcile.

The goal of this essay is to understand topophilia not only as a satisfying pursuit of real locality but also as an exposure of its dissolution—not only a love of places but also a desire for them to coalesce. Although the anamorphotic structure of localness I go on to describe can be discerned in a wide array of films from different periods, nations, and individual filmmakers, I argue that George Romero and his filmmaking family have an unusually strong investment in the local and that

his early films, shot on location in and around Pittsburgh, Pennsylvania, provide a particularly instructive case study in the psychodynamics of localness in film. Romero's films embrace southwestern Pennsylvania, immersing themselves in the place to such an extent that it becomes obtrusive, but in remarkable and productive ways. In a similar fashion, this essay unapologetically seeks to exploit the author's own surplus knowledge of, and felt connection to, the area in question. What follows, then, is not only an essay about localness but in crucial ways, and with considerable affection, a meditation that emerges out of it.

ANAMORPHOSIS AS A METAPHOR

In Seminar VII, Lacan defines *anamorphosis* as "any kind of construction that is made in such a way that by means of an optical transposition a certain form that wasn't visible at first sight transforms itself into a readable image. The pleasure is found in seeing its emergence from an indecipherable form."[1] Lacan's point of reference, both here and in his more famous discussion of the gaze in Seminar XI,[2] is Holbein's painting *The Ambassadors* (1533), a large, highly detailed rendering of two men surrounded by a collection of worldly goods (Figure 14.1). At the foot of the painting is an incongruously enigmatic, distended object that, when viewed from an oblique angle, becomes recognizable as a human skull. Holbein's painting, along with the other examples of anamorphosis Lacan cites, is to be understood metaphorically, with the image's overt illegibility standing for any situation in which two circuits of desire intersect and in a strong sense *interfere* with one another. In anamorphosis, each of two coherent yet oppositional perspectives (one local, one nonlocal) destabilizes the other, rendering it lacking, partial—and this lackingness and partiality are what sustain the viewer's engagement with the overall representation. In Lacan's words, "how can one not be touched or even moved when faced with this thing in which the image takes a rising and descending form?"[3]

Lacan's discussion is especially germane to this study of localness in cinema because unlike trompe l'oeil or other tricky painterly techniques, anamorphosis depends on the specific place the beholder occupies relative to the viewed object. No matter from where one gazes at an anamorphotic representation, one of its two fields necessarily distorts, becomes alien. In Holbein's painting, although the loaflike object at the bottom of the frame resolves itself as a realistic, proportionate skull when seen from the proper position in the room, this corrected viewpoint renders the two male figures, and indeed the realism of the overall canvas, an unreadable blur. In anamorphosis, the viewer can't have it both ways, but equally important is that neither the readable image nor the indecipherable stain ever reaches its final destination because each is always/already in the process of

Figure 14.1. *The Ambassadors*, Hans Holbein the Younger (1533).

morphing, of becoming something else.[4] Anamorphosis functions similarly in the films of George Romero, although they do not, of course, involve a literal optical transposition; audiences do not physically reorient themselves to view the screen at an angle. Instead, Romero repeatedly allows the region of America in which his films are produced to overflow his narratives, usurping the spotlight and daring us not to notice. The result is a nagging awareness of the gravity of local space, a disquieting sense of mundanity and inertia that registers either as uncomfortable naturalism or uncanny familiarity, depending on the geographical coordinates from which any given viewer hails.

Since the 1968 release of *Night of the Living Dead,* and its popularization in midnight screenings in the early 1970s, many critics have acknowledged that the film's rawness is one of its greatest assets. Steven Shaviro, whose chapter on

Romero is to date the best and most sophisticated theorization of the Living Dead trilogy, notes that the zombies "remain disconcertingly close to the habitual surfaces and mundane realities of everyday life. . . . Everything in these movies is at once grotesque and familiar, banal and exaggerated, ordinary and on the edge."[5] Part of this effect derives from the films' immersion in the locality of southwestern Pennsylvania and the filmmakers' adoption of real homes, rural pastures, a local cemetery, and even a well-known suburban shopping mall as stages for action. Although Romero's fourth and fifth zombie films, *Land of the Dead* (2005) and *Diary of the Dead* (2007), are nominally set in and around Pittsburgh, both films were shot in Toronto to reduce production costs. The opposite was true in the 1960s and 1970s, when Pittsburgh served as Romero's exclusive base of operations. In films such as *Night of the Living Dead* (1968), *The Crazies* (1973), *Martin* (1977), and *Dawn of the Dead* (1978), localness is not simply a budgetary imperative but a matter of considerable thematic fixation. Scene by scene, and in some cases line by line, these early films frequently seem akin to the random pedestrian whom you ask for directions in a strange town and who takes an excessive, belabored pleasure in delivering the response, as if he had secret career aspirations as a tour guide. Indeed, it could be argued that no American director embraces his localness—not hometown pride or regional difference but *localness* per se—more than George Romero.

Accordingly, I want to preface my analysis of selected moments from Romero's films with a semantic clarification: that location is not the same as localness. Whereas the success of so-called location shooting depends on the iconic familiarity of certain landscapes, buildings, and objects or on a broad (perhaps movie-fueled) knowledge of places that the viewer has not necessarily inhabited, localness works in the opposite direction, supplying a profusion of pointedly unrecognizable local details to create a sense of familiar nonfamiliarity or, better yet, specific nonspecificity. For most viewers, who are by definition noninhabitants of any given locality, it is the unremarkable mundanity of the local, and not its cultural resonance as a tourist attraction or travelogue subject, that lures viewerly desire. Moreover, whereas location shooting presumes a relatively coherent set of culturally shared connotations (regarding big-city alleyways, western ranches, alpine ski lodges, etc.), an individual viewer's success or failure at decoding localness is almost entirely idiosyncratic, depending on where he or she currently lives, or has lived, and for how long.

By setting his films in little-known corners of southwestern Pennsylvania, by periodically spewing forth a litany of local place-names, and by refusing to fully suppress the region's dialect, Romero provides a reflexive inside joke for local

audiences, a conflicted but nonetheless loving embrace of the region "warts and all," as the saying goes. At the same time, these very same regional quirks seduce nonlocal audiences with a kind of terse insularity—a blunt and inscrutable sense of the "here" in which real reality is at odds with, and consequently exceeds, the conventions of realism. By repeatedly allowing the local to unveil itself as local, Romero positions his story worlds between realism and its beyond. As in anamorphosis, however, it is the inability ever to finally settle on either plane of representation, even while both planes are copresent, that animates viewerly desire. Caught, zombielike, in the oscillating inertia of the drive, the local always appears as either "too much" or "not enough"—either a grotesque oversatiation or a confounding lack—but, in either case, as a promise of something else.

THE NAMES HAVE NOT BEEN CHANGED

A pivotal development in the evolution of Romero's cinema of localness occurs in the TV broadcasts that appear in the second half of *Night of the Living Dead*. The film's writer John Russo explains these sequences as follows: "We used to tell ourselves that [if no national distributor would take the film], we ought to be able to recoup our investment by getting the picture into local drive-ins. We even tried to ensure 'word of mouth' among local moviegoers by putting the names of real towns on screen as 'Rescue Centers' where survivors of ghoul attacks might go to receive treatment and protection."[6] In these sequences, a matte shot of the front of a television set fills the cinematic screen, and overprinted at the bottom of this mise en abyme is a list of local cities and towns, each paired with the specific location of its rescue station (i.e., "Main Post Office," "Civic Auditorium," etc.). In order, and with occasional cutaways and interruptions, we see the following names: Youngstown, Sharon, Mercer, Butler, Ford City, Indiana, Blairsville, Willard, Latrobe, Greensburg, Beaver Falls, Foxburg, East Brady, Harrisville, Oakland, McKeesport, New Castle, Clairton, Canonsburg, and Connellsville. With the exception of "Willard,"[7] the location to which the protagonists tentatively decide to flee, all the listed town and city names are real, serving both to geographically triangulate and metonymically stand for southwestern Pennsylvania as a whole (Figure 14.2).

The list represents a range of destinations, any one of which an average Pittsburgher might decide to explore on a leisurely Sunday drive, and indeed, this quotidian sense of contiguity is part of the emergency broadcasts' uncanny appeal: any local viewer could exit the movie theater and drive to these places, many in less than a half hour and certainly without need of a map. But whereas locals may receive a thrilling, even laugh-inducing metatextual jolt when a nearby town name appears, nonlocals are confronted with a hieroglyphic obstruction that

Figure 14.2. An emergency broadcast from *Night of the Living Dead* (George Romero, 1968).

unsatisfyingly designates "particularity in general." This is not to say that *Night* categorically excludes nonlocal viewers but rather that it lures them in a differ-ent way: both by confronting them with their own status as outsiders and also by producing the connotation, implicit in any place-name, that all people rely on a set of place-names as familiar points of reference in their everyday lives. Marauding ghouls may be attacking Ford City (wherever that is), but they could just as well be attacking Parkersburg, Poughkeepsie, or Petaluma.

Part of the legend of *Night* is that drive-in audiences used to cheer when they saw the name of their hometown appear on-screen as the site of a zombie incur-sion, an effect that persists for locals even today, if less loudly, in front of the TV or computer screen. Such name drops are the regional–geographical equivalent of stunt casting. To the precise extent that an individual viewer qualifies as local, the story world of *Night* responds in kind, providing ample opportunity for identifica-tion and personal connectedness. (A confession from the author: although my own upbringing in southwestern Pennsylvania connects in various ways with both the production history and story world of *Night,* I am always especially delighted to see "LATROBE—COUNTY FIRE HALL" appear on-screen. If zombies were roaming the streets of Latrobe in early 1968, then I am living proof that the hospital's maternity ward barricaded itself well.) Allegedly, when *Night* was screened on television years after its initial release, the town names were blacked out to avoid an inadvertent

"War of the Worlds" panic.[8] Such print-based on-screen hieroglyphs, to borrow a term from Tom Conley,[9] would not be so important, however, if not for the films' primary enigma: the motivation of the zombies themselves.

One tagline devised for the original release of *Night* was as follows: "Pits the dead against the living in a struggle for survival."[10] The paradox of such a statement is implicit: how can creatures that are already dead struggle to survive? Romero's films are famously high concept in this regard. The zombies may seek to devour the living, but the end result of their plodding invasion is that the living, too, will un-die. At the same time, because zombies are not dead but rather undead, they are, as the tagline suggests, trying to survive as dead, thus placing the living in the paradoxical position of having to kill the dead. Indeed, were the Living Dead franchise initiated today, it would be easy to imagine a multiplex marquee bearing the bluntly postmodern title *Kill the Dead.*[11] In pointing up these logical convolutions, my contention is that zombie films are positively obsessed with questions of ontology. And although zombie ontology is endlessly discussed by various imperiled characters, as well as in the increasingly diverse body of critical writing and extratextual discourse[12] surrounding the films, most analyses bypass a crucial distinction: wherever they appear, zombies are nothing if not locals.

The zombie, in effect, begs us to define its terms, and a huge amount of dialogue in *Night* and *Dawn*—both between characters and on emergency radio and television broadcasts—is dedicated to doing just this: defining what zombies can and cannot do. Such pragmatic ghoul assessments consistently elide a more speculative, theoretical discussion about "what it all means" in favor of arguments about how to best board up the windows. One result of this marked lack of philosophical reflection within the films is that it renders the zombies as open signifiers, metaphors for anything and everything. One of the more compelling hypotheses about zombie revivification is offered by Slavoj Žižek, who identifies Romero's zombies as returning to collect "some unpaid symbolic debt."[13] Yet cannot such a definition apply just as well to a different, equally popular supernatural being: the ghost?

Ghosts haunt places, are tied to them; their modus operandi is recurrence, seriality. Consequently, the relation of living residents to ghosts is strictly binary; in beholding one's surroundings, it is clear that ghosts are either manifest or absent, on or off. Yet despite the restless living-dead status of both zombies and ghosts, zombies cannot be said to haunt the places they occupy any more than the living do. Compared to a ghost, which typically inhabits a highly particularized locale, zombies roam widely. They are tied not to a spectral home base—a certain room in an old hotel or a specific burial site—but instead occupy a particular area or range. The appearance of zombies at a given locale can only ever be incidental, the

result of them having traversed a field of adjacent spaces—a point underscored by the discrete yet contiguous (in a word, cellular) topology of the mall shops in *Dawn*. Every bit as substantial as the localities through which they pass, if zombies are not here, they must be somewhere else. In effect, the zombie's obstinate, linear motility represents a perverse twist on the unpredictable occultation of the ghost—its tendency to pop up and just as suddenly vanish. If a ghost, by definition, appears out of nowhere, the whole point of the zombie is that it always appears out of *somewhere*. And although numerous films have shocked audiences by depicting zombie hands thrusting hungrily through walls and windows, their arrival in a place is nonetheless always just that: a gradual approach. Like a child's bus route home from school, or like Aunt Shirley's two-block commute to her weekly bowling league, zombie itineraries can be timed, charted, anticipated: "*That zombie is two minutes away*" or "*That zombie is very close to your car door*" or "*No worries, that zombie is headed in the wrong direction*." The crucial distinction is that whereas ghosts hover in some other dimension, waiting to teleport into our presence, zombies have *walked here*—a seemingly obvious point, but one that links them to the contiguity and circumscription of the local. Zombies do not glide; they schlep, and their slow, vaguely radial perambulation makes proximity a primary narrative concern.

As various characters in the films note, the best defense against zombies would be to hole up on an island with plenty of supplies. The point, of course, is not actually to go about searching for such a refuge but to remind us that the zombie problem is at its core a matter of one's local position; that is, both inside and outside the story world, *they come from the local* (to the old farmhouse in *Night*, to the Monroeville Mall in *Dawn*, and to the underground storage facility in *Day*). Indeed, over the course of the three films, zombies appear increasingly defined by their former roles in the community so that in *Dawn*, the audience glimpses a nurse zombie, a Krishna zombie, a mall guard zombie, a softball player zombie, and so on—a calculatedly diverse local citizenry. It is as if we are witnessing the uncanny underside of that other widely known Pittsburgh-based series that began in 1968: *Mister Rogers' Neighborhood*. To decipher the zombies' plaintive moans, "Won't you please? Won't you please? Please won't you be my neighbor?"

ESPRIT DE CORPSE

A great deal of local lore surrounds the casting of George Romero's films, and just about everyone who resided in Pittsburgh in the 1960s or 1970s knows someone who appeared in one, even if she herself did not. Romero's renowned special effects designer Tom Savini, himself a lifelong Pittsburgher, has said, "When you're

born in Pittsburgh, one of the things you want to be when you grow up is a zombie in a Romero film."[14] This penchant for local casting profoundly impacts the appearance of the films. As I have suggested, although each of the films requires a multitude of zombie actors and other so-called extras (for biker gang and posse scenes, etc.), Romero does not coach his extras to recede into the background but instead discretely frames each individual as if to honor his localness. This overpersonalization of the zombie hordes correlates directly with what might best be described as Romero's friends-and-family approach to filmmaking, a mode of production that aims to generate an ever-present tinge of actuality on-screen, a regular Joe quality that is anything but bland or normalized.

The audio commentary tracks included on the various DVD releases of Romero's films uniformly, and in ways too numerous to detail here, underscore my point: that what we might call the "Romero family" of filmmakers is massively preoccupied with the familial atmosphere of Pittsburgh itself, and that this intense topophilia should not be indifferently chalked up to budgetary constraints. The very beginning of a 2004 commentary on *Dawn of the Dead* is symptomatic. Just as Tom Savini is about to launch into a discussion of the mise-en-scène of the opening shot, Christine Romero jumps in: "Hey, that's my brother right there. . . . There's Molly McCloskey there talking to Gail. . . . I used to baby-sit her when she was a little girl."[15] Similarly, on one of the many available commentary tracks for *Night,* Judith O'Dea breaks in at the beginning of the first posse sequence: "There's Jim Hughes, my ninth grade English teacher's father."[16] Judging from these comments, it seems clear that one of the primary rationales behind the production of Romero's films was to repeatedly facilitate the following exclamation: "I can't believe that [this personal friend, this family heirloom, or this location] is going to appear on the big screen!" In this way, Romero creates a palpable anamorphosis, pitting the filmmakers' desire to remain covert—in other words, broadly realistic—against a "hey, mom!" impulse to be seen outside the diegesis and in one's locality.

Of the making of *Dawn,* assistant director Christine (Forrest) Romero recalls that "everybody I think I ever knew in my whole life came out to be a zombie" and, furthermore, that "they wouldn't take their make-up off. They wanted to take it home and show it to their family."[17] Likewise, George Romero points to a kind of inadvertent proto–viral marketing at work during the production of *Dawn*: "There were a few local legends about zombies wearing their makeup home and stopping at the McDonald's or the Eat'n Park, so word spread pretty quickly."[18] Yet far more outrageous than these surreal anecdotes, while functioning on the same local level, is the anamorphotic incongruity of the zombies' makeup within the films themselves: even if we know nothing of the films' eccentric casting calls, the zombies appear

just as out of place on-screen as they would have at McDonald's or Eat'n Park.

In the words of Roy Frumkes, director of *Document of the Dead* (1985), "just making films in Pittsburgh for ten years has become a sort of stylistic statement." Not only are there no "recognizable actors" (Romero's term) in the films, but from a costuming and special effects standpoint, little effort has been made to mask this problem. In fact, playing up the problem as such seems to have become its own kind of solution. Can there be any question that Romero's zombies are the most thinly disguised, makeshift monsters ever created? As Steven Shaviro notes, the films "go out of their way to call attention to their own irreality, the hilarious and ostentatious artificiality of their spectacular, outrageous special effects."[19] Moreover, whereas *Night* obscures its low-budget makeup effects by using black-and-white film stock, *Dawn* is filmed in garish Technicolor. Here, to differentiate the undead from the living, a thick layer of pancake makeup—with a color and finish resembling gray auto body primer—coats the faces of the zombies. In many scenes, especially those shot outdoors, their faces appear bright blue. To borrow a formulation from Susan Sontag's "Notes on Camp," this is not makeup but "makeup" in quotation marks—high phoniness, to be sure.[20]

Although it begs to be seen through, Savini's makeup style and color in *Dawn* can be considered a success just the same, having been imitated in too many subsequent zombie films to mention. Such transparency moves in precisely the opposite direction of a mask, calling attention to the real faces of the extras rather than obscuring them, or rendering them uncanny and grotesque. Counter to most monster makeup, which aims at excessive distortion, I want to argue that Savini's rudimentary application of a disklike patch of blue to the face of each zombie functions not as a form of concealment but as an anamorphotic *spotlight,* the result of which is that the actors' unrecognizability is fully recognized. In Seminar VII, Lacan states:

> At issue, in an analogical or anamorphic form, is the effort to point once again to the fact that what we seek in the illusion is something in which the illusion as such in some way transcends itself, destroys itself, by demonstrating that it is only there as a signifier.[21]

It is important, however, not to lose sight of the fact that the optical transposition Lacan identifies as the crux of anamorphosis pivots on a singular, decisively flawed object that is very quickly seen through. The distended skull in Holbein's painting traps the viewer not because it recedes or dissolves into the overall image but because its distortedness is every bit as finely rendered as the realistic details surrounding it. To state it differently, when viewed head-on, the blot is not vaguely

nonrepresentational but crisply so. In anamorphosis, there is no lack of clarity that what we are looking at is unclear, and this is precisely the effect Romero and Savini obtain with their blue-faced zombies. To resort to an old cliché, the artifice of the makeup sticks out like a sore thumb, taunting us to make the overall picture cohere.

On the DVD commentary track for *Dawn,* Romero and Savini talk about the artificial blood formula they used in the film in similar terms. Although the blood looked like "melted crayons," they admit that this "cartoony," nonrealistic look "may have helped them out." Whereas such implausibility and apparent shortsighted-ness is usually conceived as passive, a liability—something most independent directors hope to overcome in future film projects—we need to understand the corny, failed quality of Savini's makeup effects not only as a winning strategy but as a brilliantly seductive example of anamorphosis. Implicitly acknowledging the public's desire for increasingly sophisticated and expensive Hollywood special ef-fects, Savini plays dumb. He allows his supernatural beings to look innocuously like just plain folks and, in doing so, creates a sense of real corporeality that, when violated, is almost too much to bear.

Most disturbing are the sequences, in both *Night* and *Dawn,* in which offal from a local slaughterhouse (supposedly sheep entrails[22]) is used to simulate human disembowelment and cannibalism, resulting in the on-camera mastication of a liver, heart, intestines, and so on. In these shots, the sickening effect derives not from the fact that we believe people are eating other people; rather such images, like the zombies' blue makeup, demand the viewer's oscillation between two different perspectives. Considered at the level of the film's production, the cannibalism is a self-evident distortion; yet, at the same time, the glistening, slippery, correctly weighted presence of the sheep intestines makes clear that something has none-theless been killed. At such moments, the films seem to say that there are realistic bodies, and then there are the *real guts* you see here. In such an arrangement, the viewer finds no escape from the deadlock of anamorphosis; the domains of cast-ing, makeup, and special effects become hopelessly confused. Indeed, at certain moments, the viewer may not be able to keep up, failing to adjust her angle of view quickly enough and thus recoiling at the impression that it is the actor, and not the fictional character, whose body is being eviscerated.

INFECTION AND/AS INFLECTION

In the midst of the television broadcasts in *Night,* there is a discussion among the refugees in the farmhouse concerning who is from "around here" and who is not. As I have argued, zombies can be understood as those supernatural beings whose ontology necessitates a constant reassessment of who or what is "around here." If

zombies aren't "around here," then zombies aren't a problem. This is precisely what makes them unique, distinct. Similarly, the rural posse sequences in both *Night* and *Dawn* connect zombies with fish, deer, and other huntable wild game, which either are or are not "around here." The key to these sequences is that both in the films' story worlds and at the level of casting, the local origins of the zombies are no different from those of the other supporting characters. In viewing the posse sequences, one quite easily (and correctly) surmises that many of the assembled cast members were avid deer hunters—as are many men in southwestern Pennsylvania—and, in lieu of a wardrobe department, were requested to bring their own rifles and hunting clothes with them to the set.[23] Of particular note is an uninterrupted long take in *Night*, shot on a handheld 16mm camera, wherein a TV field reporter approaches the leader of one search-and-destroy mission while he is on a coffee break. What transpires are some of the most lively and memorable lines in the film. Indeed, the interview could rightfully be considered the single most important dialogue exchange in the history of zombie cinema, helping to cement both the gritty, lo-fi aesthetics of the subgenre and the parabiological rules of play by which zombies can be vanquished.

The pivotal dialogue takes place between two real-life Pittsburghers: television personality Bill "Chilly Billy" Cardille, host of an actual Saturday night horror movie program called *Chiller Theatre,* and Sheriff Conan McClelland, played by George Kosana—a nonactor who, like many of the posse members in the sequence, worked in a Clairton steel mill.[24] McClelland's gruff, unflappable delivery speaks not only to his deputies' rough-and-ready demeanor but also to their localness as actors, deputized into service by Romero and company. The crux of the sequence is that Romero, in his role as the film's editor, lets actor Kosana speak at great length and in a seemingly extemporaneous fashion. This would not be significant except that the actor's speech so perfectly represents the dialect known as Pittsburgh English—referred to colloquially as Pittsburghese by many of those who speak it. McClelland's speech thus stands in for the voices of the other posse members, who remain visible but largely silent:

> MCCLELLAND, *shouting to a posse member off-screen*: Hey, Cash! Put that thing allaway inna fahr. We doh wannit getnup again.[25]
> CASH, *off-screen*: Arright, I gotcha.
> CARDILLE: Chief? Chief McClelland, how's everything going?
> MCCLELLAND: Aw, things arn gohn too bad—menner takin it pretty good. *(Shouts to another posse member off-screen.)* You wanna get ahnee other siduh road over there!

CARDILLE: Chief, do you think we'll be able to defeat these things?

MCCLELLAND: Well, we killed nineteen of um tuhday right innis area. Those last three we caught tryna claw their way into an abandoned shed. Dey musta thought somebody was innair. There wuddentdoh. We hurdum makin awl-ki-na noise. We came overuhn beatum off, blastedum dahn . . .

CARDILLE: Chief, uh, if I were surrounded by six or eight of these things, would I stand a chance with them?

MCCLELLAND: Wellairs no problem. If ya hadda gun, shootum inna head—dat's a sure waytuh killum. If ya don't, getcherselfa clubbera torch. Beatum er burnum—aaygo up priddy easy.

As a native of southwestern Pennsylvania, I am fairly convinced that even a transcription by a professional linguist might fail to distinguish the more subtle phonetic variants that mark McClelland as a Pittsburgher: the pronunciation of *good* as something approaching but not quite "gwoodt," the unusual vocalization of words ending in *L,* so that *well* sounds more like "wehw," and so on—features partially masked by the sheer speed with which his lines are delivered (also a Pittsburgh trait). In these instances, as well as in the less subtle variants transcribed earlier, the meaning of Kosana's lines is never incomprehensible; rather it is as if the standard American pronunciation has been tinted, painted over, or smudged—subtly, but not substantially, deformed.

Such inflections appear sporadically throughout *Night* and Romero's other early films. In the corresponding posse sequence in *Dawn,* we hear an off-screen voice say, "I herdare abaht tenner twelve dahn inna woods," a localness effect that is redoubled when we see one posse member wearing a Pitt Panthers football T-shirt and others popping open cans of an iconic local beer, Iron City. The very first lines spoken in *Hungry Wives* (1972) are punctuated with Pittsburghese: "I'll be gone about a week. Oh, by the way, I brought her pilluh (pillow)." So is the dialogue of the slope-dwelling hausfrau to whom the eponymous Martin first delivers groceries: "Go arahnd to the side! Go arahnd to the side!" *Night* concludes not only with a disturbing funeral pyre for protagonist Ben, who has survived the night only to be shot in the head and then lumped together with the other zombies, but also with a conflagration of Pittsburghese. Sheriff McClelland directs the proceedings: "Nick, Tony, Steve—you wanna get aht in that field an build me a barnfahr (bonfire)?" "You!—drag that ahtta herrin throw it on the fahr." "Okay, he's dead—let's go gettim. Atsa nuther one ferda fahr."

Linguists are interested in Pittsburghese, among other reasons, because of a phonetic feature called *monophthongization*—a variant that occurs repeatedly in

the dialogue quoted earlier. Appearing in place of a diphthong "ow" sound is an "ah" sound in words such as *out* ("aht"), *around* ("arahnd"), and *county* ("cahny"). Linguist Barbara Johnstone describes this feature as "truly local, in the sense that it has rarely been noted elsewhere,"[26] and goes on to explain that when Pittsburghers deliberately trumpet their authentic localness in speech (or embrace it as a region-defining stereotype on T-shirts, bumper stickers, etc.), they will often invoke the most common word that contains a double monophthong: the word *downtown*, pronounced and usually spelled as "dahntahn"—a reference to the city of Pittsburgh itself.[27] Romero's deployments of Pittsburghese function in a similar fashion. By placing Pittsburghese under glass, his films represent the otherness of Pittsburgh localness back to locals, inviting them to gaze anamorphotically at themselves. That McClelland's dialect is doubly framed by the speech of two newscasters (in the studio, and then in the field) sets this difference in high relief, reaffirming its nonstandardness.

In *Night*, we encounter three distinct registers of speech: (1) the accent-free voice of the newscasters and of professional actors (e.g., Duane Jones and Judith O'Dea), the meaning of which is singular and stable; (2) the accent-heavy voice of nonactors (George Kosana or the prerecorded mall promotional announcements in *Dawn*), the meaning of which is bifurcated and unstable or, in my terms, anamorphotic; and (3) the preternatural vocalizations of the zombies, the meaning of which is beyond any question of stability, empty of content and thus radically uncertain. Given their frequent proximity with one another in various scenes, the stark difference among these voices begs a crucial question: what would human speech sound like if we subtracted out the words? That is, what would remain if we evacuated language itself *(langue)* from speech *(parole)*, leaving only the unconscious structures and sonic colorations proper to dialect? The answer is that it would sound like the wheezing grunt-drone of the zombies, creatures that figuratively, and in some cases literally, have southwestern Pennsylvania soil stuck in their throats.

Linguists such as Johnstone tell us that the relatively unique combination of inflections characteristic of Pittsburghese may be the residue of early German and Scotch-Irish settlement, speech patterns that were exacerbated by the relative isolation of the region, which is separated from the eastern seaboard by the Allegheny Mountains. However, we need not probe the history of immigration in southwestern Pennsylvania to understand the relevance of dialect to Romero's oeuvre or its relation to zombies in general. For what is regional dialect if not an "undead" quality in language, a ghoulish recursion to ancestral forms in which speech is chewing on itself, digesting its own proximity?

To wit, I want to read the ever-present moaning of Romero's zombies as un-diluted *Pittsburghese itself*—as a local accent without the structural framework of language to render it intelligible and thus mediate its effects. The zombies have regressed into a presymbolic state; however, in lacking language, they do not lack an accent. Imagine for a moment the classic Romero zombie vocalization—the *aaahhhhnhnhnhn* sound to which his movies gave birth and that has since become a zombie film cliché. What we hear in such utterances is monophthongization in its purest form: a desireless vocal object in which the contour and variation proper to speech becomes stuck in its place. Kosana's Pittsburghese and the zombies' moans both represent a localized, drive-based persistence of past phonologies in the present, an unconscious obstinacy that flaunts normalization (e.g., the news broadcasters' desire-based renunciation of local accents in favor of so-called Network American English, which sounds hypercorrect by comparison). Such a claim—that zombie speech is pure dialect—accords with a commonplace theory about zombies: that they represent the return of the repressed, a residue of the past that intrudes within the present. Taking into account their inability to move very quickly or very far from their point of reanimation, along with their propensity to pass along their infection *by mouth,* what are Romero's zombies if not the carriers, and indeed the disseminators, of local dialect? Or, understood from a different vantage, what is dialect—wherever it appears and however it sounds—if not an inert zombification of speech?

CONCLUSION: THE DESIRE FOR PLACE

By way of conclusion, I want to argue that Romero's decomposed zombies, with their distorted voices and dogged persistence, rise up as a metaphor for the problem of localness itself. Whereas the inclusion of the anamorphotic skull at the foot of the Ambassadors evinces a "sign of the classic theme of *vanitas,*"[28] to the extent that Romero's films provide a memento mori, they do so with the corollary that the inertia of the local will always outlast us. In this sense, place, or, more specifi-cally, localness, is always/already undead. Whereas humans come and go—born into local places and dying out of them—local places doggedly persist, albeit in a partially degraded, zombified form. Correspondingly, whereas the appearance of Romero's zombies ranges from more or less normal looking to grossly scarred and partially eaten, most are not overtly disfigured—the zombie body, as such, usually retains the basic shape of the living body. In a word, we might say that the zombie corpus, like the soon to be postindustrial Pittsburgh cityscape of the 1960s and 1970s, is *dilapidated.*

At the beginning of *Dawn,* a scientist on television (David Crawford) says,

"Every dead body that is not exterminated becomes one of them—it gets up and kills! . . . If we'd dealt with this phenomenon properly—without emotion, without emotion—it wouldn't have come to this." The argument, reiterated by various authoritarian broadcasters throughout *Night* and *Dawn,* is that people can't let go of their deceased—they can't let go of their attachment to *what is no longer what it once was*—and this attachment to the familiar is precisely what permits the zombies to proliferate. Given free rein, the zombies would simply continue their endless slog forward toward a place that they can no longer inhabit, and this sense of a forced displacement within the confines of the local is precisely the point (Figure 14.3).

With the decline of big steel, and the resultant transformation of boom towns into dilapidated zomboid cityscapes such as Braddock, Aliquippa, Homestead, and many others, the zombies' depurposed, aimless persistence had special resonance in 1970s Pittsburgh. Indeed, the sieges in *Night* and *Dawn* resemble nothing so much as a union strike turned violent—a fairly regular occurrence in southwestern Pennsylvania in the 1960s and 1970s but also a region-defining event throughout its long history. Strikes by steel workers, coal miners, truck drivers, and laborers in other related industries sometimes involved shots being fired by strikers at scabs and their vehicles[29] as well as lock-ins (in which management would enter a manufacturing plant only to be refused exit by pickets), random objects being set ablaze on picket lines, roving caravans of striking workers whose goal was intimidation, vandalism of homes and property, and so on.[30] In extreme instances, U.S. marshals or National Guard troops were deployed to break up the violence—interventions not unlike the martial law imposed on Evans City in *The Crazies.*[31] At the risk of stating the obvious, we must remember that such violence took place mostly *between* workers; in other words, in a labor strike, as in a zombie attack, *they* are just a little too much like *us.* Given this history, it should come as no surprise that violent strike-related episodes in steel and other industries occurred in many of the places listed in the films as zombie refuge centers: Sharon, Butler, Indiana, Blairsville, Latrobe, Greensburg, Beaver Falls, McKeesport, Canonsburg, and Connellsville.[32]

In all this, it is crucial not to miss that the living dead are the localities themselves, which in general expire and decompose on a slower clock than the humans who inhabit them. In the sphere of the local, all places are either already zombies or zombies waiting to happen. Reflecting on the state of the Pittsburgh economy when *Martin* was shot in 1977, George Romero describes Braddock, the film's setting, in provocative terms: "Guys were still sitting in the taverns waiting for the mills to open again. You know? It was like: 'It's gonna come back. It's gonna come back.' . . . Up and down the rivers all around the 'Burgh . . . it was the American

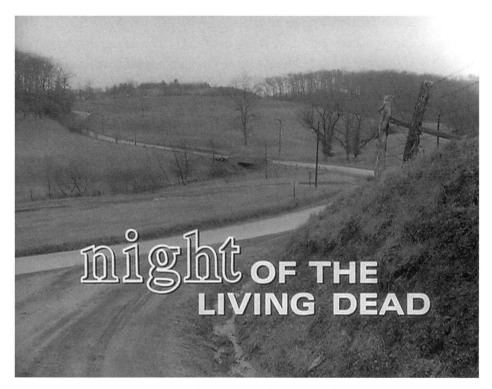

Figure 14.3. The opening shot of *Night of the Living Dead*. It would be difficult to imagine a more representative image of the landscape of rural western Pennsylvania.

Dream, and all of a sudden—where'd it go?"[33] Understood on this local level, Romero's zombies embody the look of industrial decay in their plodding, nearly blind search for someplace new to resume living. Romero himself is, of course, a kind of postindustrial maverick, making his living as a filmmaker in the Steel City, and as such, his zombies, with their dilapidated appearance, serve as a tidy allegory about the impossibility of ever moving on. At the same time, the largely unmodified settings of Romero's films both present and reflect on the local as a decomposed, disgusting stain—a stain, that is, unless the audience itself qualifies as local, in which case, the uncanny stain comes into focus as something more like home.

To encounter localness in cinema is either to be welcomed or rebuffed by the familiar—to be engaged, whether positively or negatively, by its hyperparticular gaps and excesses. By confronting each possible perspective (the inhabitant, the noninhabitant) with its absent counterpart, localness ensnares viewers at the limit of their own specificity of experience. In reaching this limit, we find ourselves standing at the crossroads of knowledge and disbelief—in other words, disavowal per se. Whereas local audiences feel a certain ownership in a locally produced story

world, projecting themselves into its places, they nonetheless know full well that they have otherwise been screened out of the fiction. Conversely, for nonlocals, whose initial engagement is staked in familiar narrative and formal conventions, the naturalistic particularity of the local can emerge as a rude disruption, an unexpected overflow. In George Romero's cinema of localness, unusual dialects, obscure scenery, and arcane points of reference—in short, all the petty details that Hollywood typically renders peripheral, covert, repressed—drift uncomfortably into the foreground, baiting nonlocals with a lack that they did not anticipate and cannot ignore. The key is to understand such incoherence and contradiction not merely as a failure of realism but as a terrain on which desire thrives. As I have argued, localness in cinema is anamorphotic, a collision of two points of view within a single field of perception, with each perspective uneasily containing the other's desire in the form of an agitating, unreadable blur. Localness fascinates because of, and not despite, this irresolvable copresence of two pictures, each of which is haunted by the other, yet neither of which can be completed. The desire for the local in cinema is in this way self-perpetuating, conducting audiences on a zombielike tour of real spaces, while guaranteeing that any final, satisfying arrival must be impossible.

NOTES

1 Jacques Lacan, *The Ethics of Psychoanalysis, 1959–1960*, trans. Dennis Porter (New York: W. W. Norton, 1997), 145.

2 Jacques Lacan, *The Four Fundamental Concepts of Psychoanalysis*, trans. Alan Sheridan (New York: W. W. Norton, 1978), 79–90.

3 Lacan, *Ethics*, 142.

4 In the context of an essay on zombie films, it is highly provocative that the anamorphotic blot, in which he ultimately locates "the gaze as *objet a*," is characterized by Lacan as "something decomposed and disgusting." Lacan, *Ethics*, 273.

5 Steven Shaviro, *The Cinematic Body* (Minneapolis: University of Minnesota Press, 1993), 83.

6 John Russo, *The Complete Night of the Living Dead Filmbook* (New York: Harmony Books, 1985), 41.

7 The invented name may be a reference to Glenwillard, a river town across the Ohio from Ambridge, Pennsylvania. Glenwillard is about seventeen miles from Evans City, the real location of the besieged farmhouse, which is the distance one of the characters specifies they would have to travel to the Willard rescue station.

8 *Night of the Living Dead,* Millennium Edition DVD, directed by George A. Romero (1968; Elite Entertainment, 2002), Commentary Track 1.

9 Tom Conley, *Film Hieroglyphs: Ruptures in Classical Cinema* (Minneapolis: University of Minnesota Press, 2006).

10 Russo, *Complete Night of the Living Dead,* 89.

11 The tagline for Romero's 2007 film *Diary of the Dead* comes very close: "Shoot the Dead."

12 I am thinking specifically of Max Brooks's book *The Zombie Survival Guide: Complete Protection from the Living Dead* (New York: Three Rivers Press, 2003).

13 Slavoj Žižek, *Looking Awry: An Introduction to Jacques Lacan through Popular Culture* (Cambridge, Mass.: MIT Press, 1991), 23.

14 *Dawn of the Dead,* Divimax Edition DVD, directed by George A. Romero (1978; Anchor Bay Entertainment, 2004), Commentary Track 1.

15 Ibid.

16 *Night of the Living Dead,* Commentary Track 2.

17 *Document of the Dead,* directed by Roy Frumkes (1985; Synapse Video, 1998).

18 Ibid.

19 Shaviro, *Cinematic Body,* 102.

20 Susan Sontag, *Against Interpretation* (New York: Picador, 2001), 280.

21 Lacan, *Ethics,* 136.

22 Russo, *Complete Night of the Living Dead,* 78.

23 Ibid., 63.

24 *Night of the Living Dead,* Commentary Track 1; Russo, *Complete Night of the Living Dead,* 46.

25 To evoke Kosana's dialect for a broad, nonspecialized readership, I have opted for a phonetic transcription, or *eye dialect,* rather than a notational one such as the International Phonetic Alphabet. Although the result may appear cartoonish, my intention is not at all pejorative, and I have made every effort to accurately represent the speaker's pronunciation.

26 Barbara Johnstone, Neeta Bhasin, and Denise Wittkofski, "'Dahntahn' Pittsburgh: Monophthongal /aw/ and Representations of Localness in Southwestern Pennsylvania," *American Speech* 77 (2002): 160.

27 Ibid., 148–66.

28 Lacan, *Ethics,* 135.

29 "Haulers' Strike Spurs Violence: Picket Shot in Pennsylvania as Steel Dispute Continues," *New York Times,* September 21, 1967, 52.

30 C. Dodd Manon and Lois T. Manon, e-mail correspondence with the author, February 25 and March 4, 2009. The author's parents were invited to write up their recollections of the violence surrounding a two-month strike at Latrobe Die Casting Company during spring 1977. The account they produced, quoted here at length, bears a startling resemblance to various zombie sieges, posse sequences, and barricade scenarios in *Night* and, especially, *Dawn.* It also represents an ingrained, hyperparticular knowledge of a mostly forgotten scene. Imperceptible

to outsiders, such historical residues do not haunt local residents. Instead, like Romero's zombies, despite having expired, such events linger in local streets, edifices, and vacant lots, awkwardly refusing to vacate the premises: "The former Latrobe Die Casting (LDC) Company of Latrobe, Pennsylvania, manufactured aluminum parts for industry, employing approximately four hundred people at its height of operations in the 1970s. In April 1977, shortly after employees voted to unionize the previously nonunion plant, management rescinded most of the many benefits it had offered throughout the years, and a wildcat strike ensued. As the strike continued, carmakers and other customers were concerned about obtaining the stockpile of parts in the plant as well as the specialized toolings (which the customers owned) that would enable them to manufacture those parts elsewhere so as not to slow their own productions.

"In an effort to get these items out of the facility, U.S. marshals attempted to escort cars containing twelve members of LDC management through the pickets to the gates of the plant. These were 'second-tier' managers—the sales manager, personnel manager, casting scheduler, casting floor supervisor, quotation/sales-men, sales engineers, and so on—and included quality control manager Dodd Manon [the author's father]. None of the company's top-tier managers, such as vice presidents, were part of the group. The men sat in cars surrounded by strik-ing workers from noon to 7:00 P.M. The strikers were in ponchos in the pouring rain, yelling and throwing stones from the parking lot at the cars. Some of the men in the cars speculated there were guns under those ponchos. As the mood turned more violent, the picketers burned railroad ties, with flames rising as high as the power lines overhead.

"Finally, Pennsylvania State Police sent by Governor Milton Shapp formed a wedge to push back the strikers and allow the cars through the gates. The cars, with the armed marshals walking alongside, were followed by trucks driven by strikebreakers from Detroit, there to transport out the castings and toolings. The loaded trucks went out the gates at midnight, causing more chaos. At that time, the strikers threw rocks at the plant, breaking out ninety-nine windows. (One member of management broke out the final window from inside to make it an even one hundred.) The local police (unionized) sided with the strikers, some-times supplying them with beer while they picketed. The managers remained in the plant for seven days and nights and were supplied with food through a hole on a secluded side of the fence surrounding the plant. They were finally released when the local sheriff escorted them out through the crowd of strikers.

"On the night of the release, at one or two in the morning, the Manon family was awakened at their rural home by the sound of rocks hitting their house and smashing the windshields of their cars. Lois Manon [the author's mother] was both irate and frightened for the safety of her children. Dodd Manon called to alert a coworker, Max, who lived in a nearby town. Max said not to worry about him: 'All my cousins are up in trees with guns waiting for them!' Several incidents of stoning homes and making threats were reported by those who had been locked in the plant for that week.

"Today, men on both sides of the LDC strike, many of whom have remained in the area, will occasionally meet by chance at a local diner, shopping mall, or the YMCA and stop to reminisce about the people who worked for LDC and the events of the strike. Although the company ceased operations in 1991 and the primary plant and office buildings have been repurposed, they appear much the same in 2009 as they did in 1977."

31 "Pennsylvania Alerts Units of Guard in Truck Strike," *New York Times*, May 2, 1970, 65.

32 Sharon: "Trouble in the Streets," *Time*, January 23, 1956, http://www.time.com/time/magazine/article/0,9171,861941,00.html; Butler: "Trouble Watch at Butler Mines," *Pittsburgh Post-Gazette (PG North)*, January 5, 1978, 1; Indiana: "Man Hurt in Mine Strike," *Charleroi Mail*, August 26, 1950; Blairsville: "Coal Strike Erupts into Violence," *Daily Collegian—Penn State University*, October 19, 1978; Latrobe: "Marshals Escort Trucks Past Pickets in Latrobe," *Pittsburgh Post-Gazette*, April 29, 1977, 3; Greensburg: "Mine Strikes Spread, 7,000 Reported Out," *Pittsburgh Post-Gazette*, September 12, 1933, 1; Beaver Falls: "A Steel-Hauling Trucker Is Shot in Pennsylvania," *New York Times*, November 28, 1978, A16; McKeesport: "Strike Violence at Fort Pitt Steel Forces Court Hearing on Issues," *Pittsburgh Post-Gazette*, October 14, 1978, 2; Canonsburg: "Gov. Duff Moves on Milk 'Violence,'" *New York Times*, June 13, 1950, 21; Connellsville: "Picket Suffers Shotgun Wounds," *Evening Independent*, July 24, 1937, 1; "Five Hurt in Mine Clash," *New York Times*, July 27, 1937, 10.

33 *Martin*, directed by George A. Romero (1977; Lions Gate Entertainment, 2004), *Making Martin: A Recounting* featurette. In *Martin*, the unemployed boyfriend Arthur (Tom Savini) speaks both for and to Pittsburghers when, in an early scene, he says to the protagonist, "[You're from] Indianapolis, huh? It's a good town." Then, for a split second, he breaks the fourth wall, glancing skeptically at the camera: "Well, I hear there's work there."

15 | On the Grounds of Television

MEGHAN SUTHERLAND

Since the medium of television emerged in the United States more than half a century ago, it has almost invariably been understood as a form of displacement. When we see a place on television, we are most often somewhere else—at home instead of at the ball game, at a bar in the United States instead of at the Olympics in some other country, in Iowa instead of on the New York soundstage that stands in for New York in the world of sitcoms. Television's reputed capacity for providing a real-time "window on the world" also lies chiefly in the nonspecificity of the place in the world it might show us. When the box is not turned on, the blank screen becomes something like a placeholder, the place where any place at all has the potential to present itself. As the medium's earliest corporate promoters frequently pointed out, the word *television* itself names nothing more or less than a technology of displacement; the "miracle" it performs on our relation to the space–time of the world is simply the work of the image through which this transaction occurs.[1] The producer and engineer Jody Dupuy puts matters most plainly in a 1945 manual for General Electric, where she writes, "Man has always wanted to be in two places *at the same time* and now he can be by means of television. Tele is Greek for 'at a distance.' Vision, of course, means the 'ability to see.' Therefore, television is the ability to see at a distance."[2]

With the spirit of Dupuy's reference to ancient Greece in mind, we might call the medium of television an ontology of displacement; with the talk of miracles in mind, we might even go one step further, to the language of deconstruction, and call it an ontotheology of displacement—an act of Genesis performed only half-heartedly on the seventh day. After all, the very essence of television technology in these accounts is to make present on-screen any spatiotemporal place that has been displaced by the spatiotemporal place in which the screen is present; it is to remake as plenitude whatever space or time a being lacks, or as Dupuy puts it, "to be in two places at once." Television technology could thus be said to give a discrete, material existence—the console—to the entwined dynamics of

displacement and potentialization that Martin Heidegger has described as the essential ontological effect of modern technology on the natural world.[3] Seen this way, television displaces the natural order of places in the world precisely by storing the totalizing potential to *present* any place in the world "live" on-screen, in the "standing reserve" of the electronic screen. It embodies nothing less than the machine on which the "world picture"—Heidegger's dystopian metaphor for the technological destruction of being—might actually take place as a material image.[4]

Of course, this scenario only really coheres if we are talking about television technology as a picture in the strictly metaphorical sense. And in this case, the latter could not really be said to displace anything, with the possible exception of a houseplant or some furniture.[5] It is only the appearance of a *particular* image of place on-screen that actually affects the ontological displacement of extant time and space that is attributed to television technology as a medium of electronic presence; the apparatus only exists as a conceptual embodiment of this possibility, until the image of an absent place appears on-screen. In other words, whenever we are talking about a technological medium of representation—one that shows actual pictures of the world, too—things get messier than Heidegger's metaphorical economy of modern technology can accommodate in its original conception. As Ernesto Laclau points out in a discussion of political representation that applies equally to the aesthetic sense of the term, the phenomenon of representation is itself necessarily a form of displacement. He writes:

> There is an opaqueness, an essential impurity in the process of representation, which is at the same time its condition of both possibility and impossibility. The "body" of the representative cannot be reduced for essential reasons. A situation of perfect representation would not involve any representation at all.[6]

In the context of media representation, we might paraphrase this idea by saying that the picture of the world on-screen necessarily gives the off-screen world a part of its existence and that the phenomenon of its obvious material distance—despite the proximity to us of the screen on which it appears—is the ground of the displacement that television technology can broker in the world. Or rather, we would not need a picture of the world if the world did not need a picture to appear as such. In this sense, technologies of media representation in general can only really be said to carry out the ontological effect of spatiotemporal displacement insofar as they automate a peculiar ontological ricochet between a *particular* representation of place on-screen and the *abstract* figuration of the world that its technology implicitly

configures off-screen as a total collection of places electronically connected by a network of terminal screens. The ephemeral image of the absent place on-screen both redoubles and divides the material effect of electronic presence that its technology embodies in this series of connected terminals, making the image both the creator and the specter of the technological apparatus' ontological substance.

If this scenario sounds like a confounding one, that's because it is. It is the crux of media ontology that remains yet to be hashed out, the blind spot that allows a consummate materialist like Fredric Jameson to agree with a consummate simulationist like Jean Baudrillard at the postmodern antipodes of this discourse: television technology destroys the referential order that is proper to the world as such.[7] Of course, to think of the representation of place on television in the terms I would like to suggest is already to think outside the bounds of the materialist–dsimulationist dichotomy. For doing so is to recognize that the *aesthetic* or representational dimension of the televised image of place plays a constitutive role in producing the ordered existence of the material world that we imagine it to displace, by the dint of *technology*, in that very same gesture. The question that remains, then, is the nature of this role and the extent to which a more philosophical understanding of it might shift the discursive coordinates of media ontology altogether and, in turn, provide a different way of thinking about the grounds on which we relate to the world, through television, as the material place of society—a place we can only ever see in part, after all, and if that, from a distance.

MAPPING CAPITAL

To get a sense of both the terms and the stakes of this endeavor, it is instructive to consider the ways in which television scholarship has approached the question of media ontology heretofore, especially as it relates to issues of technology and place. For although none of this work explicitly takes up Heidegger's work or the concept of the world picture, almost all of it treats the ontological claim of television's presence as a mystification of technological essentialism and, even worse, one designed to sell television sets on the basis of their capacity to transmit "live," remote images into the home—a promise of total social, spatial, and temporal plenitude that neither cinema nor theater can make but that, in the end, proves to be a mere economization of the world.

Jane Feuer's landmark essay "The Concept of Live Television"—an essay whose subtitle, "Ontology as Ideology," says it all—is perhaps the most influential instance of this work. In it, Feuer argues that both the notion and the aesthetic codes of television's liveness perform an ideological function for the idea of the medium itself, positioning the electronic presence of the TV image as a conductor of spatial

and interpersonal unity that does not really exist outside the horizon of the latter's own economic capitalization of the audience. For instance, discussing a scene from *Good Morning, America* in which the correspondents hold a conversation with an anchor in the studio from a range of remote, on-site locations, Feuer proposes that this show, in particular, further uses the conceit of its liveness to conceal "a mutually reinforcing ideological problematic of national and family unity" in the guise of mere technology.[8] In other words, television technology produces a compensatory illusion of holism and plenitude for the spatial, temporal, social, and even ideological fragmentation that it simultaneously produces in material reality. By extension, the viewers it connects through the medium of the live image ultimately really exist, at least in the last instance, on a separate *kind* of terrain altogether—a more literal terrain that does not conform to the neat economic contours of the television screen, the on-site place that appears on this screen, or the well-capitalized audience formation that regards it from a sprawling array of different off-screen places, all of which are in fact geographically dispersed and thus also more real, situated, particular, and idiosyncratic.

While Feuer's critique of television ontology here differs from others in many details, the singular emphasis that it places on the temporal plenitude of liveness reappears in virtually all the work on television ontology, as does its emphasis on technology and capital as the twin sources of the spatial displacement that results from this ideological illusion of *being present*. Mediated time and space exist in a capitalist economy of their own, with the television apparatus situated as the broker of a zero-sum game between the plenitude of one and the poverty of the other. The disparity between the two is precisely what makes the medium's ontology an ideology. The imagination of social unity becomes dependent on television's ability to articulate the presence of this unity in the image of its own consumer demography, which implicitly coheres only in the off-screen space of the apparatus, where real individuals regard the presentation of live copresence on-screen as a commodified audience formation. As Stephen Heath has put it—and as Guy Debord's notion of the "society of the spectacle" suggests from yet another vantage—"television shifts [sociopolitical] representation into economic terms" so that "as long as networks are broadcasting, there is always a guaranteed majority: electronic assembly gives an instantaneous mass, creates a majority discourse."[9] The promise of unity and presence devolves into a reality of mass homogenization and, worse yet, into the endless recapitalization of a social corpus that is alienated from itself precisely *because* the technology of the medium has displaced it from actual copresence.

Despite the numerous insights of this expressly Marxist tradition of television theory—and there are many very valuable ones—it is worth noting that the scenario

it presents simply replicates the ontological suppositions of television technology that it purports to demystify as a capitalist ideology; that is, it takes for granted—just as industry evangelists like Dupuy did—that the existence of a proper place off-screen *precedes* the existence of place on-screen that the "miracle" of television makes possible for its community of consumers. The image of a displaced place on-screen simply serves as an evanescent *occasion* for the technological connectivity that connects real places—whether the motivation for this connectivity is the discursive suturing together of a universal society, a heteronormative TV family, or simply a mass audience for detergent ads. This metaphysical conception of the relation between medium and reality—one where technology exists secondarily to the primary terrain of the world—thus reduces the image of a place on-screen to a kind of immaterial relational capacity between the comparatively material places and people situated on the receiving ends of the apparatus. The image of place, in turn, becomes secondary to the places in reality that it brings together electronically, and now in the name of capital alone. As an Althusserian conception of material existence, this approach to media ontology admits that the image of place holds the *potential* for material significance in its material counterpart. However, this significance lies strictly in the imaginary ideological effects that it succeeds or fails to *project* onto the geographical substance of the place off-screen. It is only the apparatus itself that holds sway as a material locus of mediation, and thus the economy of social space articulated around media technology will always and inevitably boil down to the same ideological figuration: the consumer economy of the audience for TV advertising. In this way, the ontological status of place both on-screen and off-screen can be taken for granted.

In one way or another, this metaphysical conception of media technology inflects both the very best and the very worst of the writing that has been done on television and place. Whether the technology of television erodes and disorders a sense of place, as it does in Joshua Meyrowitz's *No Sense of Place,* or whether the speed of electronic connectivity effects a capital-intensive virtual geography by connecting distant places in material geography, as it does in McKenzie Wark's understanding, the ontological status of the image of place on-screen remains as much unexamined as the place it affects off-screen.[10] A representation of place can be good or bad, and it can have a destructive or productive effect on a real place if it is taken up ideologically. But either way, the place that television technology *shows* us on-screen does not *exist* on the same register as the referential one off-screen; the material *effect* of the former only takes place once it has been transformed into a phenomenal fact of the latter, so that the proper existence of the material world itself either affirms or disputes the ontological significance of the representation

within it. In other words, this technology-based approach to media ontology inevitably reduces *every* representation of place on television—and precisely because every place on-screen could be *anywhere*—to the imaginary status of ideology. The place in which the spectator is situated in turn becomes the only true reference point from which to judge the ideological effects of the image on the world.

This foundational approach to media has had a profound effect on the kinds of questions that television scholars have raised about the medium's relation to the social world as well as the methodological frameworks through which they have raised them. For one thing, it has effectively organized the field around a remarkably impoverished notion of place—a concept that geographers have long understood to entail a much more complicated relation between the registers of representation and real terrain.[11] Perhaps most important for our purposes, however, it has also served as the implicit theoretical basis for almost three decades worth of ideological analysis of television representation as it effects real social discourses; the turn away from theoretical paradigms to real ethnographic studies of television reception and industrial practices; and the rise of fan studies as a site of resistance to television ideologies. It is not that these approaches are entirely wrong or unimportant, and it is not that the work resulting from them holds no value. They are simply based on a theoretical paradigm that greatly reduces the complexity of the problem at hand—a problem that demands an *equally* rigorous attention to larger philosophical issues concerning the relation between the processes of representation and the discourse of material reality itself. For as we have already seen, the medium of television is not simply a medium in the technological sense, nor is it simply the visual mechanism of capitalism or some univocal dominant ideology of togetherness that can be "demystified." Television is also a medium in the comparatively broad aesthetic sense of representation, and in this respect, its entanglement with the material world that is fashioned as a real set of places and social discourses around it demands precisely that we rethink the ontological nature of this relation.

DRAWING CROWDS

I can think of no better place to begin such an undertaking than at the scene of a disaster. For as the colloquialism "disaster scene" already suggests, the conceit of disaster implies an enfoldment of the spectacular, the social, and the locative: disasters draw crowds. Events of disaster—whether natural or man-made—thus tend to occasion particularly intensive discourses of place in the media. Three Mile Island, Hiroshima, Columbine, Blacksburg, the Audubon Ballroom, and even the grassy knoll: for better or worse, the names of these places now serve as something

like the grave markers of discourse. They accrue immediate significance as the names for which events of death have *taken place,* with all the spatiotemporal violence this notion implies. Moreover, they accrue this significance precisely by circulating repeatedly through the anxious mourning of a media discourse that we otherwise dismiss quite casually in its capacity to bear truth or meaning. They accrue it in our traversal and retraversal of the discursive cartography that these places mark out, each one another incontrovertible point on the media landscape where the material locus of death has *in fact* occurred.

In the 1990 essay "Information, Crisis, Catastrophe," Mary Ann Doane opens up an extremely provocative way of thinking about the significance that the idea of death holds here with respect to the discourse of disaster. "What is at stake in televisual catastrophe," she writes, "is not meaning but reference. The viewer's consuming desire, unlike that of the novel reader, is a desire no longer for meaning but for referentiality, which seems to have been all but lost in the enormous expanse of a television which always promises a contact forever deferred."[12] As Doane points out, the "intractability" of the death that disaster coverage brings to light effectively "corroborates television's access to the momentary, the discontinuous, the real . . . its ability to be there—both on the scene and in your living room."[13] However, in a logical progression that will surprise no one at this point, Doane recognizes television's encounter with death as nothing more than the ideological "lure of referentiality"; the discontinuity it affects becomes a mere instrumentalization of the viewer's desire and trust for the regular temporal rhythms of the ad-supported television schedule, and the corroboration of its "access" to the real becomes an illusory display of "technological prowess" meant to distract us from the comparatively abstract and ongoing crisis of the capitalist economy that it upholds in this very fashion. In other words, the medium of television once again becomes a technological instrument of temporal displacement that, in each and every case, renders place an illusion and the audience a commodity.

Anyone who has endured the overwhelming tedium of a forced or overcapitalized television disaster knows that there is some truth in this reading.[14] And yet, anyone who has endured the coverage of a disaster worthy of the name also knows that the death that takes place on-screen is not just a lure, and that television is indeed "there on the scene"—in a way that is most assuredly *meaningful.* The reality of both death and place assures us that disaster coverage does not simply take place on the terrain of a simulation, and if we are on the terrain of something like ideology, then it is only because we are indeed on a *terrain* of some kind to begin with. After all, before television's representation of disaster can mobilize death to "corroborate" the referentiality of the television schedule, capitalism, or anything

else, the image of the place on-screen must corroborate the referentiality of the *there* that television *is* in the event of death. In this sense, the image of place—*broadcasting live, from Oklahoma City, in front of what remains of the Alfred P. Murrah Federal Building*—does as much to corroborate the referentiality of the death at hand as the death at hand does to corroborate the referentiality of this absent, otherwise unseen, and perhaps unknown place on-screen. If one has never been to Oklahoma City, does not know the Alfred P. Murrah Building exists, and does not know that anyone who died there existed either—however acutely present this loss now feels—then all these very material beings come into social existence at once, when the picture of this scene appears. In the image, they *take place* together.

This way of taking place, this very elementary level of meaningfulness, cannot be reduced to any one ideology, and it does not depend sensu stricto on the technological specificity of the image as an index or a signal, the temporal effect of television liveness, or any other single form of technological specificity. It is, of course, caught up in all these things in various ways, but it is also and most fundamentally caught up in the ontological dimension of representation itself and in the paradoxical procedures by which the latter, as a medium in the nontechnological sense, *necessarily* conditions our relation to the world as a material place in which we exist with unknown others. What is more, as the intensive discourse of place that surrounds events of disaster only further confirms, this meaningfulness holds much more complex and affective implications for this relation than the market imperatives of capitalism and its technologies can account for by themselves. To suggest anything else—at least in the American context—is to honor a metaphysical conception of the *capitalist* economy as the founding ground of the politics that attend the economy of representation and, indeed, to naturalize the materialism of capital as the ground of the discursive materiality of the social tout court. What, then, and how, does the image of place mean in the media representation of disaster?

To attend to the emotional discourses of place that grew up around the media coverage of two recent scenes of disaster—the terrorist attacks of September 11, 2001, and the destruction of Hurricane Katrina in 2005—is to recognize how complex a meaningful answer to this question must be. For these discourses suggest the extent to which the images of these two disasters taking place on television screens and video feeds around the world assumed the discursive function of *revealing* a comparatively real or material ground for the American social corpus as a whole. And yet, they suggest just as well the extent to which the sociogeographical particularity of the images themselves produced markedly different, even contrary referents for this entity in the material reality they revealed.

VISITORS

In the days, weeks, and months following the event we call 9/11—perhaps only because the name New York means too many other things already—the phrase "we are all New Yorkers now" seemed to belong to everyone and no one at once. The phrase is most often attributed to an editorial by Jean-Marie Colombani that ran in the French newspaper *Le Monde* on September 12 and began with a claim that must have shocked a good portion of its readership: "We are all Americans now. We are all New Yorkers."[15] On any other day, these words might have bitterly announced the opening of a McDonald's in some quaint provincial town. But on this day—the day after thousands of people from all walks of life had died together in the rubble of the World Trade Center—they evoked the liberal humanist ideals of ethical universalism and the consolations of social unity, not the global economic homogenization that attends them in practice. It thus seems more than coincidental that in the days to follow, the words became a kind of transnational cultural refrain. Between the terrible experience of watching the iconic towers fall together on live television and the spatially diffuse threat of terror that this experience announced, the phrase became an incantation of collective civil existence that, if repeated by enough people at the right intervals in the day, would in fact produce the performative realization of a universal social subject—with all the normative Western moral values that subject implies.

The phrase was most officially imported to U.S. soil when Hillary Rodham Clinton, then still a freshman U.S. senator for New York, used it in her first national address to follow the attacks. But by then, people from across the country and around the world had already begun to repeat the words in blogs, write them on newspaper editorial pages, and declare them aloud to be broadcast on television news feeds.[16] Of course, it did not matter if these self-proclaimed New Yorkers had ever been to New York or if they had until that point spit out the phrase "New Yorkers" as an epithet for either one or all of the reputedly un-American types thought to frequent the place—the foreign, the intellectual, the queer, the liberal, the poor, the elite, the nonwhite, and so on. It did not matter, either, that the phrase took on a wide range of highly particularized meanings in each instance of its dissemination. In the *Le Monde* editorial, for instance, Colombani uses it to paraphrase John F. Kennedy's 1963 "*Ich bin ein Berliner*" speech and the cosmopolitan spirit of international collaboration that it has come to embody in popular memory. Her dramatic expansion of New York to the scale of a global rhetorical polis performs an appeal to civilized nations urbi et orbi to confront the "barbarous logic" of the global terrorist threat together, drawing heavily on the ideals of world citizenship

and ethical universalism that Immanuel Kant associates with the cosmopolitanism right of "universal hospitality" in the famous treatise "To Perpetual Peace."[17] Just as Kant invokes the geometric plenum of the world as a terrestrial basis for the cosmopolitan ideal of universal hospitality—arguing that "the *right to visit,* to associate, belongs to all men by virtue of their common ownership of the earth; for since the earth is a globe they cannot scatter themselves infinitely, but must, finally, tolerate living in close proximity"—Colombani invokes New York as the affective capital of this world. If the end of postmodern irony and the brief sense of worldwide social and ethical universalism often imputed to 9/11 could be said to have a rhetorical datum in popular media discourse, the phrase "we are all New Yorkers" is it.[18]

When Hillary Clinton declared that "we are all New Yorkers" on the floor of the U.S. Senate, she did so, of course, in the name of national rather than international unity. More specifically, she did so as a way of surreptitiously addressing an American populace that had been jigsawed into a political war zone of red and blue states by the 2000 election—a scenario that would hold dire economic consequences for the notoriously blue New York if congressional support for funding the city's reconstruction were to fall along the same fractious lines. Here, then, the phrase "we are all New Yorkers" draws on the same cosmopolitan discourse of supraterritorial citizenship that Colombani does, but it invokes a decidedly more material, even practical, sense of civic responsibility to the city itself. And it seems likely that the millions of civilians who echoed the same refrain in cities all over the world used it in a thousand more ways yet. But it is hardly striking that a phrase designed to inspire a transcendental rhetoric of social unity would take on a different significance each time it is repeated.[19] What is striking is the extent to which the work of collective mourning for the deaths that took place on September 11 entailed not just a discursive reconstruction of the national and global social body or the ideal of universalism, but a discursive reconstruction of the very grounds—terrestrial and ideological at once—on which these bodies might exist in the first place.

What is even more striking is the extent to which images of New York City served as both the literal and figurative site of this reconstruction, providing an affective, material referent for the discourse of universalism that is, so to speak, universally recognizable. Indeed, though the standard accounts of 9/11 treat the deaths that took place on-screen that day as a purely symbolic *media* event that inevitably reinforces the entwined spatiotemporal abstractions of capitalist exchange and media spectacle—especially to the extent that this reinforcement further alienates society from both itself and anything real—these accounts rehearse only the parts

of this story that we already know too well;[20] namely, they reduce the entire event of 9/11 to a problem of spatiotemporal abstraction through the technology of live television—a narrative into which the media's embrace of the phrase "we are all New Yorkers" would seem to fit all too well. However, it must also be noted that as the place that suffered the most devastation on 9/11, the industrial hub of live broadcast television news, and a quintessentially cosmopolitan place in the more ordinary sense of the term, the city that appeared on-screen in the course of covering this disaster provided a distinctly particular and decidedly material embodiment of the cosmopolitan rhetoric that accrued over, through, and around its image. In the course of the attacks themselves, for instance, the networks often cut to grand panoramic views of the city's iconic downtown skyline, situating the scene of the smoking towers in their proximity to the Statue of Liberty on Ellis Island. The latter, of course, represents not only a monument to the city's cosmopolitan spirit, but also the historical port of entry for the international population that literally embodies it and thus a geographical manifestation of the city's porous relation to the world that is recognized, in turn, throughout the world. Once the towers had fallen, the aerial views on-screen lingered over equally stupefying scenes of the city's familiar landmarks as they took on new purpose—for instance, throngs of citizens from all walks of life walking home together across the Brooklyn and Williamsburg bridges, and doing so above an on-screen graphic that matter-of-factly issued the impossible order "REMAIN CALM: EVACUATE LOWER MANHATTAN."

At street level, network correspondents and their cameramen fled the explosions, crashes, dust, and flames alongside an array of citizens who also displayed the religious, racial, ethnic, and economic diversity of the bodies subject to the violence under way. The frantic man-on-the-street interviews with whoever happened to be *in this place on this day right now* only served as de facto reinforcements of the event's indiscriminate effect on *everyone,* from the local deli owners and neighborhood residents, to the white-collar and blue-collar workers of the financial district, to the unlucky early-bird tourists from Boise who thought they might get their picture taken in front of *the* World Trade Center. And this *everyone,* of course, implicitly included everyone at home, whose sight lines traversed the streets of the city in visually palpable ways: in the shaking hands of camera technicians who were running for their lives from the towers as they exploded before their eyes. Of course, this everyone also included the people who were pictured on-screen indiscriminately helping one another at the scene of disaster; the wrenching pictures of the missing papered all over the streets of the city, from Chambers Street to Union Square; the names of the dead repeated at sporting events and memorials ever since. And lest we forget, it included the throngs of tourists—or, as Kant might

say, "visitors"—who would make pilgrimages to Ground Zero to make contact with the *particular* material event of cosmopolitan sentiment that took place both *in* and *as* New York on their television screens. Because the deaths of 9/11 also, and quite literally, *took place* on-screen, the electronic transmission of television effectively broadcast terror to all who received its signal; the diffuse spatial conceit of broadcast was translated into that of an equally diffuse death threat. In short, on 9/11, the instantly recognizable image of both New York City and its famously diverse population gave a particular material body to the cosmopolitan subject of universalism—anyone and everyone in the world—while the technology of electronic transmission broadcast the death to which it was subject throughout the cosmopolitan territorial domain of universalism—anywhere and everywhere in the world. And when seen this way, the very *existence* of the phrase "we are all New Yorkers now" in popular discourse must be recognized not strictly as a social, spatial, or temporal abstraction or as a vapid generalization of liberal humanist ideology; it is also, and by necessity first, a testament to the particular material *force* that the image of New York, as the scene of a distinctly televisual death, held in constituting the discourse of a cosmopolitan social existence that emerged from 9/11.

REFUGEES

If the mobilization of the phrase "we are all New Yorkers now" as a patriotic rallying cry for the invasion of Iraq did not entirely disrupt the humanist image of a universal social body, the expressly dehumanizing discourse of race and nation that emerged from the subsequent coverage of Hurricane Katrina did.[21] In the course of a disaster that unfolded mostly on cable and Internet news outlets over a lurching series of days—still live, but at the temporal behest of the weather rather than with the expedience of TV immediacy—a discourse of place developed around terms categorically opposed to the cosmopolitan vocabulary of 9/11. For this discourse of place was most properly a discursive *evacuation* of place, or rather, *a scene* of displacement rather than just a technological phenomenon of it. On virtually every channel, news correspondents and environmental experts spoke solemnly about the possibility that the storm would simply wipe the city of New Orleans off the map. And in a shameful episode that has since assumed the status of a national media firestorm, they referred to the citizens seeking shelter and survival in the harrowing scenes on-screen—a large proportion of whom were black—as "refugees."

As the Reverend Jesse Jackson and a procession of angry New Orleans residents pointed out in the on-screen debates to follow, to speak of the city's population in this way was to evacuate not just the city but the idea of citizenship—let alone American citizenship—altogether.[22] Even worse, because the citizens portrayed

as "refugees" on-screen were almost invariably black, this evacuation represented nothing less than a material and discursive dispossession of black America. This scenario only devolved further in the wake of the storm, when the same reporters declared the city to be *uninhabitable*—a savage place where the jurisdiction of law had simply washed away—while the images on-screen displayed overhead shots of black people collecting food and supplies from abandoned stores. Simply put, the destruction of New Orleans assumed an all too material place in the prevailing discourse of Hurricane Katrina: it became a metaphor for the destruction of black communities and cultural traditions nationwide.

Of course, it would not be right to say that the media discourse of Hurricane Katrina unfolded entirely around an empty place or a place soon to be extinct. On the contrary, much of the racial charge that attended the discourse of both Hurricane Katrina and the evacuation of New Orleans, in particular, had to do with the nature of the place that upstaged every other place on the devastated Gulf Coast, both on-screen and in newspapers. For in the course of the storm, the American people both at home and displaced from home—and white people especially—were introduced to the now-famous Lower Ninth Ward, a historically black neighborhood in New Orleans situated outside the familiar confines of the French Quarter tourist zone and the lush Garden District zip code showcased regularly on MTV's 1996 *Real World: New Orleans.* Along with the murderous scenes of deprivation that unfolded in poorly lit feeds from a Superdome unrecognizable to any Sunday football fan at home, an endless stream of on-location reports from the Lower Ninth Ward assumed the role of representing at once the spectacular, the geographical, and the social epicenter of the storm's destruction—a Ground Zero for the grave state of American racial relations. In dramatic scenes shot largely from the aerial remove of helicopters, viewers looked down on residents dangling from rescue ladders and houses submerged up to the X-marked rooftops. In fact, the spectacle of Katrina's havoc on the very idea of the black community became so deeply identified with the Lower Ninth Ward that, as anthropologists and New Orleans residents Rachel Breunlin and Helena Regis point out, the name "Lower Ninth Ward" itself "became a metaphor for any flooded downtown neighborhood. On CNN . . . images taken from the city's Seventh and Eight Wards, among other neighborhoods . . . were consistently referred to as the Ninth Ward."[23] In other words, even the discourse of place *surrounding* Katrina became a spectacle of the displacement that the neighborhood served to embody, with the failure or success of recognizing this particular place properly—of *knowing* place on-screen—only further articulating the segregation of its intimate terrain of knowing.

It is not that acts of interracial compassion just as heroic as those seen in 9/11

did not appear on-screen in the course of the storm, or that poor and rich communities, both white and black, were not more broadly affected by the storm's devastation all along the Gulf Coast, or that citizens from across the country and around the world did not respond with an outpouring of compassion and even donations. Nevertheless, in a marked departure from the discursive codes of collectivity that are associated with the media discourse of disaster in general, both the heroism and the charitable support were almost invariably articulated around the obvious evidence of racial, economic, and geographical dispossession that the Lower Ninth Ward served to exhibit so matter-of-factly. And in this way, the disproportionate ruins of death and destruction that correspondents found in this low-lying neighborhood, which had become a black enclave in the first place because of its vulnerability to flooding, effectively came to embody the discursive *locus* of an environmental legacy of American segregation.[24] As if to put the socio-geographic implications of this legacy into no uncertain terms, in January 2006, the embattled New Orleans mayor Ray Nagin ultimately gave up the coalitionist rhetoric that had always defined the city's power structure and declared to the media that New Orleans as a whole would become, once again, a "chocolate city."[25]

With the images that inspired this sentiment in mind, it is hardly surprising that the coverage of Katrina from the Lower Ninth Ward did not produce the galvanizing image of social unity, collective survival, and ethical universalism that 9/11 did. Even if we temporarily bracket the significance that racial sentiments *not* worked out through geography might hold in this scenario, it is worth noting that the conceit of this *particular* disaster effectively volatilized the literal and figurative "ground" on which Kant's formulation of universalism rests as such. Because Hurricane Katrina was an ecological disaster that rendered parts of the United States uninhabitable, the images of the Gulf Coast in general, and of the Ninth Ward, in particular, almost immediately manifest the earth as a place of *scarcity* rather than holism. To borrow Kant's language, they bodied forth images of a place in the world where it was unavoidably apparent that people "cannot scatter themselves infinitely, but must, finally, tolerate living in close proximity."[26] Insofar as the torturous enclosure of the Superdome replaced the Kantian plenum of the earth as the place of social holism, images of it foregrounded nothing so much as the claustrophobic discomfort that can also attend such proximity. And in this sense, the insult of the term *refugee* manifests nothing quite so much as the racial dimension of the anxiety about place that the destruction of Katrina produced as a disaster of geographic segregation.

More to the point, the images of New Orleans in ruins on-screen effectively telegraphed the realization that a lot of other places—namely, the places where

people watching television at home might live, and where these "refugees" would have to go—would also be affected by the destruction. For that is the ethical conceit of hospitality that defines cosmopolitan right in its relation to the ground on which a universal society might stand: *the right to visit.* And yet, if anything, images of the Lower Ninth Ward (real or not) made manifest both the impossibility and the imperative of an ethic of hospitality between places and races in the United States.[27] The particular racial geography they made visible gave body to an image of the world as an unstable habitat for society—one that *was,* in fact, neither universal nor cosmopolitan at the fatal level of the ground. It rendered the American social body a place that might soon be *wholly uninhabitable,* especially if we could not "tolerate" living together, as we *evidently* had not when the Lower Ninth Ward was settled. And in this way, the images themselves affected nothing more or less than the spatial and ethical disincorporation of the American social landscape—the revelation of the distinctly unethical reality of racial and geographical expropriation on which the entire ideal of Western universalism was grounded.

To think of the role that the image of place plays in both this case and the case of 9/11 is to recognize the extent to which the *existence* of society as such depends on the image of place in all its particularity, an image that only ever assumes a material form *through* this particularity when it appears on-screen in the moment of death. The place of disaster necessarily precedes the technological abstraction of social connectivity by figuring the nature of the ground, the people, the places, and the media scales by which these coordinates can or should be connected through mediated discourse in the first place. In the case of 9/11, for instance, the image of New York and New Yorkers provided a hospitable place for the global discourse of cosmopolitanism that accrued around it, or better yet, *through* and *in* its visual matter of fact; Katrina did not.

When seen this way, the relationship between an image of place on-screen and the place *of* which it *is* in the social world must be understood as constitutive of material social existence rather than simply connective. For better or worse, the medium of television must likewise be recognized as the distinctly visual *place* for the discursive production of material society and not just as a *displacement* of social materiality or the epiphenomenal by-product of media technology. The image belongs to the materiality of place in all its particularity and *presents* this particularity on-screen as an effective, if partial, discursive embodiment of society in general; it *places* society in the medium of discourse in ways that hold ontological force, so that each time we see an image of the world, it becomes a particular image *of* the world in a substantive, if casual, sense—one that has nothing to do with technological specificity per se. The electronic mediation of disaster simply heightens

this effect of representation more generally. For it is the material specificity of the enfoldment of image, place, and social existence in one another that endows the image of place with such ontological force in the presence of death. Indeed, when we speak of disaster, the latter's place in the world first and foremost provides a kind of discursive referent for a social geography that we cannot see for ourselves until we see it on-screen, at a remove, and only then in part.

This scenario resonates in provocative ways with Michael Warner's characterization of the relationship between the discourse of disaster and the construction of the public subject in mass cultural media. Noting that the ideal subject of the public sphere is figured in political philosophy as an abstract one without sensual attachments or particularity—much as the ideal subject of universalism is—Warner argues that "by injuring a mass body—preferably a really massive body, somewhere—we [as mass media consumers] constitute ourselves as a noncorporeal mass witness."[28] However, to approach this operation through the discourse of place rather than subjectivity raises more complicated ontological questions about the role that mass media representations play in populating the social landscape. For indeed, Warner and others have rightly recognized the subject of publicity as an ideological conceit; in fact, according to Althusser, subjectivity in general represents the very ground of every other ideology. So it's not such a big deal to say that the ideal subject of the public sphere doesn't *really* exist. If one shifts this discussion to the material terrain of place traversed earlier, though, one must deny the existence of things we might give up less easily, namely, the place of both society and the world. For as Warner's emphasis on the "somewhereness" of disaster already indicates, this way of thinking about the mass subject still depends on the same metaphysical conception of mass media as a *displacement* of space and time by the abstract orders of capital and technology. Indeed, in his formulation, the entire ontological phenomenon of the media public as subject depends on the disaster on-screen taking place in the abstract space that exists only vaguely, through the displacement of the media apparatus, as *anywhere else*; that "anywhere" is precisely where the viewer gains his share of disembodied being.[29] And as the preceding disaster scenes demonstrate, the social bodies that emerge from the discursive wreckage they occasion not only take place on a much more particular, material terrain than abstraction; the particularity of this terrain necessarily represents the terrain of the social world in its own image—if only for an instant. The slant rhyme between these two scenarios thus confronts us with the same question with which we began: how can we conceptualize the ontological status of media technology, and how might doing so shift the coordinates through which we understand television's place in the social world?

TELETOPIA

If we keep in mind the cosmopolitan rhetoric that the images of both Katrina and 9/11 inspired—whether in negative or positive terms—we can best approach this question through the philosophical discourse that relates place as a material experience to the ideals of universalism. As I have already begun to suggest, when Kant adapted the more ephemeral premodern discourse of cosmopolitanism to the avowedly secular domain of Western humanism, the grounds on which he did so were strikingly literal. "Since the earth is a globe," he reasoned, "no one [has] a greater right to any region of the earth than anyone else."[30] By extension, it is only reasonable that everyone should have the cosmopolitan right to universal hospitality, or as he puts it, "the right of an alien not to be treated as an enemy upon his arrival in another's country."[31] The universal holism of the terrestrial world itself thus provides the rational, material, and practical basis for the realization of the social and ethical ideals of universalism. It represents nothing less than a terrestrial form of the categorical imperative, the telos of topos. There is only one problem: the total surface of the world, in its very capacity to make a place for the universal social subject of cosmopolitanism, cannot be universally experienced *as* a place by this subject. Society is, as Kant points out, dispersed in an array of seemingly isolated places across the surface of the globe. It thus requires that "an additional unifying cause must be superimposed on the differences among each person's particular desires in order to transform them into a common will—and this is something no single person can do."[32] To provide subjects with an experience of the cosmopolitan relation between the universal and the particular that the figure of the earth embodies, then, Kant must concede the power of actually realizing this relation to a distinctly telescopic representation: in a dynamic he calls *unsocial sociability,* the *divisions* between individuals scattered around the globe must somehow be rendered a *connection,* and the disjointed *distances* of time and space that disperse society must be rendered *present.* In short, if the terrestrial *medium* of the entire unseen earth is indeed to serve as the *figurative* ground of a universal society to emerge in its image, then for Kant, it must become—through yet another medium—the *literal* ground of an *immediate* habitation, which is to say, a *place.* Put otherwise, the very phenomenon of *medium* must become the absolute topos of social materiality: the place from which cosmopolitanism originates and to which it is destined, or even more simply, the cosmopolitan place par excellence.

In a reminder of the ties that bind the economic and social ideals of liberalism at their foundation, Kant poses the notoriously competitive moment of exchange as the medium most likely to succeed in manifesting this holistic figuration of the

social—however grudgingly.[33] And yet, particularly with the discourse of disaster elaborated earlier in mind, it is difficult to dismiss the feeling that the trope of cosmopolitanism has always really been a dream of television, and likewise, that the insolvent paradox it names in philosophy—an entanglement of medium and place, reality and representation, economy and society, time and space—has always really been a displaced attempt to make sense of the profound ontological questions that visual media technology raises about the nature of the grounds on which social and ethical relations exist.

At the very least, it seems safe to say that the social and ethical ideal of television technology has always been articulated through the trope of cosmopolitanism and, more to the point, through the metaphysical notion of superimposing onto earth that telescopic relation that Kant imagines as the ground for universalism. This vision of electronic media technology comes through most clearly in Marshall McLuhan's utopian conception of the *global village,* which McLuhan describes as an experience of "electric speed" that brings "all social and political functions together in a sudden implosion" and thus "[heightens] human awareness of responsibility to an intense degree."[34] For indeed, if television technology could be said to broker an experience of media connectivity *as* a habitable, material place, then it makes sense that McLuhan would insist so much that "the medium is the message." Figured as an ontology of technological displacement, a way of "being in two places at once," the medium of television would affect the realization of social and ethical universality as such. Its promise of staging the "universal hospitality" of "intimacy" between viewers in different places, and liveness at the scene of death, would indeed make television both the telos and the topos of "perpetual peace" that Kant envisions. Its spatiotemporal intervention in the world would likewise make the cosmopolitan "right to visit" foreign territories through the surface of the screen a universal human right—virtual in every sense.

Of course, it does not. In the half century or so that has passed since McLuhan first introduced the idea of the global village in *Understanding Media,* the entwined philosophical prospects of universal hospitality and the universal subject have been recognized as complementary parts of the ideological worldview of Western liberalism.[35] McLuhan's global village has likewise been reduced to a quaint form of techno-utopianism—on the terrain of both television scholarship and television events like Hurricane Katrina.[36] In the spirit of this same overarching critique, I have also tried to suggest that media theory can no longer abide the metaphysical conception of the relation between media and the social world on which both these scenarios paradoxically rest. And yet, the discourses of place I traversed earlier would seem to indicate that the entire conceit of disaster television—at least at

a practical level—remains firmly grounded on a cosmopolitan ideal. To be more specific, it rests on the implicit understanding that people in distant places can, should, and even ought to feel a sense of responsibility for people with whom they do not share a particular material place in the world—provided they can *see,* through the telescopic presence of media technology, that they do indeed share a place of existence in the social plenitude of the world. What is more, on September 11, the discourse of social unity that emerged in the name of New York provided a practical rhetorical embodiment of this same sentiment: the image of place, in all its materiality, effectively *realized* the cosmopolitan subject of universalism that the world on its own could not realize—unless in and through the temporary material plenitude of the television screen. Television can thus be understood as the one and only material place in which the universalization of cosmopolitanism *takes place*—the proper place of the cosmopolitan ideal—and the city's endless stream of "visitors" at Ground Zero could be understood to bring their own material force to this realization in the alternate place off-screen. At this point, then, the nature of the impasse before us is fully apparent: how can we speak of the particular ontological force that images of place hold in the social world—as representations—without embracing the techno-utopian understanding of their presence?

Returning to Ernesto Laclau's conception of representation offers one possible solution to this impasse. As Laclau makes clear in *Emancipation(s)* and elsewhere, this way of understanding representation shifts the ontological problem of universalism away from the Kantian metaphysics of the earth and places it instead on the figurative terrain of representation. Thus, if we must reject the plenitude of material being that universalism posits as the holistic truth of society, then we must also reject the plenitude of material being that a purely particularized conception of society might seem to promise as a corrective; the two present different sides of the same metaphysical division between the ideal and material world, figure and ground, presence and absence.[37] Instead, Laclau proposes that we think of the relation between the two as a hegemonic relation, forged precisely on the terrain of the ontological displacement that representation names as such, and organized by its aesthetic codes and rhetorical figurations as well. In this scenario, the holistic entity "society" exists in material reality, but only through the inherently unstable hegemonic process of representation, where one *particular* fragment of the social order assumes the role of representing society as such—for instance, the way that the proletariat assumes the role of representing the plenitude of society in a Marxist account. Interestingly enough, though, because representation, as a form of displacement in its own right, cannot *embody* any pure plenitude of being, Laclau characterizes the hegemonic signifier of society as an "empty but ineradicable

place" in the differential order of language—one that only ever appears as an "absent fullness" in discourse, and appears thus precisely because representation inherently fails to *be*. In other words, society *exists* in the materiality of discourse, so it can never *be in place* and *wholly present*, and it is likewise never fixed; the plenitude of being that the holistic entity "society" would entail necessarily exceeds the economy implied by either a *particular* place in the material world, where *part* of society exists, or a *universal* representation of that place, such as the world Kant imagines through the figure of the world.

This way of figuring the plenitude of society—as an "empty but ineradicable place" in the ontological terrain of representation—resonates strongly with the way that the image of place functions in the representation of disaster. As we found in the utterly opposed discourses of social reality that accrued around the images beamed out from New York and New Orleans during 9/11 and Hurricane Katrina, respectively, television does not present the plenitude of social existence as an abstraction of totality or as a consistent dominant ideology of the "ruling" structure; the old materialist ontology of social embodiment fails hopelessly to describe the way we live out our social existence in relation to an array of fleeting glimpses of the "real" social world that exceed our place, wherever it is: on a thousand screens, everywhere we turn. Instead, though the technology of the television apparatus promises to provide a kind of "empty place" in the implicit plenitude of media connectivity, where the image of *any* place might appear, the economy of the screen inevitably falls short of this promise; it regenerates and shifts as surely as weather and disasters do. For as an economy of representation—and not just the economy of a market—the enclosure of the screen can only ever lay any material claim to represent one *particular* place in the world at a time. This one particular place can thus only *temporarily* assume the discursive function of representing the ground of social plenitude that the medium of television technology simultaneously figures as a total off-screen connectivity that is *structured* and *enduring*; the image itself gives materiality to the referent of "society" in much more *unstructured* ways, even as it accrues in our minds as an image of society, collected from the thousands of images we see of places in the world of society where we *are* not. In this sense, it is only in the constant reverberation between the two registers of mediation that the medium of television configures in discourse—on one hand, that of technology, and on the other hand, that of representation—that the figure of a universal "society" ever fully *appears* in material reality. And even then, of course, the image will re-lace and change. After all, television cannot *place* the discursive entity of a universal society in material reality; it can only ever extend us the hospitality of a visitation.

NOTES

1 The early television director Gary Simpson uses the term *miracle*—a kind of language that is typical of early discourses of television technology—in a production manual from 1955, where he writes, "The miracle of television is actually Man's ability to see at a distance while the event is happening." See William I. Kaufman, ed., *How to Direct for Television* (New York: Hastings House, 1955), 13, quoted in Lynn Spigel, *Make Room for TV: Television and the Family Ideal in Postwar America* (Chicago: University of Chicago Press, 1992), 99.

2 Jody Dupuy, *Television Show Business* (New York: General Electric, 1945), n.p., quoted in Rhona Berenstein, "Acting Live: TV Performance, Intimacy, and Immediacy (1945–1955)," in *Reality Squared: Televisual Discourse on the Real,* ed. James Friedman (New Brunswick, N.J.: Rutgers University Press, 2002), 17.

3 For Heidegger's most explicit discussion of technology, see Martin Heidegger, "The Question Concerning Technology," in *The Question Concerning Technology and Other Essays,* ed. and trans. William Lovitt, 3–32 (New York: Harper Torchbooks, 1977).

4 See Heidegger, "The Age of the World Picture," in Lovitt, *Question Concerning Technology and Other Essays,* 115–54.

5 I discuss the relation between television technology and the idea of the world picture in greater detail in an essay that I see as a companion piece to this one: "Death, with Television," in *On Michael Haneke,* ed. Brian Price and John David Rhodes, 167–90 (Detroit, Mich.: Wayne State University Press, 2010).

6 Ernesto Laclau, *Emancipation(s)* (London: Verso, 1996), 98.

7 See Jean Baudrillard, *Simulacra and Simulation,* trans. Sheila Faria Glaser (Ann Arbor: University of Michigan Press, 1995); Fredric Jameson, *Postmodernism, or the Cultural Logic of Late Capitalism* (Durham, N.C.: Duke University Press, 1991).

8 Jane Feuer, "The Concept of Live Television: Ontology as Ideology," in *Regarding Television: Critical Approaches—An Anthology,* ed. E. Ann Kaplan (Los Angeles, Calif.: University Publications of America, 1983), 18.

9 Stephen Heath, "Representing Television," in *Logics of Television: Essays in Cultural Criticism,* ed. Patricia Mellencamp (Bloomington: Indiana University Press, 1990), 277, 278.

10 See Joshua Meyrowitz, *No Sense of Place* (New York: Oxford University Press, 1985); McKenzie Wark, *Virtual Geography* (Bloomington: Indiana University Press, 1994). For a good collection of works on place, space, and television, see Anna McCarthy and Nick Couldry, *MediaSpace: Place, Scale, and Culture in a Media Age* (London: Routledge, 2004). Victoria E. Johnson offers a suggestive treatment of the relation between place and media in *Heartland TV: Prime Time Television and the Struggle for U.S. Identity* (New York: New York University Press, 2008).

11 For a discussion of the philosophical discourse of place from the classical to the

contemporary moment, see Edward Casey, *The Fate of Place* (Berkeley: University of California Press, 1998).

12 Mary Ann Doane, "Information, Crisis, Catastrophe," in *Logics of Television*, ed. Patricia Mellencamp (Bloomington: Indiana University Press, 1990), 233.

13 Ibid., 238.

14 Doane's elaboration of the role that live aesthetics play in this capitalization also forms part of a necessary critique of media economics. For another prominent version of this critique, see Patricia Mellencamp, "TV Time and Catastrophe, or *Beyond the Pleasure Principle* of Television," in Mellencamp, *Logics of Television*, 222–39.

15 Jean-Marie Colombani, "We Are All Americans," *Le Monde*, September 12, 2001, 1.

16 Ellen Goodman, a columnist for the *Boston Globe*, is also frequently cited for popularizing the phrase in the American context, and for doing so in yet another sense than the one meant by Clinton or Colombani. See Ellen Goodman, "All in This Together," *Boston Globe*, September 26, 2006.

17 Colombani uses the phrase *barbarous logic* in "We Are All Americans." See Immanuel Kant, "To Perpetual Peace: A Philosophical Sketch," in *Perpetual Peace and Other Essays*, ed. and trans. Ted Humphrey (Indianapolis, Ind.: Hackett, 1983), 118.

18 Lynn Spigel discusses this sentiment and its brevity in relationship to post-9/11 television programming in "Entertainment Wars: Television Culture after 9/11," *American Quarterly* 56, no. 2 (2004): 235–70.

19 E.g., William Safire has dubbed the saying "we are all . . ." a *template phrase*. See Safire, "No Slogan Left Behind," *New York Times Magazine*, February 26, 2006, 21.

20 See Jean Baudrillard, *The Spirit of Terrorism*, trans. Chris Turner (New York: Verso, 2003), 5; Slavoj Žižek, *Welcome to the Desert of the Real: Five Essays on September 11 and Related Dates* (London: Verso, 2002), 15–18.

21 For a discussion of the process by which the phrase "we are all New Yorkers" morphed into the expression "we are all Americans" in the jingoistic promotion of Operation Iraqi Freedom, see Richard Jackson, *Writing the War on Terror: Language, Politics, and Counter-terrorism* (Manchester, U.K.: University of Manchester Press, 2005), 88–90.

22 For online access to Jackson's discussion of the "refugee" controversy and the journalist Alison Stewart on MSNBC, see http://www.msnbc.msn.com/id/21134540/vp/9186615#9186615.

23 Rachel Breunlin and Helena Regis, "Putting the Ninth Ward on the Map: Race, Place, and Transformation in Desire, New Orleans," *American Anthropologist* 108, no. 4 (2006): 748.

24 For a basic overview of the discourse surrounding the Lower Ninth Ward in the coverage of Hurricane Katrina, see Michael Eric Dyson, *Come Hell or High Water: Hurricane Katrina and the Color of Disaster* (New York: Basic Books, 2006), 10–12.

25 For a transcript of Nagin's speech, see http://www.nola.com/news/t-p/frontpage/index.ssf?/news/t-p/stories/011706_nagin_transcript.html.

26 Kant, "To Perpetual Peace," 118.

27 I am alluding here to Jacques Derrida's deconstruction of universal hospitality and the problem of refuge that it announces. Jacques Derrida, "On Cosmopolitanism," in *On Cosmopolitanism and Forgiveness,* trans. Mark Dooley and Michael Hughes (London: Routledge, 2001), 1–24.

28 Michael Warner, "The Mass Public and the Mass Subject," in *Publics and Counterpublics* (New York: Zone Books, 2002), 179.

29 In Warner's words, the media disaster occurs "of necessity anywhere else." Ibid.

30 Kant, "To Perpetual Peace," 118.

31 Ibid.

32 Ibid.

33 Kant, "Idea for a Universal History with a Cosmopolitan Intent," in Humphrey, *Perpetual Peace,* 32.

34 Marshall McLuhan, *Understanding Media: The Extensions of Man* (Cambridge, Mass.: MIT Press, 1994), 4.

35 For just one example, see Jean-Luc Nancy, *The Creation of the World, or Globalization,* trans. Francois Raffoul and David Pettigrew (Albany: State University of New York Press, 2007).

36 See Lisa Parks, *Cultures in Orbit: Satellites and the Televisual* (Durham, N.C.: Duke University Press, 2005).

37 Ernesto Laclau, "Universalism, Particularism, and the Question of Identity," in Laclau, *Emancipation(s),* 20–21.

Acknowledgments

We would like to thank, first and foremost, the contributors to this volume, all of whom have been exceedingly patient as this collection has made its slow way to publication. Apart from their patience, we want to thank them for the ingenious ways in which they responded to the collection's preoccupations. We also offer special thanks to Rosalind Galt for extra help with images, and to Sam Cooper and Michael Lawrence.

We want to thank the anonymous readers of the manuscript who offered initial support and useful critical advice. We thank especially Sabine Haenni, who gave us extremely helpful criticism and enthusiastic encouragement as the project moved through its final stages of preparation.

Support from the British Academy allowed us to present some preliminary versions of four of the essays here printed at a panel on place that we organized for the annual conference of the Society for Cinema and Media Studies, held in Chicago in March 2007.

Last, we would like to thank Jason Weidemann and Danielle Kasprzak from the University of Minnesota Press. Jason understood the interest of the project and encouraged us from the very beginning, and his support has seen this unusual collection through to the end.

Contributors

Rosalind Galt is senior lecturer in film studies at the University of Sussex. She is the author of *The New European Cinema: Redrawing the Map* (2006) and *Pretty: Film and the Decorative Image* (2011) and the coeditor of *Global Art Cinema: New Theories and Histories* (2010). Her articles have appeared in journals such as *Screen, Cinema Journal, Senses of Cinema,* and *Discourse.*

Elena Gorfinkel is assistant professor in art history and film studies at the University of Wisconsin–Milwaukee. Her publications on erotic film culture, cinephilia, sexploitation, and cult film have appeared in *Framework, Cineaste, World Picture,* and the collections *Cinephilia: Movies, Love, and Memory* (2005) and *Underground USA: Filmmaking beyond the Hollywood Canon* (2002). She is at work on a book on American sexploitation cinema of the 1960s.

Frances Guerin is lecturer in film studies at the University of Kent. She is the author of *A Culture of Light: Cinema and Technology in 1920s Germany* (Minnesota, 2005) and *Through Amateur Eyes: Film and Photography in Nazi Germany* (Minnesota, 2011). She is an editor of and contributor to *The Image and the Witness: Trauma, Memory, and Visual Culture* (2007). Her essays have appeared in numerous publications, including *Cinema Journal, Screening the Past,* and *Film and History.*

Ji-hoon Kim is a doctoral candidate in the Department of Cinema Studies at New York University, where he is currently working on a dissertation titled "Relational Images: The Art of the Moving Image, Medium Specificity, and Media Exchange." Prior to his doctoral study in the United States, Kim worked as a film critic, film festival programmer, and lecturer and also translated D. N. Rodowick's *Gilles Deleuze's Time Machine.* His research interests include film and media theory, experimental film and video, moving images in contemporary art, digital cinema and media art, and East Asian cinema. His essays have appeared in *Screen* and *Global Art Cinema: New Theories and Histories* (2010).

Hugh S. Manon is associate professor and director of the Screen Studies Program at Clark University, where he specializes in Lacanian theory and film noir. He has published in *Cinema Journal, Film Criticism, Framework, International Journal of Žižek Studies,* and numerous anthologies, including articles on Tod Browning, Edgar G. Ulmer, Billy Wilder's *Double Indemnity,* Michael Haneke's *Caché,* and Stanley Kubrick's films noirs. He is interested in lo-fi and punk representation in relation to the psychodynamics of failure and is currently developing a book project titled *Lack and Losslessness: Toward a Lacanian Aesthetics.* Born and raised in western Pennsylvania, Manon is a fourth-generation attendee of the University of Pittsburgh, where he earned his PhD in cultural and critical studies.

Ara Osterweil is an artist, writer, and professor of film and cultural studies at McGill University in Montreal. She is currently working on several scholarly projects about American film and art in the 1960s and 1970s.

Brian Price is associate professor of film and visual studies at the University of Toronto. He is author of *Neither God nor Master: Robert Bresson and Radical Politics* (Minnesota, 2011) and coeditor of *On Michael Haneke* (2010) and *Color: The Film Reader* (2006). He is a founding editor of *World Picture.*

John David Rhodes is senior lecturer in literature and visual culture in the School of English at the University of Sussex. He is the author of *Stupendous, Miserable City: Pasolini's Rome* and *Meshes of the Afternoon* (2011) as well as the coeditor of *Antonioni: Centenary Essays* (2011) and *On Michael Haneke* (2010). He is a founding coeditor of *World Picture.*

Linda A. Robinson is assistant professor in the Communication Department of the School of Arts and Communication at the University of Wisconsin–Whitewater. She holds a PhD in film studies from Northwestern University, and her research interests include cinematic nostalgia and the interrelationships between the past, history, and film.

Michael Siegel holds a PhD in modern culture and media from Brown University. His dissertation examined the films of Dario Argento in relation to the politics of urban change in post-1968 Rome. He has published on fascist Italy and neorealism and is currently translating a book on Hollywood cinema from Italian to English. He is a faculty member at Brown University and Clark University.

Noa Steimatsky is associate professor in the Department of Cinema and Media Studies at the University of Chicago. She is author of *Italian Locations: Reinhabiting the Past in Postwar Cinema* (Minnesota, 2008) and is completing a new book on the human face in the cinema—a project launched with a Getty Postdoctoral Fellowship. Steimatsky was also the recipient of a National Endowment for the Humanities Prize at the American Academy in Rome, where she conducted her research on the Cinecittà refugee camp. This project is being expanded into a book and has also been adopted for a documentary film project in Italy.

Meghan Sutherland is associate professor of film and visual studies at the University of Toronto. She is the author of *The Flip Wilson Show* (2008) and has written essays on media, politics, and philosophy for *Cultural Studies, Framework: The Journal of Cinema and Media,* and *Senses of Cinema.* She is a founding coeditor of *World Picture.*

Mark W. Turner is professor of English literature in the English Department at Kings College London. He is the author of *Backward Glances: Cruising the Queer Streets of New York and London* (2003) and *Trollope and the Magazines: Gendered Issues in Mid-Victorian Britain* (1999). He has published widely on queer urban modernity and is the editor of the complete journalism of Oscar Wilde.

Aurora Wallace teaches in the Department of Media, Culture, and Communication at New York University. She is the author of *Newspapers and the Making of Modern America* (2005) and *Media Capital* (forthcoming) as well as articles in *Journalism History, Philosophy and Geography, Space and Culture, Environmental Values, Journal of Visual Culture,* and *Crime, Media, Culture.*

Charles Wolfe is professor of film and media studies at the University of California, Santa Barbara. He has published widely on various aspects of commercial, independent, and documentary filmmaking in the United States and, with Edward Branigan, is the series coeditor of the American Film Institute Film Reader Series, which, to date, has published twenty-four volumes of new critical essays on topics of contemporary concern in film, television, and new media studies. He is currently working on a book-length study of Buster Keaton's silent film comedies and American modernism.

Index